363.25 MGHETHDRAWN

363.25 M648 Miller, Larry S Police photography 51636

POLICE FOR PHY

LARRY S. MILLER

East Tennessee State University

anderson publishing co. 2035 Reading Road Cincinnati, OH 45202 800-582-7295

Police Photography, Fourth Edition

Copyright [©] 1977, 1987, 1993, 1998 Anderson Publishing Co. 2035 Reading Rd. Cincinnati, OH 45202

Phone 800.582.7295 or 513.421.4142 Web Site www.andersonpublishing.com

All rights reserved. No part of this book may be reproduced in any form or by any electronic or mechanical means including information storage and retrieval systems without permission in writing from the publisher.

Library of Congress Cataloging-in-Publication Data

Miller, Larry S.

Police photography / Larry S. Miller. -- 4th ed.

p. cm

Rev. ed. of: Police photography / Sam J. Sansone. 2nd ed. c1987.

Includes bibliographical references and index.

ISBN 0-87084-816-X (pbk.)

1. Legal photography. I. Sansone, Sam J. Police photography. II. Title

TR822.M55 1998

363.25--dc21

98-18745

CIP

Dedication

This fourth edition is dedicated to Ruth, Ryan, Casey, and the memory of Sam J. Sansone.

	· 200	

Preface

The year 1971 was the beginning of a new age for the law enforcement profession. The Law Enforcement Assistance Administration was operating in full resplendence, providing financial assistance to local law enforcement agencies. Criminal justice programs were emerging in institutions of higher learning across the country. 1971 was also the year Sam J. Sansone's *Modern Photography for Police and Firemen* was first published. As a young crime scene technician, I remember my excitement in obtaining a copy of Mr. Sansone's book. I would never have imagined that, 25 years later, I would be updating his classic work.

This fourth edition of *Police Photography* is designed, as was the original, to teach the fundamentals of photography and their application to police work. Toward that end, this book is organized into two main themes: (1) the photographic process; and (2) the application of photography to police work. Mr. Sansone's original material has been updated and new material has been added. New material on cameras, films, equipment, and processing techniques has been included, and information on digital photography has been added.

I have attempted to maintain Mr. Sansone's proven style of presentation in this edition. I believe I have transformed the book into a current text of which Sam would be proud.

LSM

Acknowledgments

Credit is extended to:

George Reis of Free Radical Enterprises, 18627 S. Brookhurst, Suite 114, Fountain Valley, CA 92708 for assistance with research and contributions on digital imaging for law enforcement.

Ray Smith of Image-Pro Plus, Media Cybernetics, 8484 Georgia Avenue, Silver Spring, MD 20910 for assistance with digital software for law enforcement and image contributions.

Patrick Nolte of the Anaheim (CA) Police Department for assistance with digital imaging uses for law enforcement.

Ward Schwoob of the Florida Department of Law Enforcement, Tallahassee, Florida, for assistance with crime scene photography.

Hayden B. Baldwin of Forensic Enterprises, Inc. for information regarding crime scene and digital photography.

Eastman Kodak Company, Rochester, New York, for their cooperation in contributing to this book.

The U.S. Department of the Navy for permission granted to use materials employed in their photographic naval training courses.

The Johnson City (TN) Police Department for assistance with photographic resources.

Arthur Bohanan of the Knoxville (TN) Police Department for assistance with fingerprint comparison and digital imaging techniques.

Dr. William Bass and Dr. Murray Marks of The University of Tennessee–Knoxville, Department of Anthropology for information on skeletal identification and forensic anthropology.

The Photography and Criminalistics students of Sam J. Sansone (Classes 1967-1986) of Lorain County Community College, Elyria, Ohio, for the use of photographs submitted by them in their school projects.

The following companies for their cooperation with photographs or information concerning their products:

Electrophysics Corp., Nutley, NJ 07110
Free Radical Enterprises, Fountain Valley, CA 92708
General Electric, Cleveland, OH 44101
Luna Pro, Kling Photo Corporation, Woodside, NY 11377
Media Cybernetics, Image Pro Plus, Silver Spring, MD 20910
Minolta Company, New York, NY 10001
Paco Corporation, Minneapolis, MN 55440
Pete's PhotoWorld, Inc., Cincinnati, OH 45201
Play Incorporated, Snappy, Rancho Cordova, CA 95670
Polaroid Corporation, Cambridge, MA 02139
Saunders Photo/Graphic Inc., Rochester, NY 14611
Sigma Corporation of America, Hauppauge, NY 11788

Simmon Bros., Division of Berkey Photo, Inc., Woodside, NY 11377 Star-Tron Technology Corp., Pittsburgh, PA 15238 Sunpak, Division of Tocad America, Inc., Hackensack, NJ 07601 Tiffen Manufacturing Corp., Hauppauge, NY 11788 UltraViolet Products Inc., San Gabriel, CA 91778 Unitron, Inc., Bohemia, NY 11716 Well's Camera Shop, Kingsport, TN 37662

Special credits are hereby given to the following individuals for assistance with photographs and information:

Lori Cox, Johnson City Police Arson Unit; William DiGiovanni, Shaker Heights Police Dept., Ohio; Martin G. Johnson, Shaker Heights Police Dept., Ohio; John E. Kimmet, Jr., Elyria Police Dept., Ohio; Jeff Kraynik, Palm Bay City Police Dept., Florida; Stan E. Puza, Lorain Police Dept., Ohio; George Rosbrook, Lorain County Community College, Ohio; Leon Smith, Wyoming Police Dept., Michigan; Michael Tomaro, Pepper Pike Police Dept., Ohio; and Richard Whitt of the 1st Judicial District Drug Task Force (TN).

Contents

Dedicationiii	
Prefacev	
Acknowledgmentsvii	
Chapter 1 The Police Photographer	1
Police Photography—A Short History1 The Many Uses of Photography in Police Work4 Public Relations5 Police Photography and Fire Investigation5 Evidential Photographs5 Future of Photography6 References7	
Chapter 2 Light and the Simple Camera	9
Refraction10 Light11 Light—Our Most Important Tool11 Intensity of Light12 The Simple Camera13 A Pinhole Camera13 Disadvantages of the Pinhole Camera13 Adding a Lens14 Adding a Shutter14	

Care of Lenses....47

Chapter 3 Cameras		15
110 and Ultra-Miniature Cameras15 126 Instamatic Cameras16		
The 35mm Camera16 The 120 Medium Format Camera17 The 4 x 5 Camera21		
Polaroid Cameras23		
Digital Cameras24		
The Police Camera25		
Chapter 4		
Film		27
The Emulsion27		
The Base27		
Basic Film Sizes28		
110 Film28		
126 Film29 35mm Film29		
DX Film29		
120 Film31		
4 x 5 Film31		
Color Sensitivity32		
Speed34		
Graininess34		
Contrast35		
Sharpness and Acutance35		
Special Black-and-White Films35		
Color Film37 Color Reversal Film37		
Color Negative Film37		
Color Balance38		
Selection of Color Films for Police Work38		
Handling Films38		
Professional vs. Consumer Films39		
Chapter 5		
Equipment		43
Lenses43		
Normal Lenses43	and the state of t	
Wide-Angle Lenses44		
Telephoto Lenses44		
Zoom Lenses46		
Lens Speed46		
Autofocus Lenses46		
Lens Mounts47		
Macro Lenses 47		

Filters47
Care of Filters51
Exposure Meters51
Choosing a Meter52
Using a Meter52
Proper Exposure52
Incident and Reflected Light53
Cautions and Techniques for Meter Use53
Spot Meters53
Flash54
Electronic Flash54
Flash Meters56
Miscellaneous Equipment56
Lens Attachments56
Tripods57
Tripod Substitutes57
Cable Release58
Lens Brush58
Paper and Pencil58
Chamban 6
Chapter 6
Exposure
Exposure59
The "f" System60

Methods of Regulating Time....60 Controlling Intensity....60 Controlling Time....60 Combining Control of Intensity and Time....61 Depth of Field....61 More About Focus....62 Photography of Moving Objects....62 A Simple Exposure Method....63 Automatic Cameras....63 Built-In Meters....63 Subject Reflectance and Negative Density....63 Exposure with Bellows Extensions....64 Film Latitude....64 Artificial Light....65 Single Flash....65 Off-Camera Flash Technique....66 Multiple Flash....66 Painting with Light...67 Fill-In Flash....67 Exposure for Flash....69 The Inverse Square Law....69 Guide Numbers....69 Exposure for Bounce Flash....70 Exposure for Multiple Flash....70 Exposure with Filters....70

59

Negative Defects and Correction....94

Chapter 7 The Darkroom	71
The Room71	Francisco P
Work Areas72	
Storage72	
Plumbing72 Electrical Outlets and Lighting 72	
Electrical Outlets and Lighting73	
Ventilation74	
Safelights74	
Trays75 Tanks75	
Mechanical Print Washers76	
Timers76	
Mechanical Print Dryers77	
Small and Economical Darkrooms77	
Shan and Economical Barktoonis	
Chapter 8	
Black-and-White Processing: Negatives	81
Black-and-White Film Development81	
Temperature81	
Time82	
Agitation82	*
Developers82	
Water Rinse83	
Stop Bath84	
Fixing Bath84	
Hypo-Clearing Bath84	
Washing84	
Drying85	
Mixing Utensils85	
Basic Processing Procedures86	
How to Develop Black-and-White Film86	
Tray Procedure88	
Negative Processing Control89	
Predevelopment Water Rinses90	
The Need for Proper Agitation90	
Cleanliness90	
Proper Safelights91	
Useful Life of Solutions91	
Replenishment91	
Storing Chemicals and Solutions92	
Safety Precautions92	
Negative Quality92	
Density92	
Highlights92	
Shadows93	
Contrast93	
Tonal Gradation93	
Kodak Technical Pan 241593	

Chapter 9 Black-and-White Processing: Printing and Enlargement	99
Resin-Coated (RC) Papers99	
Paper Storage99	
Photographic Paper Emulsions100	
Emulsion Types and Contrast100	
Paper Bases100	
Paper Surfaces102	
Paper Sizes, Packaging, and Storage102	
The Printing Room103 Proof Sheets103	
The Enlarger105	
Negative Carriers106	
Enlarging Lenses106	
Enlarging Easels107	
Enlarging Sizes107	
Making an Enlargement108	
Enlarging Accessories112	
Timer112	
Voltage Stabilizer112	
Copy Stand112	
Dichroic Filter Lamp House112	
Stabilization Processors113	
Printing Defects and Correction113	
Chapter 10	
Color Processing	117
Color Processing	117
What to Photograph in Color117	
Photographic Color-Light Relationships119	
Color Film (Negative) Processing—C-41119	
Color Slide Processing—E-6120	
Push-Pull Film and Slide Processing120	
Color Printing120	
Determination of Filter Combinations122	
Printing Process—Negatives—EP-2122	
Evaluating Color Prints124	
Printing Color Slides125	
Color Printing Experience125	
Color Print Process—RA-4126	
Using Color Print Filters for Black-and-White Printing127	
Black-and-White Prints from Color127	
the state of the s	
Chapter 11	
Video and Digital Photography	129
Video Cameras129	
Camcorder Formats129	
Camcorder Features130	
Use of Camcorders131	
Photographing Television and Computer Screens132	

Digital Cameras132 Digital Camera Accessories135 Photo CD137 The Future138		
References138		
Charter 12		
Chapter 12		120
Accident Photography		139
Basic Considerations140		
Permission to Photograph141		
Viewpoints When Photographing Accidents141		
Working Under Poor Conditions141		
Basic Rules for Accident Photography142 What to Photograph143		
How to Photograph an Auto Accident Scene144		
Hit-and-Run Accident Scene147		
Possible Murder or Suicide147		
Chantar 12		
Chapter 13		1.40
Crime Photography		149
Perspective Grid Photographs149		
Homicide Investigations149		
How to Photograph a Homicide154		
Lighting for a Homicide Scene158		
Homicide Photography Summary158		
Suicide Investigations158 How to Photograph a Suicide158		
Suicide Photographs Summary159		
Sex Offense Investigations159		
Scene of the Crime159		
Photographs of the Suspect160		
Photographs of the Victim160		
Burglary and Breaking and Entering Investigations16	1	
Photographing a Burglary162		
Arson Investigations163		
How to Photograph a Fire164		
Photographs After the Fire165		
Equipment for Fire Photography165		
Film for Fire Photography166		
Importance of Photographs During a Fire167		
Problems and Cautions for Fire Photography169		
Other Uses for Crime Photography169		
References170		

C1 1.4		
Chapter 14		171
Evidence Photography		171
Photographs at the Scene of the Crime171		
Procedures171		
Data Sheet172		
Foot or Shoe Impressions173		
Close-Up Photography173		
Lighting for Small Objects174		
Macrophotography and Microphotography175		
Wood Photography177		
Metal Photography177		
Dusty Shoe Prints177		
Tire Impressions177		
Bloodstains178		
Bullets, Cartridges, and Shells179		
Particles and Other Small Specimens179		
Photographing at the Identification Bureau180		
Photographic Techniques180		
Darkfield Illumination Photographs182		
Backlight Illumination Photographs182		
Copy Techniques182		
Chapter 15		
		183
Identification Photography		103
Equipment for Fingerprint Photography184		
Films and Filters185		
Exposure for Fingerprint Photography187		
Fingerprints Found on Wood188		
Fingerprints Found on Glass188		
Fingerprints Found on Paper and Plastic189		
Photographing Lifted Fingerprints189		
Enlarging Fingerprint Photographs for Trial189		
The Identification Photographer190		
Identification Photographs191		
Film191		
Lighting191		
Cameras192		
Digital Identification Photography192		
Chapter 16		
		193
Questioned Documents		173
Reproduction for Case Study193		
Films and Developers193		
Erasures and Alterations194		
Chemical Methods195		
Other Methods of Photographing Erasures and Altera	tions195	
Obliterated Writing195		
Indentations196		

Contact writing197		
Carbon Paper and Ribbons197		
Differentiating Inks198		
Chanter 17		
Chapter 17		
Ultraviolet and Fluorescence Photography		199
Ultraviolet Photography199		
Ultraviolet Radiation199		
Radiation Sources199		
Illumination for Ultraviolet Photography201		
Filters201		
Film202		
Film Speed203		
Focus203		
Exposure203		
Flash204		
Blak-Ray Criminalistics and Detection Kits204 Fluorescence Photography205		
Luminescence205		
Fluorescence205		
Phosphorescence205		
Infrared Luminescence205		
Excitation Sources205		
Photographic Technique206 Illumination206		
Exciter and Barrier Filters207		
Films207		
Exposure Determination208		
Focus208		
Applications of Ultraviolet and Fluorescence Photography208		
Questioned Documents209		
Fingerprints210		
Injuries212		
Alternate Light Sources212		
Resources213		
Chapter 18		
Infrared Photography		215
		213
Cameras215		
Checking the Camera216		
Lenses216	*	
Focusing216		
Infrared Close-Up Photography217		
Aperture Compensation217		
Lighting217		
Photoflash Lamps218		
Electronic Flash Lamps218		
Lamps for Infrared Color Photography218		

xvii

Filters....219

Filters for Black-and-White Photography....219

Filters for Photography in the Dark....219

Filters for Infrared Color Photography....220

Films....220

Black-and-White....220

Color....220

Checking the Darkroom for Infrared Safety....221

Processing Infrared Film....221

Copying with Infrared....222

Illegible Documents....222

Inks and Pigments....222

Charred, Aged, and Worn Writings....223

Photographing in Darkness with Infrared....223

Night-Vision Devices....224

Appendix: Additional Readings and Resources....225

Glossary....227

Bibliography....261

Index....263

The Police Photographer

1

During a routine patrol of a suburban neighborhood, Officer Black receives a call instructing him to investigate a two-car collision a few blocks away. He drives to the scene and, before leaving his patrol car, notes that, although one of the vehicles (a late-model automobile of fiberglass construction) has sustained severe damage, no one seems to be injured.

The drivers of the two cars are arguing heatedly (neither driver, Officer Black observes, seems to have been clearly in the wrong) and nearby a passenger is sobbing. Officer Black calms the drivers, soothes the passenger, records each person's description of the accident (there were no witnesses outside the two cars involved), and radios for a tow truck to remove the damaged vehicle. Before the tow truck arrives and the autos are moved, he takes a few measurements, sketches the scene, and reaches into his glove compartment. Officer Black takes out a pocket-sized camera, checks to see that it is loaded with film, and snaps four photographs of the accident.

In addition to being a calmer-of-nerves, an investigator, a law enforcer, an impartial witness (though after-the-fact), an artist, and an agent for the immediate conclusion of a minor catastrophe in the lives of three people, Officer Black is a police photographer. That is not in his job description, but neither is his role as a street psychologist. He may never step into a darkroom or hold a single-lens-reflex camera in his hands; he may never even change the film in the camera he keeps in the glove compartment of his patrol car. However, his function as a police photographer is every bit as important as that of the head of his department's crime lab who can mix chemicals, change film in the dark with one hand, and who takes

photographs in his spare time that could vie with the best of those seen in *National Geographic*.

Both Officer Black and the head of his department's crime lab are police photographers; this book is for both of them.

Police Photography—A Short History

Photography is most obviously useful in police work when photographs serve as evidence that may prove to be invaluable to investigators, attorneys, judges, witnesses, juries, and defendants. Often, a good photograph can be the deciding factor in a conviction or acquittal when no other form of real evidence is available.

Photographs were used in court as early as the mid-1800s. In 1859, a photograph was used in the case of *Luco v. United States* (23 Howard 515 [1859]) to prove that a document of title for a land grant was, in fact, a forgery. The first recorded use of accident photography was in 1875: "Plaintiff, in a horse and buggy, was injured when, in attempting to go around a mud hole in the center of a road he drove off an unguarded embankment" (Scott, 1969). The photograph was admitted in evidence to assist the jury in understanding the case.

While neither of these early photographs used in evidence was taken by a police photographer, the use of photography in police work is well established in the early annals of photography. In 1841, 18 years before *Luco v. United States*, the French police were making daguerreotypes (an early form of photograph) of known criminals for purposes of identification.

One of the first cases to hold that a relevant photograph of an injured person was admissible as evidence was *Reddin v. Gates* in 1879 (52 Iowa 210 [1879]). The photograph was a tintype, a photograph made on a thin iron plate by the collodion process. It showed whip marks on the plaintiff's back three days after the assault. In 1907 in Denver, Colorado, all intoxicated persons were photographed at the police station.

Speeding motorists were being detected with photographic speed recorders by 1910. The state of Massachusetts approved the use of such devices and gave a full description of their operation. Radar is a more popular device for this operation today.

The use of fingerprint photographs for identification purposes was approved in 1911 in *People v. Jennings* (96 N.E. 1077, 252 Ill. 534 [1911]), although 1882 was the year in which fingerprints were first officially used for identification purposes in the United States. Gilbert Thompson of the United States Geological Survey in New Mexico used his own fingerprint on commissary orders to prevent their forgery. In 1902, New York Civil Service began fingerprinting applicants to discourage the criminal element from entering civil service, and also to prevent applicants from having better-qualified persons take the test for them.

The famous Will West-William West case took place at Leavenworth Prison in 1903. When Will West was received at Leavenworth, he denied ever having been imprisoned there before. While West was being measured by the Bertillon system (a form of identification using anthropological measurements), the clerk making the measurements insisted that West

had been a prisoner there before. Upon checking the prison records, the clerk found a mug shot, Bertillon measurements, and fingerprints of a William West already imprisoned at Leavenworth, serving a life sentence for murder. Subsequently, the fingerprints of Will West and William West were compared. The patterns bore no resemblance. The fallibility of three systems of personal identification (photographs, Bertillon measurements, and names) was demonstrated by this one case. The value of fingerprints as a means of identification was established. There was a great similarity in the photographs of Will West and William West (see Figure 1.1). An officer must be very careful when identifying a person from a photograph. After the Will West-William West case, most police departments began using photographs, Bertillon measurements, and fingerprints on their "mug shot" files. Eventually, the Bertillon system was discarded (see Figure 1.2).

One of the early uses of firearms identification is recorded in a 1902 case, Commonwealth v. Best (62 N.E. 748, 180 Mass. 492 [1902]). Photographs of bullets taken from the body of a murdered man were put into evidence along with a photograph of a test bullet pushed through the defendant's rifle. This method of obtaining a test bullet is not proper, according to modern authorities, but the use made of the comparison photographs was to be followed in many later firearms identification cases.

Prior to the modern electronic flash units of today, photoflash bulbs were used and readily accepted by the public by 1930. Prior to the photoflash bulbs, people used flash powders—dangerous explosives that produced a great deal of objectionable

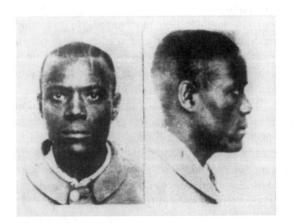

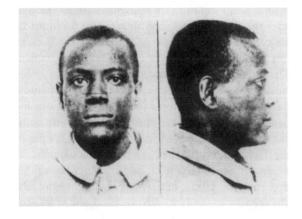

Figure 1.1
The Will West-William West case demonstrated that photographs and Bertillon measurements of persons were not accurate methods for identification. Will West (left) and William West (right).

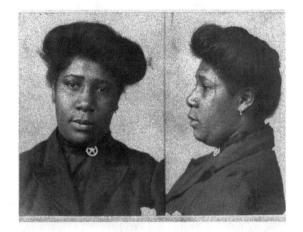

Bertillo	ni measui	ements.	Alles Anna Shaw. Alles Thioving Prostitute
71.1	Head length,	L. Foot,	Age 26 Height 5.7 3/8 Weight 222 Suite Stout
78 . 0	ffend width,	12.0	Hair Black. EyesDk.Maroon
90 .0	Length,	9.4	Complexion Light Brown Skin
	13.8	47.7	Date of Arrest Nov.27th 1908. Geneer Crockett, Owens and Scott.
			MARKS:
scar ba scar cx corner	ck of L. tending of L.eye orced. S	hand. (black mole on upper L. L.forcarm. Faint burn ut on R.forcarm. Largo shock bone through outer into edge of hair. ide and one lower front
	Organia (Caranta)		100

Height	1=66-5	Head, length	19-4	L. Foot	25-2	E (Circle Lt, Ar	d 22, years
Eng. Hght.	1 = 69=0	Head, width	14-5	L Mid P.	8-1	Periph. Z.	We.
Guts, A	91-5	Cheek	6-3	L. Lit. P	and the same of th	5	Bernie MQ
Trunk		length		L. Pore A.	100000000000000000000000000000000000000	Pocul.	79100000
			1		d	2	
	1		K				
(Inel,Re	es. Great.	g Ridge	oet.		rder Reg.	Completion Wall Mous SMOOth 127#	

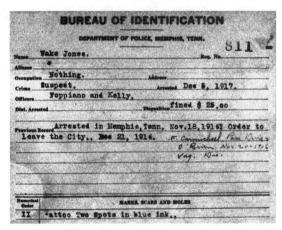

Figure 1.2
Early mug-shot files depicted photographs, fingerprints and Bertillon measurements. Eventually, Bertillon measurements were discarded as a means for identification. (Courtesy Memphis Police Department)

smoke. The photoflash bulb was a revolutionary development that made possible the taking of many evidence pictures that were otherwise unobtainable. Undoubtedly, their use contributed greatly to the development of police photography.

Ultraviolet photography was approved in a decision handed down in the 1934 case of *State v. Thorp* (171 A. 633, 86 N.H. 501 [1934]). The picture used in this case showed footprints in blood on a linoleum floor, and brought out distinctive marks in the soles of the shoes worn by the defendant that corresponded to the marks shown in the ultraviolet photograph.

In 1938, the Eastman Kodak Company introduced the Super-Six-20, which was a camera featuring fully automatic exposure control by means of a photoelectric cell coupled to the diaphragm of the lens. After 1945, Kodak again introduced cameras that

were automatic and in a price range that everyone could afford. Today, such features are used in most cameras and are within a price range that is affordable to most people. You can get an automatic camera that meets almost all of a person's photographic needs. For example, the Nikon N8008S, once a person learns how to use it, makes police photography very simple.

The first appellate court case approving the admissibility of color photographs was *Green v. City and County of Denver* (142 P.2d 277, 111 Colo. 390 [1943]). The court upheld the use of color photographs as evidence.

The Eastman Kodak Company introduced a color transparency using sheet film in 1935. Called Kodachrome, it quickly became extremely popular, resulting in the widespread use of color photographs in police photography. Then, in 1941, a color process

known as Kodacolor made it possible to make color slides, color prints, or black-and-white prints from a color negative.

In 1963, the Polaroid Company introduced Polacolor film, which made it possible to take finished pictures in black-and-white or color in less than one minute. This was one of the most significant developments in the history of photography and has led to the extensive use of color photographs as evidence. Today, Polaroid manufactures many films that are used by police.

In 1965, another important invention was placed on the market. It was the introduction of a fully automatic electronic flash unit, which made it possible to take exposed strobe flash photographs at distances from two feet to 20 feet without changing the lens opening or shutter speed. Automation was thus achieved by means of the lighting equipment rather than the camera.

In 1967, we saw the beginning of the use of videotapes as legal evidence. Sony introduced the Betamax videotape cameras and recorder/players in the mid-1970s, making them affordable for the average household. At the same time, the Matsushita Company introduced the VHS series of cameras and recorder/players in direct competition with the Betamax system. Consumers chose the VHS over the Betamax. Today, a majority of law enforcement agencies use videotapes for surveillance, recording crime scenes and interrogations, and for training purposes.

In the 1980s, we saw the introduction of quality 35mm "point-and-shoot" cameras, fully automatic 35mm single-lens-reflex (SLR) cameras with automatic lens focusing, and a host of new and better films. During the late 1980s, we saw faster personal computers with high memory capabilities allowing for the introduction of the CD Photo system and digital imaging.

The 1990s have produced more advances in the field of photography than previous decades. Primarily due to the progress of electronics and computer systems, new photographic media have been developed. During the late 1990s, a new photographic media emerged, digital imaging. When the digital videodisc was introduced in the late 1990s it set the stage for the eventual replacement of the videocassette, the laser disc, the CD-ROM, and even audio CDs with one system for digital media storage.

Today's cameras are automatic to an extent. The police photographer can now concentrate more on the subject of the picture than on the intricacies of the camera. Professionals and amateurs now use cameras

equipped with semiautomatic or fully automatic controls. Digital imaging allows photographers to take images and manipulate them and enhance them using a computer rather than a darkroom. With the wide variety of good cameras today there is no excuse for a police photographer not to be able to obtain suitable pictures for evidence.

The Many Uses of Photography in Police Work

The modern police department considers photography more than just a way to record evidence or identify a known criminal. Note the role of photography in the following aspects of law enforcement:

Identification files: criminals, missing persons, lost property, licenses, anonymous letters, bad checks, laundry marks, and civilian or personnel fingerprint identification files. In the case of a catastrophe such as an airplane crash, the fingerprints from a civilian file prove to be helpful in making positive identifications.

Communications and microfilm files: investigative report files, accident files, transmission of photos (wire photo, fax, and E-mail), and photographic supplements to reports. With modern-day electrophotography machines and computers, accident reports can be made in seconds and sold to insurance adjusters for nominal fees. An excellent source of revenue for a department is the sale of photographs of traffic accidents to insurance companies and lawyers.

Evidence: crime scenes, traffic accidents, homicides, suicides, fires, objects of evidence, latent finger-prints, and evidential traces. Evidence can frequently be improved by contrast control (lighting, film, paper, and filters), by magnification (photomicrography, photomacrography), and by invisible radiation (infrared, ultraviolet, soft X rays, and hard X rays).

Offender detection: surveillance, burglar traps, confessions, re-enactment of crimes, and intoxicated-driver tests. One of the newest applications of police photography is to record on videotape arrests in which the suspect offers resistance. This practice has been instituted by many law enforcement agencies to counter charges of police brutality.

Court exhibits: demonstration enlargements, individual photos, projection slides, videotapes, and computer presentations (e.g., Microsoft PowerPoint presentations). Reproduction and copying: questionable checks and documents, evidential papers, photographs, official records, and notices.

Personnel training: photographs, films, computer presentations, and videotapes relating to police tactics, investigation techniques, mob control, and catastrophe situations.

Crime and fire prevention: hazard lectures, security clearance, detector devices, and photographs taken of hazardous fire conditions when fire prevention inspections are made.

Public relations: slides, films, computer presentations, and videotapes that pertain to safety programs, juvenile delinquency, traffic education, public cooperation, and civil defense.

In general, then, there are four primary ways of using photography in police work: (1) as a means of identification; (2) as a method of discovering, recording, and preserving evidence; (3) as a way to present, in the courtroom, an impression of the pertinent elements of a crime; and (4) as a training and public relations medium for police programs.

Public Relations

Aside from the obvious uses of photography in police work, the photographer must be aware of the importance of police photography in public relations. For instance, burglary has a low clearance rate: about 13 percent (Federal Bureau of Investigation, 1997). The inability of police departments to catch these particular criminals is, of course, founded in the elusiveness of the criminal and his or her ability to vanish into the dark. The public, however, regards this percentage as ineptitude on the part of the police. Careful and thorough photography of a burglary scene can go a long way toward solving the crime, thus dispelling this and other misconceptions of the public.

Police Photography and Fire Investigation

Arson is probably the least investigated index crime for two reasons. First, it is difficult to show that a fire was, in fact, intentionally set. Second, a controversy exists as to who should investigate arson.

Should it be the police, who have extensive knowledge and experience in investigations? Or should it be the fire department, which has much more knowledge about the causes of fires? In large cities, this problem is solved because they have their own arson investigation units. But in smaller towns, this may not be the case; neither department wants to get involved in this problem, so it may go unsolved.

Regardless of who is responsible for photographing the scene during an arson investigation, his or her main role is to document the fire from its origin to its completion. Another aspect of this job is to document aspects of the operation for the training of new fire fighters, to show both correct and incorrect procedures for future study.

The primary principle to remember in police photography is that a finished photograph must be accurate. As a means of evidence, a photograph can be factual and, in many cases, quite revealing. In other words, the essence of photography lies in its ability to both record and clarify. In order to use the camera to its fullest advantage, then, it becomes necessary to learn the fundamentals of the photographic process; to learn and understand the techniques of, and wide range of possibilities for, photography in law enforcement.

Evidential Photographs

Court photographs serve two purposes: (1) the photograph itself is documentary evidence; and (2) the photograph is a record of evidential objects that may or may not be present in the courtroom. When the photograph itself is evidence, it implicates a defendant in a criminal act. This is apparent in surveillance and "sting" operations, in which photographs or videotapes depict identifiable persons engaging in illegal activity. When the photograph serves as a record of items or situations of evidential value, the photograph is used to illustrate details of the evidence or scene, or to represent evidence that is not present or is unseen in court. Crime scene photographs, microphotographs, macrophotographs, medico-legal photographs (autopsies), and photographs of objects that cannot be conveniently brought into the courtroom are examples.

It should be noted that when photographs are introduced as evidence in court, the photograph will not stand alone. A person, present when the photograph was taken, must be able to testify that the pho-

tograph accurately and fairly depicts the scene as it was and that the photograph is not misleading or sensational. For this reason, no photograph of evidential value may be altered or retouched in any manner. Objections may even be raised about placing identification markings on photographs, such as in the case of fingerprint comparisons. When in doubt as to whether such markings may be objectionable to the court, it is advisable to prepare two sets of photographs, one with and one without such markings. A removable transparent overlay may also be used for such markings on one photograph. As early as 1899, a court observed:

It is common knowledge that as to such matters, either through want of skill on the part of the artist, or inadequate instruments or materials, or through intentional and skillful manipulation, a photograph may not only be inaccurate but dangerously misleading (*Cunningham v. Fair Haven & Westville R. Co.*, 72 Conn. 244 at 250, 43 A. 1047 at 1049 [1899]).

Videotapes, color photographs, and digital images are generally admissible on the same grounds as black-and-white photographs, namely: (1) they depict relevant issues in the case; (2) they are true and accurate representations (which may require the testimony of the photographer); and (3) their probative value is not outweighed by their prejudicial effect (i.e., gruesomeness or inflammatory character).

In Wright v. State (250 So. 2d 333 [1971]), the court held that three of eight color photographs introduced were grossly inflammatory and unnecessary to explain or elucidate any portion of the state's case. However, in Albritton v. State (221 So. 2d 192 [1969]), the same court held that color and black-and-white photographs depicting injuries to a 16-month-old baby demonstrated visual evidence of the extent and severity of the child's injuries.

Color photographs in and of themselves do not determine their admissibility or inadmissibility as evidence. The legal requirement lies in the effect of the photographs, whether in color or in black-and-white. Generally, if the inflammatory character of "gruesome" photographs is overemphasized and their probative value is minimized, the courts may find error in their admissibility. Criminal cases reflect broad discretion in the trial court for admission of photographs when the probative value is found to out-weigh prejudicial impact (*People v. Cruz*, 26 Cal. 3d

233, 162 Cal. Rptr. 1 [1980]). The best advice is to show only those photographs that explain and demonstrate, and nothing more.

While digital images are much easier to manipulate than traditional film photographs, they have stood the same legal tests. In 1997, the International Association for Identification adopted a resolution endorsing the use of digital imaging, stating that it was a natural progression in the history of photography, and therefore fell under the same criteria as photographic evidence. Despite defense attorneys' objections to the use of digital imaging because of the ease with which they can be manipulated, the courts have allowed digital photographic images on the same basis as traditional film photographs.

Future of Photography

Astounding developments are being made in photography that are going to lead to even greater use of police photography. Years ago, people laughed when someone suggested that any size photograph could be produced almost immediately without the use of a darkroom. Photographs can be made today in 35mm, 2 x 3-, 4 x 5-, and 8 x 10-inch sizes. The traditional darkroom as we know it is going to disappear. Photographic evidence will be produced not only more quickly but also more economically, and at the same time will be of excellent quality.

Because revolutionary changes are in progress and are happening so quickly, it will be difficult to keep up with them. Contemporary police photographers have more technologically advanced materials available to them than did their earlier counterparts. Even though photography may develop more and more into a digital medium with pictures recorded and stored electronically, the basic principles of photography will not change. We will still have the basic laws of perspective, correct tone reproduction, and so forth. Photographic processes are but a means to an end, and police are primarily concerned with whether the final photographic exhibit is a fair and accurate representation of a subject, rather than how it was reproduced.

In the near future, photography will lean more toward electronic digitization. Great strides in electronics have been made in the last decade and will no doubt invade the photographic finishing and development areas more fully. Already, videotape recordings of depositions, interrogations, and crime scene investigations are becoming commonplace, and digital

imaging is becoming commonplace with latent fingerprint examinations and other areas of forensic science. Color photographs may virtually supplant black-and-white photographs in all but certain scientific branches of police photography in which color would have no advantage. Sophisticated, yet easy-to-operate, cameras and advanced films are being developed on an almost-daily basis. No book can possibly keep up with all the changes taking place in the field of photography. The serious police photographer should subscribe to one of the many photographic magazines (e.g., *Popular Photography*) to keep abreast of new developments.

Photographic evidence is an important specialty—a powerful tool recognized as indispensable in the proof of facts in court. The opportunities for the use of photographic evidence in the future will be limited only by our ability to understand and appreciate the power of the photographic picture and to comprehend its limitless value.

References

Federal Bureau of Investigation (1997). Crime in the United States, 1996. Washington, DC: Government Printing Office.

Scott, C.C. (1969). *Photographic Evidence*, 2d ed. St. Paul, MN: West Publishing.

Afrikan di kana di kan Birang pelanggan di kana di ka Birang pelanggan di kana di ka

and the state of t

the state of the second se

Light and the Simple Camera

2

A photograph is the result of a manipulation, a recording—and in some cases, creation—of light. The entire science of photography is concerned with light manipulation and recording. The camera and its parts (shutter, diaphragm, focus) filter light; the enlarger manipulates light; and film, photographic paper, and exposure meters record light. Flash creates light.

Light is radiation. When an atom in a light source is changed physically (the cause of the physical change is irrelevant for our purposes), it emits a photon (electromagnetic radiation) that behaves like a wave and, at the same time, like a particle. For the purposes of photography, light may be discussed as photons that behave like waves.

Light can be compared to a ripple over a pond. If a stone is thrown into a still pond, a series of concentric ripples can be seen radiating from the source. The concentric ripples are formed because the energy from the disturbance is radiating in straight lines and in all directions over the surface of the pond. A cross section of the ripples in the pond would show that the energy moving across the pond has formed waves that are characterized by their peaks and troughs.

The distance from a peak to an adjacent trough in a wave is called the wavelength of the wave. The number of waves per unit of time is called the frequency of the wave.

Light, heat rays, X rays, and radio waves are all forms of radiant energy, each differing from the others in wavelength. Radiant energy can be identified by its wavelength and listed on a number line called the electromagnetic spectrum.

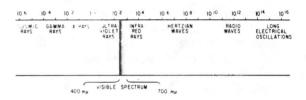

Figure 2.1 The electromagnetic spectrum.

The portion of the electromagnetic spectrum that affects the sense of sight in humans is called the visible spectrum and is limited to radiations of extremely short wavelength. These radiations are seen as colors, the longest of which is seen as "red," and the shortest of which is seen as "violet." Photography is not only concerned with these radiations and with those lying adjacent to red and violet, but also those outside the visible spectrum—infrared and ultraviolet.

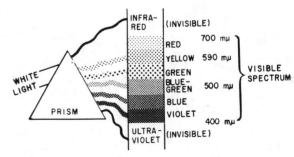

Figure 2.2 The visible spectrum.

When all wavelengths of the visible spectrum are radiated by a light source in equal amounts, the mixture is seen as "white" light. In places where no radiations from any light source can be seen, the absence of light is called "black." Whenever any wavelength of light is present in greater abundance than others, the resulting light is colored.

Light travels through a vacuum and through the air at a speed of 186,000 miles per second, but can be slowed by dense mediums such as glass or water. Mediums that merely slow the speed of light but allow it to pass freely in other respects are called transparent objects. Objects that divert or absorb light, but allow no light to pass through are called opaque. Thick metal, stone, and wood are examples of opaque objects. There are some objects that allow light to pass through them in such a way that the outline of the light source is not clearly visible. These objects are known as translucent; a few examples are opal glass, ground glass, and oiled paper.

Light sources, such as the sun, flames, white-hot metals, and stars emit radiations within the visible spectrum and are called luminous objects. All other objects, called nonluminous objects, are visible because they reflect light from luminous objects. Reflection occurs whenever an object changes the direction of a light wave but does not allow the wave to pass through it. Reflected light can be either specular or diffuse. Practically all surfaces reflect both specular and diffuse light. Smooth surfaces reflect more specular light and rough surfaces reflect more diffuse light. Diffuse light is more common than specular light; most objects are seen and photographed by diffuse light reflected from their surfaces.

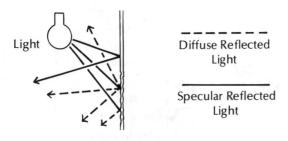

Figure 2.3 Light reflected from a sheet of pitted glass.

All surfaces vary in their ability to reflect light. A black cloth will reflect scarcely any light, whereas a white handkerchief reflects a great deal of light.

Refraction

When light passes through a piece of glass, the light is slowed from its normal speed of 186,000 miles per second. If the light passes through a sheet of flat glass, such as a modern windowpane, it will resume its normal speed when it has passed through, but it will have changed direction. Flat glass, because of its physical properties, corrects the change in direction of the light and no change is readily noticeable.

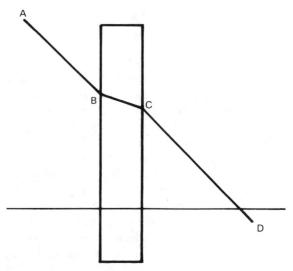

Figure 2.4
Refraction of light through flat glass.

If a piece of glass is made with sides that are not parallel, the glass will not self-correct the bending of the light. In fact, the glass may intensify the change of direction. A prism is a good example of this.

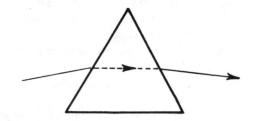

Figure 2.5 A prism bends a ray twice.

A lens is simply a piece of glass that has been constructed so that all the light rays that pass through it are bent toward or away from one point that is determined by the maker of the lens. Light rays that

meet at one point after they pass through a lens converge; those that bend away from a given point diverge. Lenses that cause light rays to converge are usually thick in the center and thinner at their edges; these are called convex lenses. Lenses that are thin at the middle and thick around the edges are concave; these usually make light rays diverge.

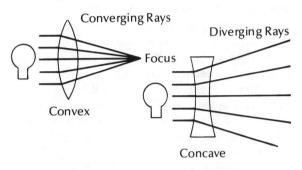

Figure 2.6
Convex and concave lenses.

The point at which light rays converge is called the focus. For any lens, this point is not the same for a subject 10 feet away as it is for a subject 20 feet away. The farther a subject is from the lens, the closer the focus will be to the lens. Subjects more than 600 feet away from a lens, however, will focus at very nearly the same distance from the lens. The difference between the focus of a subject 600 feet from the lens and another subject 1,000 feet from the lens is nearly negligible.

Distances of 600 feet or more are called infinity. In order that the lens maker can describe the properties of a lens that has been made, he or she can say that the lens will focus subjects at infinity at a certain distance from the lens. This distance is called the focal length of the lens.

Light

For the police photographer, photographs are statements of what he or she saw. The eye sees a photograph and translates the image to the mind; the mind then reacts and within itself it equates, evaluates, and responds to the photograph.

We become capable of describing photographs with words, but more importantly, the police photographer must develop the ability to describe words with photographs. This is what it is all about: communicating with photographs.

Objectively, photography is a combination of the following tools:

- 1. Light
- 2. Camera
- 3. Lens
- 4. Film
- 5. Paper
- 6. Chemistry
- 7. Composition

Light—Our Most Important Tool

There is little doubt that light is our most important tool. Light brushes on the lines, sculpts our subject, provides shadows, highlights, tones, emphasizes, subdues, lifts out, hides, and dramatizes our subject. Light can flatter, or be terribly brutal to our subject.

All cameras are essentially boxes that support the lens and contain the film or, in the case of digital cameras, a computer chip. All lenses are optics; they vary in characteristics and optical quality. The variety of film material available on the marketplace is limited. The same is true of photographic papers. Chemi-

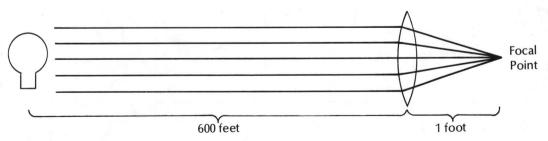

Figure 2.7
The focal length of this lens is one foot.

cal processing in color photography is very rigid, almost totally inflexible. In black-and-white photography, a limited choice still exists. While chemical processing does not occur with digital photography, there are limitations in hardware and software.

Another tool—composition—is a Pandora's box. One group in photography bases its approach on the rules of classic composition, while another boldly claims that photography must stand on its own. Composition is a principle of artistic photography. In art photography, the composition of a photograph through light and shadow is as important as the subject matter. Art photography attempts, through composition, to enhance an image, beautify and/or express a meaning that may or may not be present in the subject being photographed. In police photography, we are not striving for the beautiful or artistic picture. Artistic composition has no place in evidential photography. We are interested in obtaining all the facts of the case so that we can present them to the jury. In this sense, the police photographer is concerned with using light and shadow to the extent that the photograph taken portrays a true and factual image.

While we find that we have a limited number of cameras, lenses, films, paper, chemistry, and digital technology with which to work, light alone remains the tool of greatest selection. Here the possibilities are enormous and the selection is ours.

Intensity of Light

One important aspect of light is its intensity as it reaches the subject, and how it is reflected by the subject. This is very important for the police officer to understand, because the intensity of light on a subject varies considerably when the distance between the light source and the subject of the film is changed. The relationship of intensities is governed by the inverse square law that is shown graphically in Figure 2.8.

If an object, such as a card, is placed one foot from a light source, the light striking the card will be of particular intensity. If it is then moved two feet away from the light, the intensity of the light falling on the card will be one-fourth as great. As the card is moved farther away, the intensity of the light reaching the card decreases further as the square of the distance from the source increases. This property of light is very important to the police photographer, especially when shooting vehicle accidents outdoors at night with flash or floodlight. The officer's failure to correct the exposure as the subject moves farther from the light source will result in badly underexposed negatives due to the inverse square law. This principle is also important in the darkroom. If, for example, you have made a satisfactory 5 x 7-inch enlargement, then decide to make an 11 x 14-inch enlargement from the same negative, there should be an approximate increase of four times in the expo-

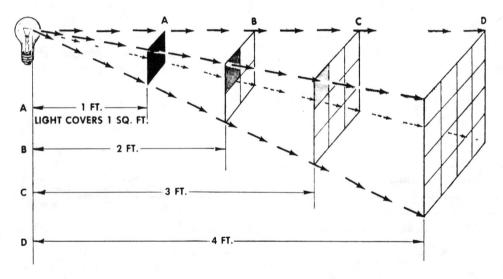

Figure 2.8 Graphic representation of the inverse square law.

sure. If the importance of this inverse square law is not recognized in the darkroom, poor quality prints and disappointment will result.

The Simple Camera

A camera is simply a box that has been designed to keep out all light except for such light as the photographer wishes to allow inside. Inside the camera, the photographer places a sheet of acetate. The acetate is coated with a chemical that changes when light strikes it; hence, the reason for making the box light tight.

To take a photograph, the photographer must let a certain amount of light through a small opening in the box. This light will strike the acetate and change the chemicals. When enough light has been let in, the photographer shuts out any excess light. The light that did enter is then recorded on the acetate.

The simple camera, also known as the box camera, is little more than a pinhole camera (see Figure 2.9) to which a lens and a shutter have been added. The lens cannot be moved in relation to the back of the camera, nor can the time the shutter is open be changed.

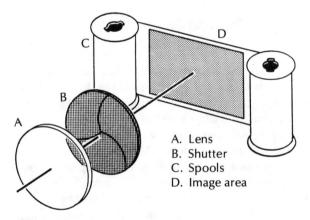

Figure 2.9
The simple camera.

But photographs, often ones of good quality, can be made with the simple camera. Who has not been in the following situation? A group of people is huddled around a pile of photographs. Someone (it never fails) says, "These are beautiful pictures. What kind of camera did you use?" Invariably the answer is, "a Polaroid," "a Kodak," or "a pocket point-and-shoot" camera. How can a cheap camera make good pic-

tures? Anyone who follows these simple rules can take good photographs with a box camera:

- The lens of a simple camera should be set so that objects from 10 to 15 feet from the camera will be in focus. As subjects get closer than 10 feet to the camera, or farther than 15 feet, they get progressively blurrier.
- Whenever possible, color film should be used in a box camera. It is difficult to make a bad color picture.
- 3. Pictures should be taken outdoors in sunlight or indoors with a flash suggested by the manufacturer of the camera. The subjects of photographs taken indoors with a flash should be between 10 and 15 feet from the photographer.
- The camera should be held steady. Any movement of the camera at the time the shutter is open will result in a blurry picture.

The simple camera is much too limited to be used by a practicing police photographer, but for learning about film and the darkroom, it is an excellent tool.

A Pinhole Camera

If a photographer wants to make a picture, he or she must do more than record light with the camera; the light must be organized so that the respective shapes, colors, lights, and darks are recorded on the film in such a way that they look like the real thing. This is done by giving the opening for light a shape that will sort out the light while it is passing through. A pinhole will serve this purpose. The pinhole does not actually bend, or refract, light the way a lens does, but rather (because light travels in a straight line) it allows only a tiny bit of light that has been reflected from any point on the subject to pass through (see Figure 2.10). When the properly sorted light has been recorded on the film, the record is called an image.

Disadvantages of the Pinhole Camera

The pinhole image is not a focused image, although it is reasonably sharp. For this reason, the image can be made large or small, depending upon how far the film is held from the pinhole. The farther the film is held from the pinhole, however, the less

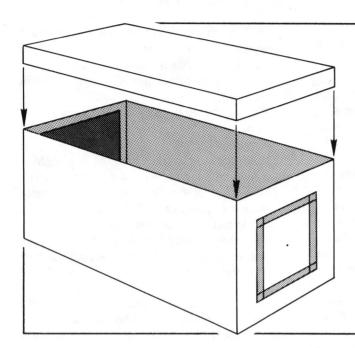

Making a Pinhole Camera

To make a pinhole camera, use a shoe box with a tightly-fitting lid. Paint the inside of the box flat black, and cut a square hole at one end. Tape a piece of aluminum foil over the hole and pierce it with a pin.

In a darkroom, tape a piece of film opposite the pin hole. Cover the box, tape it shut around the edges, and cover the pinhole with your finger. Now carry the box out of the darkroom, finger over the pinhole, and aim it at a stationary subject. Expose for one minute, carry the box back into the darkroom (cover the pinhole!) and remove the film. Place the film in a light-tight package until it can be developed.

Figure 2.10 Making a pinhole camera.

bright it will become. Added to the fact that the pinhole itself lets in very little light, the pinhole camera is not very good for gathering a lot of light and organizing it in the very short amount of time (often $\frac{1}{100}$ of a second) that is necessary for making a good picture.

Adding a Lens

By adding a lens to the camera in place of a pinhole, the photographer is able to gather much more light to be recorded. In exchange for the light gathering capability, however, he or she must now focus the lens for the various distances of subject-to-lens. This can be avoided, as it is in many budget cameras, by setting the lens-to-image distance so that subjects 10 to 15 feet from the lens are in sharp focus. In cameras with adjustable focus, the lens is moved closer to, or away from, a stationary back.

Adding a Shutter

To control the light that enters the camera, the photographer must have some kind of door that he or she may open and close at will. The door can be as simple as a finger held over the pinhole of a pinhole camera, or as complicated as the focal plane shutters of expensive cameras. However it is constructed, the door is called a shutter. Most shutters are spring loaded, and open and close automatically when a button on the side of the camera is depressed. For a fraction of a second, enough light is gathered by the lens and let into the camera by the shutter to make the necessary chemical changes that will form an image.

Cameras 3

More than almost any other art form, photography requires equipment. The primary piece of equipment for taking photographs is, of course, the camera. Yet a camera itself will not produce a photograph. The camera must be loaded with the correct size of film that is to be manipulated by the photographer. These three items—camera, film, and photographer—working together, constitute a system of photography.

The system, and therefore the capabilities of the system, may be enlarged with the addition of various pieces of equipment (each of which must be compatible with the system) and the thoughtful use of the many films that are available. For instance, a simple box camera, loaded with film and manipulated by a photographer, is a very limited system that may be enlarged and adapted to indoor use by adding a compatible flash attachment.

As demands upon the photographer are increased, he or she must refine the capabilities of the system by adding pieces of equipment, replacing pieces of equipment, simplifying the operation of equipment, and by enlarging his or her knowledge of photography. The photographer should choose a particular camera and organize all photographic work and equipment around that camera. The camera should be designed to serve all the needs of the photographer so that one camera can be employed for most, if not all, facets of the work. Then the photographer must set up a darkroom with all the accessories and equipment necessary to complete the system.

The camera must be compatible with the photographer's needs, abilities, and budget. The various film sizes and their uses should play a large role in the choice of a camera. With the current proliferation of cameras, particularly digital and those that use 35mm

film, the photographer is given a wide choice of cameras that vary in performance, complexity, and price.

Size of film, nevertheless, is the variable that needs first consideration; the camera and system should be planned around one film size.

110 and Ultra-Miniature Cameras

Ultra-miniature cameras, or "spy cameras" as they were often called, have been on the market for many years. The most notable of these cameras is the Minox B, although Minolta and Yashica also produced popular ultra-miniature cameras. The films used in these cameras were not standardized and were very small, making darkroom work difficult at best. These cameras were also expensive.

Kodak revolutionized the ultra-miniature market with its popular 110 film and "pocket instamatic" cameras, placing the conveniently sized ultra-miniature within the budget of any photographer. Refinements of the original pocket instamatic include a camera with a built-in telephoto lens, as well as various forms of flash capabilities.

The cameras are simple to operate; each is equipped with a fixed-focus lens. Most objects between four feet and infinity will be in focus, but the instruction pamphlet recommends that placing the object 10 to 15 feet away from the camera will yield the best result. The cameras are not adjustable; they are merely aimed at a subject and their shutters are then depressed.

The small size of the camera makes it easy to carry and the cartridges are easily loaded. The light weight of the camera and its odd shape, however, make it unstable when shooting. The manufacturers recommend that the shutter be "squeezed" in order to lessen vibration, which will cause a blurred image.

This camera is designed solely for ease of operation, not for accuracy. Also, because 110 film is small and difficult to work with in the darkroom, these cameras are almost wholly unsuited for police work.

126 Instamatic Cameras

The great commercial success of the 126 "instamatic" camera is evidence that, in order to sell more cameras, one need only make the simple box camera simpler. This was done by designing a method of loading and advancing film so that operation of the camera is nearly foolproof. Film for the 126 camera is packaged in a plastic cartridge that is dropped into the back of the camera; neither the film nor its paper backing is ever handled by the photographer when changing film. A lever replaces the normal winding mechanism, and also serves to cock the shutter so that double exposures are impossible. The 126 camera comes in a large range of types and prices, many with built-in exposure control.

While 126 film is similar in size to 35mm film, and therefore is handled similarly in the darkroom, it would be incorrect to expect from a 126 system the full range of photographic capabilities that are needed in police work.

The 35mm Camera

There are two types of 35mm cameras in wide use: the rangefinder and the single-lens-reflex (SLR). Both offer such features as interchangeable lenses, adjustable focal plane shutters, adjustable diaphragms, and motor drive. They differ mainly in how a subject is viewed and focused.

The rangefinder camera has a viewfinder that, like most instamatic cameras, is independent of the main lens of the camera. The viewfinder presents a split-screen rangefinder that is coupled to the main lens. The view through the viewfinder is fixed and the photographer must compensate for changed view when using a lens other than a standard one. This is accomplished by attaching a correcting lens to the viewfinder. Some viewfinders are etched with cross-hatches that allow the photographer to compensate without attachment, although this becomes difficult when using a telephoto lens.

During the 1980s and 1990s, camera manufacturers recognized that consumers wanted 35mm film in cameras that were simple to use. The 126 "instamatic" cameras gave way to the 35mm "point-and-shoot" and "disposable" cameras. These 35mm automatic rangefinder cameras are much more sophisticated than their 126 predecessors (see Figure 3.1). Most of the major quality camera makers, including Nikon, Canon, Olympus, and Minolta, currently market automatic point-and-shoot 35mm cameras. Kodak manufactures a disposable camera, allowing a camera to be carried in every police patrol car. Most point-and-shoot and disposable cameras have internal electronic flash systems, automatic exposure systems, automatic advance and rewind functions, and many boast telephoto, automatic focusing capabilities, and date/time imprinting. In addition, the traditional 35mm film cassette is now available in the Advantix format, which allows a special Advantix 35mm film cassette to be easily dropped into a camera designed for this film. While these cameras do well for general photography, they are not well suited for the wide range of photographic needs of police photography.

Figure 3.1Point-and-shoot 35mm rangefinder camera. The Minolta Freedom 90 with zoom lens.

The chief disadvantage of the rangefinder camera arises when it is used in the laboratory or with telephoto lenses. Because the main lens of the camera and the viewfinder are independent, the photographer becomes faced with the problem of parallax—an apparent displacement of an object as seen from different points—which causes difficulty when attempting to center or focus on an object closer than three feet (see Figure 3.2). It is nearly impossible to photograph through a microscope with a rangefinder camera. By the same token, it is very difficult to focus and compose rangefinder cameras mounted to a telescope or telephoto lens. These difficulties are completely solved by using the single-lens-reflex camera.

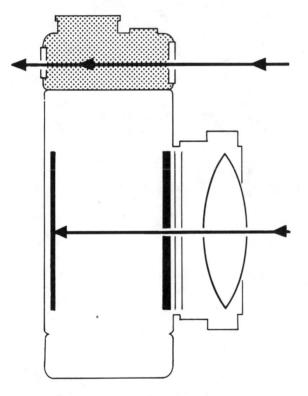

Figure 3.2 This cross section of a rangefinder camera shows the separation of optical systems.

The single-lens-reflex, or SLR, camera allows the photographer to view a subject through the main lens of the camera. The image seen through the viewfinder window is a replica image; when using a standard lens the image is similar in size and appearance to the scene before the unaided eye. The optical system for viewing the image is comprised of: (1) the main lens; (2) a mirror for diverting light away from

the film and into the rest of the system; (3) a prism for reversing and inverting the image as reflected (upside down and reversed) from the mirror; (4) a focusing screen; and (5) a viewfinder. Thus, a change in lenses will automatically cause a change in the optical system; no compensation by the photographer is necessary. Also, parallax is eliminated because there is only one point from which to view.

The mirror is mounted on a hinge and automatically flips up and down before and after the shutter opens and closes, blocking out the viewfinder only at the instant of the exposure. The majority of standard, wide-angle, and moderately long-focus lenses are fitted with an automatic iris control so that the lens is always wide open for focusing and viewing but closes down to the preselected shooting aperture when the shutter is released.

Many 35mm SLR cameras have features found on their rangefinder point-and-shoot counterparts. They are available with automatic exposure, automatic focusing, motor drive advance and rewind, and combination lens systems for macro and zoom capabilities. While the cost of cameras with such features may be prohibitive, they are nevertheless attractive to amateur and professional photographers alike. Generally such automatic features are optional and may even be a hindrance for the police photographer. If such a camera is purchased, it should have manual override capabilities for special photographic situations. Prior to purchasing such a camera, available accessories should be checked for compatibility, especially with autofocus cameras and lenses.

The 120 Medium Format Camera

Medium format cameras are designed to use 120 size film. Kodak introduced the 120 film around 1902 and it has remained very popular. Cameras made for 120 film used to be called 2½ cameras because the popular format for 120 film is a 2½ x 2½-inch negative. However, with the move toward a universal metric system, the 2½ formats are now referred to as 645, 6 x 6, 6 x 7, and 6 x 9. This sounds confusing, and it is. Actually, 645 is 56 x 40-45mm (2½ x 1½ inches); 6 x 6 is 56 x 56mm (2½ x 2½ inches); 6 x 7 is 56 x 56-72mm (2½ x 2½ inches); and 6 x 9 is 56 x 78-88mm (2½ x 3½ inches). All of these camera formats use the same film—120. The only difference is the size of the resulting negative. The most common medium format cameras come in 6 x 6 or 6 x 7.

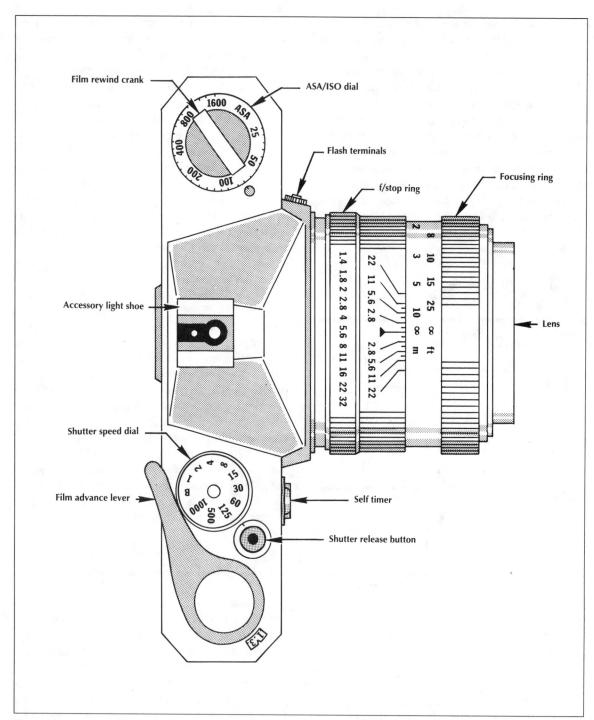

Figure 3.3 35mm SLR camera

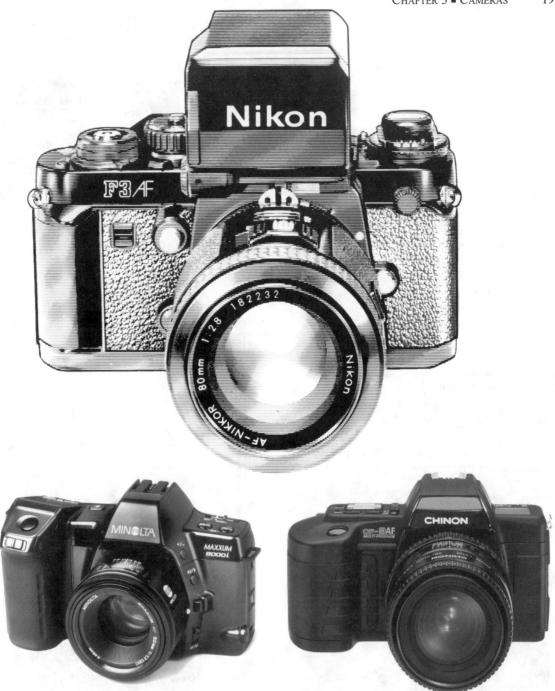

Figure 3.4

Nikon F3AF with DX-1 Finder and 80mm f/2.8 ED AF-Nikkor Lens. Minolta Maxxum 8000i Autofocus SLR. Chinon CP-9 Autofocus SLR.

There are three basic types of medium format cameras: the twin-lens-reflex (TLR), the single-lens-reflex (SLR), and the rangefinder.

The twin-lens-reflex (TLR) camera is equipped with two identical optical systems, one of which focuses on the film when the shutter is opened. The other optical system reflects a similar image up

toward the top of the camera and focuses it upside down and reversed on a groundglass screen. Because the lenses on a TLR are linked, correct focus on the viewing screen will guarantee correct focus through the main lens. As with viewfinder cameras, however, parallax may become a problem when photographing a subject closer than three feet.

Figure 3.5 Nikon accessories.

Special-purpose lenses are available in a limited variety of TLR cameras, but they are expensive because two lenses must be changed.

The 2½ SLR camera is similar in principle to the 35mm SLR camera. Most 2½ SLRs, like the TLRs, have viewing screens that show a reversed and inverted image. The cameras are held at chest or waist level for viewing. Eye-level viewing is made possible if a prism finder is attached. Some of the better 2½ SLR cameras are the Hasselblad, Bronica, and the Mamiya Professional RB67. The 2½ rangefinder camera (or viewfinder camera) is similar in principle to the 35mm rangefinder camera. These cameras have the same disadvantages for police photography as their 35mm counterparts.

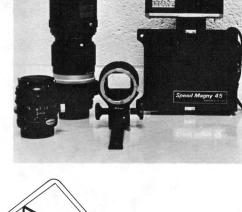

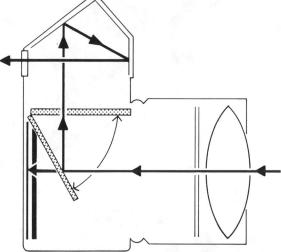

Figure 3.6
Cross section of SLR optical system.

Figure 3.7 Mamiya C330 TLR camera and lenses (left) and Hasselblad 2 SLR (right).

One advantage of the 21/4 camera over the 35mm is the larger negative size for work in the darkroom. Also, changeable backs are available for these cameras, such as the Mamiya Professional RB67, which allow negatives of 6 x 6 or 6 x 7 inches. These sizes permit highly acceptable enlargements, as many wedding photographers will attest. However, the 21/4 camera is much bulkier than the 35mm and often heavier; they are also more expensive than comparable 35mm cameras.

The 4 x 5 Camera

The "grandfather" of police and newspaper photography is the 4 x 5 camera. The 4 x 5 camera once enjoyed great popularity among professional, police, and newspaper photographers. It was inexpensive, rugged, and very versatile. Many police departments still use 4 x 5 cameras. The advantages of the 4 x 5 camera (sometimes called a press camera) are:

- With the addition of an adapter roll back, the photographer can use 120 roll film to shoot either black-and-white or color film.
- A 545 or 500 Polaroid adapter back allows the photographer to shoot many of the 4 x 5 film packets manufactured by Polaroid. Polaroid 55 P/N is especially useful in police photography; the photographer can immediately examine his or her photograph, make any necessary corrections, and retain a negative from which he or she can make additional prints in the darkroom.
- A split back adapter will convert a 4 x 5 into a "mug-shot" camera.
- With the addition of a Faurot Foto-Focuser, the 4 x 5 becomes an excellent fingerprint camera for use in small police departments. This, used with a 545 Polaroid adapter back, can be a very effective
- The 4 x 5 makes an excellent copy camera.

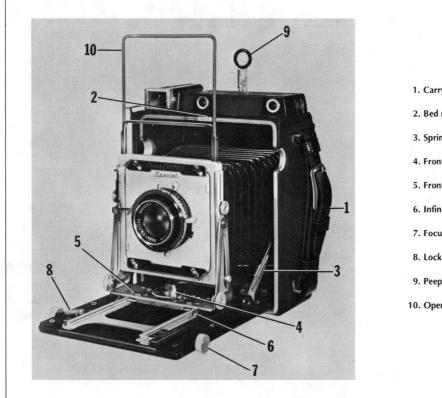

- 1. Carrying strap handle
- 2. Bed release button
- 3. Spring actuated bed braces
- 4. Front standard lock lever
- 5. Front standard
- 6. Infinity stops
- 7. Focusing knobs
- 8. Lock lever
- 9. Peepsight
- 10. Open frame

Figure 3.8 The 4 x 5 camera.

The photographer may take as many or as few photographs as he or she wishes with the 4 x 5 camera, without changing film rolls or having to wait until a roll is completely filled. In police work, there are many times when a job calls for just a few photos.

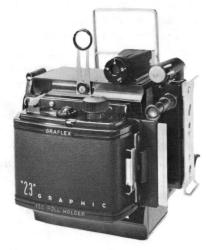

Figure 3.9
Roll film adapter.

The large 4 x 5 size of the negative is the most convenient with which to work in the darkroom. A photograph as large as 16×20 inches or even 20×24 inches is often needed for courtroom presentation; the 4 x 5 negative offers high resolution for enlargements of this size.

The disadvantages of the 4 x 5 camera are:

- It is bulky, heavy, and difficult to transport, store, and set up.
- 2. The major 4 x 5 camera manufacturer, Graflex, no longer makes or services 4 x 5 cameras.
- 3. Film is expensive, not widely available, only available in limited varieties, and processing may be difficult to obtain.
- Additional lenses, such as telephoto lenses, and accessories and flash attachments make the camera extremely bulky.
- 5. The camera has no internal light metering exposure system and a hand-held light meter must be used.

The Polaroid Land 4 x 5 photographic system is built around the Land film holder, which is usable in most 4 x 5 cameras (those with Graphic, Graflok, and similar adapter backs). It instantly adapts these cameras to on-the-spot photography without any alteration of the camera focusing system. Just slide it into position and it is ready to use.

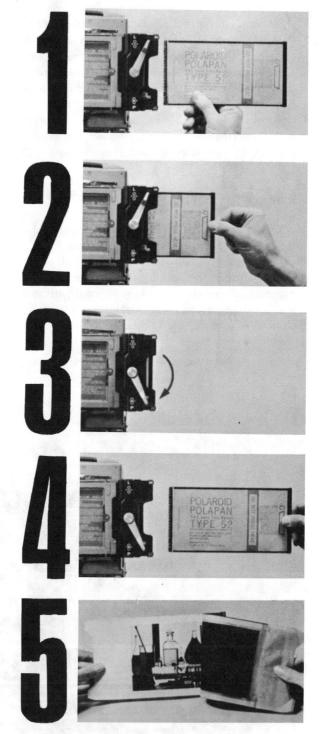

Figure 3.10Five easy operating steps allow you to take all the pictures you want without removing the holder from the camera.

Pictures taken with the Land film holder are processed in the packet outside the holder so the photographer may shoot as many as needed, one after the other, without having to wait for development. The packets can also be set aside and processed later. Once a packet is exposed and processed, development takes place immediately. However, Polaroid film is very expensive for 4 x 5 cameras, costing from \$30 to \$40 for 20 sheets of black-and-white film.

Polaroid Cameras

Polaroid has been a standard for both amateur and professional photographers for nearly 40 years. The advantage of Polaroid film is obvious—the

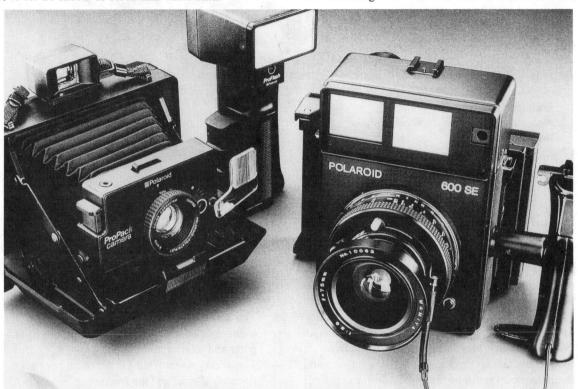

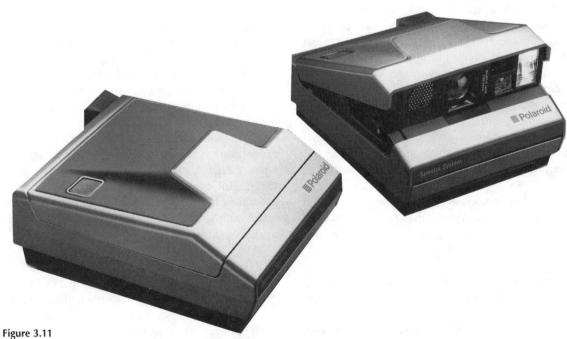

Various Polaroid cameras. The ProPack, the Model 600 SE professional, and the Spectra System.

immediate availability of a finished photographic print. Polaroid now markets films that produce negatives and slides and processors to make 8 x 10 enlargements without a darkroom. For small police departments that take photographs infrequently, the Polaroid system is attractive. Polaroid cameras, such as the Spectra, Pro-Cam, and 600 Business Edition, are relatively inexpensive and easy to operate. The major disadvantages of Polaroid cameras and films are:

- 1. Film is expensive.
- Accessories, such as additional lenses, are limited.
- 3. Most are rangefinder cameras with the same disadvantages as 35mm rangefinder cameras.

Digital Cameras

With the introduction of digital photography in the mid-1980s, many believed it would eventually replace photography as we know it. While it may be true that digital cameras will one day replace film and traditional cameras, it is still a long way from reality. After Sony introduced its Mavica digital camera in 1982, a number of leading camera and electronic companies began producing digital cameras and computer software designed especially for computer imaging. Most digital cameras produced during the 1990s were designed for amateur consumer use and resembled the 35mm point-and-shoot cameras. Casio, Canon, Nikon, Kodak, Epson, Minolta, and others produced a large line of point-and-shoot digital cameras that could store images on magnetic or electronic storage media. Camera images could be downloaded into various computer software programs for printing, storing, and/or manipulation. Some manufacturers have produced professional grade digital cameras, which allow for interchangeable lenses and accessories found on sophisticated 35mm SLRs.

There are numerous advantages for using digital cameras; the most obvious is the ability to store large numbers of photographic images on magnetic media. Other advantages include:

- The ability to produce color photographs quickly and without the need of a darkroom or film developing.
- The ability to manipulate images for contrast, color, and size on a computer.

Figure 3.12
Three digital cameras. Two of Kodak's professional DC420
SLR cameras and the Casio point-and-shoot digital camera.

- 3. The ability to produce "slide" presentations for training or educational purposes through a computer and television monitor.
- 4. The ability to transmit photographs over phone lines via E-mail and the Internet.

Despite the advantages of digital photography, there are some shortcomings. The two primary disadvantages of digital photography are image quality and cost. At present, normal photographic images are far superior to digital images. In addition, the cost of digital cameras, even amateur grade point-and-shoot types, may be prohibitive. For instance, one professional quality digital camera may cost as much as \$5,000 or more, not including the computer hardware and software needed to produce and store the images. A police department could purchase at least five good 35mm SLR cameras with all the necessary accessories for what one professional grade digital camera would cost. In addition to these two main disadvantages, others include:

- The need for high-speed computer hardware with extended memory and high capacity storage (i.e., CD-ROM) in order to store and manipulate the images.
- 2. The need for computer software programs designed for digital imaging.

- 3. The need for printers capable of reproducing color images from the computer.
- The lack of necessary accessories, such as telephoto lenses, flash attachments, and micro and macro lenses, needed for specialized police photographic needs.
- 5. Difficulty in using specialized techniques such as infrared and ultraviolet photography, painting with light, and so forth.
- The ease with which digital images can be manipulated on a computer may create legal problems for admissibility in court.

Digital photography will be discussed in more detail in Chapter 11.

The Police Camera

All cameras are basically alike; each is a box with a piece of film at one end and a hole at the other. The hole is there so that light can enter the box, strike the chemically sensitized surface of the film, and make a picture. Every camera, from the most primitive to the most modern, is based on the slogan, "You press the button, we do the rest." Automatic and computerized modern cameras try to make picture taking as easy as possible, by choosing the shutter speed or aperture for you, or by presetting the focus.

Most of today's 35mm SLR cameras do practically everything for you. They focus, select the aperture, load the film automatically, advance the film, and even set the ISO/ASA for you. Because of all of these factors, there is no reason today for a police photographer not to be able to take a good picture. The photographer may still make choices even though the cameras are fully automatic, and there are a multitude of things that can be done with today's cameras and film. The photographer may, if he or she wishes, freeze the motion of a speeding car or let it race by in a blur; bring the entire accident scene into sharp focus or isolate a single vehicle. The photographer can exaggerate the distances of the vehicles in an accident or show the correct perspective as to the distances between the vehicles.

In the past, most police photographers used the 4 x 5 camera. Today, with the great improvement of lenses, cameras, and films, it is no longer necessary to use a 4 x 5. In the past it was said that the larger the negative, the less grain would appear on the photograph.

With the great improvement in lenses and films, a photographer can do just as well, if not better, with a 35mm SLR camera than with a 4 x 5 camera.

For most of the on-the-job crime scenes, auto accidents, and other police functions, the photographer can do very well with 35mm SLR cameras, especially because today's better cameras have many more functions than the cameras of the past. There are shutter speeds of up to ASA/ISO 4000 and, with an automatic electronic flash compatible with that camera, it is possible to use it and shoot electronic flash with the Minolta Maxxum 8000i's microprocessor circuitry to solve a common daytime flash exposure problem. When the Maxxum 8000i is set to the program mode, flash duration and aperture adjustment are automatically controlled to provide optimum subject illumination. The same holds true for Minolta's Maxxum 7xi with built-in flash.

The police photographer has a wide range of cameras from which to choose. Our recommendation is to select a camera that can perform all of the functions required for general police and evidence photography. Namely:

- 1. The camera should be a single-lens-reflex (SLR).
- 2. The camera should be able to use a wide variety of films that are readily available and inexpensive (e.g., 35mm).
- 3. The camera should be manually adjustable for specialized photographic situations and films.
- The camera should be able to use a wide variety of interchangeable lenses that are readily available and relatively inexpensive.
- 5. The camera should be rugged, lightweight, compact, and easy to operate, transport, and store.
- 6. The camera should be able to adapt to all phases of police photography including traffic accidents, crime scenes, close-up evidence photography, microscope photography, ultraviolet and infrared photographs, surveillance photographs, aerial photography, and identification photography.

Given these considerations, the recommended police camera is the 35mm SLR. Other cameras that might give the police photographer some additional versatility would include a Polaroid camera, a digital camera, a video camcorder, and a 4 x 5 camera, but the 35mm SLR should be the primary choice for serious police photography.

Film

4

The primary function of film is to record the image that is focused upon it by the lens of the camera. The recorded image is called a latent image because it is not visible on the film; exposed film cannot be visually distinguished from unexposed film. However, the film has changed physically during exposure and that change can be made visible if the film is treated chemically. The chemical treatment that causes a latent image to become a visual image is called development. When the chemical change has taken place, the developed film is called a negative and the visual image is called a negative image because the tonal values of the visual image are the inverse (hence negative) of the tonal values of the subject. Black becomes white, white becomes black; dark objects appear light on the negative and light objects appear dark on black-and-white film.

The Emulsion

The emulsion is the light-sensitive part of the film; it is the medium through which the physical and chemical changes from latent to negative image take place. In a black-and-white emulsion, grains of silver halide are suspended in a thin layer of gelatin. Silver halides are sensitive to light; their characters are altered when they are exposed to light. When the altered silver halides are treated chemically during development, they are converted into a black metallic silver that remains attached to the base of the film. Silver halides that have not been exposed to light do not form this metallic silver and are washed away from the base in the development process.

A minimum amount of light is required to effect the change in the grains of the silver halide and form a latent image. This minimum amount of light alters only a few of the grains near the surface of the emulsion and produces a barely perceptible silver deposit upon development. If less than this minimum amount of light reaches the emulsion, the silver halides are not affected, and they cannot be changed into metallic silver by development. As the quantity of light acting upon the emulsion increases above the minimum necessary to produce a change in the grains near the surface, it penetrates deeper into the emulsion to expose additional grains, and also makes them subject to development into metallic silver. The thickness or density of the silver deposit in the negative is increased when the amount of exposure is increased. In any negative that records a subject that has varied lights and darks, there will be a variation of densities. The aggregate of these variations is called the brightness range.

The Base

The film bases in general use today are cellulose acetate and other acid esters such as triacetate. Cellulose acetate films are usually called safety bases because they have the advantage of low flammability. Bases may be transparent, translucent, or opaque, depending upon how the recorded image is to be used. Generally, films are made on a transparent base whether they are used as negatives or as positives, as in the case of motion pictures, color transparencies, and lantern slides.

The photographer has a variety of emulsions and bases from which to choose. Emulsions vary in color sensitivity, speed, graininess, contrast, sharpness, and acutance. Film manufacturers have created and marketed a number of films that combine these variables in such a way that, while a given film may not have a perfect combination of these variables, the photographer may obtain a film that closely satisfies his or her needs. The choice of emulsion type is a trial and error business; guidelines can be given and film type may be suggested, but the photographer should use and experiment with many films before determining which film is best for a given job. The choice of a base, however, is more easily determined.

Bases differ in chemical composition, size, and package. The composition of a base plays little or no role in choice of film; package is determined almost wholly by size. Size, however, is very important. The size of a film is determined by the size of the camera for which it is made (width) and by the number of exposures that are possible on one piece of film (length). For example, 35mm film (also known as 135) is 35mm wide (or approximately $1\frac{3}{8}$ inches). It can be used only in 35mm cameras, and can be purchased in lengths that allow 12, 24, or 36 exposures, or in bulk for reloadable cartridges in 50- and 100-foot lengths.

The choice of film size depends upon how it will be used. On the whole, small cameras are simpler and more convenient to use than are large cameras; thus, film of small size, which has been designed for use in a small camera, is simpler and more convenient to expose than is large film. However, this generalization about size, simplicity, and convenience becomes reversed when the film is taken into the darkroom. A large film will yield a large negative, and larger neg-

atives produce better results, particularly in the enlarging process, than do small negatives.

Not all emulsions are available in all sizes of film. Therefore, some compromise must be made by the photographer when choosing a film. The photographer will want a film that is convenient to shoot, convenient to process, and that produces the greatest quality photograph.

Basic Film Sizes

110 Film

110 film may be advantageous for the small police department with a limited budget. The cameras that have been designed to use 110 film are small and lightweight. However, 110 film is very small and it is difficult to enlarge to courtroom specifications. Thus, its use is limited.

The primary advantage of 110 film is its simplicity of loading. 110 film is packaged in a cartridge, a self-contained plastic envelope that stores the film before and after exposure in dual storage spaces. A printed, opaque paper backing protects the film from unwanted exposure in the camera and permits the photographer to note at a glance the number of exposures that have been made.

Figure 4.1
110 camera and film cartridge (right, top), negative (right, bottom), and print from 110 negative (left).

Among the disadvantages of using 110 film are the cameras that are designed to use the film, and the small negative that the film yields. The tiny 110 camera is portable and inexpensive, allowing each patrol officer to carry one in his or her shirt pocket or glove compartment. This camera need only be pointed at a subject, its trigger depressed, and the film advanced. Thus, taking pictures is simple, but deceptively so. The 110 camera is so small that it is difficult to stabilize. Shaky hands can easily render an entire roll of film worthless and the manufacturers of the cameras warn in the instruction booklets that the shutter must be "squeezed" in order to produce a presentable photograph.

The tiny 110 negative cannot be enlarged to more than 5 x 7-inch size, and it is difficult to enlarge to standard 3 x 5-inch snapshot size. The enlarger used for a 110 enlargement must be dust-free to a tolerance that, for the most part, is outside the capabilities of any lab except one specifically designed to process 110 film—that is, a commercial processor.

126 Film

126 film is the same width as 35mm film but is packaged in a cartridge of a design similar to 110 film, thus combining some of the advantages of 110 film with some of the advantages of 35mm film. Few good cameras are made to accept 126 film, and the photographer must be satisfied with all-purpose emulsions.

35mm Film

35mm film for adjustable and automatic 35mm cameras is the most widely used film today. 35mm film is primarily a compromise between the needs of the photographer in the darkroom and the needs of the photographer with camera in hand. But at best, 35mm is a compromise and should be treated as such. Film manufacturers, in recognizing that 35mm is the best compromise, have made it available in many different emulsion types and speeds.

Usually 35mm film is purchased in cassette form. The cassette, a metal or sometimes plastic container, allows for simple loading, is light-tight, stores the film before and after exposure, and obviates the need for paper backing. Unlike the film cartridge in which 110 and 126 film is packaged, the cassette has a single film storage space; film is wound out of the cassette and onto a roller in the camera and must be wound back into the cassette before film can be removed from the camera. Because 35mm film has

no paper backing, the accounting for remaining exposures must be done mechanically. All 35mm cameras have a provision for exposure counting.

35mm film can be bought in 12-, 24- and 36-exposure cassettes, and in bulk rolls, usually 50 and 100 feet, that allow the photographer to load his or her own cassettes. A bulk loader may be purchased for this task.

DX Film

In 1888, the Eastman Kodak Company adopted the slogan, "You press the button, we do the rest," to describe their Kodak roll film cameras. Today's photographers, raised on the visual media, expect perfectly focused and exposed pictures under any amount of light and darkness. Consequently, manufacturers have dropped the idea of simplification and followed instead one of automation. The police photographer today has all the controls that the professional photographer has.

In the quest for the perfect automated camera, most of the action today is in the 35mm camera area. The increasing miniaturization of computer circuits has allowed the development of automatic exposure and automatic focusing systems that perform beyond the capabilities of most photographers. Many new 35mm cameras have built-in motors that advance the film automatically between shots, rewind the film at the end of the roll, and provide a degree of automatic loading.

The weak link in 35mm photography was the film magazine. At its introduction in the 1920s, it was a definite improvement over roll film, but it remained what it was at the beginning: a tin can loaded with motion picture film. It has always proved a challenge for camera manufacturers to design a loading system for the 35mm that is not awkward, and until recently there was no film speed coding on the magazines.

In 1963, Kodak introduced the 126 film cartridge, the first of the familiar plastic cartridges that slip easily into the back of the camera. The 126 cartridge, or something similar, might have been the logical successor to the 35mm magazine. The film was physically the same size as the 35mm film, but provided a larger negative because it did not have the 35mm's two rows of sprocket holes to take up space. The cartridge was encoded to set the film speed automatically, and it had a film ID that could be seen through a window in the back of the camera, two features that are now available to 35mm film with the DX code.

Figure 4.2 126 camera and film cartridge (above) and 126 camera with back open and film inserted (left).

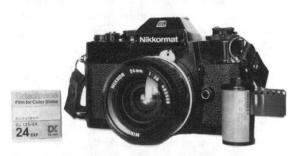

As Kodak discovered, once you have established a standard, you are stuck with it. With the tremendous proliferation of new model 35mm cameras in the 1970s and 1980s, all that was left was to try to improve the film canister without changing it radically, and that is where DX coding appeared.

The DX system comprises five separate pieces of information: four codes and a small, one-line film ID. The most obvious of the codes, and the one that will affect the photographer most directly, is the camera auto sensing (CAS) code. This is a checkerboard pattern of up to 12 squares of bare metal and black insulation. Probes in the film chamber of the camera press against these patches, forming a simple circuit board that tells the camera three things: patches two through six indicate the film speed in 24 increments from ISO 25 to ISO 5000; patches eight, nine, and 10

Figure 4.3
35mm camera and film cassette (left), negative (right) and a print from the negative (above).

indicate the number of exposures; and patches 11 and 12 indicate the exposure range of the film. Patches one and seven are common electrical contacts.

The value of the CAS code should be clear. Primarily, it will save most of the vast amount of film that is accidentally rated at the wrong film speed. With DX, there is no need to check the ISO dial every time you change film; just pop the film into the camera and you are ready to go. The only difficulty here is that people often intentionally rate their film differently from the manufacturer's ISO. It is common, for example, to overrate color transparency film slightly and black-and-white film significantly. If you own a DX-reading camera that does not allow you to override the encoded ISO, and many of them do not, you will have to resort to taping over the CAS code on the film can or the pins on the camera. If your camera has no way

to set the ISO manually, and some of them do not, you are out of luck. Most cameras without manual override function will default to an ISO of 100 when no DX coding is sensed.

Figure 4.4 DX coding on 35mm film cassette.

The other two functions of the CAS checker-board are less crucial than the film speed setting. The frame number information may permit the camera to signal you when it nears the end of the roll, or trip an automatic rewind at the appropriate moment, although the rewinding can easily be done without the DX code as most cameras have a manual feature for this as well.

The information about the film range will, theoretically, permit the exposure of a film with a wide range of situations in which cameras currently signal improper exposure or prevent exposures altogether. The picture would be mis-exposed, but the camera would know that you could get an exposure of some kind.

The second feature of the DX code that will directly affect the photographer is the information panel on the opposite side of the canister from the CAS code. This film ID is placed so that a camera with a small window in the back will permit you to see what type of film you have loaded into the camera. The ID window is much more convenient and reliable than the old technique of sticking the end of the film box in a clip on the back of the cover, but it does seem to be a potential source of light leaks if things are not fitting properly.

The remaining three DX codes are for the benefit of the lab. The bar code (which looks like the Universal Product Code you see at the supermarket) and the raster code (a series of up to 12 holes arrayed in the film leader) will assist in identifying the length of the film and getting it into the correct developing solution. The latent-image bar code, printed every one-

half frame along the length of the film, will identify the film during printing for automatic color balance.

Kodak introduced the DX film code in 1983 with confidence that other film and equipment manufacturers would adopt it, and they have. One reason that Kodak gave the code away, no fees involved, was an effort to broaden the appeal of the 35mm photographer. Most film manufacturers today use the DX code system.

Kodak also recently introduced the Advantix system, with the idea of improving the 35mm film canister. The Advantix system is essentially a 35mm film cassette in which the film stays within the canister even after development. The canister is simply dropped into the camera, designed for the system, and the coding pins located at the bottom of the canister "tells" the camera what kind of film it is, its speed, and so on. The camera automatically loads and rewinds the film. Cameras designed for the Advantix film system fall into the point-and-shoot category, and are aimed at amateur users rather than professional or technical users. Many camera manufacturers have developed cameras especially for the Advantix system, which seem to be quite popular with general consumers. However, like other 35mm point-and-shoot cameras, they are generally unsuited for police photography. Also, Advantix film must be developed in specially designed automated print processors.

120 Film

120 roll film is an adequate film for police work. This film requires a bulky camera, but yields a 2" negative that is easily enlarged. Excellent courtroom presentation photographs are possible; however, fewer emulsion types are available in the 120 size than in 35mm.

120 film is packaged on a roll in a printed lighttight paper backing and allows eight or 10 exposures depending upon the camera format used (e.g., 6×6 , 6×7 , 6×9 , etc.).

4 x 5 Film

4 x 5 film has lost favor in police work, but anyone who has used it can appreciate its size. Very sharp photographs are possible with 4 x 5 film because the large negative size requires less magnification in enlarging. Many film types are still available in the 4 x 5 size, and although the major manufacturer of 4 x 5 cameras, Graflex, has stopped making 4 x 5 cameras, it is not difficult to procure used 4 x 5 Graflex

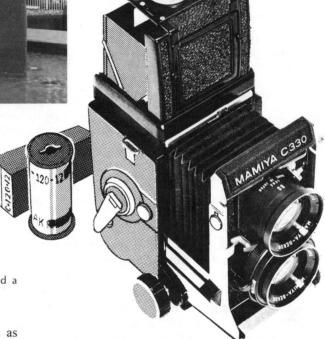

Figure 4.5120 camera and film (right), negative (above right) and a cropped enlargement from the negative (above left).

cameras. In addition, several companies, such as Sinar, Toyo, and Horseman manufacture 4 x 5 (and larger) format cameras.

4 x 5 film, often called sheet film, is an individual piece of film that must be loaded into a holder before it can be exposed in the camera. Most types of sheet film have a reference notch in one corner to allow identification, in the darkroom, of the emulsion type and the size of film. The size, shape, and number of notches vary with each film manufacturer and with each type of film. They are standardized, however, as to their location.

The choice of a film size, with the exception of 35mm, will limit the photographer in the choice of emulsion type. There is, for example, only one black-and-white emulsion available in 110 size, Verichrome Pan. In film sizes that allow a choice of emulsions, it is beneficial to know and understand the characteris-

tics of each emulsion before experimenting with them. The ability to choose the correct emulsion for a given job depends upon the photographer's knowledge of each type and his or her experience with them.

Different emulsion types react to subject light in different ways. For instance, some emulsions are more sensitive to specific colors than others.

Color Sensitivity

The final image obtained from black-and-white negative emulsions consists of a series of gray tones varying in brightness and ranging from light to dark gray. These tones represent the color of the subject.

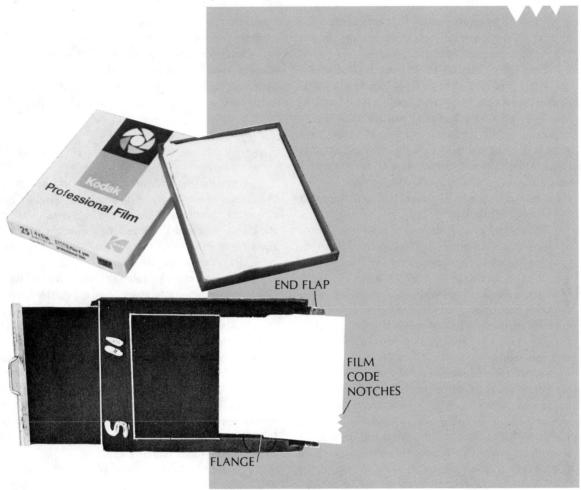

Figure 4.6

Outline of a 4 x 5 negative is shown full size (right), note film code notches. 4 x 5 film (top) and 4 x 5 film holder being loaded (bottom).

Different emulsions represent subject color with various degrees of acceptability. The extent to which this representation of colors as shades of gray is acceptable is called the color sensitivity of the film.

Pure emulsions, composed only of silver halides, reproduce only blue, violet, and visible ultraviolet regions of the visible spectrum. Thus, pure emulsions are color-blind. The addition of dyes to ordinary silver halide emulsions can increase their sensitivity to approximately the same spectral region as that seen by the human eye. The combination of dyes used influences the color sensitivity of the emulsion.

Emulsions are divided into four general types, according to the way in which they render color differences as brightness differences. These four classifications are: monochromatic, orthochromatic, panchromatic, and infrared. All emulsions are sensitive to ultraviolet radiations; a separate emulsion for ultraviolet photography is not necessary.

Monochromatic film, because of its limited color sensitivity, has no use in regular photography. It is used primarily for copying documents and line drawings.

Orthochromatic films are sensitive to the ultraviolet, violet, blue, green, and yellow-green portions of the spectrum. They do not accurately reproduce the relative brightness of a subject as seen by the eye. Orthochromatic film is available in 35mm and sheet film, and is not frequently used in regular police photography. The film's primary utility is for copying documents.

Panchromatic films are sensitive to all of the colors of the visual spectrum. To assist in the selection of the correct film for any kind of work, panchromatic films are divided into two general classes, and the classifications are based on color sensitivity.

The first of these classes is Type B panchromatic, a black-and-white film that reproduces the various tones and hues of the subject in tones of gray with a

brightness range approximately the same as that seen by the eye. The major difference between the various Type B panchromatic films is their speed.

Type B film may be divided into two sub-classes—long-scale and short-scale—according to their inherent contrast. Long-scale films, such as Kodak T-Max 100 and Kodak Technical Pan are used in portraiture, press, illustrative, continuous tone copy, and general outdoor and indoor photography. Short-scale films, generically called Process Pan, are high contrast and used for copy work when complete tonal separation is required. Kodalith Pan and Reprolith Pan are short-scale Type B films.

The second general class of panchromatic films is Type C panchromatic film. It has greater sensitivity in the red end of the spectrum than Type B film. Type C films, Ilford HP5, Kodak Tri-X, and Kodak T-Max are useful for tungsten-light photography, flash or flood photography, and for outdoor photography in the early morning or late afternoon hours of sunlight. Each of these light sources is predominately red in available light.

Infrared films have a band of color sensitivity in the ultraviolet and blue range, little or no sensitivity in the yellow-green portions of the spectrum, and a second band of greatly increased sensitivity in the visible red and infrared. These films can be of great value to the police photographer in criminalistics (see Chapter 18).

There are no special films for ultraviolet photography. Most light-sensitive films respond to the longer ultraviolet radiations, but the gelatin in the emulsion absorbs some of the longer wavelengths and all of the invisible ultraviolet band. Thus, only the visible ultraviolet region of the spectrum can be used for photography when using normal, untreated light-sensitive films.

A subject can be illuminated with ultraviolet light and reproduced by using normal photographic film and procedure if the film used has high blue sensitivity and good tonal separation properties. Therefore, the films selected should be a non-color sensitive process or commercial type.

All films are sensitive to ultraviolet radiations, but in regular photography they are considered insensitive to these wavelengths because glass lenses and the gelatin in normally coated emulsions absorb a large portion of these radiations. When it is desired to use all of the ultraviolet light band photographically, a special lens (made of quartz) that transmits ultraviolet light is used. The film used must have a very thin

emulsion coating—that is, much less gelatin than is used for regular emulsions.

Emulsions differ not only in color sensitivity but also in speed, graininess, contrast, sharpness, and acutance. The most important of these remaining variables is speed.

Speed

Film speed, or emulsion speed, is determined by the degree of sensitivity of an emulsion to light. This degree of sensitivity is called the light sensitivity of the emulsion. Emulsion speed has a direct bearing on the amount of light required by an emulsion to produce an acceptable negative image.

Some emulsions are rated as "slow" because they need more light in order to yield an acceptable image than do other relatively faster emulsions that are rated "fast." The American Standard Association (ASA) and the International Standards Organization (ISO) have assigned a numerical rating to each emulsion that is manufactured. Ostensibly, the scale begins at zero and the numerical ratings increase as film speed increases. Thus, a film speed with an ASA or ISO of 400 (Kodak Tri-X) is faster than one of ISO/ASO of 25 (Kodak Technical Pan). This rating is also called the Exposure Index (E.I.) of a film.

ASA and ISO are identical film speed standards and can be used interchangeably. Generally speaking, the slower the film speed, the finer the grain will be on enlargements. If one wishes to enlarge a photograph greatly, a fine grain film such as Kodak Technical Pan (ISO 25) should be used. Using a slower film improves the quality of the photograph, but sufficient lighting must be available. In low light situations, a higher speed film, such as Kodak T-Max 400 should be used, but the photograph quality will suffer from additional graininess on enlargements.

The Exposure Index, or ASA/ISO of an emulsion, is used to calculate the amount of light needed to produce an acceptable negative image. The method of calculation is discussed in Chapter 5.

Graininess

A negative image is composed of grains of metallic silver that adhere to a transparent base. To the eye these grains appear as a continuous deposit. However, when the image is enlarged a few diameters, a granular effect becomes apparent. This granular appearance of the enlarged image is called graininess. With greater enlargement, the granular structure of the image can be seen.

The graininess of an emulsion depends upon the size of the silver halide crystals in the emulsion and upon the clumping of the silver grains during development. As a general rule, slow emulsions are finegrained and fast emulsions are coarse-grained. The tendency of silver grains to clump during development can be reduced by using a fine-grain developer. Therefore, an image that is to be greatly enlarged should be recorded on a fine or normal-grain emulsion, and developed in a fine-grain developer. Any reduction in graininess as a result of using a fine-grain developer is also accompanied by a loss in effective emulsion speed and in contrast.

Contrast

The difference in the densities of various areas in the negative is known as contrast. A bright area in the subject reflects a great amount of light, causing a corresponding heavy density in the negative. This dense portion of the negative is referred to as a highlight. A dark area, such as a shadow, reflects very little light, resulting in a correspondingly thin density in the negative. The subject brightness between the lightest and darkest areas is also recorded on the negative in corresponding densities that are termed halftones. The difference between the darkness of highlights and the brightness of shadows in the negative is called contrast. Normal contrast is represented by a full range of densities, including highlights, halftones, and shadows. High contrast does not exhibit a full range of densities, and consists only of highlights and shadows, with little or no intermediate tonal gradation. Low contrast shows very little difference in densities.

Film is manufactured with varying degrees of inherent contrast; that is, it may have either a long-scale or a short-scale emulsion. High-contrast, or short-scale films, are used to record a short range of tones like black and white, such as is used for copying line drawings. Medium- and low-contrast, or long-scale films, are used to record a wide range of tones as employed for commercial or portrait photography. The proper selection of the film to be used should be governed by the contrast of the subject and the rendition desired.

Sharpness and Acutance

The sharpness of a negative refers to the precision with which a boundary between areas of varied contrast is reproduced. Grains of silver halide, because of their crystalline structure, tend to scatter light that they have not absorbed. This scattering, called diffusion, can cause nearby silver halides to be affected by light that has not been focused upon them by the lens of the camera. Diffusion can also be caused by the reflective properties of the film base. Thus, highlights will tend to encroach upon shadows in a negative image. Maximum sharpness, then, depends upon minimum diffusion.

Sharpness is the perception of minimum diffusion; acutance is a measure of the tendency of an emulsion to diffuse light. An emulsion of high acutance will produce a very sharp image; emulsions of lesser acutance will produce negatives that are less sharp.

Special Black-and-White Films

Ilford produces a black-and-white film, XP2-400, which uses color dyes rather than traditional black-and-white emulsion and can be processed using C-41 color chemistry. Ilford's XP2-400 has a nominal speed of ISO 400, but has extremely wide exposure latitude. It may be exposed as low as ISO 25 and as high as ISO 1600 on the same roll of film with no alteration in processing. The practical implications of this are: a single film may be exposed at ISO 400 for a few frames, be up-rated to ISO 800 for available light photography on the next few frames, and then be down-rated to ISO 50 for finest grain—all on the same roll of film. The benefit of variable speed also provides security against unintentional over- and underexposure.

In 1995, Kodak introduced their version of a C-41 black-and-white film, T400C. It is a chromogenic black-and-white film with an ISO of about 500. Like Ilford's XP2-400, Kodak T400C is a forgiving film with a wide latitude for exposure. Kodak has also released a compatible paper used in its processing labs for T400C that gives true black-and-white tones rather than the sepia-toned or purplish prints that are produced when labs print black-and-white negatives on color paper.

For departments that rely on local commercial color processing laboratories or for departments that

Orthochromatic	BLACK-AND-WHITE FILMS
Name	Description
Kodak Contrast or Process Ortho	High-contrast for copying black-and-white originals, black printed or handwritten text on white, green, or yellow paper. Daylight speed 100. Sheet (4x5).
Kodak Kodalith	Extremely high-contrast for copying line drawings and text. Daylight speed 12. Sheet (4x5) and 35mm.
Kodak Tri-X Ortho	High-speed with good shadow detail and brilliant highlights. No red sensitivity. Daylight speed 320. Sheet (4x5).
Panchromatic	
Name	Description
Kodak Technical Pan 2415	Multi-contrast for high definition, extreme enlargements, or for copy work. Excellent choice for most police photographic situations. May be developed in Kodak HC-110 for high-contras (ortho type). Daylight speed 25 to 100 depending upon type of developer used. Sheet (4x5), 35mm, 120.
Agfa Agfapan APX 25	Extremely fine grain with high resolution. Daylight speed 25. 35mm, 120.
Ilford Pan-F	Extremely fine grain with high resolution. Daylight speed 50. 35mm, 120.
Kodak T-Max (TMX)	Medium-speed for general purpose, fine grain. Daylight speed 100. Sheet (4x5), 35mm, 120.
Kodak Plus-X Pan	Medium-speed for general purpose, fine grain. Daylight speed 125. Sheet (4x5), 35mm, 120, 220.
Ilford FP4 Plus	Medium-speed for general purpose, extremely fine grain and excellent sharpness. Daylight speed 125. Sheet (4x5), 35mm, 120.
Kodak T-Max (TMY)	High-speed, fine grain, very high sharpness. Daylight speed 400. Sheet (4x5), 35mm, 120.
Kodak Tri-X (TX)	High-speed, good for fast action shots, telephoto lenses. Daylight speed 400. Sheet (4x5), 35mm, 120, 220.
Ilford HP-5 Plus	High-speed general purpose film, fine grain. Daylight speed 400. Sheet (4x5), 35mm, 120, 220.
Ilford Delta 400	High-speed, extremely fine grain and sharpness. Daylight speed 400. Can be push-pull processed from ISO 200-800. 35mm.
Ilford XP2-400	High-speed, extremely fine grain with wide latitude in exposure (C-41 process). Sheet (4x5), 35mm, 120.
Kodak T400CN	High-speed, extremely fine grain with wide latitude in exposure (C-41 process). 35 mm.
Kodak T-Max P3200 (TMZ)	Multi-speed with high- to ultra high-speed and fine grain. Excellent for surveillance and low light situations. Daylight speed 1000 to 50,000 with push-processing. 35mm.
Infrared	
Name	Description
Kodak High Speed Infrared (HE)	Infrared sensitive film for scientific and documentary photographs. Daylight speed 50. Sheet (4x5), 35mm.
Konica 750 Infrared	Infrared sensitive film for scientific and documentary photographs. Daylight speed 16. 35mm, 120.

Figure 4.7 Black-and-white film table guide.

routinely process their own color photographs, Ilford's XP2-400 and Kodak's T400C are recommended. Many police departments do not have access to a darkroom and must rely on commercial laboratories. Most commercial laboratories do not routinely process black-and-white photographs and the cost may be higher than color processing. Because Ilford's XP2-400 and Kodak's T400C are processed in the same manner as color film (C-41 process), their use may well be justified when black-and-white photographs are needed.

Kodak's Technical Pan 2415 film is a multi-contrast film used for high definition pictorial work when extreme enlargements are needed. It can also be used as a copy (orthochromatic) film for copying documents when processed accordingly.

Kodak's T-Max P3200 (ISO 1000) is a super fast film for low-light situations such as surveillance work. It can be exposed as high as ISO 50,000 with appropriate "push" processing. Special processing techniques are discussed in Chapter 8.

Color Film

There are many types of color film, only two of which are suitable for police work: color reversal (slide) film and color negative (print) film.

Color reversal film yields a color transparency after it has been exposed and processed. If 35mm slides are to be used in the presentation of evidence in court, color reversal film will provide them inexpensively. With this type of film, the negative process is bypassed and only a transparent positive is produced; the positive is mounted in a cardboard or plastic frame that can be put into a projector and shown on a screen in the courtroom. Usually these are called 2 x 2-inch color slides, and the actual picture area measures approximately 1 x 13/8 inches. These slides can be projected on a large screen in front of the jury or on a smaller daylight screen by using projection from the rear. Hand viewers may also be used. It is recommended, if possible, that all the jury members look at the same picture at the same time. Black-and-white or color prints can be made from color slides.

The suffix "chrome" in a film name, such as Kodachrome, indicates that it is a color reversal film. If the ending is "color," such as Ektacolor, a color negative film is indicated. Most film manufacturers employ this system of suffixes.

The other type of color film that is suitable for police work is color negative film, from which a color

negative is produced. This negative can be used to make color prints, color slides, black-and-white prints, and black-and-white slides.

There are some advantages to using color negative film for police photography. First, the exposure latitude is much greater. Filters, except for the usual haze filter, are seldom needed, and color corrections can be made by the photographer if he or she is doing his or her own processing.

Color Reversal Film

Slides (transparencies) need to be projected or examined in a magnifying viewer to enlarge the image size so it can be viewed conveniently. Aside from this drawback, slides offer several advantages. Slides are more economical than color prints because a print is not made of each frame, unless desired. The color and sharpness of slides are usually superior to color prints, as no quality is lost during an intermediary printing process step. However, prints from negatives are usually better than prints made from slides.

Color slide films are available in a variety of speeds, ranging from ISO 25 to 1600. Slow films, such as Kodachrome 25 and Fujichrome Velvia 50, offer excellent colors and extremely fine grain and sharpness. Kodachrome films form the color dyes in the emulsion during processing and require strict processing controls. Because of this, Kodachrome films are not designed to be user-processed. Kodak and other photo processing laboratories develop Kodachrome film. Virtually all other color slide films including Agfachrome, Ektachrome, Fujichrome, and others use the same E-6 processing that can be easily performed by the user.

Color Negative Film

Color negative film employs three layers of emulsion, each sensitive to one of the photographic additive primary colors: red, green, or blue. Color negatives record an image opposite of how it appears in real life. Dark tones look light on the processed negative and colors are the complement to colors in the original scene. For example, red is complementary to cyan; blue is complementary to yellow; and green is complementary to magenta. Therefore, a blue car will appear yellow in the negative. The combination of red, green, and blue will produce white while the combination of cyan, magenta, and yellow

will produce black. In addition, color negatives have a built-in orange mask to improve the color of the final print. More will be discussed about color-light relationships in Chapter 10.

Color films use the same standard for speed as black-and-white films. For maximum sharpness, finest grain, and most brilliant color, choose ISO 25 film (Kodak Ektar). Faster films, such as ISO 100 through 400, still offer good color, grain, and sharpness, and make it easier to take pictures in dim lighting or with slower lenses. The very high-speed ISO 1000 and 1600 films do not match the overall quality of slower films, but are excellent in dim lighting, particularly in surveillance operations.

Color Balance

Most color films, whether slides or negatives, are color balanced for daylight illumination. These films will yield natural looking colors when the main source of light is the sun, an electronic flash, or blue flashbulbs. The "color" of illumination is expressed as a rating of degrees on the Kelvin Color Temperature Scale. Daylight-rated light sources are around 5,600 degrees Kelvin. Type A photo lamps emit more yellowish light and are rated at 3,400 degrees Kelvin. Type B tungsten-halogen photo lamps produce even more yellowish light and are rated at 3,200 degrees Kelvin. There are color films available that are balanced for Type A and Type B lighting. Daylight color films will have a pronounced amber color when exposed under household incandescent lighting or Type A or B lighting. An 80A or 80B filter can be used to balance daylight color film with tungsten, photoflood, and other kinds of artificial illumination.

Some other artificial light sources such as fluorescent, mercury vapor, and sodium vapor will also photograph off-color because they are deficient in one color of the spectrum, usually red. Daylight film is the best to use, but the results will have a bluishgreen cast. Filtering to improve the color is possible but difficult because there are several different types of fluorescent, mercury vapor, and sodium vapor lights, and their color qualities all vary.

Selection of Color Films for Police Work

The selection of a color film is basically the same as with black-and-white film. As in black-andwhite photography, the photographer must determine what lighting conditions exist and how the finished print or slide will be used (e.g., enlargements). In addition, the choice between color slides or color prints must be made. If cost is a factor, color slides may be made and user-processed with a minimum of effort and cost. Prints may be made from color slides in the department darkroom or by commercial laboratories. Color print enlargements may be expensive unless the department has color processing capabilities. User color processing is much less expensive and difficult than it was a few years ago. If you are able to process black-and-white film, you can process color. There will be more discussion of color processing in Chapter 10.

A good general-purpose color film for police work should be in the medium- to high-speed range (ISO 100 to 400). For higher speeds in low-light conditions such as surveillance, Kodak's Ektapress Gold 1600 (ISO 1600) may be "pushed" to a speed of ISO 6400. The choice of color films may also depend on processing requirements. If slides or prints are needed quickly, the photographer should use a film that can be easily processed at any color laboratory or police darkroom as is the case with C-41 process print film and E-6 process slide film.

Polaroid produces a 35mm autoprocessing system for color slides without the need of a darkroom. The system requires Polachrome (ISO 40) 35mm film, which costs approximately \$20 for 36 exposures and a one-time purchase of the AutoProcessor unit that costs approximately \$150. Although the film is expensive, the convenience of having finished color slides in about five minutes is tempting for the photographer who needs finished slides quickly. The Polaroid AutoProcessor system does not require electricity, so processing may be completed in the field or at the scene. As with other color slides, Polaroid slides may be duplicated into enlarged prints.

Handling Films

Film should be handled carefully to prevent damage. A broken package admits moisture and light. Moisture accelerates the deterioration rate of these materials, which shortens their expected useful life. Accidental exposure to light ruins the materials completely. Careless handling can also damage beyond use roll film and spools, magazines, and film packs.

Condensation of moisture on the surfaces of cold film can be avoided by removing film packages from cold storage and allowing them to reach room temperature before they are opened. The time usually recommended for large film packages is 24 hours, but small boxes of films should come to room temperature within two to four hours. If the package is taken from cold storage, opened, and subjected to rapid temperature changes, as from cold dry air to warm moist air, moisture or dew forms on the film surfaces. Moisture on an emulsion caused by condensation leaves marks that have every appearance of watermarks on processed film. A sufficient tempering period is necessary.

Films should be removed from their containers in a room that is used specifically for this purpose. The room must be lightproof, clean, and dust free. The bench or table on which the film handling operations are performed should be cleaned with a damp cloth. Hands must be clean, dry, and free of perspiration. Individual films should be handled only by the edges. Handle films carefully, avoid contact with the emulsion surface, and touch the base side near the edges only. Care in handling prevents fingerprints, abrasions, and scratches caused by holders, hangers, or other darkroom gear coming into contact with the film surfaces. Dust should be removed from darkslides, film holders, and magazines by brushing them

with a soft brush. This should be done outside of the handling room.

Film should be handled in total darkness or under suitable safelight illumination for all operations including loading, developing, and fixing.

Professional vs. Consumer Films

You may have noticed that some films are designated as professional films while others do not have this designation. The police photographer should use professional films whenever possible. Color emulsions undergo a predictable and normal gradual color shift that begins at the date of manufacture and extends to an expiration date beyond which the film is not recommended for use. In manufacture a bias is built-in, based on the assumption of average time it takes the film to reach the marketplace, and storage conditions on photo dealer's shelves and in the hands of the consumer until exposed. Professional films are manufactured to strict tolerances and depend on refrigeration to maintain the emulsion quality. Dealers keep professional films in refrigerated storage and it is expected the user will do the same.

Color Print Films (C-41 Print Films) Name Kodak Royal Gold R2 Kodak Royal Gold RA Kodak Kodacolor Gold (GA) Agfa Agfacolor XRS 100 Fuji Fujicolor Reala Kodak Ektar 125	Description Micro fine grain, high sharpness, extreme enlargements. Daylight speed 25. 35mm. Medium-speed, general purpose. Daylight speed 100. 35mm. Medium-speed, general purpose. Daylight speed 100. 35mm, 120. Medium-speed, general purpose. Daylight speed 100. 35mm, 120. Medium-speed, general purpose. Daylight speed 100. 35mm, 120.
Kodak Royal Gold R2 Kodak Royal Gold RA Kodak Kodacolor Gold (GA) Agfa Agfacolor XRS 100 Fuji Fujicolor Reala	Micro fine grain, high sharpness, extreme enlargements. Daylight speed 25. 35mm. Medium-speed, general purpose. Daylight speed 100. 35mm. Medium-speed, general purpose. Daylight speed 100. 35mm, 120. Medium-speed, general purpose. Daylight speed 100. 35mm, 120.
Kodak Royal Gold RA Kodak Kodacolor Gold (GA) Agfa Agfacolor XRS 100 Fuji Fujicolor Reala	Medium-speed, general purpose. Daylight speed 100. 35mm. Medium-speed, general purpose. Daylight speed 100. 35mm, 120. Medium-speed, general purpose. Daylight speed 100. 35mm, 120.
Kodak Kodacolor Gold (GA) Agfa Agfacolor XRS 100 Fuji Fujicolor Reala	Medium-speed, general purpose. Daylight speed 100. 35mm, 120. Medium-speed, general purpose. Daylight speed 100. 35mm, 120.
(GA) Agfa Agfacolor XRS 100 Fuji Fujicolor Reala	Medium-speed, general purpose. Daylight speed 100. 35mm, 120.
Fuji Fujicolor Reala	
Reala	Medium-speed general nurpose Daylight speed 100, 25mm, 120
Kodak Ektar 125	Mediani-speed, general purpose. Daylight speed 100. 33mm, 120.
	Medium-speed, fine grain, good sharpness. Daylight speed 125. 35mm.
Kodak Kodacolor Gold 200 (GB)	Medium-speed, excellent definition, good general purpose film. Daylight speed 200. 35mm, 110, 126.
Agfa Agfacolor XRS 200	Medium-speed, general purpose film. Daylight speed 200. 35mm, 120.
Fuji Fujicolor Super HG 200	Medium-speed, general purpose film. Daylight speed 200. 35mm.
Kodak Kodacolor Gold 400 (GC)	High-speed, general purpose film. Daylight speed 400. 35mm, 110.
Kodak Vericolor Professional (VPS)	High-speed, general purpose film. Daylight speed 400. Sheet (4x5), 35mm, 120, 220.
Kodak Ektapress Gold Prof. (PPB)	High-speed, can be push-processed to ISO 800 or 1600. Daylight speed 400. 35mm.
Agfa Agfacolor XRS 400	High-speed, general purpose film. Daylight speed 400. 35mm, 120.
Kodak Royal Gold 1000 (RF)	Very high-speed for low light situations. Daylight speed 1000. 35mm.
Fuji Fujicolor Super HR II	Very high-speed for low light situations. Daylight speed 1600. 35mm.
Kodak Kodacolor Gold 1600	Very high-speed for low light situations. Daylight speed 1600. 35mm.
Kodak Ektapress Gold Prof. (PPC)	Very high to ultra high-speed with push-processing. Excellent surveillance film. Daylight speed 1600 to 6400. 35mm.
Color Slide Films (E-6 Proc	cess)
Name	Description
Agfa Agfachrome Professional RS50	Medium-speed, excellent grain. Daylight speed 50. 35mm, 120.
Fuji Fujichrome Velvia	Medium-speed, excellent grain. Daylight speed 50. Sheet (4x5), 35mm, 120, 220.

Figure 4.8
Color film table guide.

COLOR FILMS		
Kodak Ektachrome HC	Medium-speed, excellent grain. Daylight speed 50. 35mm.	
Kodak Ektachrome Prof. (EPR)	Medium-speed, excellent grain. Daylight speed 64. Sheet (4x5), 35mm, 120, 220.	
Fuji Fujichrome Prof. T (RTP)	Medium-speed, excellent grain. Daylight speed 64. 35mm, 120.	
Fuji Fujichrome Prof. D (RDP)	Medium-speed, general purpose. Daylight speed 100. 35mm, 120.	
Agfa Agfachrome Prof. RS100	Medium-speed, general purpose. Daylight speed 100. 35mm, 120.	
Kodak Ektachrome Prof. (EPN)	Medium-speed, general purpose. Daylight speed 100. Sheet (4x5), 35mm, 120.	
Kodak Ektachrome Prof. (EPO)	Medium-speed, general purpose, fine grain. Daylight speed 200. Sheet (4x5), 35mm, 120.	
Kodak Ektachrome Prof. (EL)	High-speed, general purpose. Daylight speed 400. 35mm, 120.	
Fuji Fujichrome Prof. D (RHP)	High- to very high-speed with push-processing. Daylight speed 400 to 1600. 35mm.	
Kodak Ektachrome P800/1600 (EES)	Very high- to ultra high-speed with push-processing. Daylight speed 800 to 1600. 35mm.	
Agfa Agfachrome RS1000	Very high-speed, excellent for surveillance. Daylight speed 1000. 35mm.	
Fuji Fujichrome Prof. D (RSPII)	Ultra high-speed, excellent for surveillance. Daylight speed 1600 to 4800 with push-processing. 35mm.	
Infrared		
Name	Description	
Kodak Ektachrome (IE) Type 2236 Infrared	Infrared sensitive. Process E-4 only (see Chapter 18). Daylight speed 100. 35mm.	
Kodak Ektachrome (EIR)	Infrared sensitive. Process E-6 (see Chapter 18). Daylight speed 100. 35 mm.	

Figure 4.8—continued.

We have a small or a great of the same and the

the first of the second second

Equipment

5

Lenses

The police photographer frequently needs a change of lens in order to accomplish a given task. The need for special lenses that can be readily purchased and easily interchanged is often a primary factor in the photographer's choice of a camera. Lenses for special purposes add great flexibility to a system of photography and allow photographs to be taken that would have been incomplete, misleading, or even prejudicial had the photographer been restricted to using only the "normal" lens on the camera.

A lens is an optical device that gathers light from a subject and focuses it onto a screen or film. Lenses used for photography are plastic or glass, bounded either by two curved surfaces, or one curved surface and one plane. The lens is usually the most expensive component of any camera system.

A simple lens (a single piece of glass or plastic) is known as a lens element. Two or more elements, cemented together, comprise a lens component. Freestanding single elements may also be considered components; thus, an optical system that includes two freestanding lenses and two lenses cemented together is said to have three components.

One of the main advantages of using a 35mm SLR camera is the wide selection of lenses available. All camera makers produce a variety of lenses for their cameras, and a number of independent lens manufacturers widen the selection and cost range.

There are three basic categories of lenses for use in photography: normal lenses, wide-angle lenses, and telephoto lenses.

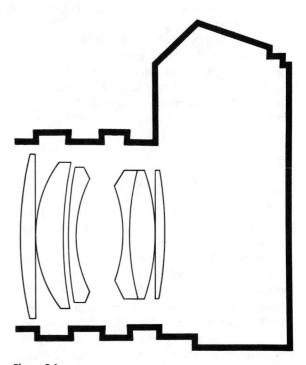

Figure 5.1 Lens elements.

Normal Lenses

Lenses are generally referred to by the measure of their focal length. A lens with a focal length of four inches is a four-inch lens, though it may only be a half-inch in diameter. In photography, a normal lens is one with a focal length equal to the diagonal measure of the image area. The image area of a 35mm camera is 24 x 36mm; thus, a normal lens for any 35mm camera is 50mm. By international standards the acceptable measured focal length of a lens may be within four percent of its marked nominal value; a 50mm lens may then have an actual focal length of 48mm to 52mm. The lens maker generally does not mark such deviations.

The normal lens is usually standard equipment on a camera, and is the intermediate between wide-angle and telephoto lenses. The picture angle of a normal lens is 45 degrees, which corresponds to the viewing angle of the human eye. Therefore, a "normal" lens allows you to view your subject nearly the same as your unaided eye, neither reducing nor enlarging the image.

For the average police photographer who will be photographing accidents, crime scenes, and other general scenes, the normal lens is adequate. However, it is not an all-purpose lens. There is no all-purpose lens; the advanced or professional police photographer must look to specialized lenses for particular purposes.

Wide-Angle Lenses

Selection of a lens is governed by the distance from a subject at which the photographer must work and by the field that must be encompassed within the picture area. The wide-angle lens has a shorter focal length than the normal lens and, as a result, it covers a picture angle wider than 60 degrees. It enables photography of a widely extended scene from a close proximity or within a confined area. In police work, wide-angle lenses should be used under restricted conditions when the police officer is unable to cover the desired picture area with a lens of longer focal length.

Typical uses for the wide-angle lens are for photographing buildings, street scenes, and interiors of homes where a crime has been committed. Crimes committed in bathrooms, for instance, are not easily photographed without a wide-angle lens.

The wide-angle lens is also convenient for the photographer who is doing candid work where exact focusing is not always possible. The large depth of field resulting from the short focal length of a wide-angle lens compensates, to a degree, for inexact focusing.

A remarkable effect that can be achieved by the wide-angle lens is exaggeration of perspective. A

close subject will appear larger than usual in the ultimate picture. Such exaggeration may sometimes result in a distorted impression, depending on the subject and viewing angle, and it gives a peculiar, interesting effect that cannot be attained otherwise.

The range of wide-angle lenses for 35mm cameras includes 8mm, 20mm, 21mm, 24mm, 28mm, and 35mm lenses. The 28mm and 35mm are the most important for general wide-angle police work. Nikon produces a 35mm PC lens that can correct for parallax. The 20mm lens has the shortest focal length usable with viewfinder focusing; a certain amount of edge distortion will be noted. Distortion is a problem with all wide-angle lenses, regardless of the manufacturer. The peripheral light rays are recorded with some degree of elongation, which is due to the angle at which they are received. Apparent perspective distortions are magnified by wide-angle lenses. When shooting with a wide-angle lens, the photographer should use a tripod and a small level to maintain normal perspective effects.

Wide-angle lenses for reflex cameras are also subject to design limitations caused by the need for an adequate back focus to clear the reflex mirror. This calls for inverted type construction.

Hasselblad has a very good super wide-angle camera that can be held in the palm of the hand. Used by many professionals for close-up candid work, it will only accept a 40mm lens.

Telephoto Lenses

A telephoto, or long-focus, lens has a longer focal length and provides a close-up image of a distant subject. In contrast to the wide-angle lens, the telephoto covers a smaller field of view and a shallower depth of field. Due to this shallowness, the ultimate picture assumes a relief-like quality, resulting from the lack of sharpness of the out-of-focus areas. Another characteristic of the telephoto lens is production of a flat composition; far objects appear enlarged while near objects do not appear proportionately large.

Normally, lenses beyond 58mm fall within the telephoto group. A technical distinction should be made between telephoto and long-focus lenses: a true telephoto has a shorter physical length while achieving the same angle of view as the long-focus lens. The shortening and physical convenience of the true telephoto lens is accomplished through use of negative rear elements for image dispersion. The front ele-

Figure 5.2 Various lenses. Sigma AF 70–210mm f/3.5-4.5 APO zoom lens (top). Nikkor 55mm f/2.8 macro lens (bottom).

ments converge; the rear elements diverge. Optical aberrations are more easily corrected in regular long-focus lenses (whose physical size approximates focal length) than in telephoto lenses. Optical designers have overcome telephoto lens aberrations but the effort in doing so is reflected in the cost of an advanced lens. In actual practice, all long lenses are usually called telephotos or tele-lenses.

Sigma MF 500mm f/4.5 APO telephoto lens (top). Sigma AF 1000mm f/8 APO telephoto lens (bottom).

Telephoto lenses are used to bring inaccessible objects into the image area in greater size than would be the case with a normal lens. Image magnification is proportional to focal length. A lens of about 100mm shows twice as much detail as a 50mm lens would. The area covered is much less; the 100mm lens covers the image area of a 50mm lens. When using a telephoto lens, always shoot with the shortest

telephoto lens that adequately encompasses the desired picture area.

Two other operational uses of telephoto lenses are: (1) to achieve better perspective control by being able to work at a distance; and (2) to maintain the relative size of objects placed at varying distances from the camera. These purposes are served mostly by lenses up to about 200mm.

For identification shots in police work, lenses of 85 to 135mm focal length are frequently used. Many departments photograph their arrested persons in 35mm color; the medium telephotos effectively avoid lending undue prominence to the nose, lips, and chin of a subject. Also, they crop out extraneous matter while best utilizing the film area with reproducible matter of importance.

Long tele-lenses are those beyond 200mm. Their angle of view and areas of image coverage are progressively narrowed as focal length becomes greater, but they show details in greater size and clarity than would be possible with an enlarged section of a picture made with a shorter focal length lens. The particular hazard of the long telephoto lenses is camera movement. Lenses through 200mm represent a safe limit for handheld camera use, but the slightest movement during exposure of a camera with a long lens will show up as image displacement and blurring on the film. This becomes increasingly apparent as lenses with narrow angles of view are used.

The longest handheld exposure should be the reciprocal of the focal length to the nearest shutter setting. For a 50mm lens this would be 1/40 of a second; for a 135mm lens, 1/125 of a second. To minimize camera movement, the photographer should use a tripod, cable release, the highest feasible shutter speeds, and self-timer for shutter triggering. Sometimes supports can be improvised from the back of a chair, a fence top, a table top, top of a car, a tree, or any other fixed object. The photographer may use beanbags on top of his or her tripod to stop the vibration of the camera. The beanbag technique is a good one and can be used for many shots in police work.

Zoom Lenses

The convenience of zoom lenses has made them increasingly popular with photographers. Zoom optics offer the advantages of rapid changing of focal lengths without changing lenses and having one lens serve the purpose of several, being both economical and space saving.

There are many focal length ranges covered by zoom lenses. Among the most popular are those covering the short to medium telephoto ranges, such as 80–200mm and 70–210mm lenses. Wide-angle to short telephoto zoom lenses, such as 28–85mm and 35–70mm, are very popular because one lens covers all three lens areas: normal, wide-angle and telephoto. Longer zoom lenses such as 75–250mm and 120–600mm are available but are heavier, larger, and often slower in speed.

Lens Speed

The "speed" of a lens refers to the minimum amount of light that is passed through the shutter plane or "iris" of the lens. The speed is measured as an f/number, a system denoting the lens aperture. The smaller the f/number, the faster the lens. For example, an f/1.2 lens is faster than an f/2.8 lens. Telephoto and zoom lenses typically have slower speeds than wideangle and normal lenses. Also, slower lenses are usually less expensive than faster lenses because of the number of lens elements required. For police surveillance in low light conditions, this may be a disadvantage. For instance, a 200mm telephoto lens may have a speed of f/4.5 while a 500mm lens may have a speed of only f/8. It would take more light for exposure with the 500mm lens than with a 200mm lens. Some zoom lenses are described as having one maximum aperture, such as 75-205mm f/3.8. The f/number remains constant throughout the zoom range. On other zoom lenses there may be two maximum apertures included in their descriptions, such as 28-80mm f/2.8-4.0. This means that the f/number gradually changes as you zoom from one end of the zoom range to the other. The shorter end of the zoom range is "faster" than the other end.

Autofocus Lenses

Most camera and lens manufacturers produce autofocus (AF) lenses. Autofocusing cameras, such as Minolta's Maxxum series, use an infrared sensing module to determine the distance of the subject and high-speed motor-driven focusing. Autofocus lenses allow the photographer freedom from manual focusing so that he or she can concentrate on exposure and framing. They are particularly advantageous when photographing quick scenes or when the subject is moving. Minolta's 8000i cameras even have a predictive focus control to track moving subjects.

Autofocus lenses are generally more expensive than their manual counterparts. When purchasing an autofocus lens or camera, be sure it has a manual override capability for special focusing situations. Also, autofocus lenses will not operate on non-autofocus cameras, but manual-focusing lenses will generally operate on autofocus cameras.

Lens Mounts

Lens mounts come in two basic choices: bayonet and screw thread. Although the mounts on most of the different brands of bayonet mount lenses appear the same, there are enough differences so that a lens designed for one brand of camera will not fit another. For example, a Minolta lens will not fit a Nikon, Pentax, Canon, or any brand other than Minolta. One exception is the Pentax "K" bayonet mount, which may be used on Ricoh, Cosina, and Chinon cameras. Some private label cameras use Pentax K mounts as well. Lens companies, such as Sigma and Vivitar, make their lenses available for most all camera brands. When purchasing a lens, be sure to specify the mount system for your camera. Generally, adapters are not available to adapt a lens with one mounting style to a different mount. Such an adapter would add some distance between the lens and the camera, thereby preventing the lens from focusing to infinity.

Macro Lenses

Macro lenses are designed primarily for close-up work, but can be used for conventional photography as well, because they focus to infinity. Most macro lenses are in the normal (50-55mm) or moderate telephoto (90-105mm) focal length ranges with speeds ranging from f/2.8 to f/4.5. Macro lenses are also available on some zoom lenses. The advantage of macro lenses for police work is that they can focus on small articles of evidence (such as fingerprints) at the scene or in the crime laboratory without the use of a microscope or lens attachments. Many macro lenses will focus close enough for a 1:2 reproduction ratio (about 91/2 inches). A reproduction ratio is a comparison of the actual size to the reproduction size on film. For example, a 1:2 reproduction ratio is ½ life-size, and a 3:1 ratio is three times life-size, or 3x magnification. A matched extension tube that permits 1:1 reproduction ratio is usually included with macro lenses or available as an option.

Care of Lenses

A dirty lens cannot yield sharp pictures; therefore, the lens must be kept clean. Cleaning must be done carefully or scratches will result on the lens. All outside optical surfaces should be protected as much as possible from dust, dirt, and fingerprints. Carrying cases should be closed over lenses when not in use, and lens covers should be placed over the lens. Many professionals keep a UV filter on their lens at all times for protection and also to improve the quality of their pictures. A folding camera should, of course, be folded and latched when not in use.

To clean a lens safely:

- 1. Blow on it gently, either with your breath or with a rubber bulb syringe.
- If the lens is still dirty, dust it with a soft camelhair brush, and blow again. Do not use this brush for any other purpose. Keep the brush covered and protected from dust and grit.
- 3. A smear or fingerprint can be removed by breathing on the surface (which leaves a film of moisture) then wiping the surface with a clean piece of lens tissue. Use a circular motion. Do not wipe with a rag or handkerchief. If the lens is still dirty, a drop of cleaning fluid may substitute for breath vapor.
- Brush and blow again to remove any lint left by the tissue.

Lenses should be protected from jars and jolts and from extreme and sudden temperature changes. They should not be stored in hot or moist places. Do not attempt to take a lens apart. If the lens or mounting requires adjustment, bring it to the attention of an experienced camera repairperson.

Filters

As the photographer becomes more proficient in the use of basic pieces of equipment, he or she may wish to improve the quality of work by modifying the light that reaches the film. This can be done by employing filters. Filters are used to change the composition of available light before allowing it to strike the film. These changes may be desired for artistic effect, to increase or decrease contrast, or for photographing certain colors at the exclusion of other colors. The intelligent use of filters improves a large percentage of photographs.

When the term filter is used in a photographic discussion, it usually refers to a transparent colored medium employed to regulate either the color or the intensity of the light used to expose the film. The color of the filter determines the color of the light that reaches the film, but in cases of a neutral density or colorless filter, only the intensity of the light is regulated. Filters for these purposes vary considerably because they are composed of transparent materials that may be colored to a greater or lesser degree. Some are so nearly colorless that they escape casual notice, whereas others are so deeply colored that they appear almost opaque. In all cases, however, the filter is used to modify the light that passes through the camera lens to the film.

A good photographer can make a good picture without a filter, but a professional photographer can make a better picture with the use of the proper filter. For most police work, the use of filters should be considered optional.

A filter of poor construction may cause distortion in a photograph; thus, filters should be carefully

chosen if used. Never use a filter that is merely held over the lens. This type of filter is extremely unpredictable. Also, care should be taken when using filters with and without lens shades on wide-angle lenses. A condition known as vignetting, which allows the film to pick up the edges of the filter on the lens, may occur. The finished photograph may come back with a circular border.

An adequate filter is constructed of filter material sandwiched between pieces of glass. When buying a filter for a threaded lens, it is necessary to know the correct size of the lens. Do not mistake the focal length engraved on the front of the lens as filter size. The focal length of a lens is its optical length that has no bearing on the filter size, which is the diameter of the filter threads on the front of the lens. One should check the instruction manual or carefully measure the diameter of the filter threads with a metric ruler. Most normal (50mm) lenses accept either 49, 52, or 55mm filters. Wide-angle, zoom, and telephoto lenses may accept one of these sizes also, or 58, 62, 67, 72, or 77mm.

Figure 5.3 Various filter attachments. The Tiffen Master Control system.

The photographer with more than one camera or lens may purchase filters to fit the larger of his or her cameras or lenses and an adapter-reducer for fitting the filter to the smaller camera or lens.

Some filters are used for black-and-white photography, some for color, and a few for both color and black-and-white. Among the filters used for both color and black-and-white photography are skylight, haze, neutral density, and polarizing filters. Skylight

and haze filters reduce excessive blue caused by haze and ultraviolet rays. They are useful for outdoor photographs and may be kept in place on the lens at all times for lens protection.

Neutral density filters are used to reduce light transmission. They do not otherwise affect color or tonal quality of the scene. They are very handy when using a high-speed film under bright light conditions, or where the use of a slow shutter-speed or wide aper-

Figure 5.4

Example of how a polarizing filter reduces glare. The photograph on top was taken without a polarizing filter and the one on bottom was taken with a polarizing filter.

ture is desired for a creative effect. Neutral density filters are available in strengths designed to reduce specific amounts of light by f/stop units.

Polarizing filters, like neutral density filters, are a neutral gray and do not affect the transmitted color in a way that will change its color temperature. When light is reflected by a nonmetallic surface such as water, it is polarized. With a polarizing filter (in a rotating mount), the photographer can intercept this polarizing light and dramatically reduce reflections in the photograph. These filters also increase the saturation of a blue sky in a color photograph (or darken the tone of the sky in black-and-white photography) as long as the lens/filter combination is not pointing directly at the sun. This is the only filter that can increase the blue saturation in the sky in a color photograph without altering the remaining colors in the scene. The polarizing filter is very handy for photographing vehicles in auto accidents.

There are a number of different polarizing filters produced by manufacturers. Basically, there are two main types: (1) the type used over the camera lens; and (2) the type designed to be used over studio lights. Polarizing screens and filters may be used for both color and black-and-white photography. Polarizing devices used over the lenses have small posts known as indicator handles projecting from the rims of the metal cells for aligning the axis of the polarizing grid.

The polarizing filter may be thought of as a screen with an optical grid or slots, which stops all light that is not vibrating in a plane parallel to the axis of the grid. This film or sheet of plastic may be used by itself, or may be cemented between thin sheets of glass and mounted in metal cells. The mounted filters are attached to a lens by means of screw threads, a filter holder, or lens shade.

Colored filters for black-and-white photography stop one or another color of light from passing through and striking the film. They are useful to highlight a subject that would not normally contrast readily with its surroundings. Using a deep red filter (e.g., Kodak No. 25) to photograph a red automobile will cause the automobile to print as white or light gray. This relationship between filter and subject color is a reciprocal one. In addition to a color that is lightened, there is also at least one color darkened. The greatest darkening occurs when the color is complementary, or opposite, to the filter color.

Complementary colors are often depicted as a color wheel or circle. Normally, both additive colors (red, green, and blue) and subtractive colors (magen-

ta, cyan, and yellow) are included (see Figure 5.5). Colors that receive the greatest print darkening are directly opposite on the color wheel. Because cyan is directly opposite red on the color wheel, it will be darkened more than any other color with a red filter. Colors adjacent to cyan (blue and green) will be darkened to a lesser degree. Chapter 10 discusses these color characteristics in greater detail.

Figure 5.5 Color wheel.

Blue filters. A blue filter can be used effectively when photographing blood with black-and-white film. When used outdoors, a blue filter will make the sky, or any blue object, appear white in the photograph.

Green filters. Green filters are often used in place of blue filters for photographing blood. Often, they work better than blue filters. Green filters will also bring out the contrast of red stop signs.

Yellow filters. Yellow filters can be used to photograph white cars; the detail of the car will stand out. Yellow filters also cut through haze to a certain extent, and can be used with good results to photograph an accident scene on a hazy day. A dark yellow filter will emphasize tire marks in photographs of accident scenes.

Filters are often used extensively in questioned document examination photographs, particularly ultraviolet and infrared. Additional discussion of these uses can be found in Chapters 16, 17, and 18.

Color photograph filters are basically color balancing filters that allow daylight film to be exposed with artificial light and film balanced for artificial light to be used with daylight. For instance, an 80A filter allows daylight film to be exposed under 3,200 degree Kelvin artificial illumination with natural looking results. This is particularly important when photographing documents with daylight balanced color film under artificial tungsten illumination.

Care of Filters

The simplest form of filter is a sheet of dyed gelatin, which requires considerable care in handling. Scratches, discolored spots, and finger marks render these filters useless. They are supplied in various sized sheets that are individually wrapped in tissue paper and supported by lightweight cardboard. These filters may be used between the lens cells, behind the lens, or in suitable holders, which usually means that individual filters must be cut to the desired size. When cutting the filter sheet to fit a lens or holder, remove the cardboard. Do the cutting with the tissue coverings in place. These papers should be removed only after the filter is placed approximately as desired. Only the edges of the filter should be touched with fingers.

Colored glass filters and filters cemented between glass should be treated as carefully as lenses. If dirty or injured, they detract from the quality of the final picture. Filters of this type should be cleaned by polishing them with lens cleaning tissue. Any lint or dust on them, however, should first be removed with a camel-hair brush. A lens tissue slightly moistened in lens cleaner or pure alcohol may be used if necessary, but care must be taken to keep the liquid away from any exposed edges of cemented filters.

When not in use, filters should be stored in their cases. All filters must be protected from moisture, excessive heat, and unnecessary exposure to strong light.

Exposure Meters

It is almost impossible to make a good print from a bad negative, but making a good print from a good negative is a simple process, requiring little effort and only a reasonable amount of skill and care. It is important, therefore, that the negative be uniformly exposed and processed. A good exposure meter, when properly used, is the best insurance a photographer can carry to be sure of uniform exposure.

While most cameras have built-in metering systems, photographers may find it beneficial to have a handheld light meter as a backup. This is especially true when using lenses without camera metering capabilities. Many lenses, especially large telephoto lenses (e.g., 500mm) have a fixed f/number with no coupling mechanism for the camera's internal metering system. A handheld exposure meter may be used to accurately calculate exposure with such lenses.

The photoelectric type is the most accurate exposure meter available. With this instrument, the intensity of light is measured, and the light value of a scene is indicated on a scale. Calculator dials attached to the meter are designed to compute the correct exposure rapidly by considering the light value in relation to the film speed. The problem of transcribing light values into terms of exposures is simplified, and direct readings in numerous combinations of f/stop and shutter speeds suitable for photographing the scene are shown on the calculator dials.

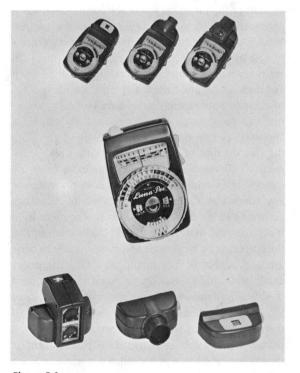

Figure 5.6
Luna PRO meters and accessories.

From experience, it is recommended that the Luna PRO line of exposure meters be used for police work. The Luna PRO is exceptional in that it is a system exposure meter. By means of instant-lock-on attachments, it makes refinement of measuring tech-

niques possible not only in camera work on location and in the laboratory, but in enlarging or in photomicrography. Figure 5.6 shows Luna PRO meters and various attachments. There is an enlarging attachment that can be attached easily to the front of the meter and used to read correct exposures under the enlarger. This feature alone can save, in a few months, enough on the expense for paper to pay for the meter, and also saves a great deal of time. This is a valuable asset for police departments. The Luna PRO is so easy to use that, within a short time, its operation will become almost automatic.

Choosing a Meter

The most important part of the exposure meter is the photoelectric cell. It is a simple device that admits a certain amount of light and emits a current in proportion to the amount of light falling on it.

The first practical exposure meter came about as a result of the invention of the selenium barrier-layer photocell, which was incorporated in the earliest Weston meters and in many others until very recently. The barrier-layer cell is self-generating—that is, it emits current in proportion to the light falling on it and does not require batteries or other outside sources of current. Some meters today have two cells, a normal cell for average illumination and an attachable "booster" cell for making readings in dim light. With the introduction of the cadmium sulfide photoconductive cell came a great breakthrough for exposure meters. The cadmium sulfide cell does not generate any current at all; it merely changes its resistance according to the light falling upon it. The more light it receives, the more current will pass through it. But the current must be provided from an outside battery, a new type that is very small, has a long life under small loads, and whose voltage is quite constant until it is finally exhausted. Some meters (such as Luna PRO) incorporate a cadmium sulfide cell and a small mercury battery as their basic elements. Generally, a push-button switch is provided so that current is drawn from the battery only when a reading is being taken. Under these circumstances, a single battery will last up to a year or longer.

Although the Luna PRO has been highly recommended for police work, the photographer may wish to experiment with several of the many meters on the market. However, the Luna PRO, with its system attachments, is a very versatile meter, and should not be overlooked when making a choice between meters.

Using a Meter

The principle of operation of most exposure meters is basically the same. The film speed number and the light value reading are set on the calculator dials. Numerous combinations of exposure are then shown opposite each other as pairings of f/stop and shutter speed. To use the meter:

- Set the calculator dial on the ISO/ASA rating of the film. Once this setting is made, it need not be changed as long as film of that rating is used.
- 2. Direct the meter at the scene to be photographed and obtain a light value reading. Usually this reading is taken from or near the camera position. The reading should be taken from a position that includes only the area to be covered in the photograph. Hold the meter near eye level with the photoelectric cell directed at or near the center of the scene. Do not hold the meter so that the light from the sun, auxiliary lights, or large highly reflective surfaces can reach the cell directly. Avoid including more sky than necessary by directing the meter slightly downward. Be particularly careful not to obstruct or interfere with light that could reach the cell.
- Set the light value reading on the calculator dial.
 Then all that remains is to select the desired combination of f/stop and shutter speed from those indicated on the dials (on Luna PRO set light value reading on yellow triangle at bottom of meter).

Proper Exposure

There are many more shutter speeds and aperture numbers on the meter calculator dials than are found on any one make of camera. These calculators were designed to make the meter convenient for use with every standard type of domestic and foreign camera by including practically every f/stop and shutter speed found on them. Select and use only those combinations that are marked on your camera and disregard the others. Remember that intermediate shutter speeds cannot be obtained by setting the index between two marked speeds on the shutter housing. However, should the meter indicate a diaphragm setting that is not marked on the lens, the index may be set between two marked f/stops for an intermediate setting, or it may be set to the nearest f/number.

Figure 5.7 shows the face of a light meter set for a film rating of ISO/ASA 50. The meter was set while pointed at a subject that gave a reading of f/8 at ½0 of a second. A camera shooting the same subject would give a good, even exposure if set at f/8 and 30. Other combinations of exposure are available with this reading: f/4 at ½25, f/5.6 at ½0, f/11 at ½5, and so on.

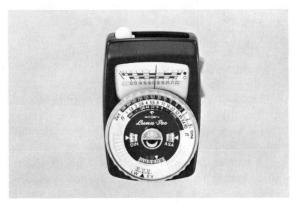

Figure 5.7 Luna PRO meter set at ISO/ASA 50 reading f/8 1 /so of a second.

Any combination of exposure settings can be used for a given reading, depending upon the effect desired by the photographer. For instance, an action photograph of a speeding car may be shot at f/2 at 1/1,000 of a second; a nonmoving subject may be photographed at f/32 at 1/4 of a second for a sharp image (a tripod would be a necessity for an exposure longer than 1/30 of a second). Considerations concerning the best combination for a shot are discussed in Chapter 6.

Incident and Reflected Light

Light values may be measured in either of two ways: as incident light or as reflected light. An incident light reading is taken by holding the light meter in front of the subject and pointing it back at the camera. With the Luna PRO and other meters, an opal white bulb must be placed over the light cell before taking an incident light reading. Reflected light is read by pointing the light meter toward the subject, holding it pointed slightly downward, and taking the reading.

There is considerable controversy regarding the subject of determining light values as to whether the reflected or incident method is superior. Each method has certain advantages and disadvantages. The incident method is especially useful when the intensity of

illumination is very low. It is extremely accurate in measuring the intensity of light falling on the subject. On the other hand, the photographer is more interested in the amount of light that is reflected from the subject. Black velvet absorbs a very high percentage of incident light, while a sheet of white paper reflects perhaps as much as 85 percent. Obviously, the light reflecting quality of the subject must be carefully considered when determining exposure by incident light readings. Some meters are manufactured specifically for reading incident light values. Certainly these meters are just as capable of accurate readings as those reading reflected light. Either type is quite reliable, but both must be used with intelligence.

Cautions and Techniques for Meter Use

The ISO/ASA setting of most meters is connected to the aperture dial. A change in the ISO/ASA reading will change the aperture reading, while the reading for speed will remain the same.

Because a light meter averages light values, it cannot guarantee 100 percent accuracy, particularly in situations in which there is a bright sky, snow, or a beach. On a bright day, the meter should be aimed downward to measure the light reflected from the ground and not the light from the sky. When the ground is highly reflective, as when it is snow covered or when the photographer is over water, readings should be taken of lighted areas and also of areas in shadow. The aperture should be set midway between these readings.

An 18 percent gray card, available at any camera supply store, is often useful for taking readings of reflected light. The palm of a hand may substitute for a gray card in many situations.

Spot Meters

At times, the photographer will want to meter only a small part of a scene. A spot meter measures reflected light in a very small section of the scene before it. Ordinary light meters measure light over an angle of 30 to 50 degrees, whereas a spot meter can measure at an angle of one degree or less.

A spot meter is particularly useful when the exposure is based on one important tone in a scene. Backlighted areas, shadow areas, brightly highlighted

areas, and extreme changes in illumination can affect an accurate reading from an ordinary light meter. A spot meter can accurately read each area so that an exposure can be calculated to compensate for these extremes in illumination.

Spot meters are handy to have in those instances where extreme changes in illumination occur, but should be considered an optional piece of equipment for the police photographer. The cost of spot meters may be prohibitive for the amount of actual use to which they are put in police photography. An ordinary light meter can be used to measure different parts of a scene and an average of the readings can be taken. The photographer may also wish to bracket exposures to make sure certain areas of the scene are properly exposed. Some exposure meter manufacturers produce light meters that double as spot meters. While the cost may be high, they should still be considered. In addition, some SLR cameras have built-in spot meters. The Nikon N8008s 35mm SLR has a built-in spot meter that measures 2.3 percent of the picture area in addition to the camera's built-in center-weighted and matrix metering systems.

Flash

Whenever the photographer goes inside to shoot photographs or must work outdoors at night, he or she must be concerned with making use of available light or creating enough light to suit the required purposes. Although the available light may be sufficient to shoot with a wide aperture, the photographer may wish to stop down (larger f/stop number) for a clearer, more focused image. In this case, the available light may not be enough. No matter what the desires or limitations may be, the police photographer will eventually, and may more often than not, need to create light. To do so, he or she merely adds a piece of equipment, an electronic flash, which will give, on cue, a satisfactory amount of light for the short period during which the shutter is open.

The principle of flash (synchro-flash) photography is essentially nothing more than igniting a flash-lamp at the proper time so that it burns at peak brilliance while the shutter is open for exposure. Where there is no movement in the scene being photographed, the shutter may be opened before the lamp is ignited and closed again after the light has completely expired. In such cases, it is a very simple matter to synchronize the action of the shutter with the

firing of the lamp. However, when a fast shutter speed is necessary, an extremely sensitive and accurate synchronizing mechanism must be employed. This mechanism is usually an electrically or mechanically operated device that trips the shutter after the lamp, and tripping the shutter must be accurate to approximately the thousandth part of a second (millisecond) to ensure correct synchronization at faster shutter speeds. If the shutter opens too early or too late, only a small portion of the flash is used, resulting in underexposure of the film.

Electronic Flash

Electronic ("strobe") flashes have been around for more than 100 years. Electronic flash units have come a long way, and today there is an electronic flash unit for everyone's requirements.

A typical flash unit consists of a power source (AC or battery), one or more energy-storing capacitors or condensers, a triggering circuit, a flash tube through which the stored energy is released as a brief flash of light, and a reflector that directs the light toward the subject. The duration of the flash from a strobe unit is intense and very short, making it excellent for stopping action and minimizing the effect of camera movement.

The quantity of light produced by a strobe unit is determined by the watt/second rating of the power supply, the size of the flash tube, and the size of the reflector. A large energy charge in the power supply will produce a brighter light than will a smaller charge; a large flash tube will produce a brighter light than a small tube. The size, shape, and surface texture of a reflector greatly affect the light output; a large reflector yields more light than a small one, a bowl-shaped reflector yields more light than a flat one, and a polished reflector yields more than a matte (dull) finish reflector. An average reflector increases the light output of a flash tube by 10 times—about three f/stops—by directing the light forward.

Strobe units use one or more of the following power sources: penlight batteries, nickel-cadmium batteries, high-voltage batteries, and AC (house) current. Penlight batteries are inexpensive and provide up to 300 flashes per set. Penlight batteries are not rechargeable, but they are also not expensive. Nickel-cadmium units are more expensive than penlight-powered units, and they must be used at least once a month or their capacitors will deform, causing very

long recycle times and possibly preventing the unit from recharging at all.

Many two-piece units operate using high-voltage batteries, which are heavy and expensive, but give very short recycling times and provide around 1,000–1,500 flashes before having to be replaced. High-voltage batteries cannot be recharged, and they wear down even when not in use. These units are usually more powerful than others, and more expensive.

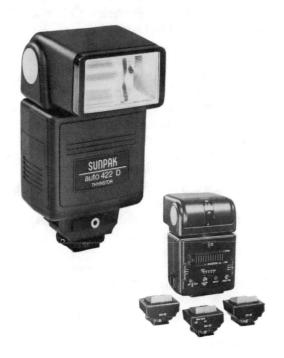

Figure 5.8 Sunpak 422D.

Some penlight-powered units, most ni-cad (nickel-cadmium) units, and high-voltage battery units can be operated with AC (house) current power. This provides an almost infinite number of flashes without recharging or replacing batteries. Recycling times are usually slightly longer when using AC power.

Most strobe units have ready lights that indicate that they have recycled and are ready to flash again, but on many units this ready light comes on at less than full charge. Because the output of a unit is controlled in part by the amount of energy stored in the capacitors, the light output of a partially charged unit will be less than a fully charged output. If the unit's ready light comes on when it is 70 percent charged, the unit will put out one-half as much light as when fully recycled.

Therefore, the exposure will be one full stop underexposed. This can be corrected in the darkroom, or, if foreseen by the photographer, the aperture may be stopped up one full stop to compensate.

For flash photography with an electronic strobe unit, the camera should be set on "X" synchronization. Cameras with focal-plane shutters may have a maximum shutter speed that will function with strobe (usually ½0 or ½25 of a second.) The maximum allowable shutter speed should be noted and not exceeded.

Automatic strobe units save time and trouble. Instead of determining the flash-to-subject distance, and then using the guide number to figure out which f/stop to use, the photographer just sets a predetermined f/stop on the lens and proceeds (see the instructions with the automatic unit to determine the correct f/stop to use). Automatic units have a sensor that reads the light reflected from the subject and alters the flash duration to produce the correct exposure. Flash durations as short as ½0,000 of a second are possible with some automatic units.

The latest improvement in automatic electronic flash technology has been the development of "dedicated" flash units that are electronically mated for certain electronic 35mm cameras. Besides the large synchronization contact on the "hot shoe" (an electrical contact on the camera flash mount to allow firing of the flash without the use of a cord), dedicated flash units have one or more additional contacts to match corresponding hot shoe contacts on the camera for which they were designed. When a dedicated flash unit is mounted in the hot shoe of a matching camera and turned on, the camera's shutter speed will be automatically set to the correct synchronized speed. Some dedicated flash/camera combinations also set the correct lens opening and operate with the camera's internal metering system.

Some units have thyristor circuits that save power, recycle in a very short time, and permit up to 400 flashes between chargings with ni-cad units. The principle involved is that it takes a certain amount of power to produce a 1/1,000-second flash. It takes much less power to produce a 1/5,0000-second flash. When a subject is at the maximum distance of an auto unit's range, the flash duration will be the same as the flash duration with the unit on manual (non-automatic) setting. If the subject is closer, the sensor in the unit cuts the flash short to reproduce the correct exposure. If the flash duration is less than the unit's maximum (usually 1/1,000 of a second), the thyristor circuit saves the excess power that would otherwise have been wasted.

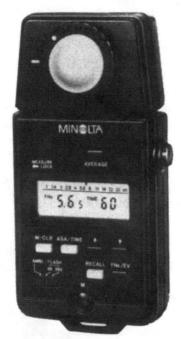

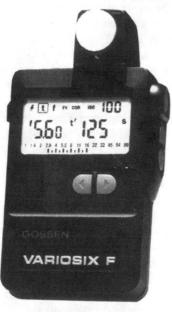

Figure 5.9
The Minolta and the Gossen Lunastar F meters measure ambient, reflected, and flash illumination.

Flash Meters

Flash meters are often used by studio photographers. It is similar to an ordinary light meter but is designed to read the brief, intense burst of light from an electronic flash. Ordinary light meters cannot record the burst of light from an electronic flash quickly enough. Flash meters were once very expensive and out of reach for all but professional studio photographers. The cost of flash meters has significantly decreased with new technology. For instance, the Shepherd FM 880 and Prolux CFM and TSM flash meters can be purchased for less than \$300.

As with spot meters, flash meters are handy to have in police photography, but should be considered optional. Once the police photographer is experienced in calculating flash exposures, the perceived need for a flash meter may be lessened. However, because the cost of flash meters has decreased significantly in recent years, the purchase of such a meter would greatly reduce the amount of time spent calculating exposures at a crime scene. As with combination exposure and spot meters, flash-metering capabilities may be built into one exposure meter. Gossen (Luna PRO) and Minolta also manufacture exposure meters that can meter flash bursts.

Miscellaneous Equipment

Lens Attachments

There are several camera/lens attachments available for close-up (macro) photography. Close-up lens sets are lens elements that screw into normal or telephoto lenses like filters. These single-element lenses are usually sold in sets of three, each with a different "strength" of magnification expressed as a diopter rating. The larger the diopter rating, the closer the lens will focus. Most close-up lens sets contain +1, +2, and +4 diopter lenses that are double threaded so that any combination of the three lenses can be mounted together.

Extension tubes are hollow metal tubes that fit between the camera body and lens and allow the lens to focus closer than normal. Extension tubes are also usually sold in sets of three, each being a different length. The longer the tube, the closer it will enable the lens to focus. Extension tubes reduce the exposure in proportion to their length—the larger the tube, the greater the light loss.

Bellows attachments are essentially the same as a flexible extension tube, but are usually used for ultra close-up photography (greater than life size).

Reversal rings screw into the front of the lens filter threads and permit the lens to be mounted backward onto the camera body. By doing so, a normal 50mm lens that focuses to only about 18 inches can be focused close enough for a 1:1 reproduction ratio.

Extension tubes, bellows attachments, and reversal rings are available with or without camera metering coupling mechanisms. If a metering coupling mechanism exists for the attachment, the camera's internal meter system can be used for exposure determination. If there is no meter coupling, the photographer may have to "bracket" exposures, assuring at least one properly exposed photograph. Bracketing of exposures is accomplished by taking a normal exposure reading, then making exposures at two f/stops below, one f/stop below, and one exposure at the normal reading. Additional discussion on exposure will be covered in Chapter 6.

Tripods

For exposures of long duration and for added accuracy with an exposure of any length, a tripod is a necessity. This is particularly true in the case of cameras that have a ground glass focusing screen, such as 4 x 5 cameras or long, heavy telephoto lenses. Tripods provide a degree of stability that is not possible when a camera is held by hand. Many tripods are available from camera supply shops; the photographer must be careful, when choosing a tripod, to purchase one that is stable and does not prove to be a hindrance.

The legs of a tripod should be given special attention. Most tripods are built with telescoping legs. The legs lock at full extension; or, in the case of some tripods, they can be tightened at any length desired by the photographer. The more sections a leg uses to extend, the less stable the tripod will be; the most stable tripod will be the one with the fewest sections.

The locking mechanisms of tripods' legs are usually of two types: those that snap and those that must be screwed. The latter is preferable because the tightening of the lock tends to strengthen the leg, but the photographer must be sure that the locks are in good working order and must not allow the leg sections to "creep."

Most tripods include a cranking rack-and-pinion type elevator that allows the photographer to further

adjust the height of his or her camera once the legs are adjusted and locked. The elevator must be of sturdy construction and must not have "play" that may transmit vibrations to the camera even though the legs are stable.

The head of the tripod on which the camera is mounted should be large and balanced enough to support the weight of the camera without vibration. It should allow the camera, when mounted, to move freely both vertically and horizontally until locked.

Any time a camera is mounted on a tripod, the danger of accidental damage to the camera is increased. For this reason, it is strongly recommended that a camera never be left unattended while on a tripod. To lessen the danger of breakage, set the tripod on firm footing with its legs spread well apart. On a hard surface, where a tripod leg may slip and allow the camera to fall, use a tripod brace or a triangle to prevent the legs from spreading. A triangle is an adjustable, folding device made of lightweight metal especially for use with tripods. If this device is not available, a triangular-shaped frame can be constructed of wood to serve the same purpose. Hanging a weight such as a camera bag between the legs of the tripod will also increase its stability. If possible, the tripod should always be set up with one leg pointing forward. This places the legs in such a position that more freedom of movement about the camera is allowed, with less danger of tripping over one of the legs and upsetting the camera.

Tripod Substitutes

Where storage space is limited, or when the photographer needs more versatility in camera placement, there are substitutes that, although do not wholly replace a tripod, can help to steady a camera. The monopod is simply one leg, usually collapsible, of a tripod. The monopod steadies the camera to a degree but will not, of course, permit the photographer to stand free of the camera.

There are also numerous mounts to which a camera may be attached and steadied. Some rest on the shoulder of the photographer. Some merely have a large handgrip that transmits less vibration from the hand to the camera. Some are even constructed like a gun butt. These mounts can be more of a hindrance than a help, but are available should the photographer want or need them.

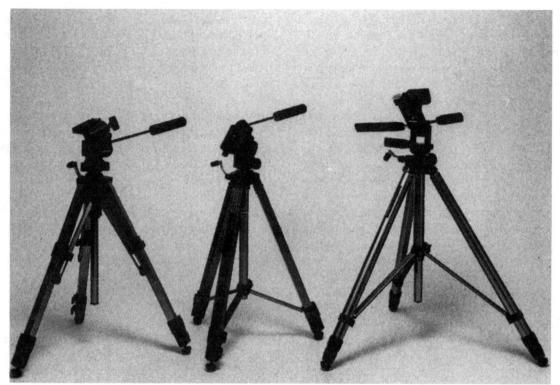

Figure 5.10
Tripods. The Mohawk tripods may be used for still and video cameras.

Cable Release

As with a tripod, a cable release is essential for lessening vibration during long exposures. A good rule is this: always use a tripod and a cable release together. They can eliminate all but the slightest vibration. Cable releases come in various lengths and are flexible with a cloth, plastic, or wound metal cover that permits the photographer to stand close to, or away from, the camera, as he or she pleases. Some cable releases have locks for time exposures.

Lens Brush

Lens brushes are usually made of camel hair, and some are attached to a rubber bulb that, when squeezed, creates a stream of air to blow dust off of a lens. Brushes should be covered (there are retractable brushes that, when capped, resemble a tube of lipstick) when not in use to prevent them from collecting loose dust.

Paper and Pencil

Although a picture can tell a thousand words, two pictures may become hopelessly confused in the photographer's mind and he or she may need a word or two to distinguish them. A photographer should always carry note-writing materials in order to annotate photographic shots, or the work may become as worthless as it would be had he or she left on the lens cap.

Exposure

6

As was shown in Chapter 2, passable photographs can be made with a simple box camera; however, the rigors of police photography demand that the photographer make pictures in all conditions of light. Photographs must be made of subjects that are far away or of objects that are no more than a few inches from the camera lens. In order to do so, the light that enters the camera must be controlled.

The adjustable camera was designed so that the photographer could control the light that is recorded on film. The focusable lens allows the camera to focus sharply on objects three feet away or at infinity. The adjustable shutter permits light to be let in for as little as 1/1,000 of a second or for many minutes.

In addition to adjusting the focus and the shutter, the photographer can control the amount of light that enters the camera at any given moment. The photographer can let in as little light as a pinhole or as much light as the diameter of the lens will allow by changing the aperture, or diameter of the opening. The mechanical device that allows the photographer to adjust the aperture is called a diaphragm. Usually, the diaphragm is an integral part of the lens system. On cameras that have detachable lenses, the diaphragms are a part of each lens and not a part of the camera itself.

Letting just enough light into the camera to strike the film is called exposure. With the simple camera, the photographer decides whether there is enough light for an exposure. If there is not, one does not take a picture or one takes a picture with a flash. The adjustable camera, however, allows the photographer to photograph under many different conditions. For basic exposure, the photographer need be concerned with only two settings: aperture and shutter speed. Aperture controls the intensity of light that is let

inside the camera, and shutter speed controls the time that it spends inside the camera. A formula for setting the adjustable camera might look like this:

INTENSITY x TIME = EXPOSURE.

Exposure

Exposure is the amount of light that you allow to reach the film by controlling the variables of aperture and shutter speed. Light meters quickly, accurately, and conveniently measure light in almost any photographic situation and help to determine the appropriate aperture and shutter speed combination. The development of light meters and faster, more sensitive films makes it possible for contemporary police photographers to use illumination from any direction such as back, side, diffused through the atmosphere, or front. Light can also be used to produce many different aesthetic effects.

Most black-and-white films have some exposure latitude built into them, but other films, such as color slide film, have practically none, making careful exposure more critical. Even the highest quality film can register only some of the many different tones your eyes can see. Some tones, and therefore some detail, are lost in the photographs. Thus, in every situation you have to choose between tones to emphasize and tones to neglect. Accurate measurement of light with a light meter tells you how to set the aperture and shutter to get both the best detail the film can register and the aesthetic effect you want.

Most modern cameras, especially 35mm cameras, have built-in light meters. The police officer, if he or she is to become proficient at photography, must

act like a professional photographer and learn how to use a light meter so photographs can be obtained that will be a credit to him or her in a courtroom. The police officer may discover that it is an advantage to use a handheld meter because of its greater accuracy and versatility.

There is an old photographer's maxim: "Expose for the shadows and develop for the highlights." That is, if you must choose between over- and underexposure, it is better to overexpose to bring out the detail of the shadow areas than to underexpose, especially because most film has higher tolerance for overexposure than for underexposure. It may be possible to correct for some degree of overexposure when printing the negative.

The "f" System

There have been at least six systems to mark the opening of the diaphragm, but most cameras now use the "f" system. The diaphragm opening, which is called a stop, is usually marked in numbers on the exterior of the lens.

The "f" system is a relationship between the diameter of the lens opening, or aperture, and the focal length of the lens. The "f" indicates the speed of the lens or, in other words, the amount of light the lens lets through in proportion to its focal length. Some years ago, the photographer more or less guessed at the size of the lens opening and then guessed at the exposure that would be required. In 1881, members of the Royal Photographic Society of Great Britain worked out a system of apertures based on a sequence of ratios so that aperture and exposure time could be controlled scientifically. They began with a unit of one as an aperture of f/4. The ratio that was worked out gave each succeeding stop an area of just one-half of the previous one. Each numerical stop, as the stops become smaller, lets in half as much light as the preceding one.

The "f" system is used in most of the world today. The following table shows the common f/stops in use today, the fraction of the focal length that each represents, and the ratio of exposures.

f-	1.4	2.8	4	5.6	8	11	16	22	32	45	64
Fraction of	1	1	1	<u>1</u> 5.6	1	1	1	1	1	1	1
Focal Length	1.4	2.8	4	5.6	8	11	16	22	32	45	64
Exposure Ratio	$\frac{1}{4}$	$\frac{1}{2}$	1	2	4	8	16	32	64	128	256

Table 6.1 F/stop exposure table.

Methods of Regulating Time

The oldest method of controlling the amount of time was to have a light-tight cap on the lens that was removed by hand, and replaced when sufficient time had elapsed.

Inexpensive box cameras were usually equipped with a single metal plate attached to a spring. When a lever was pushed, the spring rotated the plate, allowing the light to enter for about 1/50 of a second. These mechanical devices, which are used to control the amount of time the light is allowed to pass, are called shutters.

Many of the better cameras have a very complicated device that allows exposure times from one second to ½000 of a second. This is indeed a wide range. In addition, they have provisions for time and strobe exposures. Many of the modern 35mm cameras have another feature that delays the opening of the shutter for several seconds, and enables the person to take his or her own picture. This type of shutter, which is usually in the lens, is called a compur shutter or a leaf shutter.

Controlling Intensity

The diaphragm of a camera or camera lens is graduated into measurements of the intensity of the light that it will let pass through the lens. The measurements, called f/stops, are standardized and are usually printed or engraved on the lens barrel as follows: 1.4, 2.8, 4, 5.6, 8, 11, 16, 22, 32, 45, 64. Confusingly, an f/stop with a larger number, such as f/16, lets in less light than one of a smaller number, such as f/5.6.

Each f/number indicates that the diaphragm is allowing twice the light that the next higher number would let pass through the lens into the camera and one-half of the light that the next smaller number would let pass. That is, f/11 is twice as bright as f/16, but only half as bright as f/8. While learning about aperture, the photographer would do well to think of f/numbers as fractions; just as ¼ is smaller than ½, but larger than ½, so is f/4 larger than f/5.6 but smaller than f/2.8. Stop f/1 lets in 1,024 times as much light as f/32!

Controlling Time

The shutter on an adjustable camera can be set so that, once it is released, it will stay open indefinitely or for as little as $\frac{1}{1000}$ of a second. In between these

extremes are various fractions of a second, for example: 1/15, 1/30, 1/60, 1/125, and 1/250 of a second.

On the camera setting, these fractions are engraved or printed as whole numbers: 15, 30, 60, 125, and 250, respectively. The fractions of a second may vary from camera to camera; some cameras are marked 25, 50, 100, 200, indicating that shutter speeds of ½5, ½50, ½50, ¾500 and ½250 of a second are available to the photographer. Also, short shutter speeds of ⅓500 and ⅓1,000 of a second are not available on all cameras. The letter B on a shutter setting means bulb exposure; with this setting, the photographer may open the shutter and hold it open indefinitely. The letter T means time exposure; the photographer can open the shutter on a time setting and walk away from the camera. When the photographer returns and trips the shutter again, it will close.

Combining Control of Intensity and Time

The aperture and shutter speed work together to provide the film with an accurate amount of light. Which shutter speed and aperture the photographer chooses depends upon: (1) the amount of available light; and (2) the depth of field required by the subject matter of the photograph. Depth of field will be discussed in a section below.

Films respond to light quickly or slowly, depending upon their ISO/ASA (see Chapter 4). A film that reacts quickly to light, such as Tri-X or T-Max (ISO 400), will require far less light for a good exposure than will a relatively slow film, such as Technical Pan (ISO 25). Therefore, the photographer will keep the aperture smaller and the exposure shorter for Tri-X or T-Max than for Technical Pan in the same light. The photographer must know the speed of the film that is used and become familiar with the properties of the film in relation to various light sources.

When shooting outdoors in daylight, the photographer can divide the intensity of light into five categories: bright sunlight, hazy sunlight, cloudy bright, cloudy dull, and cloudy dark. If the aperture is set at f/11, a different shutter speed will be required for each category of light. Cloudy dark will require the longest exposure, and bright sunlight will require a short exposure. Conversely, if the shot is only at 1/125

of a second, the aperture must be adjusted for variations of light intensity.

In practice, however, the photographer must choose the best possible combination of aperture and shutter speed for the light conditions and the subject matter. A photograph of a moving object always requires a fast shutter speed in order to capture the object. The photographer who wishes to photograph a moving car will shoot at ½50 or ½500 of a second and adjust the aperture according to the light available. When photographing still objects, though, depth of field becomes the most important consideration in choosing exposure.

Depth of Field

The art photographer often takes pictures in which one object, a model or a flower for instance, is in sharp focus while the foreground and background are a blur. The effect is pleasant and suggests a painting. But the police photographer is not concerned with art; the facts must be presented and to do so, details must be clearly represented. The distance from the closest clear object in a photograph to the farthest clear object is called the depth of field, and the police photographer must always strive to obtain the greatest depth of field possible in every photograph.

Fortunately, depth of field increases as the lens aperture decreases; to get greater depth of field, the photographer stops down, or uses a smaller f-stop (e.g., f/22). Thus, for most police photography, the photographer will use the smallest possible aperture and adjust the shutter speed accordingly. It is no exaggeration to say that the smaller the aperture is, the better the picture will be.

The technique of using small apertures for greater depth of field does have its limitations. When the photographer focuses on an object close to the camera, the depth of field will be less than for objects farther away so the focus must be more accurate on nearby objects than for distant objects. Also, as is the case of a speeding car, or for any fast-moving object, a fast shutter speed will be required and a small aperture may therefore be impossible. The photographer must then be extremely careful to focus accurately on the moving object.

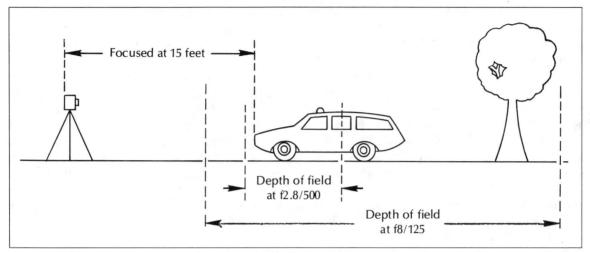

Figure 6.1 Depth of field.

More About Focus

Incorrect exposure, resulting in imperfect negatives, can be corrected in the darkroom. Faulty focusing cannot. Improperly focused photographs seldom appear in the courtroom, because they are unusable.

The most important thing a photographer can do is to focus correctly on the subject before snapping the shutter. Single- or twin-lens-reflex cameras (see Chapter 3) are easily focused, but cameras with separate viewfinders require more attention. Usually the photographer must estimate the distance between the camera and the subject and set the lens accordingly.

When focusing, it is good to remember that the closer a subject is to the camera, the farther the lens must be from the film. This is more easily seen with a bellows-type camera that becomes elongated when the lens is focused on an object far away. Most 35mm cameras have screw-type lenses that are focused by turning the lens as one would turn a screw. The lens moves closer to or farther from the film when it is turned, but the change of distance is not as obvious as it is with a bellows camera.

Many police photographs are taken at night, making focusing difficult. Whenever the photographer cannot accurately focus on the subject, the focus should be set at infinity and the smallest possible aperture should be used (thus ensuring depth of field). In such cases, it is wise to use a high-speed film and/or push-process the film.

Photography of Moving Objects

When a subject is in motion during exposure, its image on the film moves. Even when the duration of exposure is only $\frac{1}{1000}$ of a second, the image moves a small fraction of an inch during this time. However, the movement at $\frac{1}{1000}$ is only $\frac{1}{10}$ as far as it is at $\frac{1}{100}$ of a second.

The photographer must determine just how much image movement can be tolerated before it becomes objectionable; then the shutter speed must be regulated accordingly. It is necessary to visualize the use to which the negative is to be put in order to determine what constitutes an "objectionable" blurring of the image. A negative that is to be contact printed will permit considerably more blurring than one that is to be enlarged many times. Also, if a print is likely to be examined through a magnifying glass, the image must be sharper than is necessary if the print is to be viewed from a distance.

Unusual circumstances may make it impossible to obtain great degrees of sharpness of a moving object. In such cases, it will be necessary to decide whether it is more important to take a picture even though the subject is somewhat blurred than to leave it unphotographed. When it is imperative that a sharp image be obtained of a fast-moving object, it is possible to use the "follow through" method of keeping the camera constantly trained on the object and following it until after the exposure is made, rather like

shooting a duck. Of course, this method will completely blur the background, but will provide a sharp image of the object itself, even at relatively slow shutter speeds.

Although it is not always possible to do so, the photographer will achieve better results if he or she can choose the direction of movement. An object moving toward or away from the camera will not be as blurred as an object crossing the camera.

A Simple Exposure Method

The following system, called the f/16 system, has been used with astonishingly good results by the Shaker Heights Police Department (Shaker Heights, Ohio) since 1956. Here is how it works:

- 1. Set the aperture at f/16. This will ensure good depth of field.
- Set the shutter at a speed closest to that of the ISO/ASA rating of the film being used; for example, the shutter speed when shooting with Tri-X will be 250 or 500 because Tri-X is rated at 400.
- 3. Focus the lens.
- Corrections for underexposure or overexposure are made in the darkroom. No exposure meters or estimating is needed.

The f/16 system works, but the professional police photographer should attempt to set the exposure accurately every time. This is best done with an exposure meter (see Chapter 5) that measures the amount of available light and indicates several combinations of aperture and shutter speed that could be used in that light. The photographer should learn to judge available light so that exposure can be set at combinations known to have worked well in the past.

Automatic Cameras

Automatic cameras are of three basic types: shutter priority, aperture priority, and fully automatic. Cameras with shutter priority automatically set the aperture, but the photographer must select a shutter speed first. A photoelectric cell is activated on shutter priority cameras when the photographer pulls up slightly on the wind-up lever or some other mechanism specific for the camera. A needle mechanism in the viewfinder will indicate whether there is enough

light for the pre-selected shutter speed. If there is not enough light, the photographer selects another speed and tries again.

Aperture priority models automatically set the shutter speed after the photographer has selected an aperture. Although this system gives the photographer far more control over depth of field, the mechanism is also far more complicated than the shutter priority mechanism and, if not maintained in optimum condition, may throw the camera off by one complete f/stop without any indication to the photographer.

Fully automatic cameras use advanced electronic circuitry to determine exposure and automatically set aperture and shutter. Many fully automatic cameras allow the photographer to manually override these features for shutter priority and aperture priority. Most point-and-shoot automatic cameras are fully automatic with no manual override capability. As was discussed in Chapter 3, the police photographer should select a camera with manual override capability.

Built-In Meters

Most 35mm SLR cameras come with built-in exposure metering that, simply and accurately, tells the photographer whether there is enough light for a good exposure with the combination of aperture and shutter speed that has been selected. A needle inside the viewfinder window indicates whether the shot will be underexposed, overexposed, or correct.

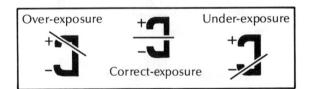

Figure 6.2 Built-in meter.

Subject Reflectance and Negative Density

Instead of one single density, nearly all negatives have a great many different densities, ranging from almost clear film to a very dense deposit of silver. Each different degree of density in the negative represents a different degree of reflectance from some part of the subject. The average scene is composed of many shades of gray, from black to white, and colors

ranging from the faintest suggestion of a color to colors of great brilliance.

When a negative is made of any scene, it theoretically records all the tones or brightness as various degrees of density. A print made from such a negative should represent the subject as seen by the eye, reproducing each shade or tone from the lightest to the darkest in the same relative degree of brightness.

While the eye observes a scene in its true colors, the black-and-white photographic process usually records colors in various shades of gray, from black to white. The portion of the scene that appears brightest to the eye should be reproduced as the lightest part of the print and the dullest part of the scene should appear darkest on the print. Whether the subject is faithfully reproduced depends upon the recording of various subject brightness as various densities in the negative in the same relative degree.

For the average outdoor scene, which consists of many degrees of brightness, we are not concerned with the exposure necessary to produce a particular density in any one part of the scene, but in the exposure for the scene as a whole to produce a general negative density. The parts of the scene that appear brightest to the eye produce the greatest density in the negative and the darkest parts produce the least density.

If the scene appears average (having an equal distribution of light and dark reflecting surfaces), use the basic exposure. When there is an abundance of bright reflections in the scene (such as from a sandy beach), close the diaphragm at least one full f/stop. However, if a scene has a generally dark appearance because of numerous large areas of low reflectance, open the diaphragm one full f/stop.

Exposure with Bellows Extensions

The f/numbers engraved on a lens can be relied on to be sufficiently accurate to produce a satisfactory exposure as long as the lens is focused at or near infinity. It is only necessary to calculate the new effective lens speed when photographing nearby objects that are within a distance of eight focal lengths from the camera. Considering that in close-up photography this may mean as much as two whole f/stops and may reduce the image brightness by one-fourth, the film can be excessively underexposed.

On a 35mm camera, when using a bellows extension adapter or, when the bellows is extended beyond one focal length, the new effective f/number can be determined by the following formula:

$$Effective f/No. = \frac{Indicated f/No. x Lens-to-film distance}{Focal length}$$

For example, an 8-inch focal length lens is focused on a close object so that the lens-to-film distance is 16 inches. If the indicated stop is f/16, what is the effective f/number?

Effective f/No. =
$$\frac{16 \times 16}{8}$$
 = 32 or f/32

Film Latitude

The human eye is extremely inaccurate in the process of determining exposure. It is such a remarkable mechanism, in automatically compensating for extremes in brightness range, that it has difficulty recognizing the problems that are inherent to the film. The pupil of the eye opens or closes as necessary to compensate for extreme differences in brightness values. We can read a newspaper in bright sunlight or moonlight, even though there may be a measured difference in illumination of almost one million to one. Extensive training and experience enables the human eye to estimate roughly both the intensity of light and the range of brightness of a scene. This is inadequate, however, to achieve the accuracy necessary to consistently expose film correctly. An exposure meter is far more accurate than the human eye for the purpose of determining exposure. The "eye" of the meter stays open all the time (remains at a constant setting) to indicate the exact intensity of light.

The exposure latitude of modern negative-making materials usually takes care of considerable error in exposure, but does not tolerate carelessness. To use any film to the best advantage, it is necessary to know the correct exposure required. It is also necessary to develop the film according to the recommendations of the manufacturer. Film speed values (and consequently exposure) depend on the film being processed according to the manufacturer's instructions. Developing in any solution other than the recommended solution may result in an apparent gain or loss in film speed. By developing in a solution of unknown potential, the results are unpredictable.

It is impossible to formulate a set of specific rules or tabulate the exact exposure required for a certain subject under every possible lighting condition. The best that can be done is to generalize and approximate. Each police photographer may have his or her own personal concept of how the subject can best be

reproduced and this may vary somewhat from the opinion of another.

Exposure meters may vary slightly in their calibration, lenses may vary considerably in the percentage of light transmitted, and the actual speed of operation of the shutter may not be the same as the speed indicated on the shutter housing. For these reasons, it is not unusual to obtain negatives varying considerably in density when exposed in different cameras, even though the same indicated shutter speed and f/number is used with each one. It is necessary for the serious photographer to make a series of practical tests with the equipment and determine or account for these possible variations. In this manner, "normals" can be established, by which the most desirable density can be consistently obtained in negatives.

Artificial Light

In Chapter 2, it was said that photography involves controlling, recording, and creating light. Much of the police photographer's job requires that

artificial light be created because many auto accidents and crimes occur during the hours of darkness. A flash may be required at many accident and crime scenes.

Two types of flash are used by photographers: strobe and photoflash. Photoflash refers to any kind of flash that is created by an instantaneous ignition of a flashbulb which, once used, is discarded and replaced by a fresh bulb for the next shot. The more common strobe refers to a recharging unit with a flash tube that flashes thousands of times before requiring replacement.

Single Flash

Most cameras come equipped with a shoe or bracket to which a flash or strobe is attached when needed. They are also built with an electric input which, when connected to the flash, synchronizes the flash to the shutter. Because of the convenience of attaching a single flash directly to the camera and shooting, most amateur photographs are made with a single flash at the camera. Such pictures are charac-

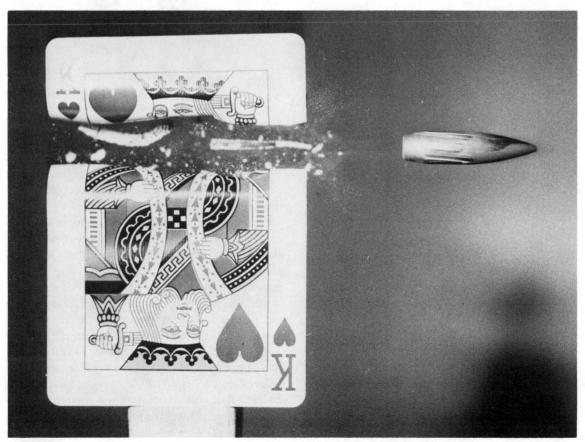

Figure 6.3 Photographer using a single strobe at a high shutter speed.

terized by flat lighting on the subjects and harsh black shadows in the backgrounds. When the flash originates very close to the lens, the eyes of persons in the photograph may appear red in color films; this is called the "red-eye" effect and can be most disconcerting. The "red-eye" is actually light being reflected off the retina. Some point-and-shoot cameras with built-in flash decrease the "red-eye" effect by allowing the flash to illuminate before the shutter is open, thus allowing the iris of the person's eyes to contract before the picture is taken.

Objectionable effects of single flash lighting can be minimized or overcome by several methods, the simplest of which is to detach the flash from the camera. If the flash must remain on the camera, it should be covered with some kind of diffusion material, such as a white handkerchief, cheesecloth, or frosted cellulose acetate. Diffusion, however, reduces the intensity of the light and exposure must be increased accordingly.

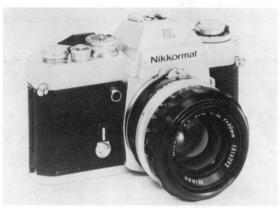

Figure 6.4
This camera is equipped with a "hot shoe" for attaching the flash. The conscientious photographer will rarely use the shoe.

Off-Camera Flash Technique

One of the best methods for using a single flash is to detach the flash from the camera and direct it at a surface other than the object being photographed. The light will bounce off the surface (a wall or ceiling) and provide the subject with a soft, even illumination. This technique is called bounce flash and works best in a white or off-white room with a low ceiling. It is ineffective outdoors if there are no surfaces to reflect the light.

Bounce flash is so widely used that some strobe and photoflash units are made to tilt while remaining attached to the camera. The photographer should, however, learn to hold the camera in one hand and direct the flash with the other.

Adjustments in exposure must be made for bounce flash because the light must travel farther; this will be discussed in another section.

Figure 6.5Bounce flash technique.

Multiple Flash

If the flash needed for a photograph comes from more than one source, the light will be more even and will create fewer harsh shadows. Multiple flash can be accomplished by stringing together a number of flashes or by purchasing slave units that flash automatically when the main unit flashes. Slave units are inexpensive devices that attach to the "hot shoe" of a secondary electronic flash and "sense" the main flash unit when it discharges. Most slave units are so sensitive they can activate 100 feet away in direct sunlight. It should be noted that many point-and-shoot cameras have pre-bursts of light from built-in strobes to reduce "red-eye" effect. If such a camera is used with a slaved flash, the slaved flash will prematurely discharge when it senses the pre-flash from the camera strobe.

Multiple flash is particularly helpful for shooting outdoors at night where bounce flash is impossible. Ten units can be used to illuminate an entire parking lot.

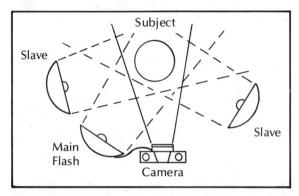

Figure 6.6 Use of multiple flash.

Painting with Light

Painting with light is a technique that simulates multiple flash, but requires only one flash unit. It can be used only with subjects that are absolutely stationary. Here is how it works:

- 1. Two people are required for painting with light; one walks around with a strobe unit while the other remains at the camera.
- With the shutter of the camera open (a T setting), the photographer holds his or her hand over the camera lens to keep out stray light.
- 3. The person with the strobe unit in hand walks to the first position from which a flash would be fired, instructs the photographer to remove his or her hand from the camera lens, and then fires the flash. The photographer then replaces his or her hand over the lens.
- The person with the strobe unit walks to a new position and repeats the process again and again until the entire area to be photographed has been illuminated.

When painting with light, the person who carries the strobe must be careful to remain outside the field of view of the camera, or he or she may appear as a ghost not once, but several times in the finished picture. Also, the photographer must take care that nothing moves while the process is taking place, or the evidentiary value of the photograph will be lost. A photographer could, using the painting with light technique, fill an entire parking lot with the same automobile photographed over and over again.

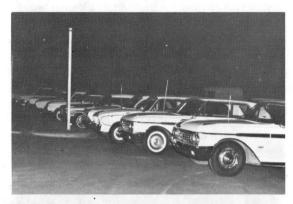

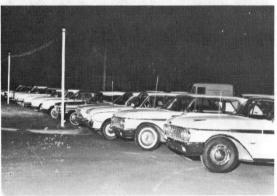

Figure 6.7Difference between photos taken at night with a single flash (top) and with painting with light technique (bottom).

Fill-In Flash

Many photographs taken in daylight could be improved by using fill-in flash. Many areas in daylight are in dark shadows (e.g., the underside of a car or the area under the hood) and need fill-in flash in order to appear on the finished photograph.

It may appear ridiculous at first glance to observe a photographer using a flash when taking a picture in bright sunlight. Actually, it is just as sensible as using two or more lights when taking any interior view or a portrait; one is the key light and the other is the fill-in. Working in bright sunlight, the sun is the key light and the flash is the fill-in. It is often desirable to reduce or otherwise change the lighting contrast of a subject in bright sunlight. When the sun casts deep shadows on the subject, it is quite difficult

to obtain both the highlight and shadow detail in the negative. By filling the shadow areas with a flash, the contrast is reduced to obtain good detail in all parts of the subject and make a much more pleasing picture. Synchro-sunlight is a method of using supplementary illumination synchronized with sunlight for the purpose of obtaining better shadow detail in all types of outdoor photography.

The outdoor flash can do an excellent job of lighting a difficult shot if properly handled. It can also produce a crude over-illuminated effect of having been shot at night with a single flash. The challenge is to balance two extremes of exposure on a sin-

gle negative, each in itself providing the correct exposure to the film. These two extremes are the normal daylight exposure for the highlights and the normal flash exposure to light the shadows. Thus, a flash exposure and a sunlight exposure must be harmoniously balanced during the instant the shutter is open in order to achieve a pleasant result. Naturally, the ratio between flash and sunlight varies according to subject matter and the particular effect desired. Whether the shadows are to be eliminated or merely subdued must be determined by the photographer, and the flash and sunlight balanced accordingly.

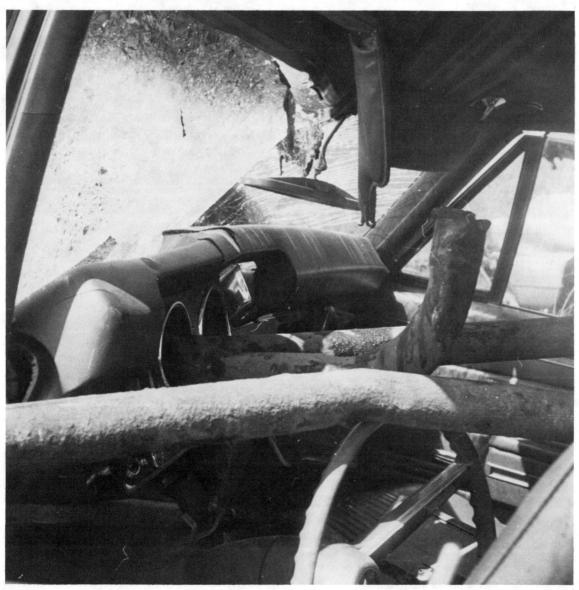

Figure 6.8 Photo showing use of fill-in flash for good contrast.

Exposure for Flash

The primary consideration when figuring exposure for flash is the distance of the subject from the flash. In daylight photography, the distance between the subject and the camera makes little difference to the exposure; with flash photography, the distance from the flash to the subject is crucial.

Many electronic flash units have sensors to measure available light on a subject and automatically adjust the power of the flash illumination. Auto-exposure flash units judge the exposure correctly in most cases because most scenes contain many middle tones. Auto flashes are designed to emit enough light so that a scene will be reproduced as a middle tone. However, not all photographic situations fall into a "normal" flash area. Some scenes are dark while others are bright with harsh shadows. It is important for the police photographer not to become overly reliant on automatic exposure flashes. In the absence of a flash meter (see Chapter 5), the ability to manually calculate flash exposures for any number of photographic situations will be of benefit to the police photographer.

The Inverse Square Law

As the light created by a flash moves away from the flash source, it seems to dissipate or to disappear. The light from a single flash will illuminate a subject 20 feet away only slightly, but at 10 feet the single flash is adequate, and at five feet it is too bright. Why?

As the flash is moved away from a subject, the light must not only travel farther; it must spread out more. A single flash that is one foot from a subject will provide a square foot of light, but a flash two feet from the same subject will provide four square feet of light. If the subject being photographed has a surface area of one foot, it is plain that it will be illuminated by four times as much light at one foot than at two. This is called the inverse square law. Inverse means fraction, and square means a number multiplied by itself. An object illuminated at 20 feet is five times as far from the flash as one illuminated four feet from a flash. Five squared equals 25; the inverse is 1/25. Therefore, an object 20 feet from the flash receives only ½5 of the light that it would at four feet, so the photographer must adjust the camera accordingly.

Guide Numbers

Correct exposure for flash is determined with the use of mathematical formulas that have been greatly simplified by the manufacturers of flashbulbs and strobes, who have worked out guide numbers and tables for figuring exposure. For every combination of shutter speed and film speed, there is a guide number that represents the product of the flash-to-subject distance multiplied by the f/stop.

Guide numbers for flash units are often greatly inflated by the makers of these units and must be carefully tested by the photographer and, in many cases, completely reassigned. Frequently, strobes are not working at peak power and will not produce as much light as they should. Here is how to arrive at a guide number for a strobe flash:

- Load the camera with a film that is normally used.
- 2. Set up a subject exactly 10 feet away from the flash. It is suggested that large f/stop numbers written on an 8 x 10-inch gray card be used.
- 3. Place the camera on a tripod.
- 4. Attach the strobe unit to the camera in the position normally used.
- 5. Make a series of exposures at half stop intervals (e.g., f/5.6, 6.7, 8, 9.5, 11, etc.).
- Print the f/stop used on a gray card and include it in the picture as a reminder when the roll is returned.
- 7. Have the roll processed.
- 8. When the pictures are processed, select the picture with the best exposure.
- 9. Multiply the f/stop by 10 (the distance used in the test), and this will be the guide number for the strobe unit. If the picture with f/8 was the best photograph, then 8 x 10 = 80, so 80 would be the appropriate guide number.

Once the proper guide number has been determined, the flash-to-subject distance can be used to determine the proper f/stop. Divide the guide number by the distance from flash to subject for the correct f/stop. For instance, if the guide number of the flash is 80 and the distance from flash to subject is 20 feet, then $\frac{80}{20} = 4$ or f/4 would be the proper f/stop.

Exposure for Bounce Flash

Whenever the photographer bounces the flash to provide even light, the flash travels farther than the flash-to-subject distance, and the exposure must be adjusted accordingly. This exposure is determined by adding the flash-to-ceiling distance to the ceiling-tosubject distance, dividing the total into the guide number, and then increasing the exposure indicated by approximately two f/stops. For instance, if the guide number of the flash is 80 and the distance from the flash to the ceiling is five feet and from the ceiling to the subject is five feet then 80/10 = 8 plus an increase of two f/stops would indicate f/4 as the proper f/stop. The photographer may wish to "bracket" exposures in order to make sure a properly illuminated photograph is obtained. In the example above, the photographer would make three exposures: one at f/8, one at f/5.6, and one at f/4. Although this is a very useful method, it does require some experience to estimate the distances and reflective ability of the surfaces of the room. Obviously, dark-colored surfaces reflect less light, and require additional exposure, than those painted white.

Exposure for Multiple Flash

When automatic exposure flash units are used for multiple flash, they should be set on manual mode. The sensor on an automatic flash is designed to produce properly exposed pictures, assuming it is the only source of flash.

In multiple flash photography, one flash is usually used as the main light. The camera exposure is based on the light from the main flash unit. Secondary flash units are used to fill in shadows, illuminate the background, or to add rim lighting to the subject. The light from a secondary flash unit is not as

great as that from the main flash unit. Lighting ratios are used to compare the brightness of the main light to the fill light. To calculate the exposure, set the camera lens to the f/stop given by the flash's calculator dial for flash-to-subject distance. The fill flash and any other secondary units are positioned so they will illuminate the subject less strongly than the main flash. For example, if the main flash unit is five feet from the subject and the exposure is f/11, set the lens aperture to f/11. If fill lighting is to be two f/stops less than the main light source (4:1 ratio), position the fill flash at a distance that will produce an f/5.6 exposure. If the fill and main flashes are of equal power, the fill flash distance in this example would be 10 feet.

Exposure with Filters

Many filters cut down on the amount of light that reaches the film, so exposure must be adjusted accordingly. With automatic cameras, this is not a problem because the through-the-lens metering will compensate.

For all other cameras, the photographer must know the filter factor of the filter being used. The filter factor is a figure that tells the photographer how much more light is needed for correct exposure. A filter factor of two, for instance, means that the exposure should be doubled. For an exposure that would be $\frac{1}{125}$ at $\frac{1}{16}$, the photographer would double the exposure and shoot with the filter at $\frac{1}{125}$ at $\frac{1}{11}$, or $\frac{1}{16}$ at $\frac{1}{16}$.

Some filters are marked with figures like 1X, 2X, and so on. These are not filter factors. They mean that for a filter marked 2X, the aperture should be opened up two stops.

Before using any filter, the photographer should carefully read any directions that come with it.

The Darkroom

7

The processing of film and the enlarging of negatives can only be done in a properly equipped dark-room. A darkroom is, literally, a room that is dark and in which light-sensitive materials may be handled without fear of accidental exposure.

Below are the design characteristics of a basic darkroom. The student may have the use of a college darkroom while the police photographer will have use of a department lab. The characteristics described below should serve to orient both the student and police photographer to an environment that, when being used, is not seen or not seen well.

The basic components of a darkroom are the room, work areas, storage areas, plumbing, electrical outlets and lighting, and ventilation. The photographer must become very familiar with these components and their requirements so that the sense of touch and memory serve the purposes of sight when the room is dark.

The Room

The location of the darkroom depends on the available space in the building and the type and amount of work to be accomplished. A small room that is well arranged is more than adequate; a large, rambling place could lead to time-consuming activities. The size of the darkroom will depend on the size of the department. A small department may have to do film developing, printing, and finishing in one room. A large department, on the other hand, may have three separate rooms: one small room for film developing, a small room for enlarging and printing, and a larger room for the finishing process. The

three-room setup is good because it keeps all three processes separate and allows more than one person to work at the same time. This is impossible in the one-room setup, because each procedure requires a different amount of lighting.

The approximate minimum-size room that can serve as an efficient darkroom is approximately six by eight feet. Width of passages between working areas should be at least three feet, but if it is anticipated that several people will normally work in the darkroom at the same time, wider passages are desirable.

Figure 7.1 shows an example of a typical dark-room arrangement used by the Shaker Heights Police Department (Shaker Heights, Ohio).

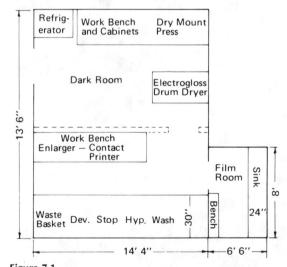

Figure 7.1

Darkroom design for Shaker Heights Police Department (Shaker Heights, Ohio). Doorway from darkroom leads to identification bureau.

Work Areas

The height of the bench tops should be approximately three feet from floor level. Bench width should be about two feet. Underneath the dry working area there is usually room for one or more cabinet units with drawers, shelves, or combinations of both, as desired. Bench tops should be chemically inert, watertight, and fairly resistant to abrasion. Good quality, solid-color linoleum is an economical topping material.

When planning the space to hold the enlarger, if you make it 25 inches from the floor, you will find that you can sit down and work while doing the enlarging (see Figure 7.2). If you are going to do any lengthy amount of work in the darkroom, you may find this position more comfortable.

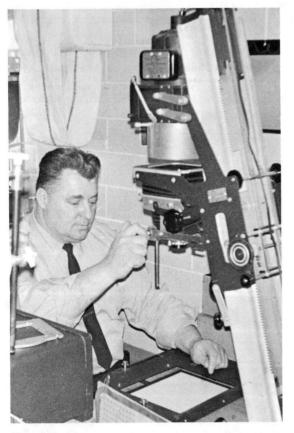

Figure 7.2
Enlarger base (top) is 25 inches above the floor, so one may work while seated.

Storage

Wall shelves or overhead cupboards above the benches provide convenient storage space. The bottoms of these units should be at least two feet above the bench top. Shelf width of about 12 inches is adequate.

Many of these furnishings are commercially available in wood or metal from suppliers of laboratory furniture. Similar units sold for kitchen installation often will serve the purpose also, and are available in semi-assembled, unfinished form at reasonable prices.

Figure 7.3
These darkroom sinks are constructed of stainless steel.

Plumbing

An adequate and reliable supply of pure, clean water should be provided in all darkrooms. The processing sinks should be constructed of stainless steel, but with care, serviceable stoneware, lead-lined, fiberglass, and even wooden sinks can be constructed. All pipe fittings to stainless steel sinks should be made with brass or copper fixtures extending at least four inches from the sink.

To minimize future maintenance problems, drain plumbing should be constructed of stainless steel or PVC, neither of which is impaired by the flow of photographic waste. Normal piping materials will withstand this type of use for many years, but eventually they will require replacement.

Plumbing installation is most economical and efficient when all sinks and drains are located along the outer walls of the darkroom area so that a common raceway can be utilized for all. This offers the additional advantage of making internal partitioning simpler and more flexible.

Long runs of non-insulated, exposed piping should be avoided in order to minimize temperature fluctuations of the water supply. Thermostatic mixer valves for regulating the water temperature are convenient and timesaving. In warm climates, where the "cold" water supply averages 80 to 90 degrees Fahrenheit for long periods of the year, some thought should be given to providing refrigeration facilities for cooling the water.

Electrical Outlets and Lighting

All electrical circuits should be designed for 30-ampere loads, and the number of these circuits must be dictated by the total load of the electrical equipment that may eventually be used in the darkroom. Film and print dryers, mounting presses, and copying lights all constitute large power drains that should be anticipated and provided for.

Electrical circuits should be provided with resettype ground fault circuit breakers. In addition, the control panel should be located as close to the darkroom as possible so that service can be restored quickly after an interruption, without the necessity of going to another part of the building to reset the circuit breaker.

The lighting circuit should be separate from the equipment circuit in order to prevent safelights and

room lights from being extinguished when equipment overloads interrupt the supply.

Convenient outlets should be located in the walls at chair-rail height, immediately behind the apparatus that they are to serve. This eliminates the hazard of trailing wires on the floor, and it also places the outlets far enough above the floor so that there is little danger of their being accidentally splashed with spilled solutions or with water when the floor is mopped.

The switch for the general illumination safelight should be installed within easy reach, next to the entrance to the darkroom, at a height about four feet above the floor. The switch for the white light should be located much higher (about six feet), and can be provided with a coverplate or mechanical or electrical interlock to prevent its being turned on inadvertently.

Safelights should be provided on the basis of one for every five linear feet of bench or sink working space. They should be located not less than four feet above the working level and, at this distance, 15-watt bulbs should be used. If the darkroom is adjacent to the identification room, its electrical circuits should be separate from those of the studio, so that changing equipment loads in the darkroom will have no effect on the output and color temperature of the flood lamps. Conversely, the use of separate circuits will prevent varying lighting equipment loads from affecting printing exposures and drying times in the darkroom.

Constant voltage controllers for enlargers and printers are desirable for minimizing the effects of random voltage fluctuations in black-and-white printing. If color printing is anticipated, voltage stabilization is almost mandatory.

If possible, both 100- and 220-volt service outlets should be provided in all rooms.

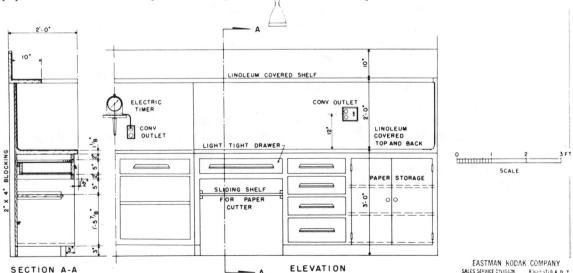

Figure 7.4 Workbench design.

Ventilation

A darkroom should be clean and thoroughly ventilated. Clean fresh air should be pumped into the darkroom. This is preferable to using an exhaust fan because it produces a positive static air pressure in the darkroom and, by causing air leakage currents through cracks and crevices to move outward rather than inward, it helps to minimize any dust problems. (Glass fiber furnace-type air filters may be used over the air intake to lessen the amount of dust brought into the darkroom.)

The ventilating system should provide a volume of air sufficient to change the air in the darkroom from six to 10 times per hour. More may prove "drafty" and less, inadequate. A pattern of air flow should be planned so that the fresh air is brought in at the "dry end" and exhausted from the "wet end." Thus, vapors from open trays and sinks will be quickly exhausted without traveling the length of the darkroom. Lightproof louvers (nesting W type) are commercially available in a variety of sizes and can be utilized as exit ports for the air flow.

Film and print dryers that give off heat and water vapor should be provided with individual external vents to prevent their raising the temperature and humidity of the whole darkroom area.

The arrangement of a darkroom should be convenient, with a place for everything and everything in its proper place. Sinks should be of adequate size and should be constructed so that they drain thoroughly. Duckboards are recommended to keep trays and tanks above the bottom of the sinks. There should be adequate and correct safelights placed at recommended working distances. Sensitized materials, other than those in actual use, should never be stored in the darkroom. The temperature of the laboratory should be maintained as closely as possible to the normal processing temperature—approximately 70 degrees Fahrenheit is the optimum temperature. The well-equipped darkroom contains the following items: waterproof aprons to protect clothing, a supply of clean towels, a thermometer, a timer, and the necessary film hangers, trays, or tanks. All darkrooms should be well-stocked with prepared developing chemicals, and their containers must be correctly labeled. In general, good photographic work demands that all operations be conducted in a clean, orderly, and systematic manner.

Safelights

Safelights are enclosed light sources equipped with a filter. The function of a safelight is to transmit a maximum amount of light that is of a color that will not damage sensitized materials. Because the color sensitivity of sensitized materials varies with different emulsions, the color transmission of the safelight must vary accordingly in order to remain safe.

The Kodak Wratten OC (light amber) and DuPont S-55X (orange/brown) safelight filters are generally preferred for printing because of their high safety factors (photographic papers are predominantly blue-sensitive) and the good working light they provide.

Film, because of its greater color sensitivity, must be handled in total darkness; thus, no safelight is truly "safe" when developing film. However, if the sensitive materials can be viewed at a distance under their illumination without fogging for the period of time that is normally required to expose and process them, the safelights serve their purpose adequately. As the sensitivity of the material increases, less exposure to the safelight is required to produce fog. If specific safelight instructions are lacking for a given type of paper, the best plan is to make a test using the paper under the questionable light source. Such a test is simple and only involves exposing portions of a sheet of the paper for various periods (e.g., two, four, six, eight, and 10 minutes) at a normal working distance from the safelight. Then, after developing the paper, if a fogged appearance is noticeable beginning with the eight-minute exposure, the test shows that six minutes is the limit of permissible safe exposure under the existing conditions. Leave a strip of paper unexposed so that you may compare the strips made at the various times to see if they are fogged.

There are two remedies for an unsafe light. One is to increase the working distance from the safelight to the sensitized materials being used; another is to replace the bulb in the safelight with one of lesser wattage.

Wherever possible, the walls of the darkroom should be painted a light color to reflect the maximum amount of (safe) light and thus improve visibility.

	Туре	of paper	Lamp	Safe working distance	
Safelight filter	Contact	Projection	wattage		
KODAK:					
Series #O	Safe	Safe	25	3 ft	
Series #00	Safe	Unsafe	25	3 ft	
Series #OA	Safe	Safe	25	3 ft	
Series #OC	Safe	Safe	15	4 ft	
Series #10	For pan	chromatic	15	4ft	
	emu	Ilsions	130		

Figure 7.5 Darkroom safelight recommendations.

Trays

Trays, though once made of enameled metal, are now constructed of plastic or stainless steel. The darkroom should be equipped with a minimum of four trays of a size larger than the materials to be processed.

Tanks

It is more convenient to develop roll film in a small tank than in a tray. The results are usually better, and the possibilities of damage to the film are minimized. Design detail and construction differ somewhat among the various manufacturers' models of roll film tanks, and obviously there are corresponding differences in details of loading, manipulation, agitation, and so forth.

Some manufacturers (such as Nikor and Kindermann) produce tanks constructed of stainless steel. They are unbreakable, easily cleaned, and have spiraled reels to hold the film and a tank with a light-tight cover. Each reel is constructed for a specific size of roll film such as 35mm or 120. The tank cover has a light trapped pouring hole with a leakproof cap to allow solutions to be poured in and out of the tank during processing under normal room light conditions. Larger tanks are made that can hold several reels stacked vertically (see Figure 7.6). This allows the convenience of developing several rolls of film at one time.

Figure 7.6 35mm and multiple roll Nikor stainless steel tanks.

Other tanks are manufactured, usually of plastic, for developing roll film. Plastic tanks are lower in cost but are also less sturdy than stainless steel tanks. One consideration for using plastic or steel tanks is the ease with which film can be loaded onto the reel. Some photographers indicate that the steel reel is easier to load in total darkness, while others maintain that plastic reels are easier to load. When purchasing tanks, the photographer should check both plastic and stainless steel varieties at a photographic supply store to determine which is best suited for him or her.

Figure 7.7Paterson plastic developing tank and reel. The reel is adjustable for 35mm and 120 size film.

Mechanical Print Washers

Mechanical washer designs vary to accommodate the type of printing accomplished, but their general function is to wash prints in a continuous and changing water bath. The recommended class of mechanical print washers consists of a tub-like tank and a perforated cylindrical drum that revolves in the tank. Fresh water is circulated in the tank and through the drum by an inlet and an overflow outlet. The power for rotating the drum is supplied by the force of the water entering the tank from the bottom, hitting the fins, and making the tubular inside tank turn around. The drum has a locking hinged door for convenience in loading and unloading prints (see Figure 7.8).

Timers

Most darkrooms contain two types of timers: a large wall clock with a sweep-second hand, and interval timers connected to the contact printers and enlargers (see Figure 7.9). The wall-clock timer most often used has a black background with white numerals and hands. The dial has one-second graduations and a large sweep-second hand. It is mounted on a shelf convenient to the developing tray. It should be sufficiently illuminated so that the photographer can accurately time the development of the print.

There are a number of models of interval timers used to time the exposure when printing. Some are built into the printer or enlarger and others are connected electrically. All work on the same principle. The exposure time is set by moving a pointer to the

Figure 7.8 Arkay mechanical print washer.

Figure 7.9
Omega interval timer (top) and Gra-lab timer (bottom).

desired time on the dial; the "expose" button is pressed and the printing paper is exposed. When making a number of prints from one negative, such a timer is invaluable in giving each print exactly the same exposure. A "focus" button is usually provided on the various timers to permit the operator to turn on the printer light and view the image that is being printed.

Mechanical Print Dryers

Only fiber-based black-and-white papers should be heat dried on mechanical dryers. Resin-coated (RC) papers and color print papers should be dried using forced air flow or by hanging in a dust-free area (see Figure 7.10). Using a mechanical dryer for RC and color papers may cause the emulsion to crack or alter the color on the print. However, if a fiber-based black-and-white paper is used, it can be dried on a mechanical dryer.

Figure 7.10Premier flow air dryer for resin-coated (RC) papers.

There are several models of machine dryers that dry fiber prints to a ferrotyped, or glossy, finish. Glossy print dryers are equipped with a wide conveyor belt that carries the prints around a chromium or stainless steel-plated, highly polished, heated, slowly revolving drum (see Figure 7.11). The washed prints are placed on the apron portion of the conveyor belt, emulsion side up. The belt carries the prints between the polished drum and a rubber squeegee roller. The pressures of the drum and the roller squeeze the surplus water off the prints and roll them into smooth contact with the polished surface of the drum. The cloth belt holds the prints in firm contact with the

revolving drum. The speed and temperature of the drum can be regulated so that the prints are completely dried with one cycle of the dryer. When the prints have traveled one revolution around the drum, they fall off the drum into the print tray.

Figure 7.11
Floor model fiber-based paper dryer. (Courtesy of Pako Company, St. Paul, MN)

Machine glossy dryers have a capacity for drying many prints per hour. Good results can be obtained when the emulsions of prints are properly conditioned, and if the drum is kept clean and well-polished. Sometimes prints that are dried glossy are found to have drying marks that are termed oystershell markings. These marks are caused by uneven drying. The dryer should be operated so that the prints are dried slowly and completely with one revolution of the drum to prevent drying marks and to reduce curling and wrinkling.

The polished surface of the drum should be cleaned periodically with a mild soap and hot water to remove any gelatin, residue, or dirt that may have collected. Then the surface should be thoroughly wiped dry and the drum should be repolished with a soft cloth.

Small and Economical Darkrooms

Many small departments may not have the space or the budget to equip a full-fledged darkroom. Some departments have converted available space (such as restrooms and closets) into permanent or temporary

Figure 7.12
Bathrooms can easily be converted into temporary darkrooms.

darkrooms (see Figure 7.12). The only requirements are that the room can be made dark, and that it has electrical outlets and a water supply.

Darkroom equipment setup for 35mm film, including an enlarger, can be purchased for less than \$500. Many mail order and photographic supply houses offer packages of darkroom equipment at very economical prices. Those considering setting up a darkroom should consult the various trade magazines (such as *Popular Photography*) and compare prices on equipment in the advertisement sections.

At a minimum, the following equipment is necessary to begin processing black-and-white photographs and color slides:

- 1. enlarger
- 2. enlarging easel
- 3. timer
- 4. four developing trays

- 5. film developing tank with reel
- 6. polycontrast or multicontrast filters (if using multicontrast paper)
- 7. safelight
- 8. plastic bottles, one gallon and one pint sizes
- 9. mixing rod
- 10. graduate, one liter size (indicating U.S. and metric volumes)
- 11. bottle opener (to open 35mm film cassettes)
- 12. scissors
- 13. print tongs (clothes pins work nicely)
- 14. appropriate chemicals (see Chapters 8, 9, and 10)
- 15. thermometer

Optional equipment includes:

- 1. film washer
- 2. print washer
- 3. film dryer

- 4. motorized film agitator
- 5. print dryer
- 6. focusing scope (for enlarger)
- 7. paper trimmer
- 8. paper safe
- 9. refrigerator

While this list is not all-inclusive, it is sufficient to begin making black-and-white prints and color slides. The photographer may find other equipment useful as he or she obtains more experience in the darkroom. Once the basic equipment is obtained for black-and-white processing, color processing can be accomplished with the addition of a few, inexpensive items (see Chapter 10).

	4	

Black-and-White Processing: Negatives

8

After the camera work is done, getting to the final picture is generally a two-step process: (1) production of the negative from the exposed film; and (2) production of the positive, or print, from the negative. Both operations, if performed in the usual manner, require a darkroom. The darkroom's equipment does not need to be elaborate, but it must be totally dark for handling today's films, which are often sensitive to light and are usually panchromatic (sensitive to all colors of light). Years ago, it was possible to use a red light in the darkroom, and look at the film to see how it was developing. If it needed more time in the developer, it could be examined and then put back in the developer. This cannot be done today. Basic equipment should include a tank for developing films, trays for print processing, an accurate thermometer, a timer, a graduate for measuring liquids, bottles for storing solutions, a safelight, a printing frame or printing box, and if enlargements are wanted, and they usually are, an enlarger.

A timer for the enlargements is not essential, but it is handy and desirable. Some timers will function as both an interval timer for negative development and an enlarger lamp control for print exposures.

Black-and-White Film Development

The beginning police photographer should start with one of the many excellent prepared developers that come as liquids to be diluted with water, or as mixtures of powdered chemicals that only need to be poured into water and dissolved according to the instructions on the label. Start with a developer recommended for the film you have exposed. Film

comes packaged with development recommendations and these should be followed, unless other reliable and reasonable instructions are available. Do this until enough experience has been accumulated that will make experimental changes meaningful and productive. Recommendations from film manufacturers and developer suppliers are based on both scientific knowledge and practical tests. These recommendations are, of course, intended for average conditions, and it makes sense to alter procedures only if experience proves the need. So that you can learn to recognize and meet this need, it is important in the beginning to adhere to one film and one developer. For any one film-developer combination, the results (leaving exposure aside for the moment) depend on three factors: temperature, time, and agitation. Control of these three factors reduces film development to the approximate difficulty level of making French toast for breakfast. It is possible to guarantee a predicted result by developing the film for a known time at a fixed temperature with controlled agitation.

Temperature

The ideal temperature for most standard developers is 68 degrees Fahrenheit or 20 degrees Celsius. It is best to develop at the recommended temperature if possible, but most of the popular developers will perform well over a fairly wide range of temperatures. Most developers will work from 65 degrees Fahrenheit to as high as 80 degrees Fahrenheit if the time factor is altered in an inverse relationship; that is, the lower the temperature, the longer the development time. How much time change is needed to com-

pensate for abnormal temperatures is best determined by consulting a time-temperature chart for the film-developer combination involved; see the printed data sheet packaged with the film. It is inadvisable to develop at a temperature higher than 80 degrees Fahrenheit because the possibility of damage to the emulsion layer becomes great. High temperatures may soften and swell the emulsion gelatin of the film, making it especially susceptible to damage. At temperatures substantially less than 65 degrees Fahrenheit, the developer solution may not function properly.

Accurate measurement of the developing solution temperature is important. The laboratory thermometer must be accurate. It should be checked regularly with a second standard thermometer or with a medical thermometer kept for that purpose. Inaccuracies in darkroom thermometers are common.

Ideally, all solutions in black-and-white processing, including the final rinse wash water, should be kept near the same temperature as the developer. Generally, this means plus or minus five degrees Fahrenheit, although some darkrooms attempt to hold plus or minus two degrees Fahrenheit. Variations in temperatures between solutions, if relatively large, may cause what is called reticulation-a cracking of the emulsion. In the case of small negatives, a very small degree of reticulation seems to show up as a grainy print. However, without a temperature control device on the water tap, maintaining close temperature tolerances is difficult, and you will find that reticulation is not a major danger except when temperature changes are sudden and in excess of 10 degrees Fahrenheit.

Time

The time factor is variable, depending primarily upon the particular film-developer combination involved. Here again, we must refer to recommendations supplied with the film or the developer, and even these are only guides; they are not absolute values. There is no such thing as a correct development time for all workers under all circumstances. The variables are personal preference, equipment, and agitation.

We can, however, begin with recommended times and modify them to meet individual requirements as experience dictates. A rough guide for alterations is as follows: If negatives consistently emerge with too much contrast, cut the development time 20 to 30 percent; if they are consistently too soft (lack-

ing in contrast), boost the development time about 25 percent. The longer the development time, the more silver is formed and the blacker the image. Contrast, or the difference between highlights and shadows, also increases with time, but only up to the point at which the chemical fog level begins to overtake the increase in the highlight density; then flatness, or low contrast, results.

Agitation

Careful and consistent agitation is as important as time and temperature; however, it is often neglected. Fresh developer must be worked into the emulsion layer while the exhausted developer and by-products of the development reaction are swished out and away from the surface of the film. Agitation also keeps the solution uniform so that streaks on the negative caused by exhausted solution flowing across the emulsion do not occur. Agitation should begin the moment the film is placed in the developer and should continue for the first five seconds of the development period. After that, agitation is usually advisable for about five out of every 30 seconds for the remainder of the time.

Some photographers, however, agitate less than this, perhaps only for five seconds out of every minute. Some agitate only twice, once at the beginning and again midway through the development period. Generally, the less agitation, the lower the contrast, but some photographers contend that reduced agitation also gives less graininess in the image. You may want to experiment with this to establish your own preference.

Developers

There are dozens of developers for black-andwhite films. Some are general purpose, for developing a wide range of films, while others are designed for fine grain, better contrast, or faster emulsion speed.

Black-and-white film developers usually contain four basic ingredients: developing agent, accelerator, preservative, and restrainer. The developing agent (normally metol, hydroquinone, or phenidone) converts exposed silver halides in the film to black metallic silver. Developing agents act very slowly by themselves, so an alkali accelerating agent such as

sodium carbonate or borax is added to reduce development time. Developing agents in solution tend to oxidize rapidly so a preservative such as sodium sulfite is added to keep the solution from oxidizing quickly. Unrestrained developing agents may change unexposed silver halides into black metallic silver (known as fogging). Restrainers, such as potassium bromide, are added to prevent fogging.

Developers can be classified into two groups: (1) developers for processing film at the film manufacturer's recommended ISO/ASA speed rating; and (2) developers that increase the film speed rating so slower films may be "pushed" to higher ISO/ASA speeds.

Some standard speed developers are:

Kodak D-76: One of the more popular film developers. D-76 gives full emulsion speed, maximum shadow detail, normal contrast, and good grain characteristics. In addition, D-76 can be used to push-process films up to two f/stops by overdeveloping 50 percent to compensate for the underexposure.

Kodak Microdol-X: Known for the fine grain and high sharpness of image detail it produces. Microdol-X is not as active as D-76 and should not be used to push-process film.

Kodak HC-110: A liquid concentrate that can be diluted to make six different working solutions to process a wide variety of films. It has good grain, long density scale, and good shadow detail.

Kodak T-Max: A normal contrast, general purpose developer for use with Kodak T-Max films. It is also good for push-processing.

Kodak Technidol: Designed especially for Kodak Technical Pan film.

Ilford ID-II Plus: Similar to Kodak D-76 and offers increased shadow and middle tone brilliance. It can be used for push-processing.

Agfa Rodinal: One of the oldest developing formulas in use. It is known for the sharpness it produces on slow- to medium-speed films.

Edwal FG7: A good general purpose developer that gives good resolution at normal or pushed speeds.

Ethol UFG: An ultra-fine grain and general purpose developer that can also be used for pushing film beyond the manufacturer's recommended ASA/ISO ratings.

Some increased-speed developers are:

Acufine: One of the more popular developers for pushing films beyond recommended ASA/ISO ratings. It has uniform fine grain, good resolution, and long tonal range.

Ilford Microphen: Can increase the speed of Ilford's HP5 Plus film three times (from ISO 400 to ISO 1200). It is recommended for high-speed films such as HP5 Plus and Kodak Tri-X.

Perfection Micro-Grain and XR-1: Two developers specifically formulated to process Kodak Technical Pan film for full tone, high resolution negatives. Micro-Grain offers speed ranges from ISO 25 to 100. XR-1 will raise the Exposure Index (E.I.) of Technical Pan to 80 and may be used to raise the E.I. of Kodak Plus-X to ISO 800 and Kodak Tri-X to ISO 1600. (Perfection Micro-Grain and XR-1 are available from Porter's.)

There are many other developers available for special as well as general purpose processing. For example, Kodak's Technical Pan film may be developed in HC-110 for high contrast negatives suitable for document copy work. Or, it may be developed in Kodak Technidol, which will produce negatives with extremely fine grain, extremely high resolution, and normal contrast. The photographer should review the data sheets included in developer and film packaging. Data sheets explain the uses, development times, agitation requirements, and temperature requirements for development.

Water Rinse

- I. Properties: The water rinse is just what it sounds like, a rinse in plain tap water.
- II. Function
 - A. When a negative or print is removed from developing solution, there is a small amount of developer both in the emulsion and on the surface of the film that must be removed or neutralized to stop the action of the developing solution.
 - B. A water rinse bath helps retard the action of the reducing agent and removes the excess developer.

III. Importance

- A. If the developing solution is not removed or neutralized it may cause stains on the negative.
- B. If the negative is not rinsed, the developing solution may contaminate the stop bath and the fixing bath.
- C. To remove the developer, immerse the negative in a rinse bath of water.

Stop Bath

I. Properties

- A. Stop bath is a very weak acid solution.
- B. Acetic acid, or vinegar, is an example of a weak acid.

II. Function

- A. Stop bath instantly neutralizes the action of the developer and stops any further development.
- B. It neutralizes the alkalinity of the developer and prolongs the useful life of the fixing bath.
- C. It reduces the defect known as pinholes.
 - 1. It is advisable to use a weak acid rinse between development and fixation of all thin base films.
 - The strong acid in the fixing bath has a tendency to form carbon dioxide gas bubbles in the emulsion when the film is taken from the developer and placed directly into the fixing bath.
 - These bubbles very often break small round holes in the emulsion that are sometimes mistaken for the pinholes like those caused by dust particles settling on the emulsion prior to camera exposure.

III. Precautions

- A. The acid rinse must be weak.
- B. If the acid rinse or stop bath is too strong, it will cause blister formations on the emulsion.
- IV. Names of recommended stop baths
 - A. Edwal stop bath
 - B. Kodak indicator stop bath

Fixing Bath

When a light-sensitive material is removed from the developing solution, the emulsion contains a considerable amount of silver salts that have not been affected by the reducing agents. These silver salts are still sensitive and, if they are allowed to remain in the emulsion, light will ultimately darken them and obscure the image.

The fixing bath is employed to prevent this discoloration and to assure the permanency of the developed image. Thus, the purpose of the fixing bath is to fix the photosensitive materials by removing all of the unaffected silver salts from the emulsion.

The fixing bath for films contains the following five ingredients:

- 1. fixing agent or fixer
- 2. preservative
- 3. neutralizer or acidifier
- 4. hardening agent
- 5. antisludge agent

A fresh fixing bath will have the distinct odor of acetic acid and will feel grippy (not slick) to the fingers. An exhausted fixing bath may have the following characteristics: milky in appearance, sulfurous odor, and a slippery feeling. The large bubbles that form in an exhausted fixing bath during agitation do not disappear. An exhausted bath may become discolored and produce stains.

Hypo-Clearing Bath

Different parts of the United States have different types of water; some parts have "hard water," others have "soft water." These waters contain different chemicals and minerals that may affect washing times. It is recommended that a hypo-clearing bath be used to remove any scum from the negatives that may be due to hard or soft water. The hypo-clearing bath will decrease washing time and neutralize any fixer remaining on the negatives. Water containing iron should not be used for any photographic procedure because it may affect negative quality and stability.

Washing

Thorough washing is necessary to remove any fixing agent and hypo-clearing bath. Failure to properly wash a negative may result in brownish-yellow stains and may cause the image to fade.

I. Temperature

A. The temperature of water used for washing should be 68 degrees Fahrenheit.

B. Water at temperatures higher than 75 degrees Fahrenheit can cause the emulsion to frill or reticulate.

II. Rate and Time

- A. The rate of washing depends upon the degree of agitation and the amount of fresh water that comes in contact with the emulsion.
- B. The minimum washing time for negatives in running water is 20 minutes, in a system that completely changes the water.

Drying

The final step in processing a negative is to dry the wet film.

I. Removal of surface water

- A. Upon completion of washing, the film should be gently sponged on both surfaces with a wet viscose sponge or wet absorbent cotton. This removes all dirt sludge.
- B. Following the sponging, rinse the film and remove the water from its surface with a sponge, chamois, cotton, or squeegee.
- C. A wetting agent, such as Kodak Photo-Flo, may be added to the final rinse water. Wetting agents are used to break down the surface tension of water. The water will penetrate faster and drain more evenly. It reduces the drying time and helps prevent drying spots.

II. Evaporation

- A. The film should be attached to a line with a film clip holder or clothespin.
- B. It should hang by one corner or one end in a good circulation of dry air, and should be allowed to dry without being disturbed.
- C. It should be dried in a place as free of dust as possible.

III. Rate

- A. The drying rate of films depends upon the humidity, temperature, and amount of air circulation over the film surface.
- B. Shortening the drying time may be done by soaking the film in ethyl alcohol, which evaporates more quickly than water.
- C. Films may be mechanically dried by using a forced flow of air. There are several makes of film dryers on the market, such as Kinder-

mann, which allow film to be dried while still on the developing reel.

Mixing Utensils

Chemicals should be mixed thoroughly; to do this you will need a mixing rod. There are several different types of mixing rods on the market. Eastman Kodak has a thermometer that indicates temperature and can also be used to stir gently. Most camera stores sell mixing rods made of plastic that are inexpensive (Figure 8.1). A Hollaway electric mixer is a handy gadget to have, because it can considerably decrease the amount of time you spend mixing chemicals.

There are good plastic buckets available that can be used to mix chemicals. It is a good idea for police departments to buy plastic two-gallon buckets because they are inexpensive. Another handy plastic container is a plastic diaper pail, approximately two gallons in size, with a lid, that may be useful on occasion. Most camera stores also offer mixing buckets constructed of stainless steel; these, however, in addition to being more expensive, may develop holes and have to be discarded.

A plastic or glass graduate is a necessity for mixing chemicals. The graduate should be one liter, although the 500ml size may be used. It should indicate U.S. ounces as well as metric milliliters. A household measuring cup may also be a handy item for mixing chemicals.

Figure 8.1 Mixing utensils.

Basic Processing Procedures

Most processing of roll film and 35mm film is done in tanks. In tanks, the film is rolled loosely around a spool and is kept in total darkness as long as the tank is open. Spools vary in construction and the photographer must learn how to load his or her film onto the type of spool he or she is using. Film must be loaded into tanks in total darkness, but once the film is inside and the tank is sealed, the processing procedure may continue under white light.

How to Develop Black-and-White Film

For 35mm film:

- 1. Prepare your working place. Have tank and solutions properly placed for immediate action. Measure, with water, the amount of solution your tank will hold and make a notation of the amount. Load your bottles with the proper amount of solutions: (1) developer, (2) stop bath, and (3) fixer (hypo).
- 2. In complete darkness, pry off the flat end of the 35mm cassette with a bottle opener, a Capro film cartridge opener, or a magazine/cassette opener for 35mm film. A screwdriver should not be used.
- 3. Push the spindle on which the film is wound out of the cassette; discard the cassette. With scissors, cut off the leader so that the film is square, and discard the leader. Pull the film off the spindle so that it rolls up in your hand. The end of the film is connected to the spindle with masking tape and must be cut or, preferably, pulled off. Discard the spindle and the tape.
- 4. Loading the film onto the reel should be done very carefully. If you are using a center-loading reel type tank, hold the film by its edges and press slightly so that the film buckles in the center. Secure the end of the film to the reel by catching it in a spring clip. Continue buckling the film with one hand as you rotate the reel with the other, checking with your fingers to make sure the film is going into the grooves correctly. Continue this operation until you have wound all the film onto the reel.

If you are using an edge-loading type reel, start the film onto the open end groove of the reel, using both hands, and twist the two sides of the reel back and forth alternately. The film will automatically wind itself onto the reel. Be sure that this type of reel is perfectly dry before using. Place the reels into the tank.

Figure 8.2 Loading a Nikor center-loading reel.

Once the film is in the tank, you can turn on the white light and the remaining procedures can be done with the lights on.

5. Working at a sink, have three beakers with working solutions of developer, stop bath, and fixer ready. Set your timer for the desired time. Make sure that the developer is close to 68 degrees Fahrenheit by measuring it with your thermometer.

If the tank holds 16 ounces of solution, pour 16 ounces of developer into the tank. This must be done quickly so that there will not be any streaks in the development of the film. Agitate the tank at 30-second intervals for the remainder of the development time. Agitate a tank like the Nikor stainless steel tank by turning it upside down gently. Tanks without a sealed top can be gently agitated by turning left and right in a swirling motion. You can also place a piece of sponge rubber on your sink and hit the tank gently with the sponge. This helps to dislodge air bubbles that may adhere to the film in solution. Be sure to agitate evenly; as stated earlier, many problems can arise if you do not. After completing the prescribed time in the developer, empty the developer back into the bottle (it can be reused).

Shaded areas indicate that the procedure is to be done in complete darkness.

Figure 8.3 Holding the Nikor tank.

- 6. Pour some water into the tank, and agitate every 30 seconds for about two minutes. Pour the water out and pour the stop bath solution in, agitating again every 30 seconds for about two minutes. Pour the stop bath out and rinse again with water for about two minutes.
- 7. Pour in the fixer (hypo), agitating every 30 seconds, for about five to eight minutes. When this step is completed, save the fixer, because this can be reused.
- 8. Wash your film. Take the lid off the tank and let faucet water run into it. Wash the film for 15 to 20 minutes. Then put the film in a wetting agent or photoflo for about two minutes. Pull it out of the wetting agent. Squeegee with a good squeegee brush and hang the film to dry in a dust-free area or use a film dryer.
- 9. When the film is dry, it may be cut into strips for storage or filing until ready for printing. There are several types of storage/filing envelopes or sleeves available for 35mm negatives. Glassines and clear plastic sleeves are the most common. Glassines and plastic "archival" sleeves will protect negatives from moisture, fingerprints, dust, and scratches. Filing information, such as case name or number, can be written directly on the sleeves.

If you know how to develop one type of film, the others are done the same way with minor variations. 120 film is processed with developer, stop bath, and a fixer (hypo). The only difference in procedure is in the size and packaging of the film. 120 film comes on a spool, wrapped with paper. Be careful to develop the film, not the paper. This mistake should not occur if you feel the film, which is smoother. 120 film is

usually a thinner film, and it requires more care when being wound onto the reel. One type of tank, which is good for the beginner, is the adjustable tank, which adjusts the reel to fit the size of the film.

Figure 8.4Print-File transparent plastic negative sleeves for storing negatives. Information may be written on the top of the sheet.

Be sure that both your hands and the reel are absolutely dry, and that your hands are clean. You may want to wear a pair of rubber surgical gloves so that you will not get any fingerprints on the film. Complete the following steps to develop 120 film:

- 1. Be prepared. Have your tanks and solutions ready [developer, stop bath, fixer (hypo)].
- 2. Break the seal on the roll of film and start unrolling the paper leader. When you come to the film, it will not be fastened to the paper leader. Avoid touching the inner part of the film. Continue unrolling the paper backing; the film will roll itself as you unroll the backing.
- 3. Holding it by its edges, let the film unwind. Pick up the reel and feed the film into the outermost groove, emulsion side in, so that the natural curl of the film follows the spiral of the grooves in the reel. Avoid touching the emulsion side of the film; always hold the film by its edges. Gently "walk" the remaining film onto the reel with a back-and-forth motion. Hold the edge of the reel if necessary, so that the film will not slip back.

- 4. Put the loaded reel into tank and put on the top. Now you can turn on the room lights.
- 5. Pour the correct amount of developer into the tank, so that it will cover the entire reel.
- 6. Agitate constantly, but not violently, during the first minute, then for five seconds every 30 seconds until development time has been completed. These steps should all be done with strict adherence to the timer. Development is the critical stage in the making of negatives.
- 7. After complete development, rinse at least three times by filling the tank with fresh water.
- 8. Pour out the water and add the stop bath. Agitate gently for two minutes, then pour out the stop bath. Rinse again with water.
- 9. Pour the fixer into the tank, and agitate for five seconds at 30-second intervals for eight to 10 minutes. If your film is milky when you open the tank, re-immerse it in the fixer for a few more minutes.
- 10. Take the top off of the tank and put a hose into the center of the tank. Let fresh water run into the tank, emptying the tank at least 15 to 20 times, so that fresh water is constantly running into the tank. You may want to use a coffee can with holes punched in the bottom so that the sludge can come out the bottom. You can pour water directly into the coffee can if you do not have a hose. Wash for 10 to 15 minutes with water at approximately 68 degrees Fahrenheit.
- 11. After proper washing, remove the film from the reel or apron and hang it to dry. While hanging, run a squeegee or a brush over the film to remove excess water.
- 12. When dry, cut the film in sizes of three or four images and place them in glassine envelopes or in plastic sleeves for storage.

Tray Procedure

Sheet film, such as 4 x 5, may be processed in a tray. Because tray developing procedures take place in total darkness, the photographer may wish to purchase a 4 x 5 film developing tank if 4 x 5 film will be developed frequently. For occasional 4 x 5 developing, the tray method works well.

 Remove one film from its holder and place it face down (emulsion side down) on a sheet of paper or cardboard. Remove the second film and place face down on the first. Continue until all

- the films to be developed have been placed in a loose pile on the space provided for them. Do not attempt to develop more than four to six films for the first several processes.
- Submerge the films one at a time in a tray of water, which should have the same temperature as the other processing solutions. Pick up the film on top of the pile with the left hand (keep the left hand dry until all films have been placed in the water), drop it emulsion side down into the water, and immerse it quickly with the right hand. Pick up the film immediately, turn it over (emulsion side up) and push it back under the solution. Place the wet film, emulsion side up, at one end of the tray. Immerse the next film in the same manner. Stack it on top of the first film. and continue with this procedure until all the films are stacked in a pile at one end of the tray. The left hand should follow the last film into the tray to assist in the agitation of the films. Wet film may be handled with wet fingers. Extreme care should be taken to keep wet fingers off of dry films. Slight pressure with the balls of the fingers is not harmful to a wet emulsion, unless the emulsion becomes excessively swollen.
- 3. The films should be agitated or shifted constantly to prevent the individual sheets from sticking together. Agitation is accomplished by moving the first film from the bottom of the stack and placing it on top, or by starting a new stack at the other end of the tray. Continue agitating the films from bottom to top until they become completely saturated with water (between one and two minutes is sufficient). After the emulsion is completely saturated, the danger of films sticking together is no longer a problem.

NOTE: Presoaking the films in water prevents them from sticking together in the developer. If sticking occurs in the developer, it causes streaks and uneven development. Presoaking causes a slight increase in the time required for normal development because complete saturation of the emulsion by the developer is delayed, but assures even developer absorption by the emulsion. Compensation for this increase should be made when determining development time. Presoaking is an optional step.

4. Remove the films one at a time from the water rinse and immerse them in the developer. Place the films in the developer, emulsion side up, slide them under the surface of the solution

quickly, and agitate them vigorously to eliminate any possible air bubbles. Start the timer before the first film is placed in the developer. Use the left hand to remove all films from the water, and be careful not to contaminate the water with developer. The left hand should follow the last film transferred from the water into the developer to assist with the agitation.

NOTE: It is important to be able to quickly locate the first film placed in the developer. Align the long dimension of all subsequent films at a right angle to the first film placed in the developer.

The films are immersed emulsion side up in the developer to minimize the possibility of damage, which might occur if the emulsion, already softened by presoaking, is allowed to come in contact with the bottom of the tray. Be careful not to dig or drag the corner or edge of any subsequent films into the emulsion surface of the film below it. Do not allow fingernails to touch the emulsion at any time. Stacking the films by aligning their edges against sides of the tray helps prevent scratches and abrasions.

Agitate the films constantly. Move the film from the bottom of the stack, place it carefully on top, and press it down gently to assure a flow of solution over its surface. Tray development is considered to involve constant agitation, and the development time is approximately 20 percent less than if the same film were being developed with intermittent agitation. If the films are agitated very slowly, or if the number of films being developed is so large that an appreciable interval exists between the handling of each film, the agitation should be considered intermittent, and the developing time should be adjusted to the frequency of agitation.

When the timer rings, remove the films from the developer one at a time, in the same order in which they were placed in the developer, and submerge them in the stop bath. The right hand should go into the stop bath with the first film, and stay there to handle each film as it is transferred from the developer by the left hand. Use the left hand only to transfer the film in order to avoid contamination of the developer and spotting of the film. A few drops of developer do not materially affect the stop bath, or a fixing bath, but a few drops of either of these baths ruins a developing solution.

- After all the films have been shifted several times in the stop bath, they should be transferred individually to the fixing bath or hypo. It is necessary to agitate vigorously in both the stop bath and the hypo, because gases are released in these solutions and there is danger of gas bubbles forming on the film surfaces. If these gas bubbles are allowed to form, they cause dark spots. This is due to the continued action of the developer under the bubbles. Shift the films several times in the fixing bath, as agitated in the developer, and then safelights or white lights may be turned on. Continue shifting the films until they lose the cloudy or creamy appearance and turn dark all over. Note the time required for this change to occur because it is just one-half of the total required fixing time. Shift the films several times during the second one-half of the fixing time. Continuous agitation is not necessary.
- 7. After fixing is complete, transfer the negatives to the wash water where agitation should be continued unless a regular film washing tank or tray is available. The negatives may be put in regular film hangers for washing. If so, the hangers should be loaded under water to avoid scratching the films with the dry hangers. Usually, however, when developing is done by tray, washing also must be done by tray.
- 8. Wash the negatives thoroughly and give them the sponging treatment previously described. Then hang them to dry.

Short pieces of roll film such as 120 may also be tray processed. Agitation is accomplished by attaching clothespins to both ends of the film and "seesawing" the film through the solutions (see Figure 8.5).

Negative Processing Control

Any practicing photographer realizes that the mere composing and exposing of a scene is no assurance of a prize-winning photograph. The quality of the finished print depends to a great extent on the processing of the exposed film. A beautifully exposed negative is useless if it is fogged, scratched, or reticulated during processing.

Frequently, a photographer tends to become careless in his or her work. Also, in many cases the photographer becomes so familiar with the equipment and procedures of film processing that safety precautions, tricks, or hints of procedure, and similar points are completely forgotten.

Figure 8.5
Agitating roll film in a tray.

Predevelopment Water Rinses

The use of a water rinse before immersing the film in the developer is optional, but it has several advantages. A water rinse prevents formation of air bubbles, which usually occur when the dry film surface is immersed in a solution. If the film is immersed directly in the developer, these air bubbles will probably cause trouble. In the water rinse they can be removed by agitation without harmful effect.

The water rinse also softens the emulsion so that when placed in the developer, the developing solution is able to work uniformly on the emulsion. This helps prevent development streaks on the film.

The water rinse also removes the antihalation backing dye, which interferes with the action of some developers. It brings the temperature of the film and the film hangers to the same temperature as the processing solutions. This is of considerable value when attempting to maintain constant temperatures in the processing solutions, and helps to obtain uniform results.

To use the water rinse, the film is immersed in a tank of clear water, which should be at the same temperature as the processing solutions. The film is agitated in the water for a period of approximately two minutes, after which it is removed from the water, drained, and then processed in the usual manner.

The Need for Proper Agitation

If a film is placed in a developer and allowed to develop without any movement, the chemical action soon slows down because the developing power of the solution in contact with the emulsion of the film becomes exhausted. If the film is agitated, fresh solution is continually brought to the film surfaces, and the rate of development remains constant. Agitation also has an important effect on the degree of development. An even more important effect of agitation is that it prevents uneven development. If there is no agitation, the exhausted solution, which is contaminated with bromide from the emulsion, may slowly flow across the film from the dense highlight areas and produce streaks.

For consistent and uniform results, proper agitation of the film in the developing solution must be performed. There are two types of agitation: constant and intermittent. Constant agitation usually applies to tray development of films, in which two to six films are placed in the tray in a pile and agitated constantly by continuously moving the bottom film to the top.

Intermittent agitation applies to tank development of 35mm and roll film in small tanks, and the processing of sheet film in hangers. For 35 mm and roll fim, the proper method is to agitate the film continuously for one minute after it is placed in the developer, and for five seconds each minute thereafter. Sheet film in hangers should be placed in the solution in a group, tapping the hanger bars on the top of the tank several times to dislodge any air bells. Next, allow the hangers to remain undisturbed for one minute. At the end of the minute, lift them clear of the solution, drain one to two seconds from each corner, replace smoothly in the solution, and separate the hangers. Repeat at one-minute intervals.

Cleanliness

Cleanliness in the chemical mixing room and the negative processing darkroom is of paramount importance in all types of photographic work. Mixing vessels, trays, tanks, ledges, and sinks should be cleaned and washed frequently. Chemical dust produces spots on films. The chief sources of chemical dust are leak-

age from containers and accidental spilling of dry or wet chemicals. It is a good idea, whenever possible, to store chemicals in one room, and do the actual negative developing in another room. If it is not possible to do this, photographic work can still be done in the same room in which the chemicals are mixed if care is used to keep the room clean.

The developing darkroom should be kept clean and thoroughly ventilated. Shelves, bottles, walls, and floors spotted with chemicals that have been spilled and allowed to dry are detrimental to good work. There should be aprons, preferably waterproof, to protect clothing. There should be a supply of clean towels available. In general, good photographic work demands that all operations be conducted in a clean, orderly, and systematic manner.

Proper Safelights

Essentially, safelights are filters. The safelight's function is to transmit the maximum amount of light that may properly be used for visibility, without damage to the sensitized material. Because color sensitivity varies with different emulsions, the color-blind emulsions may be developed under a Series No. OO, No. O or No. OA safelight. Orthochromatic emulsions should be processed under a red Series No. II. Panchromatic emulsions should be processed under a Series No. III safelight, with caution. The general practice is to process panchromatic emulsions in total darkness. If the Series No. III is used, the film should not be exposed to it until at least 50 percent of the developing time has elapsed, and then examined only momentarily at a distance of about 36 inches from the safelight.

Any safelight is most efficient when its output of illumination is indirect or by reflection. If the safelight is not constructed on the indirect principle, the light should never be pointed straight at the sensitized material, but should be placed so that the light beam is away from or at an angle to it.

A good guide to correct development, and a safe procedure when developing negatives by safelight inspection, is to examine the silver densities from the back, or base, side of the negative by reflected light. If a highlight or dark area can be seen, but only very little of the halftones, the negative is underdeveloped. When the highlights and halftones appear and the shadows are barely visible, the negative is normally developed. The above directions should be considered approximate. The principle may be used, and

after some practice, negative density for both average and very thin films can be judged with a considerable degree of accuracy.

Useful Life of Solutions

The useful life of developing solutions depends on the type of container in which they are stored, the type of film processed in them, the temperature at which they are stored, and the amount of agitation used while developing.

The action of the silver in the negative on the chemicals in the developing solution results in a depletion of the chemicals' actions. As the developer is used, it becomes less efficient. This loss of efficiency is characterized by a loss of effective emulsion speed and gradation of the photographic image.

The rapidity of developer exhaustion is influenced by the type of negatives being developed. When the average density of the negatives being developed is high, exhaustion is faster. When average density is low, exhaustion occurs more slowly.

The useful life of a developer is shortened by oxidation caused by contact with air. Exhaustion characteristics, therefore, depend greatly on the age and manner in which the solution is used.

A normal negative developer, such as Kodak D-76, can safely develop approximately 96 sheets of 4 x 5 inch film and approximately 20 rolls of 36-exposure 35mm film per gallon of solution, if compensation in developing time is made as the solution is used. On the basis of a gallon of developing solution, the increase in developing time amounts to approximately 10 percent for every 16 sheets of 4 x 5 film or 5 rolls of 35mm film developed.

Replenishment

In large-scale developing, it is not economical to attempt to use a developer to the practical exhaustion point and discard it. Usually, the quality of the image declines long before the exhaustion point of the developer is reached. For this reason a replenisher may be used. The strength of the replenishers is usually adjusted so that they may be added to the tank to replace the developer carried out on the processed films; thus, it is only necessary to maintain the level of the tank at a fixed point to maintain the activity of the developer at its normal level.

Replenishment is also used in small-scale work with low-energy, fine-grain developers that decline markedly in strength even with intermittent use. With this method, as very little developer is lost in processing, the replenisher is added to the stock bottle before the developer being used is poured back in, and any excess developer is discarded. This method keeps the developer at a constant strength from one processing to another.

The exact strength and quantity of replenishment required varies with different formulas. Specifications are found in the data sheets packaged with prepared replenishers. Use the replenisher without dilution and add to the tank to maintain the level of the solution. It is frequently advisable to discard some of the developer before adding the replenisher to maintain proper negative quality. The life of the developer D-76 is at least five times as great with the use of replenisher.

Replenishment of the developers cannot be carried to an extreme, due to the accumulation of silver sludge, dirt, and gelatin in the solution. Working developers should be discarded at the first sign of stain, fog, or instability.

Storing Chemicals and Solutions

All liquids should be stored on bottom shelves. If a container should break, its contents will damage only the bottom shelf and the floor. Chemicals that react violently with each other should be stored separately to prevent explosion or fire. Large bottles and cans should be stored on lower shelves for greater ease in handling. Additionally, all chemicals and solutions should be labeled for safety and accuracy.

Safety Precautions

All chemicals should be regarded as poisons and handled with caution!

- 1. Acids and caustics may cause severe skin burns.
- 2. The fumes from acids and caustics may cause irritation to the throat.
- 3. Acids and caustics may start fires if they come into contact with certain other materials.
- 4. Always add the chemicals to water.
- Never mix an acid with a cyanide; a lethal gas is released.

- Wear protective clothing such as an apron, and make sure there is adequate ventilation in the darkroom.
- 7. Avoid unnecessary contamination of the hands; use tongs, clips, and hangers. If the skin is extremely sensitive, use rubber gloves.

Negative Quality

A normal negative is one that will produce a pleasing print or reproduction of the original scene when printed on normal printing material. If a negative is exposed normally on a film of normal quality and developed for a normal time in a developer of normal strength, it will be a normal negative. The basic characteristics of negative quality will always be in accordance with the conditions under which a negative is made. It is necessary to learn the normal appearance of the following characteristics in order to recognize any departure from the norm.

- 1. General negative density or opacity to light.
- 2. Image highlights or areas of greatest density.
- 3. The shadows or areas of least density.
- 4. Contrast, or differences between highlight density and shadow density.
- 5. Tonal gradation, or range of grays, between the highlights and the shadows.

Density

Density determines how much of the incident light falling upon a negative will pass through the image. If very little silver is present in the negative, the image appears thin (transparent) and it is said to have a low density. If there is a large amount of silver present, very little light will pass through the image, and the negative is said to have a high density, or may be called heavy or dense. A dense negative is more easily printed by contact than by enlarging; and a thin negative is more easily printed by enlarging than by contact.

Highlights

The highlights or dark areas of a negative, for most purposes, should not lack detail. If any detail is missing, the highlights are termed too dense, choked up, or blocked out. The highlights in a negative will lack sufficient detail if they are too dense. The detail will be missing in both the highlights and the shadows if the negatives are thin.

Shadows

The shadows or the more transparent areas of the negative should also contain detail. If these areas are so thin and weak that the outlines of the image are lost, the shadows are termed lacking in detail, or blank. The need for detail in both highlights and shadows for photographs of most subjects cannot be stressed too strongly.

Contrast

Contrast is the difference in density between the highlights and the shadows. If this difference is great, the negative is said to have great contrast. If the negative has less contrast than the scene from which it was made, the negative is described as having reduced scene contrast.

Tonal Gradation

The middle tones are the variations of the range of grays between the highlights and the shadows; that is, the densities that are not highlights or shadows are termed middle tones or halftones for identification. They are also termed the intermediate tones of the image. The brightness between the highlights and the shadows of a subject should be correctly reproduced as density variations by the middle tones of a negative. However, the middle tones vary with the type of film and with subject contrast, and may be omitted in the evaluation of negatives of some subjects.

Kodak Technical Pan 2415

One of the more versatile black-and-white films for police photography is Kodak's Technical Pan 2415. This film produces extremely fine-grain, high-definition negatives for extreme enlargements. Its normal daylight speed is ISO 25, but it can be rated at speeds up to 100 with certain developers. One of the versatile features of this film is its ability to be used as a high-contrast film for copying documents and fingerprints. When Technical Pan is developed in

Kodak Technidol, or other specially formulated developers such as Perfection, it will produce continuous tone, high-resolution negatives. When Technical Pan is normally developed in Kodak HC-110 developer, it will produce high-contrast negatives much like Ortho. However, with a change in developing technique, Technical Pan may be developed in HC-110 for continuous tone negatives. This makes Kodak HC-110 a versatile developer as well. Basically, the major change in developing lies with the inclusion of a bleaching compound. The following steps may be followed for developing Technical Pan in HC-110 for continuous tone, high-resolution negatives:

- Expose film normally, but at a higher ISO speed.
 This development technique tends to increase the speed of Technical Pan to ISO 100, but you should bracket exposures to ensure a good negative.
- 2. Load film into the developing tank. All solutions should be approximately 68 degrees Fahrenheit. Technical Pan normally requires a vigorous agitation in solution, but an alternative is to load the film into a double roll tank, leave the top reel empty, and fill solutions halfway full in the tank. In this way, the tank can be inverted for five seconds, then righted for 10 seconds. Agitate in this manner four times per minute.
- Pre-soak or pre-wet the film for three to four minutes in Kodak Photo-Flo or other wetting agent, diluted to one drop of Photo-Flo for every eight ounces of water.
- 4. Bleach. Obtain Kodak Sepia Toner and mix Part A (bleach) as directed and discard the toner (Part B). Dilute the Part A stock solution of bleach at about 1:1,000 with water to make a working solution. Bleach the film, with agitation, for four to five minutes.
- 5. Develop the film in Kodak HC-110 Dilution B for 12 minutes with agitation.
- 6. Fix, wash, and dry the film as usual.

This procedure will produce negatives of quality equal to those developed in Technidol or Perfection developers. This should save the department in developer costs, because HC-110 can be used to develop a wide variety of black-and-white films. Sepia Toner is very inexpensive and the stock solution of bleach should last for several months.

To use Kodak Technical Pan and HC-110 for high-contrast copy work: rate the film at ISO 100, use Dilution B for HC-110, and develop normally. At 68 degrees Fahrenheit, the developing time should be approximately five minutes.

NEGATIVE DEFECTS AND CORRECTION

Abrasion Marks or Streaks

- *Appearance*: Abrasion marks or streaks appear as fine lines usually resembling pencil scratches and running in the same direction.
- Cause: They are caused by friction on the emulsion of the film, which may be due to improper handling or storage at some time between manufacture and development.
- Remedy: Great care should be taken in the storage of the film. The boxes containing such supplies should be stored on end in order that no pressure is exerted on the surface of the emulsion. Care should be taken not to rub or drag a piece of sensitized material over a rough surface, either before or after development.

Air Bells

- Appearance: When an air bell occurs during development it is seen as a small transparent spot. Sometimes a minute, dark streak leads from the spot. When the negative is rocked in a tray, the streak projects from each side of the transparent spot in the direction the tray is rocked. If the tray is rocked in two directions, the streak forms a cross with the transparent spot in the center. When the air bells occur in tank development, the dark streak usually forms at the lower edge of the transparent spot. When the air bells occur in the fixing bath, they appear as small, round, dark spots.
- Cause: The transparent spots that occur in the developer are caused by bubbles of air on the surface of the emulsion. These prevent the developer from coming into contact with the emulsion. The darkened streaks are the result of excess oxidation of the developer, caused by air in the bubble. The dark spots that occur in the fixing bath are caused by a pocket of air holding the fixing bath away from the emulsion. This allows a slight continuation of development.
- Remedy: Immerse film carefully and thoroughly in the developing and fixing solutions; move film during development and fixation in order to break up and prevent air bells. Water always contains some air and, when there is a rise in temperature, this air is expelled and gathers in the form of small bubbles on the inside of the tank and also adheres to the surfaces of film during the preliminary stages of development. The water needed for development may be allowed to stand for several hours at the temperature required for use before beginning development operations.

Blisters

- *Appearance*: Blisters on negatives resemble the ones that develop on the human skin from slight burns.
- Cause: Blisters are caused by fluid or gas, formed between the emulsion and the film support, when the solution has become too warm and has loosened the gelatin from its support. They are also produced by a developer and fixing bath that are both strongly concentrated. In changing a film from one bath to the other, there may be a formation of gas between the emulsion of the film and its support. Blisters are frequently caused by insufficient rinsing of the film after development and placing it directly into a fixing bath that has a strong acid content. Another common cause of blisters is allowing water from the faucet to flow directly on the emulsion side of the negative.

• *Remedy:* The description of the causes of blisters indicates the manner in which these defects may be avoided.

Blurred Negative

- *Appearance*: Indistinctness or lack of definition in the negative image is typical of a blurred negative.
- Cause: The subject was not properly focused on the film; there was movement of the camera or the subject; or, through lack of proper adjustment, a portion of the film was not flat on the focal plane of the camera when the exposure was made. A blurred effect is sometimes produced by moisture or haze on the lens or by a dirty lens.
- Remedy: Care must be taken in focusing and in holding the camera, keeping the camera in proper adjustment and the lens free of moisture and dirt.

Brown Spots

- *Appearance*: These appear as brown- or sepia-colored spots or small areas on the negatives.
- Cause: Brown spots are produced by an oxidized developer or by fine particles of chemicals settling on the film prior to development. This defect may also occur during washing, resulting from rust or other impurities in the wash water.
- *Remedy:* Avoid an exhausted or oxidized developer. Do not use the developing room for the mixing of chemicals. Filter the water used for washing.

Crystalline Surface

- *Appearance*: The surface of the negative emulsion possesses a crystalline appearance that resembles frost on a window pane.
- Cause: There was insufficient washing after fixing. Hypo remains in the film and crystallizes.
- Remedy: Use sufficient final washing.

Dark Lines

- Appearance: These lines must be divided into two distinct classes: dark lines that run from dark areas to the more transparent areas of the negative, and lines that run from the more transparent areas to the darker areas. In both cases the lines are wider, not as clean-cut, and nearly as parallel as abrasion marks.
- *Cause:* The first class of line is caused by insufficient agitation of the negative in tank development. The cause of the second class of lines is thought to be of an electrolytic origin.
- Remedy: For the first class, more frequent agitation of the negative during development is needed. The remedy for this problem aggravates the defect in the second class. The known remedy is to remove all the reels or film hangers from the tank four or five times during the developing period, holding them in a bunch, and allowing the corner of the bunch of negatives to rest on the edge of the developing tank for 10 to 15 seconds.

Fading Tendency

- Appearance: Fading appears as sepia- or yellow-colored stains or areas in the negative.
- Cause: Incomplete fixation, or insufficient washing, will cause fading. Remnants of the fixing bath left in the emulsion continue their action and in time this defect appears.

Remedy: Always fix and wash the negatives fully and properly.
 Final washing is as important as any other operation in negative processing.

Fingermarks

- *Appearance*: Imprint of fingers shows up on the negative.
- Cause: Caused by impressing wet or greasy fingertips on the emulsion side of the film before or during development and fixation. If the mark is merely an outline of the finger, it was caused by water or grease on the finger; if darker, it was caused by developer; and if transparent or light, it was caused by the fixing bath.
- Remedy: Keep the hands clean and dry when handling film. There is sometimes enough natural oil on the fingertips to cause the grease marks referred to above. Handle film by the edges. When the fingers have become wet with water or solution, wash and dry them before attempting to handle film. Keep hands out of the fixing bath as much as possible, but whenever it becomes necessary to place them in the solution, always wash them thoroughly before handling the film.

Fog (aerial)

- Appearance: Fog shows up as a slight veiling of the negative or parts of the negative exposed to air during development.
- Cause: Fog is caused by exposure to air during development, especially when hydroquinone is used as a developing agent. It occurs most frequently in freshly mixed developers, especially those containing excessive amounts of hydroquinone or alkali.
- Remedy: Add potassium bromide to developer or add used developer to fresh developer.

Fog (dichroic)

- *Appearance*: This type is usually a fog of low density, consisting of finely divided particles of silver. When viewed by transmitted light it is pinkish; when viewed by reflected light, it is reddish-green.
- *Cause*: Using ammonia as an accelerator causes dichroic fog. The presence of hypo or an excessive amount of sulfite in the developer may also be the cause.
- Remedy: The fog can easily be removed by treating the negative in a wet solution of potassium permanganate. The prevention is obvious from the list of causes. Further prevention is assured by using clean trays for developer and fixing baths.

Frilling

- Appearance: In frilling, edges of the gelatin become detached from the base. The detached edge of the emulsion may either break off or fold over. When the latter happens, it is sometimes possible to partially remedy the damage by smoothing out the emulsion when the negative is dried.
- Cause: Frilling is caused by: careless handling; using solutions that are too warm; insufficient hardening of the emulsion due to insufficient fixation; a spent fixing bath, or one containing an insufficient amount of hardener; or excessive washing. Frilling is usually caused by the combination of careless or too-frequent handling of the film and any mistake that renders the emulsion of the film soft.

 Remedy: To remedy, handle film carefully and not too much; have all working solutions sufficiently cold and of proper freshness or strength.

Gas Bells

- *Appearance*: These bells appear as minute pimples or blisters.
- Cause: Bells are developed by transferring a negative from a strongly concentrated developer to a strongly acidic fixing bath without thoroughly rinsing the negative after removing it from the developer and before immersing it in the fixing bath. In warm weather, gas bells may appear in developing and fixing solutions of normal strength if the rinsing between development and fixation has been insufficient.
- *Remedy:* To remedy, use an intermediate hardener rinse bath.

Halation

- Appearance: Halation appears as a dark band or area extending from a negative record of an intensely bright object, suggesting a double image, and appearing in the print as a halo or band of light around the object.
- *Cause:* Halation results from photographing an intensely bright object that is surrounded by dark objects. The intense light penetrates the emulsion and is reflected back by the negative support.
- *Remedy:* To remedy, use antihalation film and avoid pointing the camera at bright sources of light.

Pinholes

- *Appearance*: Minute transparent spots in the negatives.
- *Cause*: These holes are caused by dust on the film before exposure.
- *Remedy:* Proper handling of the film.

Pit Marks

- Appearance: These marks show up as fine holes or pits in the emulsion.
- *Cause:* An excessive amount of alum in the fixing bath, sulfurous precipitation from the fixing bath when negatives are fixed in a tray, and too-rapid drying of the film are causes.
- *Remedy:* The best remedy is proper fixing and drying.

Reticulation

- Appearance: Leather-like graininess or wrinkling of the emulsion.
- Cause: Too great a difference in the temperature of the baths or between final wash water and air in which the negative is dried are causes. Due to the temperature of a solution of wash water, the gelatin of the emulsion may become badly swollen and, upon shrinking, contracts irregularly due to the metallic silver incorporated in the emulsion. Reticulation is also caused by excessive softening of the emulsion followed by a strong hardening bath or a highly alkaline treatment followed by strong acid.
- Remedy: Keep all solutions cool and at uniform temperatures. The reticulation effect may sometimes be removed by placing the negative in a 10 percent solution of formaldehyde for a few minutes and drying rapidly with heat. Use ample ventilation when drying negatives treated in formaldehyde.

Streaks

- *Appearance*: Streaks and patches, in the case of spots, may be dark, white, or transparent.
- Cause: Dark patches or streaks may be due to uneven development caused by not flowing the developer evenly over the film, by not rocking the tray, or by not moving the film in the developer. They also may be due to a splash of developer on film before developing, a dirty tray or tank, using a fixing tray or tank for developing, or light fog. If the edges of the film are clear, the trouble is in the camera; if the edges are fogged, it is due to manipulation in the darkroom. White or transparent patches may be due to an obstruction in the camera, which prevented the light from acting on the film, a "resist" in the form of oil or grease, that prevented the action of the developer, a splash of hypo, or touching the film with hyposoaked fingers before development. The hypo dissolves away some of the emulsion so that, on developing, the portion touched appears lighter than the rest. Drying marks in the form of teardrops or white patches are caused by splashes of water on a dry negative or by leaving spots of water on the film before drying, especially if the film is dried in warm air.
- Remedy: Precautions to be taken to avoid streaks suggest themselves when the cause of the streak is traced.

Black-and-White Processing: Printing and Enlargement

9

The final process in making a photograph is called printing or, more often, enlarging. When the photographer makes a print, he or she is making a negative of a negative, thus creating a positive. Two wrongs, in this application of photography, do make a right.

There are two methods for making a positive image: contact printing and enlarging. In both methods, light passes through the negative and exposes a sheet of photographic paper. The dense, dark areas in the negative allow little light to pass through; less dense areas permit more light to reach the paper.

In contact printing, the negative is in contact with the paper; the resulting print is equal in size to the negative. A small negative yields a small print; larger negatives yield larger prints. Contact printing has its uses in darkroom work, but in order to prepare a presentable photograph, corrections of the negative image are often necessary. These corrections are easily made while enlarging the negative.

An enlargement is the result of projecting a negative image through a lens onto photographic paper. Enlarging allows the photographer to make a print of any size within the limitations of the negative. Enlarging is a very adaptable and versatile process in which considerable control can be exercised. Although the main advantage of enlargement over contact printing is that large-size prints can be made, there are several other important advantages. Among these are the ease with which local printing control can be accomplished, various special effects may be obtained, and the fact that both composition and perspective can be improved.

The quality of the image on prints can be varied by the choice of printing materials, exposure, and processing. The results can actually correct many of the deficiencies that may exist in the negative. Because of this, it is important for the photographer to have a working knowledge of all the materials, equipment, and procedures employed in order to produce the desired results. There are many similarities between the two printing methods, especially in the papers, chemicals, and procedures involved.

Resin-Coated (RC) Papers

Resin-coated (RC) paper is very good for the police officer to use because it does not require any expensive equipment to dry. Resin-coated papers are available with glossy or matte finish. The police generally do not need a photograph to last a lifetime. After they are finished using it in court, there is not much use for it later. If they need another print later, they have the negative, and it is a simple matter to make another print. Resin-coated paper is made of plastic and is not a good conductor of heat. Police pictures are usually put away in files, which is no problem for the resin-coated paper. Another advantage of resin-coated papers is that they require less washing time than fiber-base papers.

Paper Storage

Paper storage is important because stray light fogs paper, giving it an overall gray tinge. Time and heat do the same. Store paper in a light-tight box in a cool, dry place. Open a package of paper only under a darkroom safelight. Most papers last about two years at room temperature, considerably longer if kept in a refrigerator.

Photographic Paper Emulsions

Prints are made by exposing a sensitized photographic paper that records a latent image, much as does film. When the paper is developed, fixed, washed, and dried, the image becomes visible and permanent. Photographic paper is similar to film in many ways; in photographic paper, light-sensitive silver compounds are suspended in gelatin to form an emulsion. This emulsion, unlike that of film, is coated on a white paper base that is opaque. Photographic papers, like films, are manufactured in a variety of types that differ in physical and photographic properties. Knowledge of these properties will help the photographer to select an appropriate paper for a given job.

There are three types of emulsion used on photographic paper: silver chloride, silver chlorobromide, and silver bromide. These emulsions are much slower than those used on film. High sensitivity is not needed; in fact, it is undesirable. Often, it is necessary to manually manipulate the light that exposes the paper; this requires seconds, not parts of a second, of exposure. When the photographer is manually enlarging several prints from the same negative, there is bound to be some degree of variation between exposures. This variation is not good when trying to make several match prints, but for most work the general low speed of paper tolerates small variations by lessening their effects. A fast paper, however, requires a shorter exposure and variations become much more serious.

To state an absolute speed for papers, one that would correspond to the Exposure Index of films, is impractical. Even general figures are impractical and should be regarded as no more than approximate guides, because the speed of paper emulsions tends to vary from batch to batch and with climate, age, and storage conditions. Certain tests, such as the test strip, are therefore an important step of the printing process; exposure values for individual situations must be found by trial and error.

Emulsion Types and Contrast

Silver chloride papers, with their relatively slow emulsions, are used primarily for contact printing. Silver bromide papers are approximately 100 times as sensitive as papers with a pure chloride emulsion. Because of their high speeds, pure bromide papers have limited use in enlarging. Silver chlorobromide papers are coated with an emulsion that combines sil-

ver chloride and silver bromide. Depending upon the mix chosen by the manufacturer, chlorobromide papers vary in sensitivities from slightly faster than chloride papers to slightly slower than bromide. Medium-speed chlorobromide papers are suitable for contact printing or enlarging.

Because it is not always possible to produce negatives that are exactly normal in tonal range and contrast, contact and enlargement papers are made in several grades or degrees of inherent contrast. There are low-contrast papers for printing contrasty negatives, normal-contrast papers for normal negatives, and high-contrast papers for flat negatives. The contrast grades are designated by numbers, and each manufacturer uses a similar series of numbers.

The degree of contrast control that can be exercised during the positive process, exposure, and development, is very small. It is important to use the correct grade of paper as the contrast control. The wide range of contrasts available in development papers is difficult to appreciate without studying actual comparison prints. A series of prints from the same negative, each one on a different grade of paper, shows the effects of increasing contrast with paper grade as the paper is changed from the softest to the hardest grades. The comparison also illustrates how a negative of practically any degree of contrast can be printed to a pleasing contrast when a suitable grade of paper is chosen.

Paper Bases

The paper used as the base for emulsion is the highest grade of paper available. The most stable papers are made from high-grade sulfite wood pulp and processed to be as free as possible from chemical and metallic contamination. Sulfite wood pulp with-stands alkaline and acid solutions, handling while wet, and thorough washing. Furthermore, its chemical purity prevents chemical reactions with the solutions it encounters during processing. The color or tint of paper emulsions is controlled by mixing dyes or other materials with a barium sulfate coating. A few of the emulsion tints available are white, ivory, and cream.

Ansco, Du Pont, Ilford, AGFA, and Eastman Kodak produce several different thicknesses of paper bases, classified according to weight. There are also some special purpose papers that do not fall within these base weight classifications.

Lightweight (LW) paper is furnished in a thin or lightweight stock, and is intended for purposes that frequently involve folding. Part of the weight and stiffness of photographic papers is due to the baryta coating applied to increase the reflecting power of the paper base. This coating is not applied to lightweight paper. By omitting this coating, a much thinner paper is produced, and folding is possible without cracking the emulsion. For the above reasons, photocopying

papers are made on similar thin base stock without the baryta coating.

Single-weight (SW) paper is relatively thin. It is about one-half as thick as double-weight stock, and it is used for all ordinary photographic purposes. Single-weight papers may be processed more rapidly, and they are much less bulky than double-weight. These papers are best suited for print sizes 8 x 10 inches and smaller, and for larger prints that have to

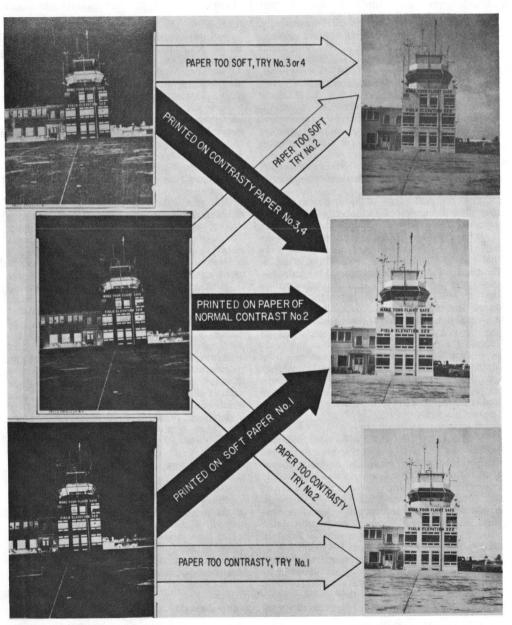

Figure 9.1Matching negative contrast with paper grade.

be mounted. Most of the common glossy and matte surfaced prints are on single-weight papers.

Double-weight (DW) paper is thicker than the average postcard. It is the heaviest stock normally used for photographic paper. However, there are emulsions supplied on a cardboard-weight base for making postcard prints. Double-weight papers are generally used for large prints because they stand up better under rough treatment. Heavy stock is usually employed for all prints that are exposed to much handling. Heavy papers are also recommended for portrait and exhibition photographs. Double-weight papers have several different surface textures.

Water-resistant papers or resin-coated papers have an acetate coating applied to the back of the base to prevent the absorption of processing solutions, which causes the expansion and contraction of the paper. The coating reduces shrinkage and the time required for washing, because solutions do not soak into the base. Special low-shrinkage papers are available in single and double weights.

Papers with water-resistant bases serve two important purposes: first, they are used to produce photographs that require the positive print to have a minimum shrinkage; and second, water-resistant bases are useful where quick production of a few prints is necessary. When the processing schedule for these papers is strictly observed, their bases will not absorb solutions or water and therefore the time required for processing, washing, and drying is reduced.

Papers that have this special base are not actually waterproof. Excessive soaking or washing allows liquids to seep between the paper base and the emulsion, causing separation of the emulsion from the base. This practice should be avoided, especially at temperatures above 68 to 70 degrees Fahrenheit.

Paper Surfaces

The effect of the print depends a great deal on the surface on which it is printed. Papers are made with a wide variety of surfaces, thus permitting the selection of a surface that contributes most to the purpose for which the print is intended. The different surface textures are formed on the paper bases by passing them between large rollers. Papers that have smooth surfaces are passed between smooth-surfaced rollers under extreme pressure, while the rougher surfaces are pressed very lightly. Special surfaces such as silk, linen, and burlap are made by passing the paper stock

between high-pressure embossing rollers that have that particular pattern on their surfaces.

Glossy surfaces give maximum detail and brilliance. They have no pattern. This glossy paper can be highly polished or can have a semiglossy effect. Smooth papers are recommended for small prints that require good definition.

Matte surfaces are softer and less glaring. They are preferred for pictorials, portraits, landscapes, and other views that do not require a great deal of detail and brilliance. The rougher bases have a noticeable texture. The rougher surfaces subdue fine detail in proportion to the degree of roughness.

Surface sheen and texture is usually designated by a letter appearing on the packaging of the paper. Glossy papers are designated by the letter F and matte or semi-matte paper surfaces are designated by the letter N. Other paper surfaces available include highlustre (S) and lustre (A, E, or G).

Graded contrast papers are made with a set amount of contrast. A numerical scale ranging from zero (low contrast) to five (high contrast) indicates the contrast range of the particular paper. Grades two and three are considered average by most photographers. For high-contrast negatives, one would use a low-contrast paper (zero or one) and vice-versa.

Variable contrast papers, such as Kodak Polycontrast RC II and Ilford Multigrade II RC, have normal contrast when printed without filters. Kodak and Ilford both make printing filters that give these papers 11 different contrasts in half-step graduations from zero to five. The main advantage of variable contrast papers is that one pack of paper can fill the needs of several different contrasts, keeping paper inventory at a minimum.

Color negative black-and-white papers, such as Kodak's Panalure II RC, allow black-and-white prints to be made from color negatives.

Paper Sizes, Packaging, and Storage

Photographic paper may be purchased in many sizes; 4×5 , 5×7 , 8×10 , 11×14 , and 16×20 are among the most often used. Prints may be cut to any size and the dimensions of a print are not limited to the dimensions of the paper, as long as the paper used is larger than the intended print.

Paper is usually purchased in quantities of 25 or 100 sheets, and is packaged in double light-tight envelopes or boxes. Photographic paper is perishable and deteriorates with age. It must be protected from

the harmful effects of heat, moisture, and physical damage. Heat and moisture, in particular, hasten deterioration of paper and shorten its usable life.

Do not keep paper under refrigeration once the sealed package has been opened unless storage conditions can be held at 50 to 60 percent relative humidity. Refrigerators containing food or unsealed containers of liquids are generally areas of high relative humidity, and are unsuitable cold storage spaces for paper. Paper removed from cold storage areas must be brought back to room temperature gradually before the packages are opened, in order to prevent condensation.

Store individual packages of paper on end so that the weight of the contents is on the edges of the paper.

The Printing Room

The printing room should contain the following materials and equipment, arranged so that the work flow moves easily from one stage to another: contact printer or frame, enlarger, enlarging easel, safelight, trays for the solutions, a graduate for measuring and mixing solutions, a thermometer, at least two pairs of print tongs, and a timer or wall clock with a sweep-second hand.

Proof Sheets

Making a proof sheet is an optional step in the process of making a finished print. With experience, it becomes possible to select and judge a negative without seeing a positive beforehand. At first, though, the photographer will find that a proof sheet is a convenient and effective way to inspect a negative before going to the enlarger.

A proof sheet is a contact print of one or (usually) more negatives. An entire roll of 35mm or 120 film can be printed on one sheet of 8 x 10 paper, thus giving the photographer a permanent record of all the photographs on one roll of film.

To make a proof sheet:

 Prepare the darkroom. You will need a contact printer or printing frame and a source of white light, such as an enlarger, if a printing frame is used. Solutions (developer, acid stop bath, and fixer) should be ready in trays large enough to accommodate the size of paper that you will be using (8 x 10). Kodak Dektol is used for the routine development of prints. It should be diluted one part developer to two parts water. A safelight with series No. O or No. OA filter should be turned on.

Figure 9.2A floor model contact printer (above) and a table model (below).

- 2. Select a paper. You may want to write on the proof sheet; a matte paper will accept pencils or pens, but glossy paper can be written on with a white or black grease pencil or wax crayon. A slow chloride paper, such as AZO, is more than adequate for contact printing. Regular enlarging paper may also be used for contact printing by decreasing the exposure time. The paper should be slightly larger than the area of the negatives to be proofed. If the negatives have not been cut, cut them to fit in the printer or printing frame but no more than is necessary. Place the negatives against the glass in the frame or printer with the emulsion side away from the glass, arranging them so that they will all be covered by the paper.
- Turn off the general illumination. Allow a few moments for your eyes to adjust to the illumination of the safelight. You are now ready to begin printing.
- 4. Remove a sheet of paper from its package and close the package before proceeding. If the paper is considerably larger than the area to be printed, you may wish to cut the paper to size.
- 5. Place the paper over the negatives in the printer or frame with the emulsion side of the paper in absolute and uniform contact with the emulsion side of the negatives (you can determine the emulsion side of the paper by touch). Press the back of the printing frame in place or close the door of the printer.

Figure 9.335mm contact proof sheet made by placing strips of negatives in contact with printing paper and exposing to light.

6. Expose the paper for 15 seconds. This may be done by turning on the contact printer and switching off after exposure time or, if the printer is connected to a timer, setting the timer for 15 seconds. For printing with a frame, the general illumination of the darkroom may be turned on or the light from the enlarger may be used. If regular speed enlarging paper is used, the exposure time will be shorter.

Because papers vary in speed, an exposure of more or less than 15 seconds may be necessary. Whether more or less time is needed will be determined after the print has been developed.

- 7. When the exposure has been made, remove the paper from the printer or frame.
- Immerse the paper, emulsion side down, in the developer. This is best accomplished by sliding the paper rapidly into the solution and pushing it under the surface. After the initial immersion, grasp one edge of the sheet lightly, lift it out of the solution, and turn it over. Replace the print, emulsion side up, on the surface of the solution, push it under the surface again, and leave it under during the remaining development time. The average developing time for contact prints is 60 seconds, but actual time ranges from 45 to 120 seconds. The print must be immersed rapidly and evenly to prevent the formation of air bubbles on its emulsion surface and to ensure that all of the emulsion is wet with developer in the shortest possible time. Agitation for the remaining developing time should be constant. Stir the solution gently, either by rocking the tray or by stirring slowly with print tongs.

The image will form slowly over the surface of the paper. Because the proof sheet is made without any masking of the negatives, large areas of the paper will have been exposed completely. These areas will become black and will be visible before the images of the negatives. Although it is difficult at first to judge tones under the illumination of only a safelight, these completely exposed areas may be used to help judge whether

Shaded areas indicate that the procedure is to be done in complete darkness.

the print is fully developed. When positive images from the negatives are fully visible and the unmasked areas are completely black, the print is fully developed. Overdevelopment will cause darkening of the lighter areas of the print and therefore should be avoided.

- 9. Lift the print out of the developer, drain it briefly, and place it in stop bath (such as Kodak Indicator Stop Bath) for a minimum of 10 seconds or in a plain water rinse for 30 seconds. Lift the print and drain it briefly.
- 10. Place the print, emulsion side up, in the fixing bath (such as Kodak Rapid Fixer or Kodak Ektaflo) and, while moving it around for a few seconds, examine it for any faults that might cause the print to be discarded. When the inspection is completed, place the print emulsion side down in the fixing bath for 10 to 20 minutes. Some papers may have a tendency to float in the fixing bath. If they float, they should be pushed into the solution and watched carefully. Be sure, also, that no air bubbles have formed on the underside of an immersed print. If a print is exposed to the air during fixing it may become stained.
- 11. When the print has been thoroughly fixed, the residual chemicals that remain in the emulsion and base of the photographic paper must be washed away. Wash the print in a quantity of circulating fresh water (60 to 75 degrees Fahrenheit) for 30 to 45 minutes (one hour for doubleweight paper). A certain amount of soaking is necessary in the wash; the water must not circulate too quickly. Prints must not be washed too long; extended washing will cause softening of emulsion, dimensional changes in the paper, and loss of water resistance in RC papers.
- 12. When washing is complete, the print may be dried by any convenient means. Because proof sheets will not be used for presentation, it is not necessary to take elaborate steps in drying. Place the print in a blotter roll or hang up to dry.

When the proof sheet is dry, the results of camera work may be inspected and negatives selected for enlarging. Negative quality should be noted. You may decide from the evidence on the proof sheet that corrections are needed for a given negative. The needed corrections can be remembered, jotted on a tablet of paper, or written on the proof sheet itself.

Enlarging differs from contact printing only in the way the exposure is made, the type of paper that is used, and the amount of developing time; all other processes are similar.

The Enlarger

The enlarger is essentially a camera in reverse; it projects rather than receives an image. Every enlarger has: (1) a lamp house with a light source and a reflector; (2) a piece of diffusing glass or set of lenses for obtaining even illumination over the negative; (3) a negative carrier or holder; (4) a lens with diaphragm; and (5) a device for focusing the lens. All of these components are suspended above a printing easel in such a way that the planes of the negative, the lens, and the easel are parallel and the distances between these planes may be changed. The distance between these planes determines image size; the greater the distance between the planes, the larger the image. Changes in negative-to-lens distance are smaller but proportionate to changes in lens-to-easel distance.

The light source for an enlarger is usually an opal incandescent lamp that is located within a lamp house that is constructed with a reflector that directs light down toward the negative carrier. The light-tight lamp house is ventilated to prevent excessive heat from the light source, which can ruin both negative and lens.

Enlargers are divided into two classes, according to the methods by which they distribute light over the negative. The first class, the diffusion enlarger, has a set of diffusing glasses (usually ground or optical glass) between the lamp and the negative carrier that spread the light evenly over the entire surface of the negative. The lamp housing is generally parabolic and the interior is a matte surface, either white or silver. The light source is an inside-frosted or opal incandescent lamp (some diffusion-type enlargers use fluorescent tubes) that is placed so that the light is reflected diffusely down toward the negative and lens. This gives soft, even illumination and tends to minimize negative flaws (such as abrasion marks and surface scratches) and grain.

The diffusion enlarger does not render an image as contrasty as a condenser enlarger (the second class of enlarger) because the diffused light is softer than the direct rays formed by the condensing lenses. The difference in contrast between the diffusion enlarger and the condenser type is approximately one grade; i.e., prints made on No. 3 contrast paper with a diffusion enlarger are approximately the same as prints from the same negative on No. 2 contrast paper with a condenser enlarger. Exposure times for the diffusion enlarger are generally longer than those for the condenser-type enlargers, due to the considerable loss of light caused by diffusion. The diffusion enlarger is especially suitable for portraiture and other printing involving negatives that are 4 x 5 inches and larger.

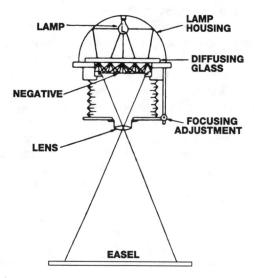

Figure 9.4
Diffusion enlarger.

The condenser enlarger has a set of condensing lenses to project light rays from an opal incandescent lamp through the negative. The condenser is a pair of plano-convex condensing lenses mounted as a unit with their convex surfaces opposed. Common types of condenser enlargers are Simmons Brothers Omega D-2 and Simmons Brothers Model Automega D-3. The enlarger is supplied with an f/4.5, two-inch focal length lens; an f/4.5, three-inch focal length lens; an f/4.5, five-inch focal length lens; and the necessary condenser lenses set for use with each lens. The condenser lenses are mounted in the housing with a separator between them. The condenser housing has three bayonet-type notches that permit assembly to the lamp house, where it is secured with knurled locking screws. The condenser enlarger produces a sharp, brilliant image with more contrast than can be obtained with the same negative in a diffusion enlarger. Where accurate reproduction of detail is important, as it is in police work, the condenser enlarger is preferable to the diffusion enlarger.

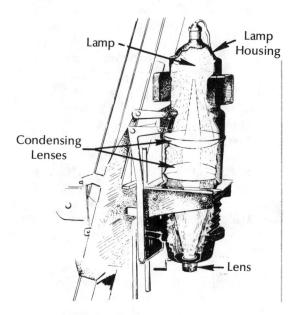

Figure 9.5 Condenser enlarger.

Negative Carriers

The negative carrier may be of two types: dustless or glass sandwich. The dustless carrier consists of two shaped metal sheets, or plates, with die cut openings in the center. The negative is placed between these plates and is positioned in the opening. When the hinged plates are closed, they clamp the edges of the negative and hold it in position. If properly designed, they function excellently for negatives that are 4 x 5 inches and smaller. The glass sandwich carrier is simply two sheets of glass in a wood or metal frame, between which the negative is placed. They are necessary for negatives that are larger than 4 x 5 inches, because large negatives have a tendency to sag in the center of dustless carriers. One disadvantage of glass sandwich carriers is that any dust or lint on them becomes part of the projected image.

Enlarging Lenses

Lenses for projection printing should be anastigmats (corrected for equal brightness and definition) with an angle of field large enough to cover the negative. No shutter is necessary because exposures are usually measured in seconds. On enlargers using tungsten lamps, the exposure is made by turning the light on and off. With fluorescent tubes, however, the light should remain on and the exposure made by uncovering the lens. Almost all enlargers are equipped with a mounted ruby red safety filter that can be swung under the lens for the purpose of viewing the negative and positioning the paper without exposure.

Figure 9.6

Dustless negative carriers.

The lens board on most enlargers is threaded to accept lenses with the Leica 39mm screw mount. An enlarging lens that is equal in focal length to the camera's normal lens should be used. For instance, because 50mm is the size of a normal lens in 35mm photography, a 50mm enlarging lens would be used with 35mm negatives. While longer focal length enlarging lenses can be used, it would require a greater distance between the lamp house and print paper. Most lenses that are shorter than the normal focal length will not cover the entire negative image frame. Some manufacturers produce a 40mm wideangle enlarging lens that will cover 35mm negatives. The advantage of a wide-angle lens is that it permits the lamp house to be closer to the paper, enabling a shorter exposure time. Also, larger prints than a normal lens would permit may be made on the enlarger's baseboard.

Enlarging Easels

There are many types of easels, each serving the same basic purpose: to hold the printing paper in a flat plane. Most easels have adjustable masking strips to regulate the borders of the prints. Those strips with masks usually have an adjustable guide for placing the paper evenly under the masking strips. The adjustable guides and masks will enclose almost any size rectangle from three to 24 inches. Other easels provide for borderless prints and some are for specific paper sizes (such as Speed-Ezel).

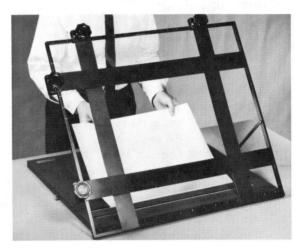

Figure 9.7 Easel.

Enlarging Sizes

In order to obtain changes in the scale of the projected image, it is necessary to alter the conjugate distances in a manner similar to that in cameras. To enlarge a negative to a greater degree, the lens-toeasel distance must be increased and the negative-tolens distance must be decreased. Some enlargers, called autofocus, are designed and constructed so that when the lens-to-easel distance is altered, the negative-to-lens distance is automatically adjusted and the image is always in focus. These printers operate conveniently for enlargements, but an auxiliary optical system must be attached in order to reduce the image size. An attachment of this type is not as convenient to use as the manual-variable-focus model, which can produce both reduced and enlarged images with the same optical system. The majority of projection printing requires enlargement, and for this work autofocus models are satisfactory.

Although it is theoretically possible to make reductions to any desired size, the bellows on most enlargers cannot be extended far enough to make reduced projections smaller than 1:1. Smaller reduction may be accomplished by substituting a lens of shorter focal length, but a more satisfactory method is to use a reducing attachment. This attachment, available as auxiliary equipment on some enlargers, consists of a section of bellows to which a short focal length lens is attached. The regular enlarger lens is not used in conjunction with a reducing attachment.

Making an Enlargement

To make an enlargement:

- 1. Select a negative. If you have made a proof sheet, you can check negative quality from the print, note any flaws, and choose the negative by the number that appears in the frame of the film.
- 2. Insert the negative in the appropriate size negative carrier so the emulsion side is down. With some negative carriers it will be necessary to cut the negatives apart; avoid this if possible. Remove all dust particles from the negative. Dust particles will also be enlarged on the print and should be carefully removed with air or a brush. Canned air (such as Omit and Dust-Off) is an excellent means of removing dust from negatives, as are dusting brushes made for this purpose. Place the negative carrier in the enlarger so that the emulsion side faces the lens; the shiny side should face the lamp house. Be sure that the carrier is seated properly.
- 3. Set the paper corner guide and the masking device on the easel to form the border width and length for the print size needed. Place a sheet of white paper in the printing position to aid in composing and focusing the image.
- 4. Make sure that the darkroom is fully prepared. Solutions should be in their trays, the desired paper should be ready beside the easel, and the safelight (O or OA) should be turned on. Turn off the general illumination.
- 5. Turn on the enlarger lamp, open the lens to its maximum aperture, and move the easel around until the desired portion of the image is on the masked opening. Raise or lower the enlarger unit on the standard so that the image is enlarged or reduced according to the desired result. When enlarging small negatives, check to see that the grain will not yield an unpleasant image. With each change of lens-to-easel distance it will be necessary to refocus.

The image will be easier to compose if it is right side up from your point of view. If it is upside down, either rotate the negative carrier in its housing or remove it and reposition the negative.

Most printing papers are rectangular; determine whether to use a vertical or horizontal format. In many cases, the manner in which the scene is composed on the negative will determine this; however, when the choice of vertical

or horizontal images seems to be arbitrary, use a horizontal format.

You are not bound to the overall composition of the negative image. Prints of excellent composition have been produced from badly composed negatives. Try to correct any errors of image composition in the negative. Straighten the horizon; if possible, try to prevent it from cutting the image on the print into two equal sections. If the horizon is not visible, make sure that vertical objects are parallel to the side of the masked area on the easel. If the space around the subject is not pleasing, try to remedy the error. Distortion of perspective can be reduced by making corrections when arranging the easel and when focusing.

- 6. Close the aperture of the lens to f/8 for a dense negative or f/11 for a thin negative, and be sure that the lens is clean. Switch off the enlarger lamp.
- Select a sheet of paper for printing, cut it lengthwise into several strips of about one inch wide, and place one of these strips, emulsion side up, in the easel. This is the test strip. Cover fourfifths of the strip with a sheet of opaque paper and expose the uncovered fifth for 16 seconds. Uncover another fifth and expose for one-half of the time (in this case, eight seconds) and continue in this manner until the entire strip is exposed. This produces a series of exposures in which each succeeding section of the strip has received one-half of the exposure of the preceding section (in this case 32, 16, eight, four, and two seconds). Develop and rinse the strip as for a contact print. Fix the strip for two minutes, rinse it, and inspect it under general illumination.

At least one of the exposures on the strip should be close to normal in appearance. Ten to 20 seconds of exposure will yield an adequate print; more than 20 seconds may cause damage to the negative from the heat of the lamp; and less than ten seconds will allow less margin of time for printing errors. Thus, if the best exposure on the test strip is two to eight seconds, the lens aperture on the enlarger should be stopped down. If 32 seconds of exposure yielded a good print, the aperture should be stopped up.

Shaded areas indicate that the procedure is to be done in complete darkness.

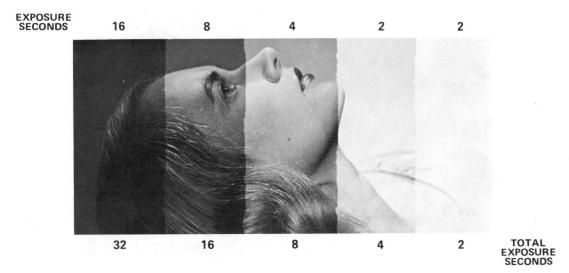

Figure 9.8 Test strip.

8. Turn off the general illumination, select a sheet of paper of desired size and contrast grade, and expose it for 12 to 15 seconds. Develop, rinse, and fix as before.

Inspect the print under general illumination. The exposure should be approximately correct. Check for contrast; a good print usually has a white somewhere in a highlight area, a black in the deepest shadow, and a well-modulated scale of grays between these two tonal extremes. If in doubt about proper contrast, make additional prints on two other grades of paper or select two other variable contrast filters. Inspect the group and decide which print has the most pleasing or realistic contrast. This method also reveals how easy it is for a mediocre print to appear acceptable until a direct comparison is made with the same image correctly exposed on the proper contrast paper grade. If there are distracting areas that are too light or too dark they can be darkened or lightened by additional exposure control in successive prints. It may be necessary to lighten or darken some parts of most prints to produce a correctly exposed image.

9. Areas that appear too dark in the print may be lightened by creating a shadow, thus exposing

the too-dark areas for less time than the overall exposure. This is called dodging and is accomplished by placing an opaque card or dodging tool between the lens and the dark area of the image for short durations during the exposure.

Accurate dodging can be done with the hands or variously shaped cards cut from black paper. A favorite tool for dodging small areas is a card of suitable size and shape pinned to one end of a stiff wire handle (see Figure 9.9).

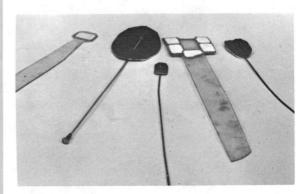

Figure 9.9 Dodging tools.

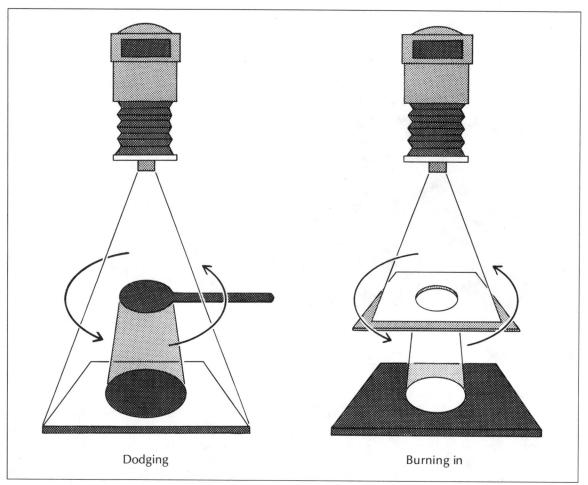

Figure 9.10 Dodging and burning-in.

The size of the area being dodged is controlled by the size of the card or dodging tool and its distance from the image. Dodging should be done for only part of the exposure. The card or tool must be moved up and down slowly and constantly to prevent a sharp line between the dodged area and other parts of the image.

10. Areas that appear too light in the print may be darkened by exposing them for a longer period than the overall exposure. Called burning-in, this process is basically the opposite of dodging. After the normal overall printing exposure has been made, switch off the enlarger. Place between the lens and the easel a piece of opaque paper with a hole in the center that is smaller than, but approximately the same shape as, the area to be burned-in, switch the enlarger back on and expose the too-light area through the hole for

an additional five seconds, moving the paper slowly but constantly to prevent a sharp outline of the hole.

When dodging and burning-in, time the amounts of exposure for every step of the printing procedure. This is the only manner in which the procedure can be controlled well enough to be duplicated for additional prints, or changes made in any portion of the image as needed. For example, the entire print may be exposed for five seconds, while the spot to be lightened is dodged, and the image exposed for another five seconds. Then the portion needing additional exposure may be burned-in through the hole in a card for five seconds. This requires a total exposure time of 15 seconds, which is as long as should be tolerated without changing the lens stop.

Experience shows that exposures of much less than 10 seconds are not easily made because of the time constraints in performing the dodging or burning-in process. If the test proves correct, duplicates can be made with no trouble. If not, any desired changes can be made in the corrective steps taken, and good results may be expected after a few test prints.

- 11. After all the printing data have been obtained, make all prints needed from the negative.
- 12. Develop each final print as for a contact print. The developing range for enlarging papers is generally from 60 to 180 seconds, with 90 seconds recommended. For some papers, when using Dektol, a dilution of 1:3 is sometimes advisable. The directions packaged with the paper may indicate a 1:3 dilution; if so, a development time of one to three minutes is necessary. One-half ounce (15 cc) of potassium bromide, diluted 10 percent, may be added for each 32 ounces of stock Dektol to increase the restraining action of a diluted developer. This may cause a greenish tone, but the tone will improve with a longer developing time.
- 13. Rinse as you would with a contact print. Kodak Indicator Stop Bath is an excellent acid stop for papers. If the excess developer is drained off prints before they are placed in the stop bath, 32 ounces of Indicator Stop Bath will properly stop development and give adequate protection for approximately 25 8 x 10-inch prints. When Indicator Stop Bath is exhausted, it becomes purple and must be discarded.
- 14. Fix as for contact prints with Kodak Fixer or Kodak Ektaflo Fixer. A gallon of either fixes 100 or more 8 x 10 prints when an acid stop bath is used. Fix for no longer than 20 minutes and no shorter than 10 minutes. Overfixation tends to cause thinning or bleaching of the photographic image; inadequate fixing leaves prints vulnerable to stains and early deterioration.

The use of twin fixing baths is recommended for thorough fixation when many prints are processed daily. Begin the twin fixing cycle with two fresh trays of fixer. After fixing 200 prints, discard the first bath and prepare a new bath, rotating the baths. Only three to five minutes of fixing is required in each of the twin baths, thus reducing total fixing time from 10 to 20 minutes to six to 10 minutes. Also, a 30 to 60 percent savings in chemicals is possible because overall

- contamination of the bath is retarded by splitting the bath. At the end of five cycles, discard all used fixing solution, wash both trays, and begin a new cycle.
- 15. Wash the print. Although many prints should be washed in mechanical washers, small groups may be washed by successive changes of water in a tray. Two trays with deep sides should be used. The size of the trays is determined by the size and number of prints to be washed. Both trays should be filled almost completely with water and all the prints placed emulsion side up in one tray. The prints should be separated, agitated, and then transferred one at a time to the other tray. The first tray is then emptied, refilled with fresh water, and the procedure repeated until the wash is completed. When using the tray method, the prints should be agitated two or three times in each change of water and the water changed at five-minute intervals until about six changes have been given for single-weight prints. Washing double-weight prints in a tray involves the use of a tray siphon. The siphon directs fresh water into the top of the tray and at the same time it removes the chemically contaminated water from the bottom of the tray. The tray-siphon method of washing prints is quite effective.
- 16. When washing is complete, the prints may be dried by any convenient means, depending upon the type of paper and the means available for drying. Resin-coated prints may be dried by hanging them up. Fiber based papers may be dried on blotter rolls, on ferrotype plates, and on mechanical apron or conveyor belt dryers. When using glossy surface fiber-based papers, the photographs do not have a pleasing appearance unless they are dried in close contact with a highly polished surface. The equipment for drying glossy prints is usually a metal plate or drum with a chromium-plated surface.

Ferrotyping is a process for producing high gloss on prints. Only prints made on fiber-based paper having a glossy surface can be ferrotyped. The principle of ferrotyping involves placing the emulsion side of a wet print (under pressure) into close contact with a smooth surface; the gelatin of the emulsions is compressed in drying, causing an increase in the gloss of the print. A ferrotype plate, sometimes called a ferrotype tin, is made of metal and has a highly polished, chromium-plated surface. These plates should be han-

dled with extreme care in order to avoid scratches. Whenever ferrotype plates appear dirty, they should be washed in warm water with a mild soap. If the plates are neglected, the dried prints stick firmly, and prolonged soaking in water is necessary to remove them.

Lay the prints emulsion side down on the polished surface. Lay a blotter over the print and use a print roller to secure complete contact between the print and the plate. The emulsion must be in perfect contact to produce a uniform glossy surface. The plate is then placed on a small drying unit, one plate on each side, the canvas pulled over the plates and secured by notches, and dried by electrical heat.

- 17. As soon as the prints are dried, examine them closely for defects or other unsatisfactory qualities. If any of the prints need to be trimmed in order to even the borders or remove frayed edges, it should be done at this time. Prints are trimmed to obtain clean-cut edges and to make the width of borders uniform and reduce prints to the desired size. Small prints are trimmed to make the width of the white margins equal on all sides. The margins may vary in width from 1/8 to 1/4 of an inch, according to the size of the print. For example, a 1/2-inch border of an 8 x 10-inch print may be trimmed to 1/4 of an inch. In the case of large prints, the borders may be uneven for an artistic effect.
- 18. The appearance of the photographic print is enhanced when the print is properly spaced on a mount of proper color, texture, and size. Mounting makes the photograph more permanent only when the material used for the mount is chemically pure and the adhesive is one that will not, over time, stain the mount or print. Cardboard is the material most often used for mounts. The mount should be large enough to balance and to appear as amply supporting the photograph. If the mount is too small, the impression of skimpiness is given; if too large, it belittles the print and makes it appear lost.

While no definite rules can be given, a 5 x 7-inch print may be placed on an 8 x 10-inch mount. This gives a one-inch border. An 8 x 10 print should not have less than a one-inch border, and usually appears better if mounted with a two-inch border.

The adhesive generally used for mounting is dry mounting tissue, which is in the form of sheets. It is manufactured to have a heat-sensitive adhesive. When heat is applied to the tissue, it becomes tacky and, when cooled, it is an excellent and permanent adhesive. A sheet of tissue is tacked to the back of the print by means of a standard laundry iron. The print and tissue are then trimmed and tacked in position on the mount and placed in a heated dry mounting press, or a standard laundry iron may be used. The iron should be set at the "silk" temperature and then two fingerprint cards, or a card the equivalent thickness of cardboard, should be placed over the photograph, before ironing.

The dampness of mounts or prints is frequently responsible for failures in dry mounting. If the prints are damp, the gelatin melts from the heat of the press and the emulsion becomes sticky. If the mount is damp, the heat of the press causes it to warp.

Enlarging Accessories

Timer

Print exposure time can be controlled by watching a clock or counting seconds, but most photographers find an enlarging timer is much easier to use. A timer automatically shuts off the enlarger lamp at the end of the time interval. Enlarging timers are available in a wide range of prices with a variety of features.

Voltage Stabilizer

Fluctuations in the electrical supply can cause the enlarger bulb to change brightness and color. This will affect the density of black-and-white prints and the color balance on color prints. A voltage stabilizer will keep the electrical current steady and improve print consistency.

Copy Stand

Some enlargers are easily converted into copy stands simply by removing the lamp house. The lamp house carriage to which a camera is attached is easy to adjust for height. Purchasing an enlarger that can be converted into a copy stand will be an asset as well as economical.

Dichroic Filter Lamp House

Designed for color printing, dichroic filter enlargers have built-in color printing filters that can also be used for variable contrast black-and-white printing papers. If the enlarger will be used for both black-andwhite and color printing, the purchase of a dichroic filter enlarger may well be worth the extra expense.

Stabilization Processors

Stabilization processors have been in use for many years by newspapers and commercial photographers who need the ability to produce black-and-white prints in a matter of minutes. Stabilization processors, such as Kodak's Ektamatic Processor, offer the advantage of rapid print processing without the need for running water, temperature control, chemical mixing, or developing trays.

The stabilization process involves the use of a photographic print paper that has developer incorporated into the emulsion. Two chemicals are used: the process-activator, which develops the print; and stabilizer, which neutralizes the activator. The print is exposed normally, then is fed into the processor. The print passes through a set of rollers and comes in contact with the activator, which develops the print. The print then passes through a second set of rollers that removes excess activator and places the print in contact with the stabilizer solution. As the print exits the processor, it passes through a third set of rollers that removes excess stabilizer and leaves the print dampdry. The entire process takes about 15 seconds for an 8 x 10-inch print. Prints may be fed into the processor, one after another, permitting a large number of prints to be processed within a short period of time. Stabilization chemicals are used at normal room temperature (65 to 85 degrees Fahrenheit).

Stabilization papers, such as Kodak Ektamatic, are considered stabilized but not permanent. If kept under conditions of low humidity and away from strong lights, prints will last up to one year before fading. Stabilized prints may be made permanent by fixing, washing, and drying in the same manner as conventional fiber-based papers. Most stabilization papers are available with an "F" surface that air dries to a lustre finish or, if fixed and washed, may be ferrotyped for a glossy finish.

Although Kodak does not recommend processing normal print papers in a stabilization processor, some normal RC papers may be used with a few chemical changes in the process. Kodak Polycontrast Rapid II RC, Kodak Kodabrome II RC and Panalure II RC papers all have developer-incorporated emulsions similar to stabilization papers. When using these RC II papers in a stabilization processor, fill both the activator and stabilizer trays in the processor with activator and use a separate developing tray of non-hardening fixer. Stabilizer is not used. When the print emerges from the processor it is fixed in the tray in the usual manner. Follow the fixing with at least a four-minute wash. RC II prints processed in this way will be permanent and will air dry to a glossy finish if the paper has an "F" surface.

Several companies manufacture black-and-white stabilization processors and they can generally be obtained for less than \$300. Some processors, such as the Durst Printo modular print processor, can be used for both black-and-white processing and color print processing.

PRINTING DEFECTS AND CORRECTION

Abrasions or Streaks

- *Appearance:* The surface of the paper is abraded or scratched and results in fine dark lines on the surface of the print, especially with glossy paper.
- *Cause*: The cause is friction or rubbing on the surface of the paper.
- Remedy: Store paper boxes on their edges. Handle with care. Make sure that processing solutions are free from grit or undissolved particles.

Bad Definition in Parts of Print

- *Appearance*: Parts of the print that are poorly defined have been blurred, as if out of focus, although the negative is sharp.
- Cause: Buckling of the paper in the contact printer.
- Remedy: Check the contact pad in the printer.

Bad Definition over Entire Print

- *Appearance:* The appearance is a completely blurred print from a sharp negative.
- Cause: This may be due in contact prints to printing from the wrong side of the negative. This defect in enlargements may be due to careless focusing or, more often, to vibration of the enlarger.
- *Remedy:* Emulsion side of paper must always be in contact with the emulsion side of the negative in contact printing. The enlarger should be firmly braced to prevent vibration.

Contrasty Prints

- Appearance: A contrasty print is one in which all the tones are too harsh. The print has excessive contrast, and is lacking in detail in the highlights and shadows.
- Cause: This is caused by using the improper grade of printing paper for the range of densities in the negative.
- *Remedy:* The remedy is to use a softer or less contrasty paper.

Flat Prints

- Appearance: A flat print is one in which all the tones are as one. The print lacks contrast, the dark areas are too light and the light areas are too dark.
- Cause: This is caused by using the improper grade of printing paper for the range of densities in the negative.
- *Remedy:* The remedy is to use a higher or greater contrast paper.

Muddy Prints

- Appearance: A muddy print is one in which the tones have a gray, mottled appearance.
- *Cause:* Prints that are overexposed and underdeveloped usually have this muddy appearance. The developer does not have a chance to complete its work, so the result is a flat, muddy print.
- *Remedy:* To remedy this appearance, expose the paper for the proper time and develop it for the proper time, according to the time recommended for the paper and developer being used.

Round Dark Spots

- Cause: Round dark spots on prints are due to air bells in the fixing bath. Development has proceeded in those spots after being stopped on other parts of the print.
- *Remedy:* Use shortstop between development and fixing. Agitate thoroughly in fixing bath.

Round Discolored Spots

- *Cause:* These spots are caused by air bells in washing that prevent the removal of hypo from these spots.
- *Remedy:* Thorough washing with constant agitation.

Round White Spots

- Cause: Round white spots are due to air bells that prevented the developer from acting on parts of the paper.
- *Remedy:* Proper agitation while in the developer will prevent this.

Small, Well-Defined Brown Spots

- Cause: Brown spots are caused by particles of rust from the washwater, iron washing tanks or ferrotype tins, or particles of chemical dust.
- *Remedy:* A water filter should be used where much rust is present. Rusty tanks should be discarded or painted.

Stained Prints

- *Appearance*: Stains that appear on a print usually have a brownish, smudged look.
- Cause: Stains that are due to printing or developing are usually caused by old, brown, or oxidized developer. Holding a print out of the developer too long for inspection causes a yellowish or brownish stain, due to the oxidation of the developer clinging to the print while it is exposed to the air.
- Remedy: The remedies for this are to use fresh developer at all times, do not hold the print up for inspection in the air any longer than absolutely necessary, and be sure that the print is quickly and completely immersed in the developer at all times.

Color Processing

10

Much of police photography is done in black-and-white. Yet the evidence being photographed is not black-and-white; most evidence is composed of one or more colors and sometimes color can be very important to a case. With black-and-white photographs, the officer often must swear to the original color of the evidence; the court must then believe that if the officer says the pool of liquid in the photograph was red, it was red. If the court is presented with a photograph in color, however, it can judge for itself whether the officer's red is truly red, whether a blue car is truly blue, whether the leaves on a tree are truly green.

Judgments of color, according to psychologists, are subjective judgments. One person's sea green may be another person's powder blue and both will be correct. The progressive police department, then, must use color photography in the cause of accuracy and truth.

At one time, color photography was prohibitively expensive and, in some jurisdictions, thought to be in bad taste. Many departments are now turning to color because: (1) the process of making a color photograph has become relatively easy; (2) many color processing materials are becoming readily available to the modern police photographer; and (3) color is vital for accurate information.

Color photography has come of age as far as courtroom acceptability is concerned, despite repeated claims by defense attorneys over the years that color photographs are inflammatory. They failed in their attempts to disallow the obvious: color pictures convey to the judge and jury a more accurate representation of the facts as they were.

What to Photograph in Color

If it is possible, traffic accidents should be photographed in color. They have more evidential value than black-and-white photographs because they portray the scene more realistically by conveying the true atmosphere at the accident scene. Generally, they are useful for showing whether traffic lights were operating, the color of the vehicles involved, personal injury, and whether the headlights and signal lights were working properly. Also, trees, shrubbery, skid marks, and tire marks show up much better in color.

Photographing a homicide scene in color is a must, regardless of how graphic the scene may be. Color photography is much more effective to show bloodstains and wound markings.

In the case of burglaries, all articles that have been stolen and recovered can be more easily identified if they are photographed in color.

Fires that may be subject to arson investigation that are photographed in color show the color of the flames and smoke much better than black-and-white photographs. Progression of the fire photographed in color may be extremely helpful later on in the investigation. Debris and possible evidence of a planned fire are more realistic if photographed in color.

"Mug" shots photographed in color have the decided advantage over black-and-white because they show the color of the skin, eyes, and hair. Unusual identifying marks also photograph better in color. The ultimate achievement for police would be for every department to have color identification photos.

With today's methods and materials, the lack of color in a photograph may even be considered a distortion of the original scene.

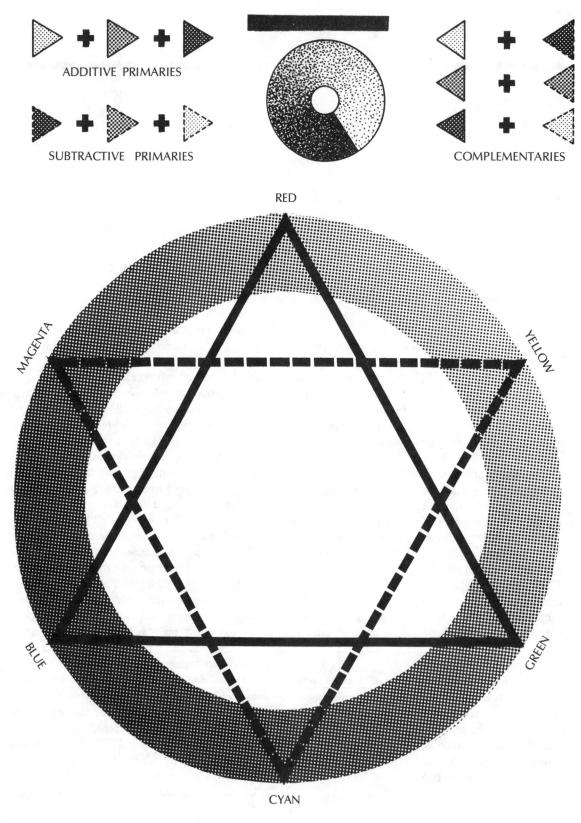

Figure 10.1 Color circle.

Photographic Color-Light Relationships

The color circle shown in Figure 10.1 represents the visible light spectrum. The six individual colors (red, green, blue, cyan, magenta, and yellow) are single points on this continuously changing band of light. However, they have special photographic relationships to each other. The additive primary colors (red, green, and blue) added together in approximately equal amounts, as with three projectors aimed at a screen, will produce white light. The subtractive primary colors (cyan, magenta, and yellow) added together in approximately equal amounts, as with three filters on a single light source, will absorb all color and produce black or shades of gray; this is neutral density.

Each primary color on the light-spectrum circle is composed of equal amounts of its adjacent colors, and is complementary to the color directly across the center of the circle from it. Complementary colors added together also form neutral densities.

The interaction of the additive primary colors, in photographic light sources, and the subtractive primary colors, in the filters, form the controls necessary in color photography. All present-day color films and color printing papers employ three layers of emulsion, each sensitive to one of the photographic additive primary colors: red, green, or blue.

Color Film (Negative) Processing—C-41

Color film is processed in much the same way as black-and-white film (see Chapter 8). The same equipment is used and the only additional requirement is color developing chemistry.

Most color film processing chemicals are supplied in liquid form. Unlike black-and-white film chemistry, in which developer and fixer are obtained separately, color chemicals are sold in kits. Color film developing kits are available in a variety of sizes, depending upon the volume of film developing performed. One advantage to the liquid forms in the kits is that smaller quantities may be mixed for processing only a few rolls at a time. While the "shelf life" of liquid concentrates vary with the manufacturer, they all generally have long shelf lives in the concentrated (unmixed) form. Each kit includes a data sheet that describes how to mix smaller quantities for developing two or three rolls at a time.

When processing color film, correct developer temperature is extremely important. A good quality thermometer capable of one-half degree Fahrenheit accuracy is recommended. Most color film processing is performed with chemistry at 100 degrees Fahrenheit. When mixing the liquid concentrates, it is a good idea to use water at a slightly higher temperature so the solutions will be ready for processing in a short amount of time. While temperature control valves on faucets are not a necessity for color processing, they can be tremendous time-savers. A deep tray filled with water at a temperature slightly higher than the processing temperature can be used to hold the containers of chemistry and bring them to the proper temperature.

Most color negative films use the C-41 process. Kodacolor, Fujicolor, Agfacolor, and others use the same type of C-41 processing. The color film cassette will indicate whether the film uses C-41 processing. Ilford's XP2-400 and Kodak's T400C black-and-white films also use C-41 processing. There are many C-41 processing kits available (Beseler, Unicolor, Kodak, etc.) that use a three-step process that takes about 15 minutes to develop a roll of color film. Some kits are variable temperature, which allows changes in development temperature that may range from 75 to 100 degrees Fahrenheit. The following processing sequence is typical of a C-41 process kit:

- 1. In complete darkness, open the film cassette and place the color film onto the developing reel and place it into the developing tank (see Chapter 8).
- 2. With the developing tank cap on, turn on the room lights and check to make sure processing temperatures of the solutions are correct.
- Pour water (100 degrees Fahrenheit) into the developing tank and agitate for 30 seconds as a pre-wash step.
- 4. Pour out the pre-wash water and pour in developer (100 degrees Fahrenheit plus or minus one-half degree). Agitate the film by means of four inversions in the first 10 seconds. Develop for 3¼ minutes, agitating by means of four inversions in the first 10 seconds of every full minute. Allow a 10-second drainage time between developer and bleach/fix.
- 5. Bleach/Fix (sometimes referred to as Blix) for 10 minutes (100 degrees Fahrenheit). Agitate the film continuously for the first 30 seconds, and then for the first 15 seconds of each full minute (using the four inversion method).

- Wash the film in running water at 100 degrees
 Fahrenheit for at least three minutes. A final
 rinse in Kodak Photo-Flo or Ilford Ilfotol is rec ommended to prevent drying marks.
- 7. Dry the film the same as you would black-and-white film (see Chapter 8). Note: Ilford's XP2-400 and Kodak's T400C black-and-white films have a milky appearance when wet. This disappears with drying and is not associated with insufficient fixing.

C-41 processing kits may vary in development times, agitation requirements and temperatures. The photographer should carefully read all instructions packaged with the kit before using.

Color Slide Processing—E-6

Color slide film is processed in much the same way as color negative film; most use the E-6 process (with the exception of Kodak Kodachrome, which must be processed in a Kodak laboratory). Most E-6 kits are three-step processes that take about 25 minutes to develop a roll of slides. The following sequence is typical of an E-6 process:

- In total darkness, open the film cassette and load the developing reel and tank with the film. Replace the light-tight cap on the tank and turn on room lights.
- 2. Pour in pre-wash water (100 degrees Fahrenheit) and agitate for 30 seconds.
- Empty the pre-wash water and pour in First Developer at 100 degrees Fahrenheit for about seven minutes, agitating with the four inversion method described in color negative processing.
- 4. Empty the First Developer and pour in Color Developer at 100 degrees Fahrenheit for about seven minutes with the same agitation.
- Pour out Color Developer and pour in Blix (bleach/fix) at 100 degrees Fahrenheit for 10 minutes. Note: some kits recommend a 30-second water rinse cycle between developers and Blix.
- 6. Wash and dry in the usual manner.
- 7. After the slides have dried, cut each slide between frames and mount in cardboard or plastic mountings. Cardboard mounts may require heat to seal the slide in the mount. Plastic mounts usually snap together and are easier to use than heat-sealing cardboard mounts.

Push-Pull Film and Slide Processing

If color film is exposed at a different ISO/ASA rating than that which is recommended by the film manufacturer, the processing can be altered to match the exposure. This is referred to as push-pull processing. On occasion, a photographer will change film in his or her camera and forget to change the camera's ISO/ASA setting, which in turn affects the camera's metering system. At other times, the photographer may intentionally wish to expose film at a higher ISO/ASA rating, particularly with low-light situations. C-41 and E-6 kits explain the changes in development times for push-pull processing. Generally, with C-41 processing, decrease development time by 25 percent for every f/stop overexposed (pull processing) and increase development time by 25 percent for every f/stop underexposed (push processing). For example, if you exposed color film rated at ISO/ASA 100 on a meter setting of ISO/ASA 400, you have underexposed the film by about two f/stops. You should increase development time by 50 percent. Underexposing or overexposing beyond two f/stops may not give satisfactory results even with changes in development time.

When using push-pull processing with color slide film (E-6 process), the increase or decrease in development time is used only with the First Developer. The Color Developer times remain the same.

Color Printing

Color prints can be made with any enlarger that can produce black-and-white prints if it has a space between the condensers and the light bulb to place filters. Most enlarging lenses are color-corrected and are good for color work. If the enlarger only accepts filters that are placed between the lens and the easel, several possibilities remain open. Conversion kits are available that allow acetate filters to be placed between the light source and the negative.

Enlargers that use cold light heads should be avoided because they emit light of several possible colors. Light from a tungsten enlarger head is yellow, not white. The glass in the enlarger's optical system may add its own color to the light. Light must be corrected because almost every box of color-printing paper varies in relative overall speed and in relative color sensitivity.

If a photographer lacks a dichroic enlarger with built-in filter wheels, he or she will have to place filters between the light and the lens. The CP2B or UV filter is always used and is inserted to remove ultraviolet radiation. A heat-absorbing glass is used to decrease infrared radiation. The CP2B filter may be placed anywhere in a filter pack. The heat-absorbing glass is best placed between the light source and the rest of the pack. In addition, the photographer will need the following basic minimum selection of subtractive filters: one each CP05M, CP05Y, CP05C-2; CP10M, CP10Y, CP10C-2; CP20M, CP20C-2; and two each CP40M, CP40Y, CP40C-2. Additional magenta (M), yellow (Y), and cyan (C-2) filters may be acquired if needed, as may CP red (R) filters, but the basic filters listed should suffice for most printing. The values 05 through 40 in the filter designation refer to color densities; an 05Y is a very pale yellow; a 40Y is much deeper. Be sure to use a Wratten series 10 safelight for certain steps.

Figure 10.2
Various color enlargers. The Omega D11 with color print filter drawers (top left); the Chromega dichroic enlarger (bottom left); Saunders LPL Super Dichroic enlarger (top right); and, for smaller budgets, Beseler's Dichro 67 enlarger (bottom right).

Determination of Filter Combinations

The determination of filter combinations can also be simplified by thinking of all filters in terms of the subtractive colors in Table 10.1. Note that a particular red, green, or blue filter may not give exactly the same color adjustment as the corresponding subtractive pane.

The following procedure is based on the relationships in Table 10.1.

 Convert the filters to their equivalents in the subtractive colors—cyan, magenta, and yellow—if not already done. For example:

$$20R = 20M + 20Y$$

2. Add the values for each color. For example:

$$20M + 10M = 30M$$

3. If the resulting filter combination contains all three subtractive colors, take out the neutral density by removing an equal amount of each. For example:

10C + 20M + 20Y = 10M + 10Y + 0.10 neutral density, which can be removed

Printing Process—Negatives—EP-2

The major difference between color and blackand-white printing is that, with color, consistency of process is paramount. The photographer must watch the voltage to the enlarger, water temperature, and cleanliness; additionally, he or she must perform each step of the process exactly the same way, every time.

Color prints are made by using Kodak Ektacolor or any EP-2 compatible photographic paper. Chemistry is also obtained in kits for EP-2 processing. Many of these kits can be used at a variety of tem-

peratures ranging from 70 to 110 degrees Fahrenheit. The higher the chemistry temperature, the shorter the development time. Most color papers are resin-coated (RC), so washing and drying times are minimal.

Color prints may be processed in trays (in total darkness) or in process drums. A process drum is a tubular device, resembling a 4-inch PVC pipe, that allows processing in normal room light (see Figure 10.3). Once the exposed paper has been loaded into the drum and the end caps are attached, room lights may be turned on. The drum has lightproof baffles for pouring in and draining chemicals. Agitation is accomplished by hand rolling the drum or by using an optional motor base that turns the drum automatically. Drum processing is preferable to tray processing. Processing drums are inexpensive, easy to use, and require only small amounts of processing solutions.

Color prints may also be processed in a color print processor. Color print processors are very similar to black-and-white print stabilization processors. Color processors range in price, starting at approximately \$1,500. While the cost of such a unit may be prohibitive for a small department, they are a timesaving item if color printing is performed on a regular basis. The Durst Printo modular print processor can print black-and-white as well as color enlargements up to 11 x 14 inches in size, uses standard black-and-white and EP-2 chemistry and paper, and costs approximately \$1,800.

Begin color printing by dusting the negative and placing it in the enlarger's negative carrier with the emulsion side down. Turn off the room lights, turn on the enlarger and focus, and compose the image in the same manner as in black-and-white printing. Turn off the enlarger and place the color printing filter pack in the filter drawer, or set the enlarger's dichroic filter wheels to the recommended setting. Instruction sheets packaged with color papers suggest a starting filter pack for many types of films. Use the suggest-

A RED FILTER (absorbs blue and green)	is equivalent to a YELLOW FILTER (absorbs blue)	plus a MAGENTA FILTER. (absorbs green)
A GREEN FILTER (absorbs blue and red)	is equivalent to a YELLOW FILTER (absorbs blue)	plus a CYAN FILTER. (absorbs red)
A BLUE FILTER (absorbs green and red)	is equivalent to a MAGENTA FILTER (absorbs green)	plus a CYAN FILTER. (absorbs red)

Table 10.1 Filter combinations.

ed filter pack as a starting point. In addition, some papers have a color bias recommendation. If the bias is stated as -.10M, begin filtration with a .10M filter in place to correct the paper back to "normal" color balance.

Make an exposure test strip by setting the enlarger lens at f/8, placing a sheet of paper in the easel, and covering all but about ½ of the paper with a piece of opaque cardboard. Expose the paper for five seconds, then move the cardboard to uncover another ½ of the area. Expose for five seconds and repeat the process until the entire sheet of paper has been exposed. The test print will consist of six sections, each varying in exposure from five seconds to 30 seconds.

Load the exposed test print into the processing drum with the emulsion side facing the inside of the drum. Attach the end caps to the drum and turn on the room lights. Begin processing the paper according to the instructions provided with the chemistry kit you are using. Processing color prints in most drums requires only two ounces of each solution per 8 x 10-inch print. After processing, the print should be allowed to dry before judging the density and color

balance of the exposed sections. Most color papers have a color cast when wet and must be dry before evaluating the color.

After the test print has dried, examine each section to determine the best exposure and whether changes in the filter pack will be required. Judge density first. What looks like a problem with filtration may simply be a print that is too dark or too light. If the print is from a color negative, the section exposed for five seconds will be the lightest and the section exposed for 30 seconds will be the darkest (if the print was made from a slide, the reverse will be true). The chart in Table 10.2 will help in determining the necessary changes in the filter pack.

If the amount of color cast is slight, change the filter pack by .05 in the appropriate filter color(s). If the print has a pronounced color cast, change it by .10, and by .20 if the color cast is strong. When possible, always remove filters instead of adding them. Color papers are usually manufactured in such a way as to require some combination of yellow and magenta filtration to produce the necessary color balance. Only occasionally will you find the need for cyan

Print Color Cast:	Remove this Filter:	Or, Add this Filter:
Yellow	Cyan and Magenta	Yellow
Magenta	Cyan and Yellow	Magenta
Cyan	Yellow and Magenta	Cyan
Blue	Yellow	Cyan and Magenta
Green	Magenta	Cyan and Yellow
Red	Cyan	Yellow and Magenta

Table 10.2 Prints made from negatives.

correction. All three of the complementary colors are never used at the same time because the combination of all three is black.

Filters of the same color combine their densities when added together. A .10Y + .20Y + .30Y equals .60Y. However, when two different filters are added together, such as .20M + .20Y, their densities do not add up to .40R but remain .20R.

Filter pack changes also affect exposure times. A change in the amount of filtration and a change in the number of filters through which light must pass will affect the print density. Instructions included with the color printing kit should include a table for compensating for filtration changes in exposure. The usual recommended starting filter pack for daylight balanced film is .50M + .50Y. However, for emulsions like Kodacolor films, a .30M + .30Y is a more suitable beginning point. As for exposure times, making a test strip is the best approach.

Evaluating Color Prints

Once a test print has been exposed, processed, and dried, you can determine what changes are necessary in exposure and color balance. While the trial-and-error method works fine, it is also time-consuming and expensive in terms of paper costs. It may take a beginner in color printing an entire box of color paper to produce one acceptable print. With experience, the photographer will learn how to use the trial-and-error method with more consistent results. There

are other methods that may save time and materials for the beginner. Kodak makes a color print viewing kit for this purpose. Other methods are ring-around charts, subtractive calculators, and color analyzers.

A "ring-around" chart is a series of test prints that vary in known quantities from a standard print containing an acceptable color balance. Ring-around charts are manufactured by several companies in differing configurations. The photographer simply compares his or her test print with the ring-around to determine which print on the ring-around most closely matches the test print. The correct filtration amounts that should be added or subtracted from the test print filter pack are designated by the ring-around.

A subtractive calculator is an inexpensive device that helps to determine correct exposure and filtration. The calculator is placed under the enlarger and, with the negative to be printed in the negative carrier, the calculator is exposed in the same manner as would a piece of photographic paper. The calculator then indicates the recommended exposure time and f/stop. The only filter required for the test exposure is the UV filter. The print is "calculated" on the basis of average tones in the negative. If the negative contains the right combination of average tones, the print will be satisfactorily exposed and will contain the desired color balance.

Electronic color analyzers store information that has been programmed into it on the basis of an average "perfect" negative and the print made from it. It will provide exposure and filtration data for other negatives by comparing them with the stored information. The key to using a color analyzer is producing the "perfect" print through normal trial-and-error processes. Once programmed, the color analyzer can save time and paper for future prints. Color analyzers are available in a wide range of sophistication and prices, beginning at approximately \$300.

Figure 10.4
The Soligor/Melico SM20 is a color analyzer available for amateur or professional use.

Printing Color Slides

Color prints can be made from color slides by using a color reversal paper and reversal chemistry. The slide must first be removed from the cardboard or plastic mounting and used as if it were a negative. Color printing from slides uses the same basic filtering and exposure process as color printing from negatives.

The most important difference between slide printing and negative printing is in the response to changes in exposure and filtration. If the print is too dark, increase the exposure. Do not decrease the exposure as you would in negative printing. Remember, the process works the same as film works in your camera. Therefore, your test print strip will be opposite, as are prints made from negatives; darker areas will have been exposed for less time and lighter areas will have been exposed for longer times. Adjust color balance by making the same changes in the filter pack that you want in the print. Adding a color to the filter pack will increase that color in the print; decreasing a color in the pack will decrease it in the print. The suggested beginning filter pack for prints made from slides may have yellow and cyan filtration. This is different from the beginning filter pack for prints made from negatives, which has yellow and magenta filtration. Follow the instruction sheet packaged with the paper you are using. The chart in Table 10.3 will help to determine corrections needed in filtration.

Prints made from slides will have a characteristic black border (because the paper is a reversal paper). You can make white borders by masking. Expose the print first; then place the mask over the image area. Remove the slide from the negative carrier and expose the border areas of the paper for one to two times the printing exposure time. You should use a mask slightly smaller than the image area to avoid dark edges where the border meets the picture.

Color Printing Experience

Color printing involves a great deal of work and time for the beginner. However, with a little experience, the photographer will be able to make color prints as easily as black-and-white prints. Consistency of procedures, temperatures, and materials cannot

Print Is:	Do This:	Or, Do This:
Too Dark	Increase Exposure	-
Too Light	Decrease Exposure	_
Too Magenta	Add Y + C	Subtract M
Too Red	Add C	Subtract Y + M
Too Yellow	Subtract Y	Add C + M
Too Green	Subtract Y + C	Add M
Too Cyan	Subtract C	Add Y + M
Too Blue	Add Y	Subtract C + M

Table 10.3 Prints made from slides.

be overemphasized. If there is any change in time, temperature, agitation, negative emulsion, or paper emulsion, you will have to start over with another calibration print. It is recommended that the police photographer select one type of color print film and one type of color print paper and stick with them. Kodacolor is different than Fujicolor, and Fujicolor is different than Agfacolor. The same is true for color print papers. When correct filtration is determined for a particular color film and paper, start with that filtration for other prints made from that type of film. Usually, when correct filtration is determined for one photograph on a 36-exposure roll, the remaining 35 negatives will have the same or nearly the same filtration. The same will hold true for normally exposed photographs on other rolls of the same type of film.

Color negatives may be contact printed like black-and-white negatives. The only difference is to use the normal UV filter and the filter pack you determined from printing negatives of the same type of film in the past. In this way, each proof can be evaluated to determine which ones will need filtration correction and which ones will not need filtration correction.

Storage of color papers, films, and chemicals is the same as for black-and-white. The photographer should read and follow the storage requirements included in the color chemistry kit, as some may have different requirements than others.

Color Print Process—RA-4

Kodak recently introduced an alternative to the EP-2 color print system, designated RA-4 (RA meaning Rapid Access). The RA-4 system offers much shorter processing time and technical improvements both in paper and chemistry. Color printing papers designed for EP-2 processing are not compatible with RA-4 processing and vice versa.

The main improvement over EP-2 processing is speed. RA-4 developing takes 45 seconds. The overall process takes about five minutes. RA-4 chemistry and papers are designed for automatic print processors but can be used with hand-operated or motorized-drum processors the same as for EP-2. The 45-second recommended development time is not feasible with EP-2 drum processors. However, if such a processor is to be used, decrease the development temperature to 90 degrees Fahrenheit and develop for one minute.

Hand-operated or motorized-drum processors and automatic roller processors that were previously used with EP-2 chemistry must be thoroughly washed before using RA-4 chemistry. The EP-2 residue will contaminate RA-4 chemistry and render it useless.

Kodak has plans to phase out production of their EP-2 system. However, other manufacturers will no doubt continue production of EP-2 products due to demand. In addition, other companies, such as Fuji,

Contrast	CP Filters with Kodak	CP Filters with Other
Grade	Polyconstrast Papers	Multi-Contrast Paper
0	80Y	80-100Y
1/2	55Y	55-70Y
1	30Y	30-70Y
1 1/2	15Y	15-30Y
2	0	0
21/2	25M	25-30M
3	40M	40-45M
31/2	65M	50-65M
4	100M	60-100M
41/2	150M	100-150M
5	200M	170-200M
	Y = Yellow	M = Magenta

 Table 10.4

 Color print filters for black-and-white papers.

have begun distribution of their versions of RA-4 papers and chemistry. Kodak's RA-4 system is not patented, so there will be plenty of RA-4 compatible products available.

Using Color Print Filters for Black-and-White Printing

Dichroic head enlargers and color printing (CP) filters may also be used for black-and-white printing with Kodak Polycontrast, Ilford Multigrade, or other multi-contrast papers. The conversion table in Table 10.4 may be used for this purpose.

Black-and-White Prints from Color

Black-and-white prints can be made from color negatives and slides fairly easily. Making a black-and-white print from a color slide requires a black-and-white negative. This involves taking a picture of the slide onto black-and-white film. There are slide duplicators available that can be attached to the cam-

era body. In the absence of a slide duplicator, the image may be projected onto a projection screen or a wall with a white matte finish for the copy photograph. The image may also be projected directly onto a piece of film, using the enlarger (in total darkness). Kodak Technical Pan should be used for such copies because the quality will suffer somewhat during the duplication process.

Black-and-white prints made from color negatives can be made with any black-and-white paper. However, the resulting print will have an overall gray cast and may not be satisfactory. Kodak produces a black-and-white print paper, Panalure, intended for making black-and-white prints from color negatives. Panalure is an F-surfaced, single-contrast panchromatic paper sensitive to all colors of light and produces prints with a full tonal range. Enlarging and processing procedures are the same as those for other black-and-white single-contrast papers. Because Panalure is sensitive to all colors of light, you must use a Kodak No. 13 safelight (or total darkness) rather than the usual Kodak OC safelight that is used with normal papers.

Video and Digital Photography

Video Cameras

Technological advances in electronics have made video cameras and "camcorders" relatively inexpensive, portable, and highly sophisticated. Once the initial investment is made with the camera, videotapes are very inexpensive. Videotape has several advantages over still photographs: (1) video gives immediate results without the need for processing; (2) videotapes can be used more than once simply by recording over previous recordings; (3) visual movement allows the viewer to accurately perceive the scene as it is shown; and (4) sound may be included.

The terms video camera and video camcorder are used somewhat interchangeably. The primary difference between a video camera and a video camcorder is that a camcorder has a built-in recorder/playback unit, while a video camera is attached to a separate recorder/playback unit. Video camcorders have replaced the two-piece unit in popularity because they weigh less and are easier to handle.

The uses of videotape in police work are numerous. Videotapes are excellent means for documenting traffic stops (with the camera mounted inside the police vehicle), interviews, interrogations, and lineups. Videotapes are useful to show a judge how "drunk" a drunk driver was at the scene of an accident or at the police station during booking. Videotapes can also demonstrate probable cause for stopping suspicious vehicles in suspected drug trafficking operations. Also, videotapes can help demonstrate that a charge of police brutality on a traffic stop or arrest is founded or unfounded. Camcorders can be used at crime scenes, at autopsies, and for surveil-

lance and "sting" operations. The portability and low cost of camcorders make them suitable for a wide range of police work.

Camcorder Formats

Camcorders are generally available in six basic formats: VHS (full size), VHS-C (full size compact), Compact Super VHS (with higher resolution than standard VHS), 8mm, Hi-Resolution 8mm, and Digital. Standard VHS and 8mm camcorders use tapes with resolutions of 250 lines (same as broadcast television). 8mm camcorders, as well as the higher resolution VHS camcorders, can also use tapes with resolutions of 400 lines. Digital camcorders have the highest resolution—500 lines.

VHS camcorders use the same type of cassette as VHS tabletop home video cassette recorder/players. Compatibility with VHS camcorders is usually not a problem because the tape cassette can be removed from the camcorder and played on any other VHS tabletop player or, the camcorder itself can be connected to a television monitor and the tape played directly from the camcorder. Most VHS camcorders have standard play (SP) speed (the tape travels 33.35mm per second), allowing two hours of recording on a T-120 VHS tape. Compact VHS (VHS-C) camcorders use the same size tape as standard VHS but within a smaller cassette to allow for smaller cameras. In order to play a VHS-C tape in a regular VHS player, an adapter must be used. The VHS-C only has a 30-minute recording time.

The 8mm format was developed to allow camcorders to be more compact than VHS camcorders. An 8mm tape cassette is similar in size to an audiotape cassette, which allows for much smaller camcorder units than the VHS format. The 8mm video quality compares favorably with VHS, due in part to a highquality metal particle (MP) tape used in 8mm camcorders, which are available in either standard resolution (250 lines) or high resolution (400 lines). Most 8mm camcorders can be directly connected to a television monitor to play back recordings. Some 8mm camcorders must use a separate playback unit that is connected to the television monitor. An 8mm tape cassette will allow up to two hours of recording and may be transferred to VHS (dubbed) by connecting the video/audio cables directly into the VHS recorder.

Digital camcorders have the highest resolution (about 50 percent more detailed than the best reception on broadcast television). They use a DV cassette that is about the size of a matchbook. They can receive up to 90 minutes of recording. Because of the small cassette size, many of these cameras are about the size of a 35mm point-and-shoot camera. Some models, such as JVC's GR-DVM1, can record still images (snapshots) as well as moving images. The audio on digital camcorders is equivalent to CD quality.

The selection of VHS, 8mm, or digital camcorders for police work is basically a matter of choice and budget. While 8mm and VHS-C cameras are compact, they must be used to play back the tape or have an adapter available for playback. In addition, 8mm and VHS-C do not have as much recording time as VHS tapes. VHS camcorders are larger in size, but are compatible with any VHS recorder/player and can record for two hours (some models longer) on one T-120 tape. Compatibility is the most important factor for police work. When the 8mm or VHS-C cassette format has been used for videotaping footage that is to be presented to a jury, the police officer must have the proper equipment available to play back the video. Dubbing (making a copy) an 8mm or VHS-C tape onto a regular VHS tape may be the answer, but it involves more time and effort and may need to be authenticated in court. Because of the ease in editing videotapes, the camera operator may have to testify as to the accuracy of the tape's contents, procedures used in the taping session, and whether editing was done on the tape. Digital camcorders are small, lightweight, and have the highest resolution; however, the cost of these cameras may be prohibitive for many law enforcement agencies.

Figure 11.1
Two typical camcorders. VHS regular cassette model (top) and 8mm cassette pocket model (bottom).

Camcorder Features

Image sensors: Video cameras use an image sensor to change visual images into electrical signals that are recorded onto magnetic tape. There are two types of image sensors: pickup tubes and solid state sensors. Pickup tubes are less expensive than solid state sensors, but have a distinct disadvantage. If a camera

equipped with a pickup tube is pointed at a bright light source, the tube may become damaged. Solid state sensors use an electronic chip rather than a tube, and therefore do not have this disadvantage. Solid state sensors also are smaller in size, use less power, and have no warm-up delay. The metal-oxide semiconductor (MOS) and the charge-coupled device (CCD) are two types of solid state sensors. Most camcorders today have CCD solid state sensors.

Lenses: Most all camcorders have motorized zoom lenses controlled with a three-position rocker switch on the handgrip. Zoom ratios are usually 8:1 or 6:1, and many have macro capabilities. Lenses are usually fixed-mounted, so there are few interchangeable lens models available. On camcorders that do allow interchangeable lenses, the standard mount is the "C" mount. Sony manufactures an 8mm camcorder (EVC-X10) with a standard "C" mount lens that can use a variety of telephoto lens accessories as well as "night-vision" optic accessories. Similarly, Kodak manufactures the MegaPlus 1.6i digital camcorder. There are accessory wide-angle and telephoto lenses available that attach directly to fixed-mounted camcorder lenses. Most camcorders are also equipped with an auto-focus mode. The auto-focus can be switched to manual focus if desired.

The amount of light entering the lens is controlled by an iris diaphragm. Most video cameras are equipped with an automatic iris that opens and closes automatically to adjust for exposure. Many camcorders allow the automatic iris to be manually adjusted as well, to compensate for bright backgrounds and shadows. The iris control may also be used for fading in and out of scenes rather than an abrupt on-off at the beginning or end of a scene. Some camcorders have an automatic backlight switch that lightens the main scene to compensate for unusually bright backgrounds.

A camcorder's sensitivity to light is determined by lens speed (f/number) and the characteristics of the image sensor. Unlike photographic film, in which the photographer can select a high-speed film for low-light situations, all videotapes run at the same speed. Video camera light sensitivity is specified using a lux unit. A lux unit is the minimum amount of light necessary to produce a video image. Lux ratings may be as high as 20 or as low as one for camcorders. The lux brightness scale is the metric version of the foot-candle scale. Seven lux equals three-fourths of one foot-candle. One lux is about the amount 10

birthday candles will produce. The recommended light level for a good quality video image is at least 500 lux. Below 500 lux, image quality and contrast become poorer.

Many camcorders are equipped with electronic shutters that allow the camera operator to select a shutter speed. Many camcorders allow $\frac{1}{1000}$, $\frac{1}{1000}$, and $\frac{1}{1000}$ of a second shutter speeds. Fast action scenes may be recorded at higher speeds to reduce blurring of moving objects.

Viewfinders: Most camcorders have an electronic viewfinder containing a miniature television screen (called a cathode-ray tube or CRT) or a liquid crystal display. Because camcorders are single-lens recorders, the viewfinder shows exactly what the lens sees. The viewfinder can also be used as a monitor to play back recorded images. Various messages are also indicated in the viewfinder such as the amount of time remaining on the tape, low-light levels, battery charge, and mode of operation.

Some camcorders are equipped with a character generator and a date/time indicator. A character generator allows titles to be superimposed over the scene that is being recorded. On some camcorders, the character generator looks like a tiny typewriter keyboard, and some models have an optional separate keyboard. An automatic calendar/clock will imprint date and time on the tape during recording. This feature is particularly useful for police work. The imprinted date/time will readily acknowledge that the tape was not tampered with or edited.

The viewfinder will also indicate a white-balance level. The white-balance control allows a scene to be recorded with correct color balance. Most camcorders have an automatic white balance that can be manually overridden. Before shooting a scene, the camera may be color balanced for the scene's available light by pointing the lens at a white background and pushing the white-balance control button. The camera will then continuously adjust the color for the best balance.

Use of Camcorders

While there are many advantages for video camcorders in police work, there are a few disadvantages. First and foremost is the quality of the videotaped image. Because the final image must be viewed on a television screen, the screen's quality will be most important. High resolution monitors are more expensive than traditional "home-style" television sets, but they do improve the quality of the image. Larger screen television monitors are a must if the videotape is to be shown to a group (such as a jury). Large-screen television monitors tend to be expensive.

The fact that video camcorders also record sound can prove to be a source of frustration. While audio capabilities are an advantage when videotaping interviews and interrogations, it may be a disadvantage when recording in surveillance operations or crime scene investigations. It can be disconcerting for a jury to view and hear a videotape with excessive background noise or police officers behaving inappropriately at the crime scene. The operator should disconnect the microphone from the camera if he or she does not wish to have what is said being recorded and heard later by others.

Photographing Television and Computer Screens

On occasion, the need for a still photograph of a video image will arise in police work. Still photographs may be taken from a video image by photographing the television or computer screen with a conventional camera. Videotapes should be "paused" or "freeze-framed" at the location where a still photograph is desired. Use a slow shutter speed of 1/30 of a second or slower (1/8 of a second is recommended). Television images are formed by a rapidly moving electron beam creating each image line on the screen. The beam moves faster than our eyes can see, but a still photograph at a shutter speed higher than 1/30 of a second will freeze the electron beam and the photograph will show a dark band across the screen. This is caused by the shutter being open a shorter amount of time than it takes the television to form a complete picture image. Television screens also reflect light from windows and light fixtures, so to avoid reflections, photograph the screen in a darkened room or with a polarizing filter. Common daylight-balanced color film may be used to photograph a television screen, but may have a slight blue-green cast. Adjusting the television color so that it is slightly red will compensate for the color imbalance. With color slide film, the use of a color compensating filter (CC10R or 20R) over the camera lens will also help compensate for the color imbalance. With color negative film, use CC20B.

The best results will be found when using a long focal length lens, such as a 100mm telephoto. Longer lenses will minimize the effect of screen curvature. Additionally, use a slow film, such as ISO/ASA 100. With Ektachrome 100 Plus Professional, use a one-second exposure at f/8 or f/11. If a color-compensating filter is used, increase exposure by ½ of a stop.

Polaroid's Screen Shooter cameras (DS-34 and NPC models) allow Polaroid photographs to be made directly from television and computer monitor screens. The cameras are equipped with a CRT framing hood that covers monitor screens up to 12 inches diagonally. The hood is also adaptable for 35mm SLR cameras. However, hard copies of screen displays on computer monitors may best be obtained by simply printing them out on a high quality color printer. There are many software programs available for "screen printing" exactly what is seen on the monitor. Similarly, videotaped images may be "captured" using a video capture software program such as the Snappy Video Snapshot (discussed later in this chapter).

Digital Cameras

When Sony first announced the Mavica (Magnetic Video Camera) in 1982, many thought it would replace traditional still photography much in the same way that camcorders have replaced home movie film cameras. Digital cameras are still a source of controversy among photography experts.

Digital photography is a cross between conventional film-based cameras and a scanner. The front of the camera uses a lens, aperture, and shutter to focus an image, but the image is not focused onto light sensitive film but onto a semi-conductor chip called a CCD (charge-coupled device). Data are passed to an ADC chip (analog to digital converter), compressed, and then recorded on either built-in memory chips, a removable PC card, or a magnetic disk. On most digital cameras, there is a 1.5-second delay between when the shutter is pressed and when the camera actually takes the picture. That is the time necessary for the light sensor to read the scene and either adjust the diaphragm opening (f/stop) or change the shutter speed, check the auto-focus (if so equipped), and trigger the flash (also if equipped). Because of this delay, there may be a problem with moving images. Also, there is usually a four to nine-second delay when the camera is converting the image into digital form, compressing and saving the image, and recycling the

Figure 11.2
Polaroid's Screen Shooter camera.

flash. On most digital cameras, this additional delay prevents exposures from being made until after the camera recycles. On some camera models, another exposure may be taken while the camera is "busy" with the first image and will create a double-exposure on the same "frame."

Digital cameras record electronic images on a magnetic disk, tape, or memory chip that allows you to see the "photograph" on a television screen. On some models, as many as 192 pictures may be made on one disk or memory chip before "downloading" into a computer. Like videotapes, they can be reused by "photographing" over the old pictures or by deleting unwanted pictures on the camera. Many are equipped with a viewfinder television screen that allows the photographer to immediately see what the picture looks like. If the photographer is not pleased with the result, he or she can retake the picture immediately.

Despite the high-tech nature of digital cameras, many lack the basic features of moderately priced point-and-shoot 35mm cameras. The quality of the pictures is based on the image sensor (CCD). The image sensor is based on pixels—the more pixels the sensor has, the more information it can detect. The size of the image sensor is also important, and is mea-

sured diagonally (usually ½ or ⅓ of an inch). A small image sensor might yield poorer low-light images than a large one with the same or lower pixel count. Most digital cameras fall in the 640x480 pixel resolution range, or 307,200 pixels. Compared to a 35mm print of 20 million pixels or a Polaroid print of 2 million pixels, the digital print is of far less quality. Some digital cameras, such as Minolta's RD-175, boast up to 1528x1146 resolution (1.75 million pixels), but the cost of these cameras is more than \$5,000.

Silver crystals contained in traditional film are much smaller than the picture elements (pixels) that make up a digital photograph. When a digital image is enlarged beyond 4x6 inches, the prints may become "pixelated" (broken up into blocky squares). This is a particular problem with the low-end point-and-shoot digital cameras with resolutions of 640x480 or less. Also, digital cameras can record two states of tone and color-light or dark-while film can capture a range of continuous tones and colors. A persistent problem with digital imaging is color balance. Most CCDs are balanced for direct sunlight and electronic flash and do not do well with other light sources. The image sensors currently in digital cameras have very little color temperature latitude. Therefore, any digital photograph taken with illumination other than

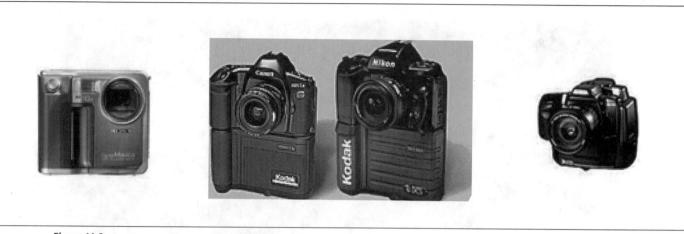

Figure 11.3
Examples of digital cameras: Sony's Mavica, Kodak's DC420 with Canon and Nikon bodies, and Minolta's RD175.

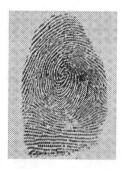

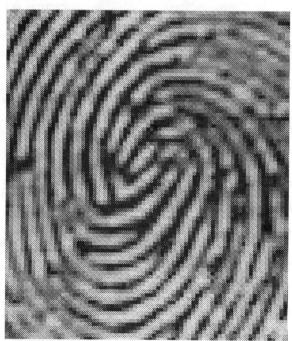

Figure 11.4 Example showing a digitized fingerprint and pixelated image after enlargement.

sunlight or electronic flash may appear with less detail (called "clipping"), low contrast, and incorrect color balance.

There are several digital cameras available that are of use to law enforcement. Kodak produces a digital imaging unit that is attached to a standard 35mm SLR, namely the Nikon E2N or N90 and the Canon EOS cameras. The resolution of these cameras is $1,000 \times 1,280$. Kodak also produces the DC420 camera, which can be obtained as a regular digital camera or in near infrared mode (the DCS420IR camera) with resolution of $1,012 \times 1,524$.

Digital cameras are intended for applications in which viewing a picture on a television monitor or transmitting images via phone lines is convenient or desirable. The picture quality varies in models and price category, but even the most sophisticated digital camera cannot compare in quality to film camera photographs. However, digital photographs have the advantage of being easily transmitted via telephone lines, stored in computers, or electronically printed in seconds. Because filing and storage of records is of concern to police departments, the ability to store photographs in a computer and on magnetic media is an important advantage. Mug shots, accident photographs, photographs of fingerprints (see Figure 11.4), crime scene photographs, and others are currently stored on computers and magnetic media in many law enforcement agencies. Usually, a regular film photograph is "re-shot" electronically using a scanner and digitized for magnetic media storage or telephone line communications (much like a fax machine). Using a digital camera could eliminate the need to "re-shoot" images for electronic digitizing. Police departments should explore the possibility of using digital cameras for mug shots and other photographic situations in which the use of a television monitor and magnetic storage are convenient. Canon, Fuji, Konica, Nikon, Olympus, Panasonic, Sony, Minolta, Kodak, Casio, Epson, Polaroid, Vivitar, and Yashica all currently produce digital cameras ranging in sophistication and price from around \$200 for Vivitar's 2000 (153,600 pixels) and Kodak's DC20 (183,889 pixels) to more than \$5,000 for Minolta's RD175 (1.75 million pixels). Kodak packages a digital "darkroom," which includes everything a police department needs to start using digital photography. The digital darkroom includes a D420 camera, computer, scanner, printer, and software for nearly

\$30,000. Polaroid offers a digital microscope camera (DMC), with a resolution of 1,600 x 1,200, that can be attached to a compound microscope.

Digital Camera Accessories

Most of the commercially available digital cameras are of the point-and-shoot design with minimal available accessories. These cameras usually have fixed focus lenses, which may or may not have macro capabilities. Many do not have telephoto or close-up lens attachments or filter attachments. Many do not have the capability to work with electronic flashes. The professional model cameras that do allow for interchangeable lenses, flash attachments, and filter attachments will cost several thousand dollars. Minolta produces a digital "back" that can be attached to its 35mm Maxuum cameras in addition to its RD175 camera. Kodak uses Nikon or Canon cameras for its D420 camera system. Polaroid has an option for a digital back for its MP-4 copy camera.

Figure 11.5 Kodak's 16i high resolution digital camera for laboratory purposes. The camera can be easily mounted to a copy stand or a microscope.

Even the lower pixel resolution cameras can produce good images on a television or computer screen. However, if a hard print is needed, a suitable color printer is required. While most of the computer color printers using laser or inkjet can produce a print from a digital photograph, the quality may not be acceptable. Many color printers have a photo resolution mode, such as Canon's Bubble-Jet printers and

Epson's photo quality ink-jet printers, which can produce acceptable prints. There are a number of specially designed color photo printers available that use thermal or dye-subliminal transfer ink to produce higher resolution prints, such as the Kodak 8650 or Fujix Pictography 3000 printers, but even these are not of the same resolution as a Polaroid print and appear quite grainy. Resolution quality for ink-jet printers is generally expressed in dots per inch (DPI). The higher the DPI, the better quality the resulting print. Ink-jet printers should have 720 or higher DPI as a minimum for acceptable prints. Sometimes the terms pixel and dots per inch are used interchangeably. These are two different measures of resolution and should not be confused. A pixel contains all image element information of color and lightness (value) and may be made up of several dots (at least three to make one pixel). A dot may have only one color and only a value of "on/off." The cost of a color printer designed for printing digital photographs will start around \$500 and increase from there.

In addition to the camera and printer, a high memory Pentium grade computer will be required along with proper software. A high resolution flatbed color scanner may also be useful in digitizing regular photographs for use on the computer. A high capacity drive is required to store digitized images, such as a Zip drive which can hold 100 megabytes of storage. A recordable or writable CD-ROM drive may also be a necessity. There are several software programs available for downloading and manipulating digitized images, such as Adobe's Photoshop and Kodak's QuickSolve for law enforcement use. The software programs allow for digitized images to be downloaded into the computer, stored on a desired medium, and manipulated by adjusting for color, contrast, and imaging. The fact that a digitized photograph can be easily manipulated on the computer may create legal admissibility concerns for court presentations. As many celebrities have testified, tabloid papers have been accused of using digitally manipulated photographs in their publications. It is very easy to put one person's head onto another person's body by manipulating the images on the computer. However, the ability to manipulate digital images may also be an advantage for police work. Latent fingerprints on multi-colored backgrounds and questioned document examination may create enhanced photographs through digital imaging. Software programs designed for digital photographs, such as Adobe Photoshop, Free Radical Enterprises, and Image-Pro Plus enhancement software, may be able to alter an existing photograph by manipulating contrast, color, and sharpness and filtering out unwanted or interference backgrounds, producing a better image than the original. Image-Pro Plus (Media Cybernetics) software allows the acquisition of images from videotapes, scanners, digital cameras, and photo CDs for enhancement using filtration and pixel manipulation. Such manipulation may enhance a digital image so that it can be better visualized (see Figure 11.6).

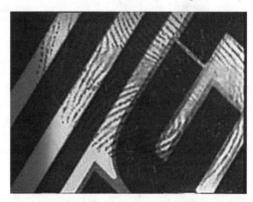

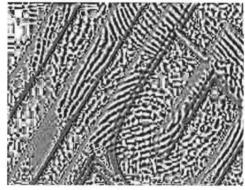

Figure 11.6
Latent fingerprint on a soda can photographed digitally before "enhancement" (top) with Image-Pro Plus and after "enhancement" (bottom) using the Local Equlization Filter mode. (Images provided courtesy of Media Cybernetics, L.P.)

Another accessory for digital photography that may have use in law enforcement is video "capture" hardware. A number of manufacturers produce a device and software that allows a still picture to be taken from a videotape. One of the more common brands is the Snappy Video Snapshot. This inexpensive accessory (costing less than \$150) allows the capture of any frame on a videotape or television screen as a still digital photograph. The Snappy device has been successfully used in establishing pos-

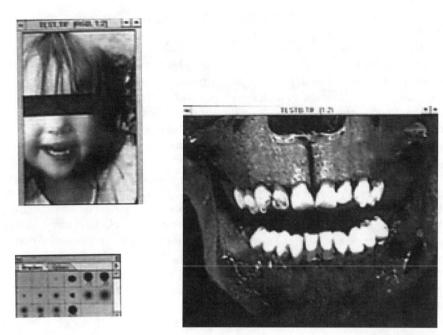

Figure 11.7

Home videotape image of child "captured" using the Snappy video device and comparison with skeletal remains. A positive dental identification was made using the Adobe Photoshop software program. (Courtesy of The University of Tennessee–Knoxville, Department of Anthropology)

itive identification of skeletal remains by "capturing" facial and dental images from home videos for comparison with unidentified human remains (Marks, Bennett & Wilson, 1997).

While the future may show the replacement of traditional film photography by high-tech electronics, it is still a long time away. Until video quality and cost match, or become superior to, film photography, the traditional photograph will continue to be the standard. At present, digital photography should complement film photography in police work.

Photo CD

One of the greatest advantages of digital photography over conventional film photography is the ability to store large amounts of data in a small space. The use of magnetic media to store vast amounts of information has been one of the most apparent aspects of the computer age. Hard copy files can now be stored on magnetic media (such as on disks and tape) or on compact discs (CDs). Conventional film photographs can be digitized and filed on such media by using a scanner or a recordable CD. Photo CDs have emerged as a convenient option for many photographers using conventional film cameras who

wish to store, view, and manipulate photographs on a computer. Photo CD is more than a file format (such as TIFF, PICT, JPEG, BMP, etc.) used with scanners; it is actually three things: an image format, a storage medium, and a color space.

Normally, when a photograph is scanned, the resolution of the scanner is set to a certain pixel size. If, at a later time, larger images are needed from the stored image, a second scan may be required to avoid pixelating the image. Photo CDs allow for images to be stored in multiple resolutions called Image Pac. When original photographs are scanned to Photo CDs, there may be as many as six levels of resolution stored for the single image ranging from thumbnail size prints (192 x 128 pixels) to very large enlargements (6.144 x 4.096 pixels).

Scanned photographs require a storage medium in order to access the image. Because of the large amount of memory required to store digitized images (as much as 96 megabytes for one 6,144 x 4,096 image), storage media must be on magnetic tape (such as backup tapes), removable high capacity disks (such as SyQuest or Zip drives), or on recordable CDs. In addition, magnetic media has the limitation of being read only by compatible computer systems. Most newer computers have a CD player, allowing Photo CDs to be "played" regardless of sys-

tem (i.e., Macintosh or IBM). Photo CDs also have the capacity to store hundreds of images on one CD.

Because a traditional film photograph is digitized, the ability for a wide range of tonal and color values can be recorded through scanning for Photo CDs. Photo CD uses the YCC color space, which has the advantage of encoding a wide range of brightness and color values. This allows for accurate reproductions on computer monitors or as printed hard copies with photo quality printers.

Many photo finishers offer a Photo CD option for developing film at a slightly higher cost than for prints themselves. While recordable CDs may be purchased by a police department, the cost may be prohibitive since they may cost several thousand dollars. However, requesting prints and Photo CDs from a commercial photo finisher may be more attractive for smaller departments. This may be the best of both worlds, having conventional film cameras along with the ability to digitize photographs.

The Future

As was indicated in Chapter 1, no textbook can possibly keep up with the advancements being made in electronics and photography. By the time this text is in print, there will no doubt be more advanced cameras and digital imaging equipment available for the law enforcement officer; new products are being introduced everyday. We already are prepared for the eventual replacement of videocassettes, laserdiscs, CD-ROMs, and the audio CD by digital videodiscs. While the U.S. Justice Department may raise their eyebrows concerning possible anti-trust violations between leading electronic and photographic industries, the consumer in the twenty-first century will be the big winner, seeing a standardization in the way media is produced and stored.

References

Marks, M.K., Bennett, J.L. & Wilson, O.L. (1997). "Digital Video Image Capture in Establishing Positive Identification." *Journal of Forensic Sciences* 42(3):492-495.

Traffic accidents happen very quickly. For the drivers and passengers of the vehicles involved in an accident, the short time in which the collision takes place can be traumatic and can influence the perceptions of all involved. Descriptions of the accident are not always accurate; therefore, the patrol officer who arrives at an accident scene must determine and record whatever evidence is available. The officer will note the descriptions of the accident as told by the drivers, passengers, and other witnesses. Measurements will be taken and weather conditions will be noted. Also, if the officer is equipped with camera and film, photographs of the accident scene will be taken.

With traffic accidents as well as their costs on the increase, the importance of permanent, accurate, and unbiased records of an accident scene cannot be overstressed. Photographs, taken carefully, can provide a good part of the record of an accident. Measurements and other descriptions are also very important. Except for the minor details of an accident, a good photograph can capture many aspects of an accident scene that may be overlooked in the turmoil of the moment.

Photographs can be a great aid to the court, as they present physical circumstances of a case in a manner that is easily understood. Most people are visually oriented. A photograph of large or perishable evidence is accepted in place of the original. Items such as skid marks, footprints, or a body to show the location and type of injury should be included in the photograph. But before the shutter is snapped, the investigator should consider, "What will this tend to prove?" If the answer is "nothing," the photo should not be taken.

The police photographer must be qualified. The photographer must know what he or she is doing and

why, because the more important the picture, the stronger the attempt will be to discredit or disprove it. Commercial photographers are usually unsatisfactory for several reasons. In addition to being expensive, they may not know police photography requirements, they are often reluctant to appear in court, and they may not keep records to ensure that the photograph will be admitted into evidence. If a commercial photographer is used, the officer should direct the photographer to take the type of picture the officer needs, and to record exposure and other related data. It should be remembered that these photographs are not for publicity but are for evidence, as is the sketch of the crime scene. Valuable as they may be, the investigator should not depend on photographs alone. They may be an important part of the case, but photographs alone do not constitute a complete investigation.

Pictures of the following subjects are often needed as evidence or to complete the records of a case: (1) general scene from driver's viewpoint; (2) point of impact; (3) traffic control devices; (4) skid marks, showing length and direction; (5) condition of roadway at location, showing defects, position of cars, victims, and parts of vehicles after impact, indicating points of collision; (6) view obstructions or lack of obstructions; (7) blood, flesh, hair, fabric threads, scrape marks, and the like, which are frequently present in hit-and-run cases; (8) tire prints; (9) footprints; (10) defects in vehicles involved, such as a missing headlight; (11) trucks lacking turn signal indicators; (12) the roadside showing the kind of environment; (13) sagging springs of an overloaded vehicle; and (14) the license number of the vehicle(s) for identification.

Photographs, however, usually do not show measurement or dimensions. The photo may be incorrectly exposed, blurred, or otherwise impaired. The accident sketch, therefore, is important as the record of the investigator's intricate, personal examination of the scene. However, the use of the perspective grid photographic mapping technique will allow accurate measurements to be made with a photograph. The basic procedure is to include a rectangle of known size in the photograph of a flat surface, such as road pavement, that permits mapping of objects on that surface. The rectangle may be a sheet of paper, a legal pad or a two-foot square grid made for this purpose. Chapter 13 explains in detail how perspective grid photography can assist with making quick, accurate measurements and preparing scale sketches of accident and crime scenes.

In photographing the scene of an accident, the usual limitations of color, lighting, and contrast affect the choice of film, lenses, filters, and developer conditions. It is essential to obtain extreme definition and clarity in photographs for presentation in court, in order that points of importance such as the position of vehicles, point of impact, parts of damaged vehicles, and so on are clearly defined. Combined with these desirable properties, the photograph should have the absolute minimum of perspective distortion possible.

When photographing the scene of an accident, the object is to include all possible details that have a bearing upon the cause of, or reason for, the accident. The experienced police photographer can obtain a reasonable estimate of the exposure required. With today's wide range of automatic 35mm cameras, it is almost impossible for a person to get a bad exposure. Even with the less expensive, modern cameras, once a police officer learns how to use the camera, it is simple to obtain a well-exposed photo.

The viewpoint from which the photograph is taken is important. By directing the camera in a slightly different direction, obstruction of vision at a crossroads, for example, or the visibility of a sign may be magnified or minimized, giving a false impression.

When photographing the approach to the scene of an accident for the purpose of showing obstructions to the view of the driver, the camera is held at the eye level of the driver of the approaching car. This gives a true picture of what the driver could see when approaching a crossroad or rise, such as a humpedback bridge. In the latter case, the camera held down or at higher than normal eye level would give a false

impression of the amount of obstruction offered by the bridge. The photograph should also be taken in line with the travel of the driver's body relative to the road if a photograph representing the driver's view is to be produced. In the case of a pedestrian witness, the camera should be at the eye level of a pedestrian to give an effect of what the witness saw. Markings of the first impact should be carefully recorded to assist in establishing responsibility for the accident.

This is a rather important point about the type of lens used to take the photograph. A normal lens (such as 50mm with 35mm film) is the best choice for this purpose because, when the scene is completely and pleasingly located in the viewfinder, the photograph will show normal perspective. A too-distant viewpoint, minimizing distances in depth, or a viewpoint too near, exaggerating these distances, will not be obtained by the above method. Such photographs would be obtained by the use, for example, of a long focus or telephoto lens and a short focus or wide-angle lens, respectively.

Panchromatic or color film should, of course, be used to take the photograph. Especially when multicolored road signs may be involved in the case, or if an incorrect filter is used, the clarity of the signs may be falsified to give the impression of clarity where none exists or of obscurity where the sign is perfectly clear. The best practice when photographing an accident scene is to use a normal-angle lens and a panchromatic or color film with a correction filter, to focus on the main object, and then to stop down the diaphragm to the smallest possible aperture. This last phase will be determined by the presence or absence of motion at the scene. If persons or objects are moving about the scene, then the aperture must be such that the exposure is sufficient to record these moving objects reasonably free from blurs. For car interiors, expose for the shadows. For general views of cars, any medium-speed emulsion can be used, with the exception of slow "process" types because these are designed for low-contrast subjects.

Basic Considerations

The police officer controls the accident scene. He or she must assure that no one moves the vehicles involved in the accident until all the needed photographs and measurements have been taken. Many weeks may pass before the case comes to court, and the officer must be prepared with careful records cov-

ering any detail of the accident that might be needed by the attorneys in court.

The entire scene of the accident should be photographed with all the vehicles in the position of collision and later with the vehicles removed. An overall view should be taken, along with four different angles, one each from the north, south, east, and west. While photographing an accident scene, the photographer should consider, "Will this view, angle, or position be of any value to me later when I am called to testify in court?"

In addition to taking all the necessary photographs, the photographer should draw a diagram showing all the distances from the camera to the object photographed. All material objects should be measured. Everything should be documented.

Permission to Photograph

Although some people object to being photographed at the scene of an accident, the police photographer has the right to photograph any evidence available at the scene of an accident on public property. Private property, such as a shopping center parking lot, may pose a problem to the police photographer. Technically, the security officer is responsible for investigations concerning accidents on the property. Permission to photograph may, however, be obtained in writing from the owner who is often willing to cooperate. If necessary, a search warrant that will take the place of the owner's written permission may be obtained.

Viewpoints When Photographing Accidents

The viewpoint from which each photograph is taken can make a great deal of difference in the story the picture will tell. A shift of only a few inches can, for instance, hide a stop sign behind a bush although it may have been visible from the road. Obstructions to vision at a crossroads are relative to the position of a driver; the nature of such obstructions may be maximized or minimized in a photograph merely by moving the camera a few feet. Thus, it is very easy for the photographer to give a false impression that will not be helpful in conducting an investigation.

When photographing the approach to the scene of an accident, the photographer may wish to show any objects that obstruct the view of the driver. The camera should be held at a distance above the ground that approximates the eye level of the seated driver. The distance above the ground will vary from vehicle to vehicle and with the physical height of the driver. The photographer may have to squat to photograph the view from a sports car, or stand on top of a ladder in the case of a large truck. Any appreciable variance from this position will create a false impression of the driver's view. The camera should, of course, be pointed in the driver's direction of travel. When photographing what a pedestrian saw, the camera should be held at the eye level of the pedestrian.

Working Under Poor Conditions

Accident photography is nearly always done outside and, because bad weather, darkness, and glare are often the causes of accidents, the photographer often must work under poor conditions.

At night: Making pictures in the dark is a very difficult job. Even with the largest flash, most of the flash will not be reflected. Foreground areas will be overexposed and the background will be underexposed. The photographer will get good results at night with a multiple flash method such as painting with light or strobe and slave (see Chapter 6). Focusing in the dark, though difficult, can be accomplished by shining a flashlight or spotlight at the object to be focused. The camera should be on a tripod to aid in this process. If this is not possible, the lens should be focused at infinity; most objects will then be in focus. Photographing license plates at night can be very difficult. The flash unit must be held at a distance from the camera so that glare from the highly reflective plates is directed away from the lens. Three shots of a plate, with the flash unit five, seven, and 13 feet from the camera will yield good results.

At dusk: Shooting at dusk should be done with a combination of available light and flash.

Bad weather: The Rochester, New York Police Department has a novel approach to the problem of protecting photographic equipment, and preventing flash units from shorting out during rain or heavy snow. Before leaving the car, the police photographer tightly covers the camera with a clear plastic bag from which he or she has sucked out the air. In Shaker Heights, Ohio, police officers use a large golf umbrella that they carry with their photographic equipment.

Daylight flash: Unlike most outdoor photography, the subjects of accident photography cannot be posed nor can the photographer manipulate the camera to get only the most well-lighted angles or wait for the sun to move for better lighting. When shooting the shaded side of a car, the underside of a car, or the interior of a car, a flash should be used to bring out details that would otherwise be hidden in shadow. The photographer should cover the flash with a double thickness of handkerchief or a diffusion attachment when shooting inside vehicles or the shots will be terribly overexposed. Automatic strobes must be used carefully because daylight may throw the flash sensor off its proper exposure.

Basic Rules for Accident Photography

Photographing an auto accident is something that must be done correctly the first time. All photographs must be obtained in a few minutes and nothing must be omitted. The accident photographer must be doubly careful to record everything because the omission of a key photograph could misrepresent the case.

Upon arriving at the scene, the photographer should reconstruct the accident in his or her mind; then, using the proper equipment (35mm cameras are particularly well-suited for this task) photographs of the scene can be taken following these basic rules:

- Quickness counts. If any of the drivers, passengers, or bystanders at the accident are injured, they should receive the police officer's attention first. Then, all the necessary photographs should be taken so that the vehicles may be moved if they are obstructing traffic.
- 2. Avoid unnecessary surroundings. Objects that are not pertinent to the case should not be included in photographs of the accident. If only a small portion of the photograph is of interest in this case, you should be careful in introducing it. It is similar to a witness who rambles on with minor details that are of no importance to the case. Whenever possible, a series of photographs of a traffic accident scene should be taken from several different camera viewpoints that will give an effective presentation of the entire scene without showing too much of the surrounding area. People and animals should be avoided in the photographs unless they are involved in the case or serve some useful purpose such as showing the size or location of objects. Living creatures always attract the

- attention of the observer of a photograph, and if they have no purpose in the picture, their presence will weaken the effectiveness of the photographic evidence, as shown in Figure 12.1.
- 3. "See" through the driver's eyes. Photographs should be taken from the eye level of each driver. If there are witnesses, photographs should be taken at their eye levels from the spots where they were standing.

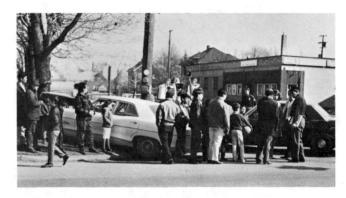

Figure 12.1
Distraction caused by people obscuring vehicles involved in an accident.

- 4. Angles to take. Shots should be taken from the four points of the compass and 25 feet from the vehicle. Additional shots, from 100 feet, will show the approach and terrain. If only a few shots can be taken, they should be at 45-degree angles from the front and rear of each vehicle. This allows two sides of a vehicle to appear in one photograph.
- Close-up shots. From a distance of eight to 10 feet, shots should be taken of the damaged parts of each vehicle. Different perspectives of the damage may be obtained by photographing each damaged area from two angles.
- 6. Tie the shots together. Some order of photographs must be established from the photographer's notes so that their order will assist in telling a story. The photographer must be prepared, with the aid of the photographs, to tell the court exactly how the accident occurred.
- 7. Practice makes perfect. The photographer must practice the craft so that he or she need only worry about how to tell the story in pictures and not about how to operate the camera.

- 8. Remember the chalk. Before any bodies are removed from the ground, they should be outlined with white chalk or bright colored spray paint. If a vehicle must be removed, its four wheels should be outlined with chalk or paint. It is a good idea to chalk a white arrow indicating which direction is north for inclusion in each photo.
- 9. Be certain. If there is any doubt about whether to take a shot, take it. Film is the most inexpensive part of the photographic process; saving film may be a false economy in the case of an accident in which a person is injured or killed. It is a good idea to take at least 20 to 30 pictures, because too much evidence is better than not enough.
- 10. *Perspective grid*. If measurements are to be made and sketches drawn of the accident scene, be sure to include a perspective grid in the photograph (see Chapter 13).

What to Photograph

- 1. All vehicles in their original positions. The officer has the authority to prevent any movement of vehicles until photographs are taken (see Figure 12.2).
- 2. Victims that have been thrown from vehicles (see Figure 12.3).
- 3. *Debris* is the best indication that the photographer can show of where the first impact occurred (see Figure 12.4).

- 4. *License plates of vehicles*. These should be clear on at least one photograph of each vehicle.
- 5. All skid marks and tire marks. Patches of oil or water, if present, should be included in these photographs. Tire marks will be straight and are caused by braking. Skid marks deviate from the general line of travel and are usually made by the front tires (see Figure 12.5).
- 6. If a vehicle has gone off the road and has made any marks in soil or soft berm, these should be photographed. They may give an indication of the speed of the car.
- A close-up of marks made in macadam roadways should be taken to indicate the texture of the road.
- 8. Photographs of the *vicinity of the accident* should be taken that do not include the accident scene itself. These should be carefully noted for reference points.
- 9. Special care should be taken when photographing a hit-and-run scene. The investigator of a hit-and-run accident has only a part of the evidence and must make a case from the best photographs the photographer can take.
- 10. Vehicle interiors. Photographs showing position of bodies, whether seat belts were in use, items inside the vehicle and, in some cases, the speedometer may be stopped at impact showing the speed of the vehicle (see Figures 12.6, 12.7 and 12.8).

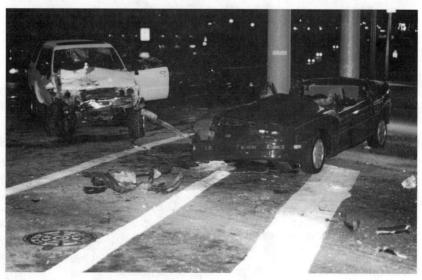

Figure 12.2 Vehicles shown in original position.

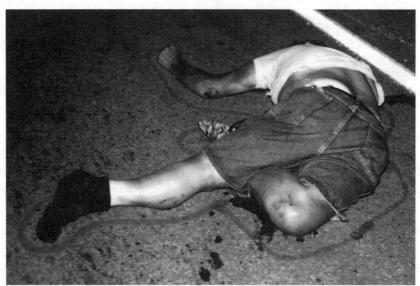

Figure 12.3 Victim thrown from a vehicle. Notice the use of paint to outline the body.

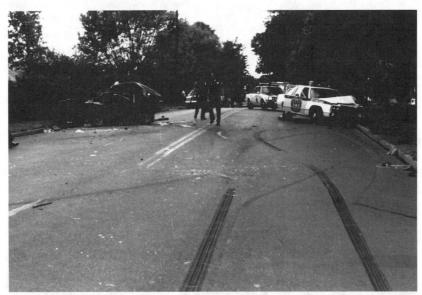

Figure 12.4
Skidmarks and debris showing place of impact.

How to Photograph an Auto Accident Scene

There is a five-step procedure that provides adequate photographic coverage of most automobile accidents. The following deals with an accident at an intersection, but it applies equally well to any vehicular accident.

 From a distance of about 100 feet, the photographer shoots toward the intersection to show how it appeared to the driver. Then from the same spot, the photographer turns and shoots toward the direction from which the second car was coming. This will establish whether any obstruction could have prevented the first driver from seeing the second driver.

- The photographer then moves up to about 25 feet from the probable point of impact and shoots again. This will establish what traffic controls were present and will show skid marks or lack of skid marks.
- 3. Next, the photographer takes these same basic three shots from the viewpoint of the second driver. The order is simply reversed. First, a shot is

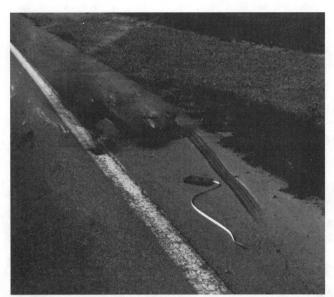

Figure 12.5
Skidmarks and gouge marks in pavement.

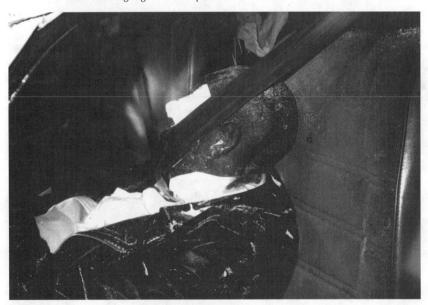

Figure 12.6
Interior shot showing the position of victim. Was the victim wearing a seat belt?

taken from the direction from which the second driver was coming, at 25 feet from the probable point of impact, then moving back, the other two basic shots are taken from 100 feet.

4. These six basic shots, three from each driver's viewpoint, should be taken quickly, within three to five minutes. The overall scene, the probable point of impact, and the final locations of the vehicles and pedestrians have all been well covered. As soon as the photographic activity that

interferes with the flow of traffic is complete, the photographer begins photographing each vehicle to illustrate damage. In the close-up views, the cars should be photographed from north, south, east, and west. Close-up views of the car's damaged areas can give a good idea of the force of the collision. Color photographs will show where one car's paint has been transferred to another, and will also make it easy to distinguish the damage under investigation from rusted areas or old dam-

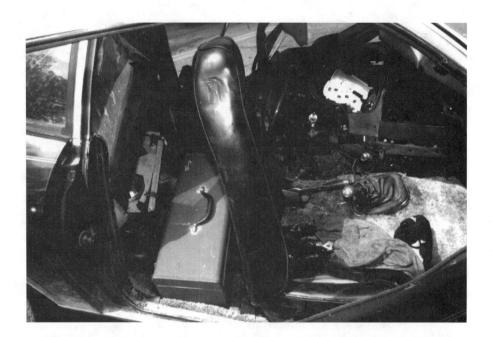

Figure 12.8 Interior shot of speedometer showing recorded speed at impact.

Warning

It may immediately seem evident who the guilty party is in an accident. Nevertheless, the police photographer must keep an open mind and not let any quickly formed opinions influence his or her approach in performing the job. If the work is done well, there will be plenty of solid evidence on which to base a sound conclusion.

- age. License plates should be photographed. Photographing shoe soles of a car's occupants can settle a possible dispute over who was driving if an imprint from the brake or accelerator pedal shows up on the sole of one of the occupants.
- 5. Any skid marks or tire tracks should be photographed head-on, to show the direction in which the vehicle was traveling; and side-on, to show their length. These photographs will help determine the speed at which the vehicle was traveling and just when the driver perceived danger. To get the best views of the marks, it is usually best to place the camera as high as possible. The Wyoming, Michigan Police Department has devised a unique system for taking pictures from a high vantage point. Their photographic car is equipped with a wooden board mounted about four inches above the roof of the car. The tripod is easily mounted and the photographs taken from this point produce a good view of the tire marks. When photographing tire marks, great depth of field is desirable to ensure that the entire length of the mark is in sharp focus. In order to accomplish this, it is best to set the aperture at f/32. This is the diaphragm opening that allows the greatest depth of field. Using this exposure will naturally depend on the amount of light available.

Hit-and-Run Accident Scene

Identifying the missing vehicle is, of course, the biggest problem in a hit-and-run accident investigation. Photography can make the task much easier.

Debris: Any debris possibly connected with the hitand-run accident should be photographed at close range. For example, a photograph showing a paint fragment from the missing vehicle on another vehicle or on a pedestrian's clothing can mean the difference between a criminal's acquittal or conviction. All the debris in the immediate surroundings should be photographed to show the point of impact. Defense lawyers will be very interested in seeing the point of impact in the auto accident.

Tire impressions: Even if tire impressions will be reproduced by plaster casts, it is a good idea to photograph them first. The camera should be placed on a tripod, with the back of the camera parallel to the ground. The photographer should select, when possible, a length of track that reveals any defects, such as

cuts, that could help identify an individual tire. The photographer should always photograph, in sections, a length of tire track to equal the circumference of each tire.

Blood: To capture as much contrast as possible between a bloodstain and its background, color film should be used. But if black-and-white film must be used, the photographer can make the blood appear lighter than its surroundings by using a Kodak Wratten Filter No. 25 (red) with Kodak Tri-X or T-Max or, Ilford HP5 or HP5 Plus. Blood can be made to appear darker by using a Kodak Wratten Filter No. 47 (blue). Fresh blood, sometimes even oxidized blood, may fluoresce if it is illuminated with ultraviolet light and photographed in the dark, using a Kodak Wratten No. 2A on the camera. Because only the area that fluoresces will appear, another photo should be taken from exactly the same camera position. The exact location of the blood spot in relation to its surroundings can be illustrated by superimposing a positive transparency of the ultraviolet negative over the other print. Also, a fill-flash photo may be taken (see Chapter 14). A photo of the trail of a pedestrian's blood can establish the direction the hit-and-run vehicle was traveling; the small points of the drops of blood point in that direction.

Possible Murder or Suicide

There is nothing accidental about some fatal "accidents." It is always a good idea to photograph anything that appears suspicious. If, for example, a dead person is found behind the steering wheel of a car that has been in a serious collision and the driver shows few bruises and little bleeding, a photo could help show that the driver was dead, possibly murdered, before the accident occurred. Often, especially when dealing with head-on collisions, it is wise to photograph the brake and accelerator pedals, the floormats, and the soles of the driver's shoes. If the accelerator pedal imprint shows on the driver's right shoe and the floormat impression on the driver's left shoe, there is good reason to suspect suicide. In any fatal accident, the interior of each car involved should be photographed thoroughly. Areas of deformation should be emphasized, particularly where there is any indication of occupant contact. Anything in the car's interior that indicates body contact, such as the steering wheel, the instrument panel, the interior of the doors, bent knobs, broken windshields, and so on, should be photographed.

A service of the serv

the state of the s

Crime Photography

13

Photographing the scene of a crime is very important, whether the case eventually goes to court or not. In fact, very few photographs end up being used in the courtroom. Photographs are not taken for courtroom presentation alone; they help the police in many ways. When a suspect is being questioned, a photograph of the crime scene may be used to refresh his or her memory. The guilty party may sometimes confess when confronted with relevant photographs. Often, detectives must take a suspect around the city to show him or her the homes that he or she is suspected of having burglarized. By showing the suspect or suspects different photographs of these scenes, the investigators can save many precious hours, and the municipality can save many dollars. If the case should come to court, the photographs can give both the judge and the jury the best possible idea of the crime scene as it was at the time of the crime.

It is, or should be, a general practice for the police photographer to take photographs of the crime scene immediately after a crime has occurred and before anything has been disturbed or removed. No one should be permitted to touch anything at the scene of a crime before it is photographed.

Perspective Grid Photographs

As was discussed in Chapter 12, accident scenes and crime scenes may be accurately measured using photographs (sometimes called photogrammetry). As long as a rectangle of known size is included in a photograph of a flat surface (such as road pavement), measurements may be made of every object appearing in the photograph and a scale map or sketch may

be prepared from the photograph. A rectangle may be made in advance (perspective grid) using a one- or two-foot square sheet of heavy cardboard or photo mat board.

When using a perspective grid, position it so that the bottom edge of the grid is along the lower edge of the photographic field of view. The camera may be elevated somewhat to improve the accuracy of the grid measurements. Generally, the higher the camera elevation, the more accurate the measurements will be. The focal length of the camera lens will have no appreciable effect on the accuracy of measurements, so a wide-angle lens may be used (see Figure 13.1). Inaccuracy usually occurs when the surface is not flat. Surfaces can slant (such as roadways) and still be flat. Avoid uneven areas, particularly outdoor fields and indoor stairwells.

If a single photograph cannot show the entire area to be measured and mapped, two or more overlapping photos may be made with the perspective grid relocated for each photo. The individual maps are made and combined into a single final sketch. For additional information, the reader is encouraged to read "Perspective Grid for Photographic Mapping of Evidence," which is available from the Traffic Institute.

Homicide Investigations

One of the most difficult jobs that a police photographer may have to do is to photograph a homicide. Most police photographers spend many hours learning how to photograph a homicide, yet have the good fortune throughout their careers of never having

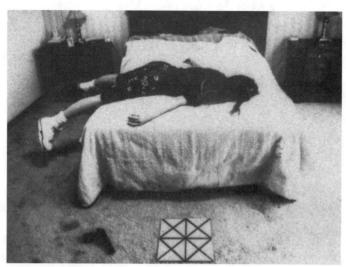

Figure 13.1Perspective grid photography. A rectangle or square is prepared and placed in the photograph.

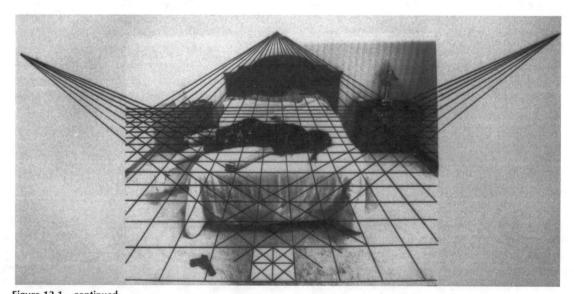

Figure 13.1—continued

Extend the rear and far edges of the grid to rise beyond the left, right, and top edges of the photograph. Continue drawing lines to these "vanishing points" until the rows of "squares" cover the photograph area to be mapped.

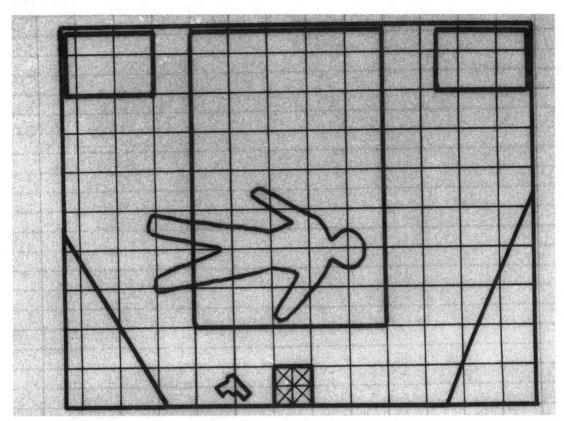

Figure 13.1—continued

Prepare an orthogonal grid map from the photograph. The two angular lines appearing on the sketch indicate the camera's angle of view. This example shows one-foot squares.

to put their learning to use. Others may have to do this job only once or twice, and though they have had little practice, they must carry out their task to the fullest of their training, talent, and intelligence.

The material below discusses the major points that should be stressed when covering a homicide; each angle mentioned should be taken carefully. The photographer may use his or her discretion in taking any additional shots that he or she feels may help to solve a case. Film seems inexpensive when one considers that these photographs cannot be taken again.

In all cases of murder, it is essential that the photographer arrive at the scene as soon as possible. Nothing should be moved and no search at the scene of a homicide should be made until all photographs have been taken that accurately record the scene. On occasion, it is necessary for the medical examiner or coroner to examine the victim to verify death, but usually it is not necessary to move the body for this purpose.

Full coverage of the scene of the crime must be made, showing the body in relation to the other objects at the scene. If outdoors, several shots from different angles and an overhead shot of the body (see Figure 13.2) and the weapon or instrument are usually sufficient, but if there are any footprints, tire marks, or other marks that could assist in tracing the person responsible, they must also be photographed. As has often been stated, it is better to take too many photographs than too few; this is especially true in a murder investigation when the photographer will not have another opportunity to return to the scene and take additional pictures.

Sometimes it is necessary to photograph injuries on the accused as well as on the victims; these injuries, as a rule, amount to scratches or other signs that indicate that the victims attempted to defend themselves. As the accused may be in custody, charged with the offense, the photographer may make arrangements to obtain the necessary pictures.

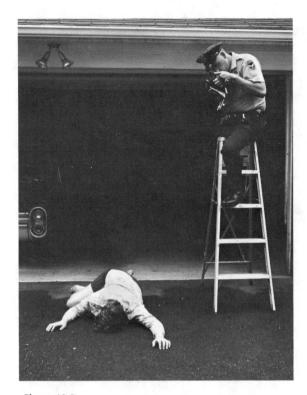

Figure 13.2 Taking an overhead shot of the victim.

If the crime scene is indoors, the same photographs will be required, but the photographer may be handicapped by the size of the room and furniture or other objects that cannot be moved. These disadvantages may be overcome by the use of a camera arranged to take photographs from directly overhead. A fairly small camera, either a special wide-angle camera or a 35mm camera with a wide-angle lens, can be adapted for use in this way. A long boom attached to the camera tripod, with the camera fixed on the end, is steadied against the ceiling, and the exposure made either by means of a long cable release or by the use of a solenoid and a battery. Some professional photographers use rubber grips to attach the camera to the ceiling, and others have obtained the same results with a clamp and a suitable attachment to a lighting fixture in the center of the room. These overhead cameras are the only satisfactory means of photographing bodies in such places as lift shafts, small bathrooms, and other small areas. Whatever method is used to obtain overhead photographs, the lighting that gives the best results without harsh shadows or "hot spots" is a flash bounced against the ceiling that acts as a large diffusing reflector.

Having covered the scene, it is necessary to photograph anything that has any bearing whatsoever on the crime, such as blood splashes, signs of struggle, or indications of alcohol or drugs. Marks of any kind should be recorded—a man was once identified by teeth marks on an apple he had bitten into at the scene of the crime. All outstanding peculiarities should be recorded, as in the case of the man who took off his shoes and socks so that he could use his feet to trigger off a shotgun, the barrel of which he placed in his mouth.

Any signs of entry or exit must be recorded, as well as any fingerprints left at the scene. As all of these photographs have to be taken before the investigating officers can search the scene or move the body, it is obvious that the photographer will have to work quickly. This can be done only if he or she has suitable equipment that is maintained in excellent condition, and an adequate strobe unit for flash photography.

After taking photographs at the scene, the police photographer should attend the post-mortem examination of the victim and take photographs as directed by the pathologist (see Figure 13.3). It is useful at this time to take photographs of the fully clothed body before it is stripped for the autopsy. Small format cameras capable of close-up work and, if necessary, having correction for parallax, can, with a small electronic flash unit, handle this kind of work. Should the pathologist require color pictures, the electronic flash will deliver light at a consistent color temperature.

Prints from all the photographs will be required without delay by the investigating officers, particularly photographs of any fingerprints that may have been found. A number of copies of these will be required so that a search may be made, and copies will also be needed to send to other law enforcement agencies. Other prints will be required for the purpose of house-to-house inquiries or for showing on television. All these requirements must be met by the police photographer with as little delay as possible, and the photographer should therefore standardize processing procedures and have ample assistance available to do so.

The police photographer may also have to take photographs at post-mortem examinations in cases of death other than murder—street accidents, accidents in the home, industrial accidents, suicides, drownings, and so on. Also, cases in which an inquest must be held are instances in which photographs are taken at a post-mortem examination. The photographs are usually required by the coroner at the inquest, though

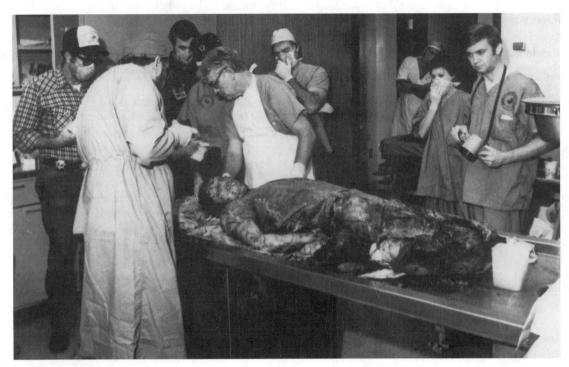

Figure 13.3 Photographing an autopsy.

in some instances where there are proceedings either in civil or criminal courts, the photographer may be called upon to give evidence.

Where cases of serious assault occur, a charge of robbery, wounding, or causing grievous bodily harm usually follows. Photographs in these cases will be required to show the extent of the victim's injuries in order for the court to assess the violence of the assault. The hearing of the case may occur weeks or even months after the assault, and during that time the victim usually has recovered from the attack and, if he or she is fortunate, the marks from the injuries have healed. Without photographs it would be difficult for any court to realize, from a medical description, the extent of the injuries. For this reason, arrangements must be made by the photographer to obtain photographs of the injuries. If the injured person is able to travel, is merely bruised, or has no wound covered with dressings, then perhaps the best way to obtain the photograph is to bring him or her to a laboratory for the pictures to be taken.

In the case of bruising, always remember that bruises are more apparent at about 24 hours after the assault, and it is better to wait for a period of time to allow the bruising to develop than to take the photographs too soon after the occurrence of the assault. Additionally, the victim is usually in a state of shock immediately following an assault, and a delay will usually produce a more cooperative subject.

Wounds may have to be treated by a doctor as soon as possible and, of course, are covered with dressings. There is no point whatsoever in photographing any person covered with bandages because, however incapacitated the person may appear, there may be very little injury, if any, under the bandages. The photographer should not, in any event, remove any dressings in order to obtain a photograph. If it is necessary to obtain photographs of wounds, this must be done by arrangement with, and in the presence of, a doctor. A telephone call will reveal when the doctor has directed that the dressing should be changed. There is normally no objection to the photographer being present when this is done, in order for the necessary photographs to be obtained. Doctors are helpful in instances such as this because the photographs are very useful to them when they appear in court to give medical testimony with respect to the wound or wounds.

In cases of serious wounds, many victims are kept in the hospital, and the photographer is asked to work quickly in order to cause the patient as little discomfort as possible and to avoid the risk of infection. The same equipment as that suggested for use at postmortem examinations is ideal for this kind of photography. In these cases, it is generally only necessary to show the extent of the wounds, and that being so, it is doubtful whether a color photograph would do a better job than one in black-and-white. The photographer should be guided by the doctor in this case, and should he or she determine that a color photograph is required, color film should be used.

The first person to arrive at the scene of a homicide has the responsibility of determining whether the victim is dead. This is the only exception to the rule that nothing be touched. In order to ascertain whether the victim is actually dead, the officer should observe carefully whether the victim is breathing and then should feel for a pulse at either the neck or wrist. While doing this, he or she should touch the body as little as possible and try not to move it out of the position in which it was found. The first duty of the police officer is to protect life and property. If there are any signs of life, first aid should be administered and the person should be taken to the nearest hospital.

If there is no sign of life in the victim, the police photographer should consider, "What will I have to photograph now so that I can convince a jury that this is the way the scene actually appeared?" All the officers at the scene should be instructed not to touch anything until the series of pictures is taken. The photographer should keep in mind that an important objective of these photographs will be to accurately convey to other investigators and persons how and where this crime was committed.

Not all homicide cases will end up in court, but those that do will require good negatives from which courtroom presentation photos can be made. A Chicago detective, giving a talk on homicide photography at a convention, once stated, "On arriving at the scene of a homicide, always keep your hands in your pockets and survey the situation for at least 10 or 15 minutes. Figure out all the possible angles you would need and then begin taking your photographs." The photographer may not be given that much time to compose the work, but the basic idea of patience and thought before photographing should be kept in mind.

How to Photograph a Homicide

The police photographer is always under a great deal of pressure from the coroner and others at a homicide scene. They may wish to rush the body to the morgue. The police photographer must not allow these pressures to interfere with the work. Later on, these same people will want to have photographs that were taken properly. Views should be taken of the entire scene, showing the location of the body and its position in relation to its surroundings.

To photograph a homicide:

- Start by taking an overhead shot of the victim.
 Try to get as high above the victim as you possibly can for this shot. You may have to improvise.
 If you can obtain a stepladder, that will suffice.
 Stand as high as you can on it, then shoot straight down on the subject, and try to avoid shooting from any angle other than vertical (see Figure 13.2). A shot from an angle or a long shot of the subject will be distorted.
- 2. If the body is in such a position that you can circle it, your first shot should be from the head to the feet, then go clockwise to the subject's right arm and take another shot. Then move down below the subject's feet and take a shot from the feet-to-head position, and for your last clockwise shot, move over to the subject's left arm and take a picture from that angle. If this scene is outdoors you will have no problem taking these shots because you will easily have enough room to operate. However, you will find that most homicides are committed indoors, where you will have a limited amount of space in which to work. Be sure to document where photographs were taken on the crime scene sketch (see Figure 13.4).
- 3. After you have taken shots of the general scene and shown the location of the body in relation to its surroundings, begin to take close-up views of the body and its immediate surroundings. In step two, you took the general views and the full length shots of the body. Now move in closer and closer, taking pictures of the head, body, arms, hands, legs, and feet. Be sure to take specific photographs of the wound marks (see Figure 13.5). These can be very important photographs for the police officer to have in the courtroom.
- 4. If a gun was used in the homicide, be sure to take photographs of any bullet holes in the furniture, walls, floors, or any other place where the bullet might have landed (see Figure 13.6). Always take close-ups of the bullet hole itself.
- Next, look around the vicinity of the crime, and
 if you find any weapons, objects or instruments
 that were used to perpetrate the crime, be sure to
 take close-up shots of all of these objects (see
 Figure 13.6).

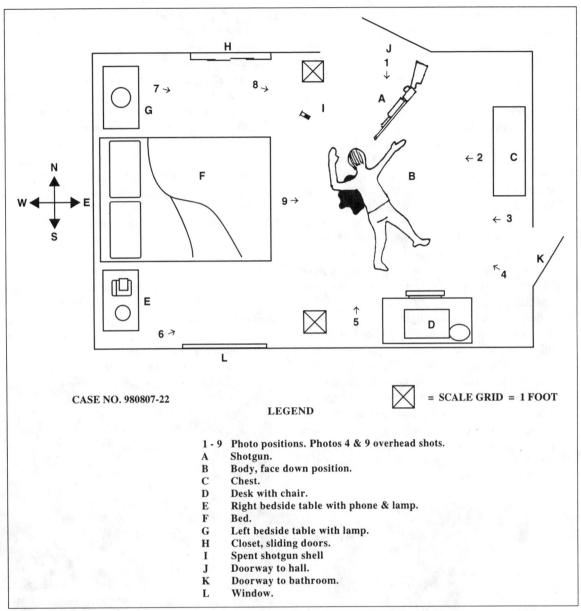

Figure 13.4 Crime scene sketch showing position of camera for each photograph.

- 6. If it is at all possible, use a tripod to take all of these shots. This is a good example of shooting to get fine detail in your negative, so try to take these photographs at f/16 or f/22. The speed can then be obtained from your light meter reading. If you are using a tripod, you can use any speed, depending on for what your light meter calls.
- 7. After you have taken the above shots and before the body is removed, you should chalk the outline of the body and also chalk any other objects that are related to the crime. When this is com-

pleted, the body may be removed. After the body is taken away, begin taking all the shots over again that you took before the body was removed. One of the major reasons for this is that once the body is gone, there is less confusion at the scene. Second, repeating the same shots with the chalk image ensures having one good negative out of two shots of the same scene. Show the chalk marks in relation to the furniture if indoors, or to other objects if outdoors.

- 8. Be sure to photograph the entire inside of a home. If the murder happened upstairs in a bedroom, photograph all other rooms upstairs, especially those adjacent to the crime scene. Be sure to photograph every ingress and egress room to the homicide scene. The best shots that you can take of a room will usually be those taken from the corners of the room. Take at least one photograph from each corner of the room. Be sure to include a perspective grid or similar measuring device in the photographs.
- 9. If the crime happened in a bathroom, which may be rather small, put a wide-angle lens on your camera and shoot with it. This is a good example of a situation in which you will probably have to shoot at f/22 or f/32. Remember also that if you have to use flash in the bathroom scene, you may have to put a handkerchief or two over your flashlamp because bathroom tile and fixtures reflect a great amount of light.
- 10. The next step is to photograph anything that might have fingerprints on it. If the objects are movable and you can take them into the crime laboratory, it makes it much better for the fingerprint specialist to photograph the object because a better job can be performed there than on the scene. If it is impossible to bring the object into the laboratory, however, you will have to photograph fingerprints or any other evidence at the scene of the crime.

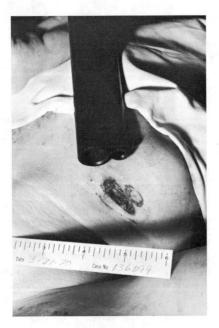

Figure 13.5 Close-ups of gunshot and stab wounds.

- 11. In a clockwise fashion, photograph the exterior of the building, usually from distances of about 75 to 100 feet away. Start with a shot of the driveway and front of the house, and move in a clockwise fashion, taking views from each side of the house. Include a view of the backyard and garage. Be sure to show all possible entrances and exits that the perpetrator may have taken.
- 12. Take photographs showing the landscaping, shrubbery, fences, buildings, and all surrounding homes to show what kind of a neighborhood it is.
- 13. Later, if this develops into an important case, aerial photographs may be taken, showing the house where the homicide occurred and its surroundings.
- 14. Take some shots from the front of the house looking down the street from both sides of the home. Of course, you should include the driveway and all other accesses to the home.
- 15. Go to the rear of the house and take some shots from the rear showing all possible ways the intruder may have come to the house from the rear, and go out to the next street.

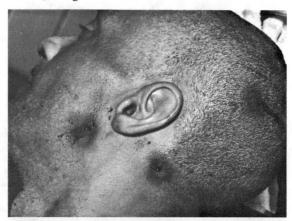

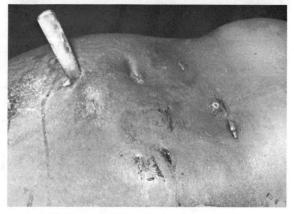

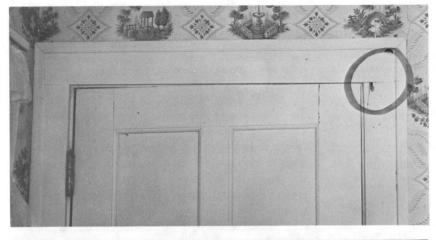

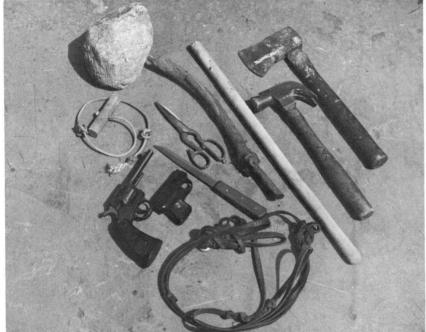

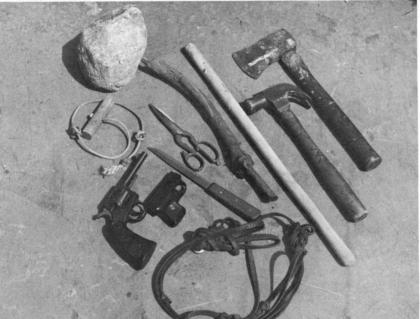

The homicide may have been committed in a small room. Always treat the small room as you

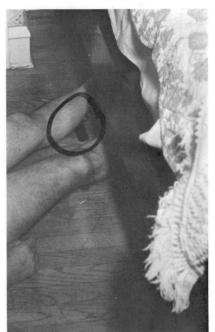

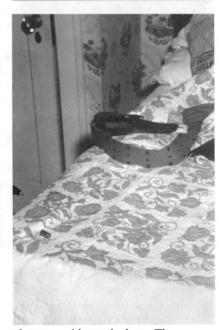

would a bathroom and use a wide-angle lens. The courts usually admit wide-angle pictures of room interiors because they often furnish pictures that cannot be obtained in any other way. Be sure to draw sketches as you work, to show exactly where you were when each of the photographs was taken. Perspective grid sketches are particularly helpful to show camera positions, if the grid is placed in the same location in front of the camera for each shot.

Lighting for a Homicide Scene

Achieving proper lighting is the biggest challenge facing the police photographer. Unlike the professional studio photographer, who has a relatively fixed lighting arrangement, the police photographer must frequently work outdoors, at night, where a flash does not provide enough light. Indoor photography, day or night, is easy by comparison.

There are several ways to attack the problem of lighting for outdoor photography at night. The photographer can:

- 1. "Paint with light."
- 2. Use a large strobe unit.
- Use three or more strobe units as slave units.
 The strobes may be connected with cords to the main strobe, or they can be rigged with slave attachments.
- 4. Use photofloods where house current is available. Light bars of the type that movie and video cameras use can be set on tripods or improvised stands and aimed at the subject.

When using color film to shoot a homicide scene it is best to use an electronic flash for all lighting. Photofloods must be checked to make sure that the color temperature is correct for the color film that is being used, and that the proper color balancing filter on the lens is used with daylight-rated film. The photographer should practice shooting outdoors at night and keep a record of everything performed so that when the practice film is developed, a record of what was done correctly or incorrectly can be made.

Homicide Photography Summary

When photographing the scene of a homicide, the photographer should reproduce what his or her eyes are seeing and relate this to other people. The photographer will have to show the manner in which the homicide occurred, views of the room with the body in it, all the rooms surrounding the crime scene, and all ingresses and egresses to the crime scene. The photographer must show whether there was any evidence of a struggle, and try to show what was happening in the room prior to the crime. Obvious evidence such as drinking glasses, bottles, and any trace evidence such as cigarette butts, blood, or broken glass should be noted. The circumstances of death can be illustrated by various views of the body, including close-up shots of the wounds and bruise marks. Finally, the photog-

rapher must photograph the weapon and the place from which it may have been taken.

Suicide Investigations

Of the many investigations to be performed by the police, one of the most difficult is a suicide. The investigator often determines whether the act is a suicide, a homicide, or an accident. Suicide victims typically wound themselves with a knife in the throat, wrist, or heart region, or with a gunshot through the temple, forehead, center of the back of the head, mouth, chest, or abdomen. Although some wounds, such as a knife wound in the back or cuts on the palm of the hand, tend to suggest a crime other than suicide, neither the position and depth of the wound nor the seeming difficulty of self-infliction should exclude suicide as an explanation.

How to Photograph a Suicide

If there is any doubt as to whether a death may be a result of suicide, the scene should be photographed in the same manner as a homicide. It may not be determined until several days, weeks, or months later whether it was a suicide; if the case should turn out to be a homicide, you will have photographs. A good rule is to treat every death investigation as if it were a homicide.

Suicide by shooting. Photograph both the entrance and exit wounds. Place identification alongside each wound as well as a ruler for measuring. The entrance wound is always larger than the diameter of the bullet. Usually, the hairs surrounding the entrance wound will be singed and the skin will be burned to a reddish or a grayish-brown color. Also, if the shot was fired from a range of less than eight inches, a smeary black coat of powder residue may be evident. If possible, photograph close-ups of the wound in color to show these various discolorations.

If the victim was shot through clothing, infrared photography (see Chapter 18) may record a better pattern image.

Suicide by hanging. Strangulation by hanging is a common form of suicide. But the investigator must not assume that a victim found hanging committed suicide. Photograph the subject at a distance from four views, showing the full body. Then move in close and show the knot, bruise marks and, if shooting in color, the discoloration of the body.

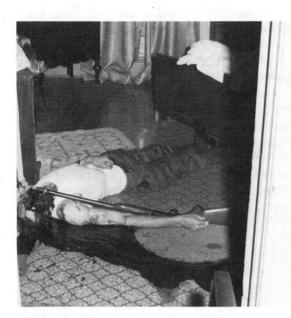

Figure 13.7 Suicide by shooting.

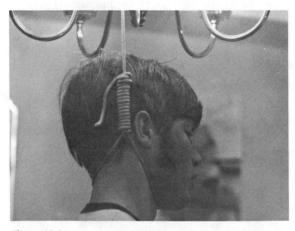

Figure 13.8 Simulated suicide by hanging.

Suicide Photographs Summary

A suicide case should be photographed as though it were a homicide, but the photographer should not assume that it is one or the other. Careful work is important, because should the death be determined a suicide, the victim's insurance company may need to see photographs of the deceased before settling a claim.

Sex Offense Investigations

The crime of rape may be taken as typical of this class of offense. The purpose of the photographic subjects listed below is to offer useful information on signs of any struggle; indications of the victim's efforts to resist, such as bruises or black-and-blue marks; and evidence of the presence of either or both parties at the scene.

Scene of the Crime

A photo of the locale itself may be important to show that the cries of the victim could not be heard or to illustrate the fact that the nature of the place would make it an unlikely meeting place for ordinary social purposes. Photographs that show the remoteness of the scene from general traffic or from the nearest dwelling house may be useful. Four views diagonal to the purported scene of the crime should be taken. A single photograph in a case like this may be very misleading. For example, a view of the scene may show it as a desolate and uncivilized area, while a slight change in the position of the camera may show that the spot is very near a dwelling house.

The positioning of the camera at an improper height above the ground may also create misleading photographs. For example, suppose the scene of an alleged sexual offense is a deep hollow in a park; if the camera is placed close to the ground near the brink of the hollow, the resulting photograph will create the impression that no hollow exists. This is because the farther bank blends with the nearer bank, creating the impression of level ground. The proper way to take such a picture is to raise the camera sufficiently to include both the hollow and its nearer and farther banks. From this level, a correct view of the surroundings will be obtained.

Photographs of stains or marks should also be taken at the scene of the crime. When photographing blood stains, it is permissible to use contrast filters. Selection of the proper filter will often enable the photographer to bring out marks that are practically invisible to the naked eye. After the stains have been photographed, specimens should be carefully preserved for submission to the medical doctor or other specialist whose duty it is to identify them and prepare photomicrographs for use as evidence.

Additional shots should be made of special features such as foot and tire impressions; broken

branches; buttons; torn clothing or other personal property; used matches and books of matches; disturbances of rocks, foliage, and other natural features; and displacement of other objects from their normal positions. An indoor crime scene may also contain evidence of a struggle, which should be photographed. Fingerprints, if found, should be photographed with a fingerprint camera, macro lens, or close-up lens attachments.

Photographs of the Suspect

An examination of a suspect by a physician and the assigned investigator may reveal evidence that will link the suspect to the scene. It is desirable to photograph such evidence in the position in which it is found. The suspect's body may show evidence of a physical struggle, such as scratches or bruises. Foreign hairs, pollen granules, or fibers may be discovered by the physician. The garments of the suspect may reveal blood, semen, or traces of grass stains or mud. Because semen fluoresces, it can be shown easily by ultraviolet photography. Trouser cuffs, pockets, or folds in clothing may contain weed seeds or soil. Similarly, if the crime took place indoors, materials peculiar to the premises may be found on the suspect's person or clothing (i.e., grease, carpet fibers, paint, etc.). When photographing physical evidence, include a data sheet and a ruler.

Photographs of the Victim

Evidence of resistance to the criminal act is particularly important in sex offense cases involving adult victims. Thus, marks and discolorations of the body in general (color film is excellent for this); the condition of specifically affected parts; and the presence of foreign hairs, fibers, and biological stains are significant. Traces associating the victim with the crime scene, such as those described in the preceding section, are also important in some cases to corroborate the victim's account of the occurrence. In photographing the person of the victim, permission should ordinarily be obtained previously, preferably in writing, from the victim or from the parents or guardian if the victim is a minor. It is recommended that the victim's physician be present when such photographs are taken.

In child physical and sexual abuse cases, color photographs should always be made of the victim's injuries. Social service or human service social workers may also request such photographs in their investigations of child abuse. Such photographs are usually made at a hospital or department of human services offices. If parents are suspected of causing the injuries to their child, human services workers are empowered to take emergency legal custody of the child and can provide legal permission for photographs to be taken by the police photographer. Bruises, lacerations, and especially, bitemarks (see Figure 13.9) should be photographed with a small scale or ruler in the photograph. Including a scale will enable forensic odontologists and pathologists to accurately match the perpetrator's teeth or the instrument that caused the injury.

One photographic technique, reflective ultraviolet photography (RUP), has been used by dermatologists during examinations to detect cancer and fungi growth on skin. This technique can also be used to document injuries on skin up to nine months after they have visibly healed (Aaron, 1991). The RUP technique can be useful in child abuse and assault cases if injuries have faded or disappeared visually (see Figure 13.10). This technique is discussed further in Chapter 17.

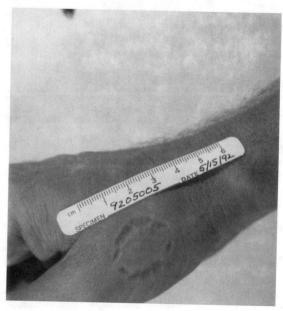

Figure 13.9
Bitemarks should be photographed with a scale or ruler.

Figure 13.10 Injury revealed by reflective ultraviolet photography (top) and photograph of buckle that caused the injury (bottom).

Burglary and Breaking and Entering Investigations

The burglary investigator should always try to take photographs with the thought of how these pictures will help to prove that the suspect was the one who committed the crime. However, you must realize that most of the pictures of a burglary will be used mainly in assisting a detective to solve the case. Rather than take a suspect around the city to show him or her some of the homes that were broken into to refresh his or her memory, detectives can show the suspect photographs to help him or her recall whether he or she was involved in any of those burglaries. A good set of burglary photographs can save the detective a great deal of work and time.

Photographs are also necessary in order for the prosecutor's office to successfully argue a case. Many cases are lost because the prosecutor does not have the right kind of evidence to use in court. The prosecutor's objective is to show that a particular crime was committed, and that the accused perpetrated the crime. The prosecutor must establish the elements of the offense and produce evidence associating the defendant with the crime scene and events.

For example, in a burglary, the elements of breaking and entering would dictate taking photographs of the exterior of the building with close-ups of the window, showing where the "jimmy" had been applied. Views of the ransacked room or the rifled safe would aid in showing the intent of larceny. Photographs of footprints and fingerprints would tend to link the suspect to the scene (See Chapters 14 and 15).

Photographing a Burglary

It is up to the officer taking the pictures to decide how many photographs to take. Usually, for a routine burglary, six to eight shots should suffice. In planning a series of photographs, the elements of the offense can dictate the type and number of photographs to be taken.

When covering a burglary photographically you should include (at least) the following shots in your set, photographing in color if possible.

- The exterior of the building in which the burglary occurred.
- The point of entry. Just as you did in the homicide case, begin with a distant shot, and then work in to get close-up shots to show the forcible

- entry (see Figure 13.11). Many times you will have to examine the house or building very carefully to find how the criminal entered. Look in the window wells of the basement, check all doors, windows, and other openings.
- Each room in the house or building that is disturbed should be photographed. If you have a wide-angle lens, use it. Take shots from all four corners of the rooms that were ransacked. Usually two pictures, one from each diagonal corner, should suffice in a burglary case.
- 4. Take shots of all furniture or articles that show evidence of being disturbed (see Figure 13.12). If the articles cannot be taken to the laboratory, then photograph each article at the scene. The lab technician will check each article you take to the lab

Figure 13.11
Points of entry (clockwise from top left) doorway; hole in flooring; close-up of hole; basement window; close-up of tools used to pry window; broken window; and another doorway.

for fingerprints, and photograph each article. When this is done, be sure to identify each item as to its origin, the date, and your name. Get in the habit of identifying any item on which you are working.

- 5. If you can determine how the criminal left the house, photograph his or her exit.
- 6. Many times, when a burglar is in a house, he or she will be surprised by someone. In his or her haste to leave the house the burglar may leave something behind, such as a hat, gloves, scarf, cigarette butts, or burned matches (see Figure 13.13). Most of these articles are usually found at the scene and they should be photographed.
- 7. All available physical evidence, such as fingerprints, footprints, tire prints, crepe sole prints, heelprints, and tool marks and tools should be photographed (see Figure 13.14).
- 8. If the merchandise that was stolen is recovered, it should be photographed. If you recover some of

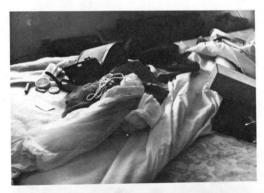

Figure 13.12 Ransacked rooms.

the merchandise later in the suspect's home or apartment, this should be photographed where it was recovered.

Arson Investigations

Arson is probably the most difficult crime to detect and prosecute because the evidence, especially the materials used by the arsonist, are usually destroyed by the fire. A photographer should go to the scene of every fire. He or she should be one of the first persons to arrive at the scene, so that photographs of the scene may begin before the arrival of fire trucks. All photographic equipment should be ready and photographs should be taken immediately. The entire progression of the fire should be photographed, taking factual pictures and leaving the sensational photographs for the news media.

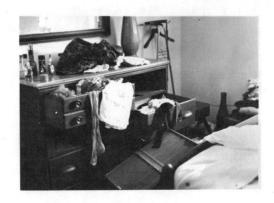

Figure 13.13
A glove left behind by a surprised burglar (top) and close-up (bottom).

One of the best methods of taking fire photographs is from a distance, with a camera that is equipped with a telephoto lens. The use of the telephoto lens avoids emphasizing one part of the fire over another. Pictures taken from a distance with a telephoto lens will often reveal important details that would appear insignificant in a picture taken at close range. Also, the smoke will not fog a telephoto lens at a distance.

As a rule, conditions will not be ideal. Look over the entire scene and try to discover the best position for photographing—preferably a high position. With the availability of large snorkel ladder trucks, the photographer may be able to shoot the scene from above (see Figure 13.15).

While the fire is burning, be sure to photograph as many of the spectators as you can. Most arsonists get satisfaction from watching the fires they started and they may be in the crowd. If you photograph all the spectators of a fire, and print so that most of the people are recognizable, you can compare the pho-

Figure 13.14 Close-ups showing "jimmy marks" on doors.

Figure 13.15

Fire ladders can be used to take photographs from high vantage points.

tographs of one fire with another. If you sight a particular spectator at many of the fires that you investigate, you would have a suspect whom you could question to further investigate whether he or she is an arsonist (see Figure 13.16).

Figure 13.16Photographs taken with telephoto lens showing suspicious action in the vicinity of the fire.

After the fire is extinguished, take exterior shots of the scene from diagonally opposite corners of the building. Also climb up high on a ladder and take more pictures of the ruins of the fire to show the extent of the fire. The immediate vicinity of the fire should also be photographed to show the location of the building in relation to other buildings in the neighborhood. It is advisable to shoot some photographs after a major fire from high adjacent buildings or even from a helicopter. Today most large cities, in conjunction with a radio station, have a helicopter to broadcast traffic reports. It may be possible to make arrangements to have the pilot fly above the fire scene and allow you to take these useful shots.

Photographs After the Fire

If the photographer for the fire department is not a trained fire investigator, then the fire department should combine both jobs, so that the individual who is the fire investigator is also the fire photographer. These jobs easily complement one another. If, however, the fire department has a photographer who is not a trained fire investigator, and they have another individual who does this work, then after the fire they should get together and go over the shots that they want. Nothing should be moved unless the chief investigator approves it. This is similar to police photography at a crime scene.

When the destruction is only partial, photographs of the interiors of every room should be taken, showing either damage by fire or smoke, or evidence of a planned fire (see Figure 13.17). These should be taken before any cleanup work is started. Pictures taken with a wide-angle lens from two diagonally opposite corners of each room will show most of the conditions in which each room was left by the fire. Sometimes, however, the photographer will have to take pictures kneeling, sitting, or even lying down, to photograph the ceiling. For this task, a pair of coveralls is almost as essential as a camera.

An indication of forcible entry, such as a broken window or broken door locks, demands close-up photography because such things are often signs that the fire was started to conceal another crime. All clocks that have stopped should be photographed, because the time shown may indicate the approximate time that the fire started.

After the photographs have been taken to show conditions immediately after the fire, photograph the debris being screened or sifted for evidence. Every step of this screening process should be photographed to show in what manner the evidence was collected. This screening or sifting process may take days or weeks before it is completed. When the point of origin of the fire or explosion is located, close-up photographs should immediately be made of any bits of evidence uncovered. After being photographed, such items should be turned over to the police laboratory.

Equipment for Fire Photography

The photographer must have a good tripod, because there are many times when slower film speeds must be used. Also, because lighting is tricky when photographing a fire, a light meter is essential to arson photography. Lighting is particularly troublesome when photographing burned interiors, because it is difficult to illuminate charred areas sufficiently. Some photographers use floodlights and move them about during long exposures to produce the effect of "painting with light." Others find photoflash illumination suitable. In partially burned rooms where the ceiling is not blackened, "bounce flashing" toward the ceiling often produces good results.

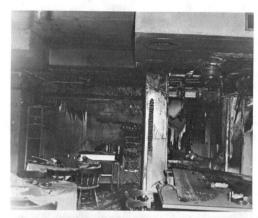

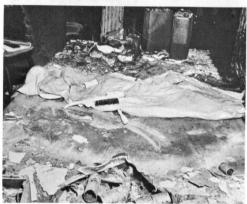

Figure 13.17
Interior of room showing damage done by fire.

Film for Fire Photography

For black-and-white pictures of fire and explosion scenes, use a fast panchromatic film such as Kodak Tri-X or T-Max or, Ilford HP-5 or HP-5 Plus. With these fast films, short exposures can be used that will be excellent for producing shadow detail. This is particularly important when photographing fire scenes, which usually contain many large, blackened areas. The exposure may have to be on the long side in order to show as much detail as possible in the charred areas.

Color photography can be done with Professional Ektacolor or a fast Ektachrome film. Color film does a much better job of rendering details of a burn pattern than black-and-white film. However, black-and-white film will show charring and "alligator" patterns better than color. The photographer should again consider using two cameras—one loaded with

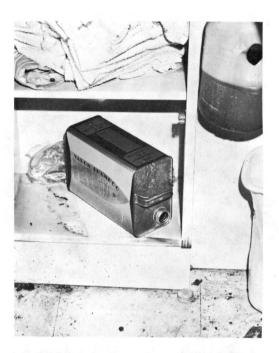

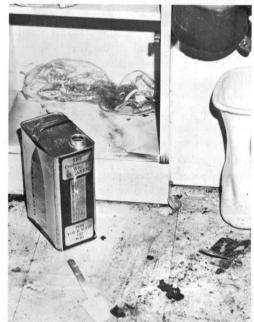

Figure 13.18Flammable liquid container in position found after the fire (top) and moved from cabinet (bottom).

color film and the other with black-and-white film. In this way, important details can be photographed with both color and black-and-white in order to assure that details will be depicted.

Importance of Photographs During a Fire

The extent to which the investigator can conduct a preliminary investigation during the actual burning will vary with the nature and severity of the fire. General observations can, of course, be made from an appropriate distance and detailed examinations of the nearby areas can sometimes be made at this stage. Much of the information suggested below can also be obtained from eyewitnesses later. Using color film and properly recording the events of the fire will be invaluable later. Below is a list of some of the evidence that can be obtained from a fire, which can help win or lose a case.

Smoke and vapors. The characteristics of the smoke, steam or other vapors that emanate from the fire are useful indicators for determining the nature of the burning substances, including the accelerants used. In the following list, the color of the smoke is related to the most common incendiary agent that may emit it:

 Steam and smoke. The presence of steam indicates that humid substances have come in contact with the hot combustible substances. The water present in the humid substance is evaporated before the substance begins to burn.

- White smoke is emanated by the burning of phosphorous, a substance that is sometimes used as an incendiary agent.
- Grayish smoke is caused by the emission of flying ash and soot in loosely packed substances such as straw and hay.
- 4. Black smoke is produced by either incomplete combustion or the preponderance in the burning material of a product with a petroleum base such as rubber, tar, coal, turpentine, or petroleum.
- 5. Reddish-brown or yellow smoke indicates the presence of nitrates or substances with a nitrocellulose base. Thus, smoke of this color can be emitted from the burning of nitric acid, nitrated plastics, film, or smokeless gun powder. A number of these substances can be used as accelerants (see Figure 13.19).

Color of flame. The color of the flame is indicative of the intensity of the fire and sometimes of the nature of the combustible substances present. The temperature of the fire may vary from 500 to 1,500 degrees centigrade, with the color of the flame ranging from red, through yellow, and finally becoming a blinding white. Some accelerants may give a characteristically colored flame. For example, burning alcohol is characterized by a blue flame; red flames may indicate the presence of petroleum products.

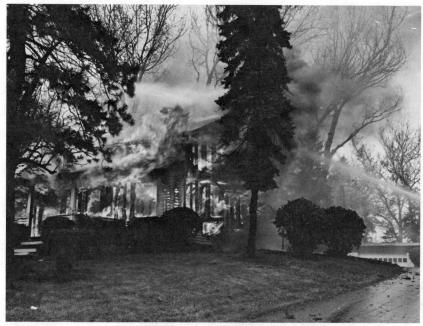

Figure 13.19
Photograph taken of fire in progress to illustrate direction and color of smoke.

Size of fire. The size of the fire should be noted at the time of arrival and at subsequent intervals thereafter. This information may be significant in relation to the time at which the alarm was received. An unusually rapid extension of the fire is indicative of the use of accelerants or some other method of physical preparation. A thorough knowledge about the construction of buildings is essential to the individual who wants to be an effective photographer of fire investigation.

Direction of travel. Because hot gases rise and fire normally sweeps upward, the direction of travel of a fire is predictable from a knowledge of the construction of the building. It will be expected that the flames will tend to rise until, on meeting obstacles, they project horizontally to seek other vertical outlets. The extent and rate of travel in the horizontal direction will depend primarily on the direction of the wind and on ventilating conditions, such as open doors and windows. The spread of fire in an unusual direction or at an exceptional rate should arouse suspicion as to the presence of accelerants or a prepared arrangement of doors and windows.

Location of flames. The photographer should note carefully whether there is more than one apparent point of origin and should try to estimate the approximate location of each. Unrelated fires in different places are indicative of arson. The incendiary may, for example, arrange timing devices in different places with the result that the separate outbreaks of flames will be apparent.

Order of searching. The area immediately surrounding the burned property should be thoroughly examined for evidentiary traces and clues. The doors and windows of the building should be studied for evidences of a break-in, particularly if the premises are normally locked during the period in which the fire took place. Tool impressions, broken window panes, and forced locks are obvious marks of such a break-in. The photographer should now progress to the interior, directing his or her observations to the charred

remains of the fire, primarily for evidence of the accelerants or other incendiary devices. Assuming that the burning has been extensive, the following order should usually be followed:

- 1. The outer shell of the remains.
- The first open area or floor from the point of entry.
- The first inner shell or wall of an inside room.
- 4. The general area suspected of being the point where the fire started.

Sketching and photographing. A photographic record should be made of the destruction accomplished by the fire and of physical evidence uncovered by the search. The photographer should follow the order of the search, photographing each area of significance to the investigation prior to the search. When the point of origin is located, it should be thoroughly photographed to show such points as the type and extent of "alligatoring," charring, and the remains of any incendiary device (see Figure 13.20). As each piece of evidence is discovered it should be photographed in its original condition and in its position when it is completely uncovered. In addition to the photographs, a sketch of important areas should be made that shows the location of the various articles of evidence. As an aid to the construction of this sketch, the photographer will find the blueprints of buildings maintained in the files of housing and building departments particularly useful in giving the dimensions and other details of the structure.

If victims are found inside the structure, the scene should be treated the same as if it were a homicide. Photograph position of bodies thoroughly and document their location on a sketch (see Figure 13.21). Photograph items found near the body and document clothing remains. If clothing has been burned away from the body, look for metallic objects such as buttons and buckles.

Figure 13.20
Photograph of pour pattern where accelerant was used to start a fire.

Figure 13.21Photograph of a fire victim showing position of the body in relation to the room. Notice the characteristic "pugilistic pose" or "fighter's stance" of the body due to heat drying of muscle

Figure 13.22 Telephoto photograph of a drug buy in progress.

Problems and Cautions for Fire Photography

The greatest problem the fire photographer will encounter is lens fogging produced by contact with heat and steam. The photographer must wait for the air to cool somewhat before attempting to photograph indoor damages. Smoke also forms a barrier that light sometimes cannot penetrate. Be careful when using flash units—they may explode in the atmosphere surrounding a fire.

Besides photographing scenes of crimes already committed, the police photographer may be called upon to photograph crimes in progress, such as "drug buys" (see Figure 13.22). Surveillance photography has long been used in police work to gather evidence and record meetings with offenders. Surveillance photographs can also be used to provide documentation for procuring search warrants (see Figure 13.23). Surveillance photography requires that images be clear with persons recognizable and automobile license plates readable. However, surveillance photography also may require that the photographer be as hidden as possible. The use of high magnification telephoto lenses and high speed film is of importance in surveillance photography. A telephoto lens of 500 or better power may be required to take clandestine

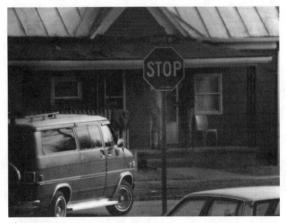

Figure 13.23
Telephoto photograph showing vehicle activity at a residence suspected of housing drug dealing. Notice the street sign included in the photograph to aid in identifying the location for a search warrant.

photographs of individuals and places of "business." Most telephoto lenses of high magnification are fixed f/stop, usually f/8, which requires faster film and/or optimum lighting conditions. However, since the police photographer cannot choose the time and place of surveillance pictures to be taken, he or she must be able to choose from equipment and film that will do the job. Film is the main item to be selected for surveillance work. The film should be a high speed (fast) film of at least 1000 ISO. There are several black and white films available, such as Kodak T-Max P3200, which can be used with speeds from 1000 to 50,000 with push-processing. Color films that can be used in

low light surveillance situations include Fuji Super HR II and Kodak Royal Gold 1000, with daylight speeds of 1,000, and Kodak Gold Professional (PPC) with daylight speed ranging from 1600 to 6400. Other equipment essential to taking good surveillance photographs includes a sturdy tripod, polarizing filters to fit the telephoto lens (particularly helpful when shooting through windows), and a "night-vision" scope attachment (see Chapter 18).

References

Aaron, J.M. (1991). "Reflective Ultraviolet Photography Sheds New Light on Pattern Injury." Law and Order, 38:213-218.

Evidence Photography

Many valuable articles of evidence can be found at the scene of a crime. Each object should be photographed individually and in relation to other objects at the scene. Three purposes are served by this procedure: (1) a permanent record is made of the original appearance of the object; (2) the photographs can be used in place of physical evidence to supplement the case report; and (3) each article is preserved from unnecessary handling, which might cause the evidence to deteriorate or otherwise become altered.

Whenever possible, some or all of the evidence samples should be retained to be photographed in the laboratory where the equipment needed for photomicrography and macrophotography are available.

As a general rule, a photograph should be taken at the scene of any piece of evidence that might deteriorate, change over time, or any evidence that cannot be moved from the scene or that might be damaged by handling. Objects that typically require individual photographs are tools, weapons, clothing, and contraband. Close-up photographs should be taken with color film (when possible) of wounds, bruises, scratches, and identifying marks on the body, and punctures in the skin of a narcotics addict.

Photographs at the Scene of the Crime

In addition to the overall shots of the crime scene, photographs should be made of items of physical evidence as follows:

 Objects that serve to establish the fact that a crime has been committed (the corpus delicti).

- Evidence relating to the manner in which the crime was committed (the modus operandi of the criminal).
- 3. Objects that might provide a clue to the identity of the perpetrator.
- 4. Clues that would connect a suspect to the crime.
- 5. Anything that has any bearing on the crime, such as blood splashes, signs of a struggle, or any indication of drinking or drugs. Any mark, no matter how slight, should be photographed.
- 6. Fingerprints found at the scene.

If a body is taken to the morgue, it should be photographed there as directed by the pathologist. The body should be photographed with any clothing that is on the body when it is found, and then without clothing. When photographing a body at the morgue, color film and a strobe unit should be used. The electronic flash or strobe unit will deliver light at a consistent color temperature.

Procedures

Three photographs of each item of evidence should be made. One photograph should be from a distance sufficient to show the object against the background of its setting so that it can be located and referred to in the overall crime scene photograph. The other two photographs should be taken close-up and with a fairly large image size to clearly show the nature of the object and its identifying characteristics. A small ruler should be included in one of these close-ups and omitted in the other (some attorneys

may object to the ruler and claim that it changes the scene). Paper or cloth rulers that include room for the date, case number, department, and the officer's name can be purchased.

Shots should also be taken from the viewpoint of the witness or witnesses, if any, to show that, from where they were standing, they could see all that was happening.

Extreme close-ups may be needed, but they involve specialized techniques and are made at the police laboratory or at the morgue.

Data Sheet

A data sheet should be included for every evidence photograph. If a data sheet cannot be included in the photograph with the evidence, the data sheet should be photographed on the film frame prior to the evidence photograph. This procedure will help the officer recall what the following photograph depicts. The use of data sheets is becoming uniform throughout the country.

The data sheet should include the date, time, case number, location, and officer's name. Dates should be written in digits in the following order: month, day, year. January is written 01, February 02, and so on, so

that all months are written as two digits. In the same way, days should be written as follows: 01, 02, 03, etc. Years are abbreviated to the last two digits: 97, 98, 99, etc. Thus, every date will be composed of six digits: January 15, 1998 is written: 011598. The twenty-first century may be troublesome and confusing for some dating sequences since the two digits would be 00. This is the primary reason for placing the year at the end of the sequence.

The time should be written in the following form: 01:15 PM. Case numbers should signify logical representations. In small departments that handle less than 100 cases a day, the case number can be written as the date plus a two digit number, separated by a dash, indicating the number of the case for that day. The third case handled on January 15, 1998, would be written: 011598-03. This numbering system can also be used for mug shots.

The location should be given as the address where the crime took place and the last space should be filled with the photographer's name.

Some cameras (such as Minolta and Nikon) come with optional data backs that imprint the date and time on the face of each photograph. Such an option may be beneficial in the absence of a data sheet and is particularly beneficial for use with crime scene and traffic accident photographs.

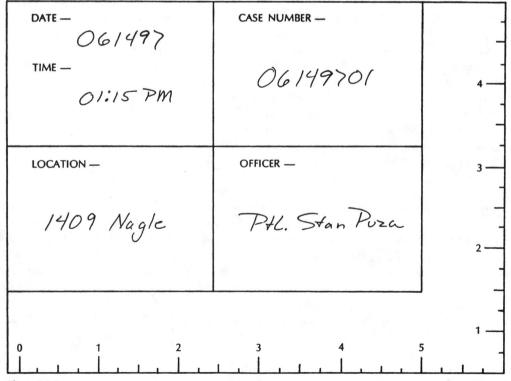

Figure 14.1 Data sheet.

Foot or Shoe Impressions

The imprints of shoes in soil are quite often found at or near crime scenes. Before reproductions are made by plaster casts or dental stone, the impression should be photographed. The camera, placed on a tripod, should be directed so that the camera axis is perpendicular to the plane of the impression; that is, the lens board and film should be parallel to the ground. The height of the camera should be adjusted so that the whole impression is included in the film with a fairly large image size. A ruler placed at the side of the impression will indicate size. If a particular area of the impression contains any peculiar characteristics that may be helpful in identifying the foot or shoe, a closer shot should be taken so that this area (including the ruler) fills the picture and the desired information is given in clear detail.

Oblique lighting (lighting that is low and to the side of the impression) is used when photographing impressions. The low light emphasizes the impression by creating shadows wherever there are ridges in the soil. Photographs made in daylight should be taken with photoflood, strobe, or photoflash placed obliquely to counteract the flattening effect of direct sunlight. Indoor shots and night shots should be made with photoflood whenever possible because this lighting can be easily controlled. Flash may provide too much light; if necessary, the flash may be cut by covering it with a handkerchief, or by using the bounce flash technique.

One method used to create shadow effects in footprints in light-colored soil or snow is to use black primer spray paint. Direct the paint spray at an oblique angle to the impression to "create shadows." A flash may not be required when this technique is used (see Figure 14.2).

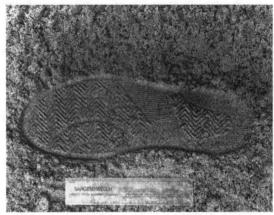

Figure 14.3
Shoe print in sand sprayed with black paint at an angle to "create shadows."

Close-Up Photography

Evidence of all kinds must be photographed close-up to show details. The single-lens-reflex (SLR) camera is best for this kind of work because of its size and because parallax is avoided. The photog-

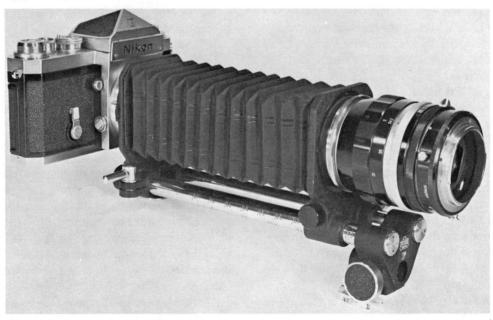

Figure 14.2
Bellows attachment. Lens is reversed to increase image size.

rapher can add any of three powers of close-up lenses to a good SLR lens, or pair them as needed. The powers of close-up lenses are measured in diopters. A +4 diopter lens is the strongest. When two close-up lenses are used together, the stronger lens (the one with the highest number) should be next to the lens of the camera (see Chapter 5).

Close-up lenses simply allow the photographer to get closer to the subject. By adding a lens of +1 strength, one can get within 20 to 40 inches of the subject; a pair of +3 lenses will reduce the working distance to about six inches, which would cover a field not more than 4×3 inches.

Depth of field is practically nonexistent in closeup photography. There is no margin for error and focusing must be accurate within a fraction of an inch. Working distances should be measured from the front of the close-up lens to the front of the object being photographed. If the camera is on a tripod, a yardstick can be used to position it at a specific distance from the point of focus.

Extension tubes or bellows can be used for large images at medium to close working distances. Bellows extensions are bulkier than tubes but are more versatile and, of course, more expensive. These units vary greatly, and generally are used with cameras that have focal plane shutters.

Basic exposure is subject to change with extension tubes or bellows, because they alter the lens-to-film distance. The light-transmitting capacity of a lens diminishes in relation to the length of the tube, necessitating a longer exposure for a given f/stop than the basic lens position requires. This obviously includes a reduction in the maximum "speed" of the lens.

The f/number is determined for the lens being used at about one focal length. If a lens is set at f/4, the opening of the diameter of the lens is 1/4 of the focal length. If the lens is placed on extension rings or a bellows attachment and extended from the film plane, the true f/number will change and an adjustment will be necessary to avoid underexposure. In order to determine the actual f/number when using extension rings or bellows, multiply the reproduction ratio by the indicated f/number and then add the indicated f/number to the product. For example, if you increased the lens-to-film plane distance with a bellows or extension ring to achieve a four-power magnification and the lens' indicated f/number is f/2.8, four is multiplied by 2.8, equaling 11.2, and the indicated f/number of 2.8 is then added to 11.2 giving a true f/number of f/14. The shutter speed should be adjusted to reflect f/14 rather than f/2.8 at four-power magnification.

Another problem is reciprocity failure. When the proper f/number has been determined and the lens is set at a small aperture, resulting in long exposure times (usually more than 15 seconds), the resulting negative may still be underexposed. One unit of light exposing film for 60 seconds will not have the same effect as 60 units of light exposing film for one second. This is the law of reciprocity. To avoid reciprocity failure, use wider apertures and shorter exposure times, and bracket exposures.

Determining the distance from lens-to-film plane for a desired power may also be a problem. If a "normal" 50mm lens is mounted on a bellows or extension ring and a three-power magnification is desired, the reproduction ratio of three is multiplied by the focal length of 50. The 150 product means that the lens must be extended 150mm from its normal position for a three-power magnification. By the same token, the magnification power can be determined by measuring the lens-to-film plane distance and dividing by the focal length of the lens. For example, if the lens-to-film plane distance using a bellows or extension ring is 170mm and the lens focal length is 50mm, the magnification will be 3.4 power. This may be useful information when a defense attorney asks "What power magnification is this picture?"

A rigid camera support is essential for close-up work that usually requires slow shutter speeds or time exposures. When using bellows or extension rings, the camera may become very heavy, making it susceptible to jarring and vibration, especially during long exposures.

Lighting for Small Objects

Special equipment is needed to light very small objects to enhance texture or to create special effects. Most close-up exposures require maximum illumination in places where shadows are cast by the equipment being used. Standard floodlights, if placed too near an object, are likely to light it too evenly and flatly; furthermore, if the evidence is perishable, heat from the floodlights may destroy it.

A 150-watt miniature spotlight is a good lamp to use for lighting close-ups. A metal tube called a snoot can be added to the spotlight for a narrower beam. Illuminators and fiber-optic lights designed for stereomicroscopes and compound microscopes also work

well with close-up photography. Ringlight electronic flashes are excellent for close-up photographs. Ringlight flashes are circular and attach directly to the camera lens.

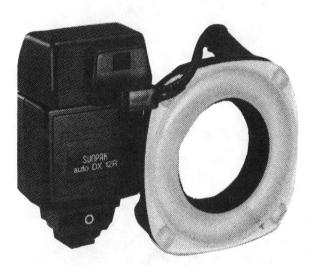

Figure 14.4 Ringlight flash attachment. The Sunpak DX 12R ringlight flash attaches to the front of the camera lens for close-up flash photography.

Axial-lighting, also called vertical illumination, is another technique for illuminating small items for photographic details. The principle of axial-lighting involves a beam splitter to project light onto an object so that it reflects back directly toward the camera lens. The photographed object appears as if it is the light source—almost glowing. Excellent detail can be revealed through this technique. A beam splitter uses an optically flat glass mounted at a 45-degree angle to a light source. A slide projector is an excellent source of illumination. The light is projected horizontally onto the glass. The glass "splits" the beam of light allowing one beam to be directed onto the object to be photographed (see Figure 14.5). The glass can be adjusted for the desired effect. Axial-lighting may be troublesome for through-the-lens (TTL) camera meters, so that bracketing of exposures may be necessary. Optically flat glass may be obtained from any glass supply house, or a true beam splitter (5 x 7-inch size) is available from Edmund Scientific.

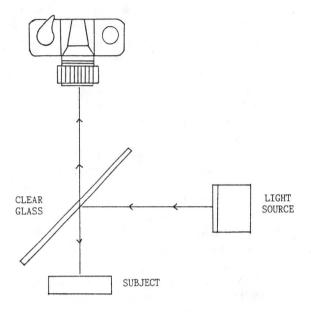

Figure 14.5 Diagram showing axial-lighting technique (top). Photo of serial number taken by axial-lighting technique (bottom).

Macrophotography and Microphotography

Macrophotography, also called photomacrography, is basically the same as close-up photography, although the lens is usually closer to the subject than in most close-up work. The photographer who frequently deals with macrophotography should have a permanent set-up with lighting and a floating table to minimize vibration. Contrast filters used with panchromatic film will help to bring out certain stains that are not visible to the naked eye.

Microphotography, or photomicrography, is photography that makes use of a microscope and is used to record minute evidence such as powdered debris, stains, hairs, and fibers. Microphotography is a specialized field and requires extensive knowledge and experience in order to obtain quality photographs through a microscope. In order to understand how photographs are made through a microscope, the operating principles of a microscope must be known. Basically, a microscope has two sets of lenses: an objective lens, which forms an image within the microscope tube, and an eyepiece (ocular) lens, which magnifies the image. For example, if a microscope objective lens is 40 power and the eyepiece is 10 power, the image seen by the human eye is magnified at a reproduction ratio of 400 times its actual size (400 power).

35mm SLR cameras work well in microphotography. Most scientific supply houses supply microscope adapters for 35mm SLR cameras. Adapters are simply metal tubes that attach to the camera body (without lens) and to the microscope eyepiece. The microscope lenses become the camera lens. Focusing the microscope should be performed while viewing through the SLR camera due to the difference in focal length with the attached adapter. Exposures should be bracketed because long exposures are usually required. A good starting point for ISO/ASA 100 film is 1/8 of a second. Remember, if color film is used, a color balancing filter may be required for the microscope's illumination source, which will cut down the exposure time even more. Most modern microscopes are equipped with tungsten-halogen lamps, which make tungsten-balanced color films an obvious choice. Lower speed films usually provide better detail than higher speed films. Ektachrome 50 for color and Technical Pan for black-and-white photographs are recommended.

Polaroid's SX-70 Instant Photomicrography System is a camera especially designed for use on microscopes. The camera has automatic exposure control and automatic focusing (Model 2), which takes much of the guesswork out of microphotographs. The camera uses only Type 778 color film, standard for the SX-70 line of cameras.

Although Nikon and other camera manufacturers produce cameras made especially for microscope use, a standard 35mm SLR camera may be used with a proper adapter. Adapters are available from most scientific and microscope supply houses such as Edmund Scientific. Video camera adapters are also available. Video cameras may be used with micro-

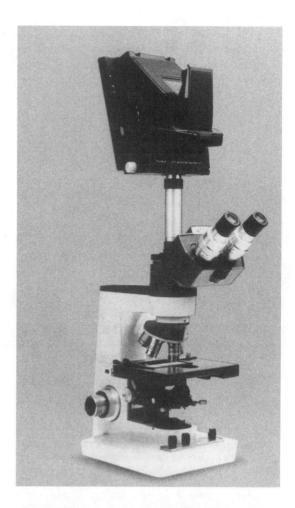

Figure 14.6The Polaroid SX-70 camera mounted to a microscope (top) and a photomicrograph of sperm cells taken with the SX-70 at 400x (bottom).

scopes as long as the video camera's lens is removable. Because most video cameras and video camcorders have fixed lenses, they cannot be used effectively with a microscope. However, many of the surveillance and security type black-and-white and color video cameras have threaded "C" mount lenses that can be removed from the camera body and attached, via an adapter, to the microscope. Sony's 8mm EVC-X10 camcorder is a "C" mount camera that may be used with a microscope.

Figure 14.7
The Unitron color video camera mounted to a stereomicroscope.

Wood Photography

Criminal cases often involve wood as evidence. Very seldom are large pieces of wood recovered. Usually the wood is in the form of splinters, sawdust, or other small fragments. In the Lindbergh kidnapping case, a large piece of wood was taken from an attic floor and a ladder was made from it. This proved to be the downfall of Bruno Hauptmann, because the piece of wood in the ladder was proven to have come from the attic of his home. Large pieces of wood are helpful to the police because of their macro-characteristics. Small fragments of wood are found in burglaries, in which they are broken from a window, door frame, or furniture. Additionally, in cases of safebreakings, the wood packing between the inner and outer walls of the safe, which is used to insulate the safe, can be used as evidence. If the wood cannot be brought into the laboratory it should be photographed at the scene with oblique lighting.

Metal Photography

Metal is replacing wood in many construction tasks, particularly in homes that have metal storm doors and windows. Metal should be photographed using the same procedure used for wood—oblique lighting. The high reflectability of some metals may make them difficult to photograph. Matte finishes, such as Calm, which can be purchased in spray can form at art supply houses, can be applied to the object to reduce reflection and glare (although some attorneys may object to its use). Additionally, reflectors can be used to subdue lighting. Cardboard covered with wrinkled aluminum foil can be used to photograph silvery objects; wrinkled gold foil should be used to photograph gold objects.

Dusty Shoe Prints

It is particularly important to photograph any shoe impressions in interiors, such as on floors or countertops, because these cannot readily be reproduced in any other manner. When there is little contrast, it may be necessary to lift the latent footprints before photographing them. For this purpose a material called "Lift Print" is suggested. This flexible rubber matrix is laid down over the print and rolled lightly with a photographic print roller. The dust forming the footprint sticks to the matrix and can be photographed 1:1 on Kodalith or another high contrast film. The Lift Print material is washable and can be used repeatedly. For further information, contact the West American Rubber Company.

Another effective method for lifting a shoe print is to desensitize a sheet of 8 x 10 photographic paper by putting it into fixer solution, and then letting it dry. This desensitized photographic paper is placed over the imprint and it will lift the print very well. Sometimes it is better to do this than to photograph the print, especially if there is not enough contrast.

Tire Impressions

The procedure for tire impressions is quite similar to that described for shoe impressions. A length of the tire track that shows a clear pattern should be shot several times close-up to give maximum information. In each photograph, the full width of the impression should almost fill the frame. One of these should show the class characteristics that will identify the

type of tire. Areas that reveal defects, such as cuts, may also serve to identify the individual tire.

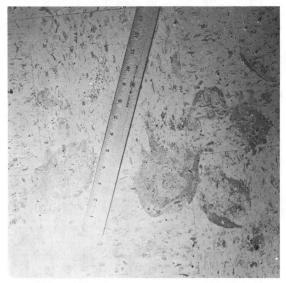

Figure 14.8
Shoe print on linoleum; ruler added to indicate size.

It is also important to photograph, in sections, a sufficient length of each tire impression, if available, to provide pictures that correspond to the complete circumference of each tire. After photography, these same areas should be reproduced in plaster casts or dental stone.

Figure 14.9
Tire impression.

As in photographing shoe impressions, oblique lighting or black spray paint should be used to create shadows and emphasize the characteristics of the impression.

Bloodstains

In homicides and serious assaults, it will sometimes be necessary to photograph in detail the pattern and color of bloodstains (see Figure 14.10). The location, area, and tapering of the stains may indicate the positions and actions of the assailant or the victim.

Figure 14.10 Bloodstains on rug.

Blood is often difficult to detect because the color of blood depends upon its age, the temperature, the time of year, and the material on which it is found. Blood may appear colorless, reddish-brown, green-brown, light olive green, or rose; the photographer cannot, therefore, look only for red spots. He or she should look in out-of-the-way areas for stains such as the bottom side of dresser drawers or table drawers that the suspect may have touched.

A portable ultraviolet light is good for detecting bloodstains, as are the various blood-screening tests (e.g., Luminol, Phenolphthalein, Leuco-malachite Green, and Tetramethylbenzidine reaction tests). Further study of blood detection tests will aid the photographer immensely. Photographs of the stain should be taken both before and after the solution is applied.

The Luminol blood detection test requires the room to be darkened in order to observe the test's luminescent activity in the presence of blood. Photographing the Luminol reaction may be somewhat difficult, but the use of the "fill-flash" technique should produce acceptable results. The "fill-flash" technique basically involves taking two pictures on one frame of film. Using a camera and flash (with manual firing capability), calculate the appropriate flash exposure for the camera-to-stain distance and stop down two f/stops from that exposure rating on the camera. For instance, if f/8 is recommended as the proper flash exposure, stop the camera lens down to f/16. Spray the Luminol onto the suspected bloodstain and darken the room as completely as possible (a photographic darkroom is ideal). Open the camera lens to the lowest f/stop setting (e.g., f/2.8) and set the exposure setting for "B" (bulb) on the camera. Expose the film for approximately 40 to 80 seconds (using ISO 400 film). While the shutter is still open on "B," close the f/stop setting down to f/16 and manually fire the flash unit, then release the shutter. This technique allows the glow from the Luminol reaction to record itself on the film and the flash allows the same film frame to record the surrounding areas so the photograph will detail where the bloodstain was found. This technique requires the use of a tripod and a lockable shutter release cable (see Figure 14.11).

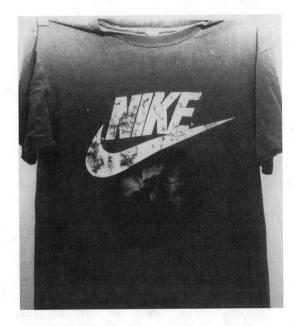

Figure 14.11Bloodstains on shirt with characteristic Luminol glow taken by "fill-flash" technique.

Close-up photographs of bloodstains will record the evidence most graphically. A diagram or sketch of the stains should also be made so that the individual stains can be identified.

Whenever possible, color film should be used to photograph bloodstains. When shooting with black-and-white film, use a blue or green filter for stains on a light background. To obtain contrast of stains on a dark background, use a red filter with black-and-white film.

Bloodstains photographed under ultraviolet light will appear black even after the fabric has been washed, leaving only a trace of the stain. A high speed black-and-white film (ISO 400 or higher) may be used to photograph ultraviolet-illuminated bloodstains.

Bullets, Cartridges, and Shells

In any crime involving firearms, a thorough search is made at the crime scene for bullets, cartridges, and shells. If found, a firearms identification expert may be able to determine if a bullet or casing was fired from a particular firearm. A comparison microscope is used for the purpose of examining a questioned bullet or casing and comparing rifling markings and ejector markings with a test bullet or casing fired from the suspect's weapon.

Comparison photographs should be made with a comparison microscope in the same fashion as microphotography. Comparison photographs can also be made in a small department using macrophotography, but this requires a great deal of patience and hard work.

Particles and Other Small Specimens

Small quantities of clue material, such as glass fragments, paint flakes, soil particles, fibers, and other substances are often unknowingly carried to and from the scene by the perpetrator. Their location on the suspect's clothing and at the crime scene should be documented carefully by close-up photographs for comparison purposes. Where such traces are minute, the evidence will be invisible in the overall crime scene photographs; hence, considerable care should be exercised to obtain a sharp close-up photograph that will clearly reveal the appearance of the substance in its original position. The location of the close-up can be indicated on the overall view by an overlay.

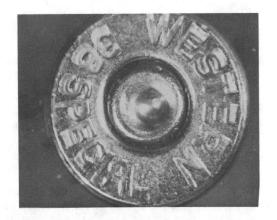

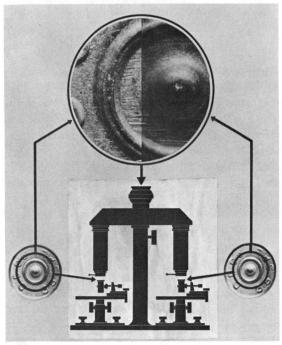

Figure 14.12 Close-up of back of cartridge shell (top). Cartridge shells and bullets can be compared for marks of similarity by use of the comparison microscope. Here (bottom) a shell (left) found at the crime scene is matched up to a shell fired from a suspect's gun (right).

Identifying a hit-and-run vehicle can be accomplished by matching paint fragments. A paint fragment found at the scene of an accident may correspond with an area of a suspected vehicle from which paint is missing.

If the case warrants it, clothing should be photographed with ultraviolet illumination to bring out any marks that are invisible to the human eye (see Chapter 17).

Photographing at the Identification Bureau

The identification photography performed at the crime scene to show the appearance of small objects of evidence can usually be supplemented or improved upon by photographs taken at the identification bureau or the police laboratory. Here, under the carefully controlled conditions of the laboratory, the photographer can arrange the object so as to present the most informative view to the camera.

Photography will also be required for recording the appearance of evidence delivered to the laboratory or identification bureau by a police officer for special processing. Because the analysis, physical testing, or processing of evidence frequently results in a change of appearance or a decrease in quantity, a record of the original condition of the article or substances submitted should be made in anticipation of any questions that might be raised in court concerning the identity or nature of the evidence. A standard lighting and photographic arrangement can usually be used for this type of photograph. However, some materials may require experimentation with lighting to obtain the best results.

Every piece of clothing brought into the laboratory should be photographed on the body before undressing, then photographed individually. Be sure to include a data sheet in each photograph.

Photographic Techniques

Several methods can be used to photograph small objects in the laboratory. If the purpose of the picture is simply identification, the objective of the photographer should be an image that is sharp in all details, free from confusing shadows, and large enough to show all important details of the article of evidence.

If the object is small, make a natural or life-sized photograph. Larger objects and groups of small objects should be arranged symmetrically and photographed so that the image almost fills the frame.

Focus on a midpoint in the field and stop down the lens opening until both ends of the object are in acceptable focus. For groups of objects, focus on the central object and stop down the lens opening until the objects at the borders are in sharp focus. If an aperture smaller than f/22 is necessary for good focus, increase the lens-to-object distance. The smaller image size should give the required depth of field. Include a ruler and data sheet in all evidence photographs of this type.

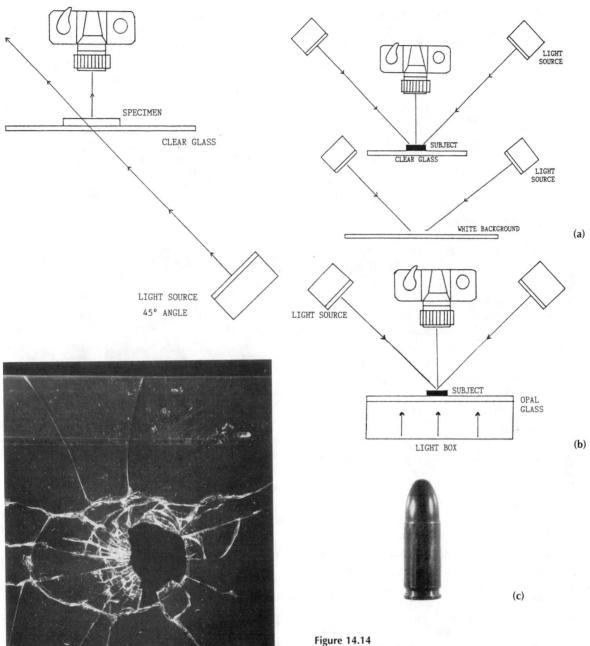

Figure 14.13Diagram showing darkfield illumination setup (top) and photo of bullet hole in glass taken by the darkfield illumination technique (bottom).

Often, the aim in small-object photography is to show texture and give an impression of depth of field in a surface by means of contrasting shadow. This Diagrams showing backlight illumination setups. Illustration (a) depicts a four light setup, and illustration (b) depicts the use of a lightbox. Both methods produce excellent results. Photo (c) shows a cartridge photographed with backlight illumination.

may be achieved by the use of grazing, or oblique light with a black background. The lighting arrangement is deceptively simple; actually, the success of the photograph depends on a careful balance between the distances of the illumination and reflector from the subject.

Darkfield Illumination Photographs

Some objects of evidential value are transparent or "colorless." Darkfield illumination is a technique whereby transparent objects may be photographed showing detail and contrast. A light source is placed behind or underneath the object and directed through it at a 45-degree angle (see Figure 14.13). This makes the object appear bright against a dark background. Darkfield illumination is useful for glass, plastic, clear fingerprint lifters, and so on.

Backlight Illumination Photographs

A lighting setup similar to darkfield illumination is backlight illumination. Backlight illumination works well with small opaque objects. An object is placed on a transparent surface against a white (or other color) background. The object on the transparent surface is raised several inches from the background. The background is illuminated with two or four light sources. The object is illuminated from above with an additional two or four light sources, and the backlight illumination must be about four times as intense as the object illumination (see Figure 14.14). Exposures are made, disregarding the backlight illumination, by using a spot meter or by turning off the backlight illumination and taking a lightmeter reading.

Copy Techniques

Macrophotography requires a suitable camera, close-up lens or close-up lens attachments (extension rings, bellows, etc.), a camera mounting system capable of holding the camera securely, and copy lights. Although there are copy cameras and systems designed exclusively for this type of photography, 35mm SLR cameras or view cameras (like the 4 x 5 Graphic) may be used. A camera mounting system for copy work can be purchased separately or, if the head on the darkroom enlarger is removable, the enlarger's stand and baseboard make an excellent copy stand. Some enlargers may be used as copy cameras themselves. Photoflood lights or tungsten lamps may be used for illumination.

Polaroid's MP-4 multi-purpose camera system allows a wide range of uses and film choices. In addition to its primary use as a copy camera, it can be used for microphotography and "off-stand" camera

work. With adapter accessories, the MP-4 can use 35mm, Polaroid, and 4 x 5 film.

The most common lighting arrangement for copy work is to have two or four lamps on both sides of the object to be photographed, directed onto the object at a 45-degree angle (see Figure 14.15). Tungsten lamps (3,200 degrees Kelvin) or photofloods (3,400 degrees Kelvin) are both adequate for black-and-white film. However, if color daylight-balanced film is used, it will be necessary to use a color-balancing filter (80A for 3,200 degrees Kelvin and 80B for 3,400 degrees Kelvin). Color film balanced for tungsten illumination may also be purchased.

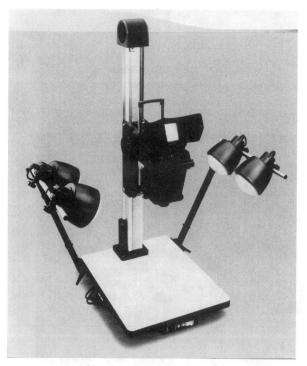

Figure 14.15Polaroid's MP-4 copy camera. Note the position of the copy lights.

Photographing glossy objects may introduce reflections. Reflections and glare may be reduced by using a polarizing filter or spray matte finish (such as Calm), available at most art supply houses. Another method is to take a flat, black piece of cardboard with a hole just large enough for the camera lens to protrude and use it as a light shield in front of the camera. This technique also works well when photographing latent prints on mirrors or chrome surfaces (see Chapter 15).

Photography has played a large part in the importance of fingerprints in police work. If it were not for photography, it would be impossible to bring fingerprints found at the scene of a crime into a courtroom and present them to a jury. There are times when fingerprints are not visible to the naked eye, but by using powders, chemicals, or alternative light sources on the latent prints, the images of the ridges can be brought out and photographed. These can be enlarged to a size that makes the print easily viewed by a jury. The known fingerprint can be placed alongside the unknown fingerprint, and a comparison can be made of the two prints, along with notation of their individual characteristics (see Figures 15.1 and 15.2). Photographing fingerprint impressions found at the scene of a crime is a rather difficult chore that demands an immense knowledge of photography in order to do a good job.

The importance of identifying individuals in police work is obvious, and identification photographs—like fingerprints—are one of the best means. Using photographs to preserve the personal appearance of an individual at a given time is necessary. The advantage of police "mug shots" is their unflattering realism, and the ease and economy with which they can be produced.

An identification photograph should be an accurate likeness of the subject, from which he or she can be recognized by witnesses or police officers. The photographer should strive to reproduce every freckle, mole, scar, or other blemish that might aid in identifying the subject. Close-ups of head and shoulders with a generally flat front lighting will accomplish this.

Identification photos are placed on file, together with the prisoner's record and other useful data, such as height, weight, age, and a description of significant

Figure 15.1
Single print, known (left) and unknown (right). The unknown print has been taken from the scene of the crime.

characteristics. Files of such photographs are extremely valuable in investigating crimes involving unknown perpetrators observed by witnesses. The witness is asked to visit police headquarters and is shown a number of photographs of criminals selected on the basis of the descriptions of observers. The witness is asked to examine the pictures at leisure and to select any that resemble the perpetrator of the crime. To aid in searching the files, special classifications of photographs are developed. For example, the file may be arranged according to the crime, such as burglary, forgery, robbery, and so forth. In crimes such as burglary, an additional classification may be made, according to the modus operandi (method of opera-

tion) of the criminal. Thus, under burglary, the use of a pass key, climbing through transoms or skylights, using an electric drill on safes, and many other criminal techniques can be used to classify the photograph.

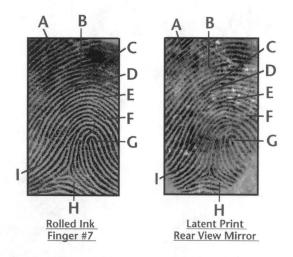

Figure 15.2
Comparison exhibit using digital technology. The inked and latent prints were digitally photographed and compared using a computer with Adobe Photoshop software, and printed using a Kodak XL8600PS printer. (Courtesy Free Radical Enterprises)

Another use of identification photographs is circulation to other police departments. Some of the larger police departments provide their officers with albums of "wanted" criminals. Such pictures enable investigators to become familiar with the facial characteristics of known criminals and can lead to arrests that otherwise might never be made. The mug shot itself is hardly sufficient proof of identity, but it is proof that may be taken into consideration when accompanied by other evidence, such as fingerprints.

Equipment for Fingerprint Photography

Fingerprint technicians may use a specially built fingerprint camera for their normal fingerprint work (see Figure 15.3). Fingerprint cameras are equipped with an anastigmatic lens set for 1:1 reproduction, and with an extension in the front of the lens equal to the distance between the optical center of the lens and the film. The camera opens in the middle, where inside there are usually eight batteries, along with lights built into the front so that the camera can be placed directly over the surface that bears the fingerprints. Because the lens-to-subject distance is set, the camera does not need to be focused. The film size of these fingerprint cameras is usually 2 x 3 inches. This is a good workable size for one or two prints, but usually four or five prints are found on an object. It is always best to try to photograph as many fingerprints as possible. Most fingerprint technicians prefer 4 x 5 fingerprint cameras, Polaroid close-up cameras, or 35mm SLR cameras with macro lenses. A growing number of latent fingerprint technicians are using digital imaging.

It is not recommended that smaller police departments have a specially built 4 x 5 fingerprint camera, because they do not use the camera often. The batteries lose power with disuse, making correct exposure difficult. For large departments that use the fingerprint camera daily, it may be useful. In addition, the batteries may be removed and the camera used with electricity with one adapter. It can be plugged into the cigarette lighter of a car by means of another adapter. A 4 x 5 camera fitted with the Faurot Foto-Focuser or similar attachment is an excellent choice for police departments routinely using 4 x 5 cameras (see Figure 15.3).

The Polaroid Company has a camera called the CU5 close-up camera (see Figure 15.3), which can be used for fingerprint work. It has a built-in electronic ringlight flash that enables it to obtain pictures free of blur caused by vibration. Although designed specifically for use with Polaroid film, it can easily be adapted for use with panchromatic sheet film packs. This can be done by using the outer frame of a used Polaroid film pack and inserting into it a standard $3\frac{1}{4} \times 4\frac{1}{4}$ film pack. The pack and frame are then loaded into the camera in the usual manner.

For small departments and departments that routinely use 35mm SLR cameras, a macro lens or close-up filter attachments are recommended. The low cost and reproduction quality of black-and-white film and familiarity with the operation of the 35mm SLR makes it preferable to specially built fingerprint cameras. For larger departments that may have certified latent fingerprint technicians on staff, a digital camera and computer software for print enhancement and comparison may be warranted.

Films and Filters

Whatever technique is used, whether it is powder, chemicals, or alternative light sources, to develop a latent fingerprint, nothing will lead to success as much as the correct choice of film and (when necessary) the correct choice of filters. In the courtroom, an exhibit of a fingerprint photograph is one form of law enforcement photograph in which black-and-white photographs are as useful as color photographs. In evaluating a fingerprint case, an unknown print will be compared to a fingerprint taken from the suspect under ideal conditions.

For courtroom exhibits, fingerprints taken from colored objects should depict a black fingerprint on a solid white background. The judge and jury will have an easier time concentrating on the pattern of the fingerprint itself on a solid white background.

Fine grain panchromatic film of medium contrast, along with some high-contrast panchromatic film, may be used to photograph latent prints. If the lines of a fingerprint are even in density, a high-con-

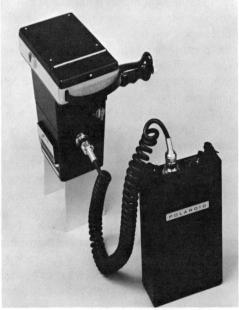

Figure 15.3 Fingerprint cameras (clockwise from bottom right). Polaroid CU5 close-up camera with strobe; fingerprint camera hooked up for electrical and auto current; fingerprint camera; Faurot Foto-Focuser; and Faurot Foto-Focuser on 4 x 5 camera.

trast panchromatic film will probably produce the best result because it will produce as much contrast between the print and the background as it is possible to obtain. Many times, however, the fingerprint lines are uneven and unclear. In this case, high-contrast panchromatic film may not be the best choice because it will accentuate the unevenness, causing the lighter portions of the print to be invisible in the finished photograph. A slow- to medium-speed panchromatic film should be used in this case. Kodak Technical Pan film is a good slow-speed film to use. It will not produce as much contrast, but if properly exposed and developed, it will preserve all the lines in the print even though they are not of equal density. Technical Pan may also be developed in HC-110 for high contrast. This makes Kodak Technical Pan an ideal film for fingerprint photography. Digital enhancement, using digitally photographed images and software available for the task, may also provide excellent prints for comparison purposes.

Most of the time, fingerprints will be found on colored objects, and this will usually require the use of filters to obtain the maximum use of panchromatic film. Filters are not needed when photographing impressions on white surfaces such as bathroom fixtures, or on gray or black surfaces such as gun barrels. However, filters are required when using alternative light sources and/or fluorescent powders (see Chapters 16, 17, and 18 for a more in-depth discussion of these techniques).

The fingerprint expert must know how to use filters to control lightness or darkness of colored surfaces upon which fingerprints are found. Ordinarily, the photographer can make a colored background photograph either dark or light at will. The decision as to how a given colored surface should be made to photograph will depend upon the tone of the fingerprint. If the fingerprint will photograph light gray or white, the surface upon which it appears must be made to photograph as black as possible (see Figure 15.4). Conversely, if the fingerprint will photograph dark gray or black, the background must be made to photograph as white as possible. A yellow filter is good for bringing out the definition of the print. A medium yellow filter needs as much exposure as a weak yellow-green filter. But the deep yellow filter gives a more effective picture of this same exposure. When using filters, the exposure must be trebled. Any time a filter is added, the exposure will have to be increased. A SLR camera with through-the-lens metering is a near necessity for this.

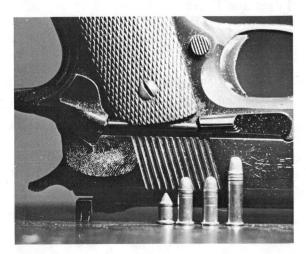

Figure 15.4 White fingerprint on a black background.

When photographing black fingerprints on colored objects, the photographer must make the colored background appear as light as possible in order to provide the greatest possible contrast with the black fingerprint. A high-contrast panchromatic film and the proper filter should be used if the fingerprint is of even density; a medium-speed panchromatic film and the proper filter should be used if the fingerprint is uneven and patchy. To photograph a black fingerprint on a colored background, a filter that has the same color as the background is appropriate. A filter that transmits the color of the object and absorbs other colors will usually solve the problem (see Chapter 6).

Because of the way light strikes it or because it has been developed with white powder, a fingerprint may appear white. This is especially true with cyanoacrylate (Super Glue) fumed fingerprints. To photograph these on a colored surface, a filter should be used that will absorb the color reflected by the object while allowing light of other wavelengths through to expose the film. The student should take a good set of fingerprints from an individual, and photograph them first with no filter, then photograph the print one time each with a yellow, red, blue, green, and orange filter. The letter of the filter used should be put in to identify the filter type in the finished print. This is the best way to learn how to use filters.

For photographing fingerprints found on multicolored objects, any filter used will eliminate certain colors but will emphasize other colors in the background. It is best to eliminate all the colors in order to produce a plain background that will contrast well with the prints. Sometimes fairly satisfactory results can be obtained by using panchromatic film without a filter of any kind when photographing fingerprints on multicolored backgrounds. This will not eliminate the background but it may subdue it, especially if the fingerprint is on even density so that high-contrast panchromatic film can be used.

Often it will be necessary to resort to either ultraviolet or infrared photography to photograph fingerprints on a multicolored background. Results obtained from these methods are very unpredictable, however. Ultraviolet and infrared photography are discussed in detail in Chapters 17 and 18, respectively.

Another method used in photographing light-colored latent fingerprints on dark or multicolored backgrounds is to use the "filmless" technique. A 4 x 5 format camera is the most practical camera to use because it has film holders in which photographic print paper can be substituted for film. A suitable photographic paper is Kodak Polycontrast, cut into 4 x 5 sheets. The paper is inserted into the film holders in the same manner as 4 x 5 sheet film. A strong light is needed, such as a 500W photoflood. Although the photographer should experiment with various exposure settings, a good starting point is f/16 at five to 10 seconds. The fingerprint image should be reversed using a mirror positioned at a right angle to the camera lens. The paper is developed in a standard paper developer (e.g., Dektol) mixed to a 1:1 solution ratio. This technique is particularly useful with cyanoacrylate-developed fingerprints. In the absence of a 4 x 5 or other sheet film format camera, the photographic enlarger may be used as a copy camera for this purpose. Some computer software programs, such as Adobe Photoshop, can enhance and manipulate colors found in digital photographs. If digital photographs are made, this technique is most useful and avoids time-consuming darkroom work.

Exposure for Fingerprint Photography

It is difficult to name a particular exposure for any shot, because no one knows what the particular circumstances are at the time a certain job has to be done. A person in this field has to do a great amount of experimenting with the camera, film, filters, and other tools of the trade. By experimenting with filters in combination with different films, and keeping a record of everything performed along with the results obtained, one can figure out just what the camera, film, and filters will do for a particular job. By using high-contrast panchromatic film and filters, one will find that exposures must be correct to within very narrow limits.

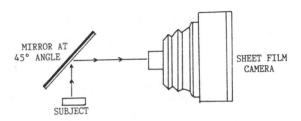

Figure 15.5
Diagram showing "filmless" photography technique (above).
Photograph (below, top) illustrating white fingerprint powder on black background (in this case the black plastic top of a paper clip holder) photographed normally with film. Photograph (below, bottom) shows the same fingerprint photographed using the "filmless" technique, which produces a "black" fingerprint.

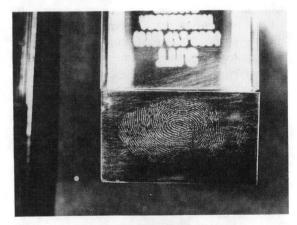

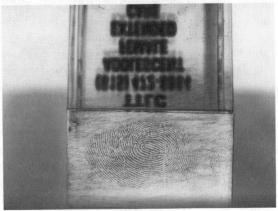

When using the fingerprint box camera, exposure results can be predicted by past experience because the lamps are always in the same position and distance from the photographic subject. Use of the batteries does wear them down, however, and this affects exposure. A good record must be kept on the length of exposures made under the various conditions encountered. The photographer can be fairly certain of good results with the fingerprint box camera, within the limits of its capabilities.

When using a 4 x 5 camera with the double extension, a photoelectric light meter should be used to obtain exposure. The light meter should be placed as close as possible to the surface bearing the finger-print without casting a shadow. The camera is double-extended when making full-sized reproductions and therefore, the exposure must be four times as long as that required when the camera is used for view work. To allow for this difference automatically, one can divide the recommended film speed by four. In addition to allowing for the fact that the bellows of the camera is double-extended, one must remember to allow for the additional exposure required when a filter is used.

Using a 35mm SLR greatly simplifies the tediousness of exposure determination, especially when using a macro lens. The camera's internal light meter system will correct for use of filters and, if flash is necessary, the same techniques as close-up photography may be used (review Chapter 14). Additionally, the use of digital cameras and imaging are particularly well-suited for fingerprint photography.

Fingerprints Found on Wood

Many times fingerprints will be found on wood surfaces, such as a kitchen or dining room table, a dresser, or on other pieces of wooden furniture. There are primarily four kinds of wood used to make household furniture: oak, walnut, mahogany, and cherry. One of the biggest problems confronting the fingerprint technician is whether to use black or white powder. The answer depends on whether it is best to make the stained wood appear light in order to contrast with a black fingerprint or whether it should appear dark in order to contrast with a white fingerprint.

It is best to develop fingerprints on dark stained woods with white powder and to photograph them with high-contrast panchromatic film and a blue filter. However, if a court exhibit must be made that will show the ridges as black lines on a white background,

it is necessary to make an intermediate transparency from the original negative and print from the intermediate transparency. Fingerprints on light oak should be developed with black powder and photographed on high-contrast panchromatic film through a red filter.

Fingerprints Found on Glass

Visible fingerprints found on glass must always be photographed before applying powder to them. Latent fingerprints found on sheet or plate glass can sometimes can be photographed without the use of developing powders. This can be done by using oblique lighting from behind the glass and against a black background. Here again, the ridges will show up as white lines against a black background unless the court exhibit is printed from an intermediate transparency made from the original negative.

Glass bottles and tumblers will often yield fingerprints. Even though the print consists only of colorless perspiratory secretions, it may be successfully photographed without the use of powders by filling the bottle or tumbler with a dark liquid, such as grape juice, and photographing with oblique lighting. The floodlight must be adjusted with great care because the convexity of the bottle or tumbler will cause disturbing reflections when the lamp is in certain positions. A polarizing filter may help to reduce reflection. With a dark impression, the bottle or tumbler should be filled with a white liquid, such as milk, before it is photographed.

Fingerprints that are found on a mirror can be photographed if great care is given to focusing and lighting. The major problem encountered in photographing prints on mirrors is a strong secondary image on the second surface of the mirror. This secondary image will create a blurred appearance on the photograph. A piece of black cardboard with a hole cut to allow just the photograph of the fingerprint image may help reduce glare as well as the secondary image. Also, use a larger aperture opening to throw the secondary image out of focus. Using magnetic fingerprint powder may also help with mirrors. The magnetic powder tends to "smear" the glass surrounding the latent image, which reduces glare. If it is possible to do so, the job can be made easier by scraping the silver off the back of the mirror.

If fingerprints are detected on both surfaces of a glass plate, it is necessary to photograph them separately. First, the print on one side is treated with white

lead powder, then photographed, and finally colored black by allowing the vapors of aluminum sulfide to act on it for a few minutes. Then the print on the opposite side is covered with the white lead powder, a dark-colored paper is applied against the print previously blackened, so as to render it invisible, and a photograph of the second print is taken.

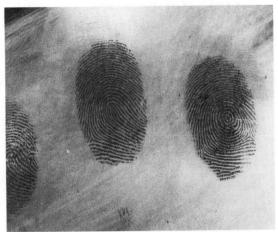

Figure 15.6Photograph of fingerprints on a mirror surface. The use of magnetic powder may help reduce glare and secondary reflections.

Fingerprints Found on Paper and Plastic

Fingerprints found on paper and plastic should be treated with powders, fumes, or liquid reagents to bring them out so that they are clear enough to be photographed. Latent fingerprints from iodine-fumed and ninhydrin-treated papers may be brought out for better contrast by using filters. Cyanoacrylate (Super Glue) fuming leaves white crystalline latent prints, but can be darkened by using black magnetic powder.

Photographing Lifted Fingerprints

Fingerprints that have been lifted should be photographed as soon as possible or the lifting material bearing the prints should be used as a transparent positive to make an enlarged negative. Many fingerprint technicians find the lifting process so easy that they have a tendency to lift prints when it is not necessary. Rarely should fingerprints be lifted when they can be photographed successfully while still on the original surface. Fingerprints have the highest value as evi-

dence while they remain on the objects on which they are found. It is true that latent fingerprints may disappear in some instances, but fingerprints developed with powders probably will last indefinitely, especially if protected with a plastic cover. Large items, such as furniture, may not be movable or storable until needed in court. Photographs should be taken of latent prints on these objects before they are lifted. Great care should be taken when lifting fingerprints. Accidents do happen and it is possible that the act of lifting a print will destroy some ridge detail, especially if bubbles or wrinkles appear in the lifting tape.

Enlarging Fingerprint Photographs for Trial

A fingerprint photographer must have the case well prepared to present before a judge and jury. In testifying to comparisons between fingerprints, the expert witness should utilize some graphic representation of the facts presented, such as enlarged photographs. For this purpose, enlarged photographs from corresponding fingers may be mounted side by side. The degree of enlargement is not important, as long as both photographs are enlarged to the same degree, and the ridges of both prints are distinguishable. Generally, enlargements of five to six times the natural size are best. Smaller enlargements are difficult to see more than a few feet away, while larger ones lose some of their contrast between ridges and background. A white border of at least one inch should be left for numbering purposes. An enlargement to about 22 x 30 inches should be made to serve as a demonstration exhibit to the court, and 11 x 14inch exhibits for each member of the jury.

The corresponding ridge formations in the two prints should then be similarly numbered and marked with straight lines drawn from the characteristic to a numbered point in the margin. Care should be taken that lines are drawn to the characteristic to be noted, not short of it or beyond it (see Figure 15.7).

When the degree of enlargement is greater, a circle should be drawn around the characteristic and a line should be drawn from the circles to the number in the margin. In such cases, the ridges will be much larger than the illustrating lines.

Because the enlarged photographs appear in black-and-white, it is preferable to use an ink other than black or white to line the chart. The ink used should be translucent, so that it will be possible to see the details of the ridges underneath it.

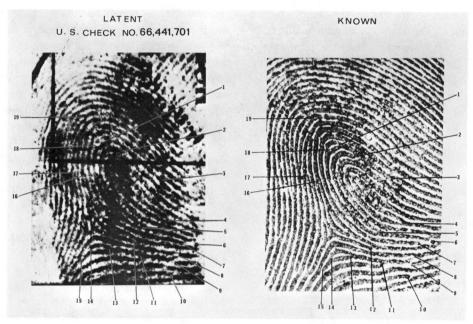

Figure 15.7
Enlarged comparison of fingerprint properly prepared for court exhibit.

A cleaner, neater, and more pleasing appearance is obtained if the numbers are evenly spaced and made to follow a sequence, such as by placing them in a clockwise or counterclockwise order. Some states do not permit numbering on these exhibits. A clear sheet of plastic placed over the exhibit and then numbered will avoid this problem. Art stores have press-on or rub-on type lettering and numbering kits that are excellent for lettering and numbering finger-print exhibits for court.

In addition, there are several computer software programs available for digital photographs that can produce court exhibits quickly and easily. However, if enlargements are necessary, caution should be taken to avoid pixelating the image (see Chapter 11). Exhibits may be presented using a color monitor and computer with programs such as PowerPoint. Using a color monitor avoids the problem of pixelating enlarged images.

The Identification Photographer

Many police departments in cities with populations of more than 15,000 possess an "identification bureau," or at least a skilled photographer assigned to perform identification work. However, because the importance of photography in law enforcement is well recognized, many smaller towns are now training selected police officers to do photographic work. It will often be found that the identification photographer in a small community is required to deal with a greater variety of tasks than is his or her counterpart in the large city. The latter will tend toward specialization in one particular branch of identification work. For example, in a city with a population of one million, several police photographers may be occupied exclusively with mug shots, while others will perform only on-the-scene photographic tasks.

The typical responsibilities of an identification unit with respect to photography are the following:

- 1. Photographing prisoners charged with serious crimes.
- 2. Photographing deceased persons in homicide cases (see Figure 15.8).
- 3. Photographing the scenes of serious crimes, fires, and accidents.
- 4. Dusting and photographing fingerprints.

- 5. Reproducing checks, documents, and other evidential papers by photographic methods.
- 6. Copying and reproducing photographs.
- 7. Reproducing official records and notices.

Figure 15.8Tattoos and other identifying marks on deceased persons should be photographed.

Identification Photographs

There are three basic ways of shooting identification photographs: (1) the front and side views; (2) the front and two three-quarter face views; and (3) the front, side, and standing views. Color film should be used to accurately capture skin tones, and hair and eye color.

- 1. The front and side views. Many police departments photograph their prisoners with a front view and a profile (or side) view (see Figure 15.9). The front view permits ready recognition of the individual, but the side view is also necessary for certain identification characteristics. Persons are so often viewed from the front that it is quite possible, at first sight, not to recognize someone when a profile photograph is shown. The public can recognize front view photographs much more readily than they can profile view photographs. However, police officers may prefer side photographs when attempting to identify an individual.
- 2. The front and two three-quarter face views. This type of identification photograph has proven to be quite satisfactory. Many times identification can be made more easily from the three-quarter face view when the front and side method fails.
- 3. The front, side, and standing views. This may be preferred because the standing view can be most helpful in identifying a suspect.

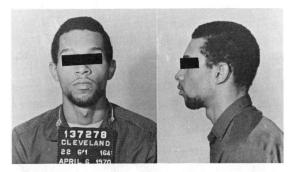

Figure 15.9Typical mug shot showing front and side view.

Film

Using the same film for identification and nearly all other purposes simplifies photography for the majority of police departments. Most any of the commercially available color print film will produce acceptable results for identification photography. ISO speed is not a particularly important factor since the subject, lighting, and camera are in a controlled, consistent environment.

Lighting

In identification work, it is particularly important to be consistent in performing all of the photographic procedures. Changing the lighting arrangements, for example, can produce markedly different facial contours. Hence, a standard lighting arrangement should be selected and strictly adhered to in all photographs. In this way, lighting, image size, and exposure can be fixed for standard poses. The operation can easily be one of routine procedure in exposing, developing, and printing the negative.

The flat lighting provided by two No. 1 photoflood lamps with diffusers will be satisfactory for this work. They should be placed close enough to the subject to permit the use of a fast shutter speed, but not so close as to become oppressive because of heat and glare. Preferably, two electronic flash units can be used in place of photoflood lights. The flash units are placed at 45-degree angles to the subject and are diffused by using diffusers over the flash or by bouncing the flash against an "umbrella" designed for portrait photography.

Cameras

There have been numerous identification and mug shot cameras available for years. The old 4 x 5 Speed Graphic had a split-back adapter to allow front and side views to be taken on one sheet of 4 x 5 film. The Deardorff identification camera allowed three poses to be taken on one sheet of 4 x 5 film or with a 4 x 5 Polaroid film back. The three poses included front, side, and standing views. Polaroid has produced the 454 identification camera, a four lens camera capable of producing four identical images on one 4 x 5 sheet of film or Polaroid film. Most police departments use a 35mm SLR system in order to take advantage of the low cost of 35mm film and adaptability to the department's other photographic equipment. More recently, police departments have been using digital cameras to record mug shot images to be stored using computer technology.

Digital Identification Photography

This is one area where digital imaging has a distinct advantage over normal film (analog) photography. Digital cameras allow for images to be taken and

stored on magnetic media. This alone is a distinct advantage over traditional film photography. Since mug shots are, most likely, the largest single part of a police department's photographic file, the ability to store large numbers of digitally produced images on magnetic media is a definite space saver. Any digital camera capable of producing 640 x 480 or better resolution can be used for mug shots. In addition, there are several software programs available that allow for storing and retrieving digital images. The RiMS mug shot and digital imaging software program allows mug shots to be taken, filed, and linked to other files. RiMS can produce electronic "mug books" viewable on a computer screen and transmittable over phone lines (i.e., Internet). Hard copies can be readily produced by using a good quality color printer capable of printing photo quality digital images. In addition, the RiMS software allows for quick photo lineups by searching its database of mug shots on file for similar characteristics of suspects (race, sex, age, etc.). The photographic lineup produces six images with the key subject randomly placed on the screen. Software, such as RiMS, can also file crime scene photographs, traffic accident photographs, or any digital image associated with a particular case.

One specialized form of evidence photography is the photography of questioned documents. Photography is an indispensable aid to the document examiner, not only in detecting alterations in documents (such as checks), but also in presenting proof of alterations.

A major part of document examination is concerned with making legible or clarifying any writing (or any marking on paper) that has been obscured. Wills, insurance policies, licenses, checks, or official records may be altered for some criminal purpose. Documents may also become illegible through exposure to fire or water or through deterioration or fading with time. The document examiner must do two things: first, decipher the writing; second, because a question of proof is involved, convince the court of the validity of his or her findings.

Photography of questioned documents can be divided into two general classes: (1) documents in which it is obvious that an erasure or visible alteration has taken place; and (2) documents that appear satisfactory, but in which forgery by alteration is suspected. In the first case, the erasure or alteration may be poorly executed and quite evident to the trained investigator, but not obvious to the untrained eye. In the second case, the work of bleaching, erasing, and altering may have been so cleverly done that there is no evidence visible, even to the trained eye of an experienced investigator.

The procedures for the various types of examinations, photographic and otherwise, can be found in standard reference works on questioned documents. Some of the more common applications of photography are described here.

Document examiners rarely give the court an opinion concerning a handwriting or typewriting com-

parison or an alteration without supporting their statements with photographic exhibits. Even though the questioned document specialist may clearly see that a forgery or alteration has occurred, a photograph of these irregularities with enlargements for court use should be obtained. In no other type of expert testimony is photography used so extensively in explaining points of proof to jurors.

Reproduction for Case Study

A good photographic copy of the questioned document should be made as soon as possible. To prevent soiling or mutilating the document, this photograph, rather than the document itself, should be used by the examiner whenever practicable. For example, in comparing handwriting specimens, the examiner will usually find it necessary to cut off sections of enlarged photographs of questioned and known writings so that the significant parts of the writings, or characteristics of individual letters, can be placed side by side for comparison (Figure 16.1).

Films and Developers

The correct degree of contrast is very important in documentary work. Faintly visible details require high contrast. On the other hand, where detail is required in both ink and paper, high contrast would "block up" one or the other, so moderate contrast is better. The best contrast for a given problem is often a matter of experimentation, both in film contrast and choice of printing paper. Generally, ortho films may

be used unless the document requires a lighter rendering of reds by use of a filter, in which case panchromatic films are needed. Kodak Technical Pan is a good choice because it can double as a panchromatic film when developed with Technidol or HC-110 with bleach, and as a high-contrast copy film when developed in HC-110 normally.

Figure 16.1 Comparison of handwriting specimens.

Proper exposure is important. A series of exposures should be made (bracketing), each one stop apart. One negative may be best for one part or one aspect of the document, another for another part. Composite prints can be made from several negatives.

While black-and-white is the norm in document photography, do not overlook the usefulness of color photography. Same-size or enlarged prints from Kodak Ektar 25 negatives show the document realistically. Color prints can show color differences better than black-and-white prints, for example: black ink from a check writer and red ink of a bank endorsement stamp.

Erasures and Alterations

Writings that have been erased, that is, removed from the paper by mechanical or chemical means, or altered in some way, may often be exposed when photographed by using special lighting arrangements. If the writing appears to have been removed completely, there may be little hope of restoring it.

Visual methods should be tried first. A small lamp, such as a microscope illuminator in which intensity and direction can be controlled, is very useful. By experimenting with the lighting angle, one may be found that will enable the photographer to

read the writing (see Figure 16.2). The document is then set up on the copy stand and lighted in the same way. Kodak Technical Pan is best for fine grain and high definition when developed in Technidol, or it may be developed in HC-110 for extreme contrast. Where faint traces are visible, a contrasty film such as Kodalith Ortho or Technical Pan developed in HC-110 will emphasize the details and exaggerate the traces so that they are readable.

Figure 16.2
Brilliant contrast and Kodalith film are used here to bring out erased pencil writing.

The correct lighting for deciphering erasures is determined by experiment. As a general guide, these steps should be tried:

- 1. Ordinary lighting. Obviously, the first step is to look at the document by ordinary reflected light.
- 2. Side lighting. Try lighting from various angles. An extreme oblique angle will often be useful. If a particular lighting and viewing angle makes the erasure visible, duplicate this setup for the camera.
- Transmitted light. Look at the document with light coming through it. Turn the document over and repeat.
- 4. *Magnification*. Examine the paper with a magnifier, such as a handheld magnifying glass or a low-power binocular microscope. Magnifications up to about 10X are the most useful.
- 5. Polarized light. Light the document with polarized light, using a Kodak Pola-Light. Also, examine it through a Kodak Pola-Screen.
- Filters. Look at the document through various filters, either separate dichroic filters or the viewing filters in the Kodak Master Photoguide.

Chemical Methods

If sufficient traces of ink or graphite remain on the paper, it is sometimes possible to read the original writing and even to show it photographically if a chemical treatment is used. An erasure can be exposed with iodine fuming. Iodine fuming is a procedure that: (1) reveals the presence and extent of an erasure; (2) restores some of the writing; and (3) delineates any area that has previously been wet.

An iodine fuming tube, the same as that used for fingerprints, is warmed with the hand and warm breath is blown through it. Moisture from the breath is removed by a layer of calcium chloride, or other desiccant, and the dry fumes of iodine will stain disturbances in the paper caused by writing. This should be photographed immediately, because iodine vapors fade quickly.

Other Methods of Photographing Erasures and Alterations

Some inks and bleaches fluoresce when exposed to ultraviolet light, so any time there is a brightness difference between visible and invisible writing or bleaching, or between different inks, this can be photographed by ultraviolet light (see Figure 16.3 and Chapter 17).

Infrared photography will reveal significant differences between absorption of infrared radiation in the original writing and in the substance used to obliterate it. Erasures, obliteration, or indented writing (ghosts) from pen, pencil, or typewriter, can be inspected and photographed with grazing light (see Chapter 18).

Obliterated Writing

If the writing has been obscured by markings, such as a series of typed Xs over the writing or a haphazard scratching of lines (see Figure 16.4), the problem of deciphering the underwriting can sometimes be solved by one of the following methods:

Filters. If the upper markings and the underwriting differ in color, use a filter of the same color as the top layer to photograph the writing with Kodak Technical Pan film. To select the correct filter, view the obliteration through filters of different colors (dichroic filters) or through the series in the Kodak Master Photoguide.

6/19/94

Figure 16.3 Date obliterated using a bleaching compound. Top photograph shows date as "94," but bottom photograph under ultraviolet illumination shows the original date as "97."

- 2. Oblique lighting. Differences in the reflecting characteristics of the upper and lower layers may permit the exposure of the obscured writing. The pressure with which the lower layer was impressed is also important. If great pressure was used, a legible, indented outline may be seen from the front or the back. Oblique lighting should be used. Direct a light at varying angles and with varying intensities across the writing. If the writing can be read with light projected at a selected angle, photograph it with Kodak Technical Pan film.
- 3. Infrared photography. This sometimes exposes alterations. It can also expose obliterated writing if the obliterating ink is a dye, because most dyes transmit infrared radiation. Infrared film is required, and a red or deep red filter must be used. While the Kodak Wratten Filter No. 25 usually works, the deeper Wratten No. 87 is preferable. Ordinary tungsten lamps are used. The camera is focused by visible light. Infrared focus differs from visible light focus. See Chapter 18 for a discussion of infrared photography.
- 4. Ultraviolet radiation. Differences in the fluorescence characteristics of obliterated writing as seen under an ultraviolet lamp can be helpful. The difference may be one of color or intensity. The reflected-ultraviolet method may also prove useful. See Chapter 17 for a discussion of ultraviolet and fluorescence photography.

5. Wetting method. Occasionally, the obliteration is made by pasting paper over the writing. To leave the pasteover intact, try wetting the reverse side of the original document with a volatile fluid, such as benzene. The writing will appear for a few seconds and become invisible as the fluid evaporates; photograph it as soon as the image appears. Use Kodak Technical Pan film with strong lighting and a wide aperture. This method is also sometimes successful with ordinary obliterations.

The date could not have been later than the since the notes which were taken at the time seem to indicate that there was full knowledge of the facts and that subsequent investigation (i.e., after could not have been later than the 15th of October, since the notes which were taken at the time seem to indicate that there was full knowledge of the facts and that subsequent investigation (i.e., after October 15) could not

Figure 16.4 Kodak infrared and a Kodak Wratten Filter No. 87 were used to decipher obliterated writing and to render it as shown in the lower photograph.

Indentations

The impressions left upon a pad of paper by writing on an upper sheet that has been removed will sometimes provide a legible copy of the message written on the missing page (see Figure 16.5). This kind of evidence is commonly found in connection with gambling investigations. The sheet bearing the original record of the bet will have been removed by the time the police officer makes the arrest. The officer must rely on the paper pad found in the defendant's possession to supply the needed corroboration.

There are two common methods for making indented writings visible. The traditional method uses oblique lighting or side lighting by directing a beam

of light from the side (almost parallel to the plane of the paper), the indentations can be brought into relief and the writing revealed. A more recent method is to use electrostatic imaging. Electrostatic imaging involves applying an electrostatic charge to the surface of a polymer film that has been placed in close contact with the paper containing indented writing. The indented impressions are revealed by applying a toner powder (such as used with copiers) to the charged film. Photographs made using either of these two methods should be of high contrast to increase the readability of the indented writings. Photographs should be made at natural size (that is, a 1:1 ratio) on Kodak Technical Pan film or Kodalith Ortho film. When using side lighting, it is sometimes impossible to obtain a satisfactory image of all the writing in one photograph, because different areas of the paper require different angles of illumination. In this instance, a series of photographs should be made. Pairs of pictures made by lighting one from the right side of the paper and the other from the left side of the paper are helpful in some cases. By very slightly offsetting the two negatives obtained in this manner, and printing them together, the writing can sometimes be made more distinct.

Moderate contrast, combined with side lighting, helps to decipher illegible indentations on paper.

Illumination angles are also important in photographing folds, tears, and other imperfections and anomalies in paper. It may sometimes be important to know if writing was added to a document after the document was folded. A macrophotograph of the ink path across the fold line will usually show whether the writing was placed on the document before or after the page was folded. If the writing was added after the document was folded, the ink path will hesitate briefly at the fold line, leaving a small "blob" of ink on the fold.

Figure 16.6
Two ink lines appearing on a sheet of paper that had been folded. Which line was added after the fold?

Contact Writing

Other techniques of discovering the nature of writing on a missing sheet of paper rely on the traces of ink that may have been passed from one sheet to another. Although there are chemical methods for the detection of these traces, the simple and effective technique of fluorescence under an ultraviolet lamp should be tried first. A faint fluorescence may be discernible from the ink traces transmitted by contact with the missing sheet.

Carbon Paper and Ribbons

Carbon paper discarded after the typing or writing of a document will reveal the original message. In addition, carbon ribbons from electric typewriters and printers may also reveal the original typed message. Try:

- Oblique writing. With the carbon side of the paper facing the lens, direct a single lamp from the side until the light appears to be reflected from the writing. This method is especially useful if the carbon has been used only once or twice. Kodak Kodalith Ortho film or Technical Pan, developed for high contrast, should be used.
- 2. Carbon paper as a negative. A much-used carbon paper that is thin and evenly perforated in spots may be contact printed as if the carbon

- were a negative. The writing is then printed directly onto photographic paper. This usually requires a long printing exposure.
- Carbon ribbon as a negative. Carbon ribbons are thin plastic ribbons coated with a black carbon base. When the typeface from a typewriter element or daisy wheel strikes the ribbon, the carbon is deposited onto the typing paper. Because carbon ribbons are single-strike ribbons, they can be photographed as a negative and "read" if the type of typewriter or printer is known. For instance, the IBM Selectric II typewriter ribbon travels from left to right, with the typeface striking areas on the ribbon in a three-tiered vertical sequence. Care must be taken in handling carbon ribbons, because the carbon backing is very delicate and can scratch or flake off easily. Mounting the carbon ribbon between two sheets of glass, or using fingerprint-lifting tape will help protect the area on the ribbon that is to be read and photographed (see Figure 16.7).

Figure 16.7

Carbon ribbon as a negative. Top photograph shows a contact print made with a portion of an IBM Selectric II ribbon. Bottom photograph shows the same portion of ribbon, but it was placed in the negative carrier and enlarged. Note the sequencing of the letters that read "IBM Selectric II typewriter."

4. Transmitted light. By illuminating carbon paper or ribbon from the rear and using a red filter (Kodak Wratten No. 25) a satisfactory photograph of the writing may be obtained with Kodak Technical Pan film developed in HC-110 for high contrast.

Differentiating Inks

In some types of forgery, the criminal adds writing to the check or other document by using an ink of the same color, but with a different chemical compo-

sition than the ink originally used. Because the added writing is usually limited in quantity, often only a single stroke, the use of chemical methods to prove a difference in inks may be risky. A photograph of the fluorescence under ultraviolet radiation or an infrared photograph is often helpful in these situations. In addition, differences may be discernible with dichroic filter examinations.

Ultraviolet and Fluorescence Photography

17

This chapter covers two main topics—"Ultraviolet Photography" and "Fluorescence Photography"emphasizing the fact that two types of photography are involved. Ultraviolet photography has been considered fluorescence photography, but although it is a common technique to use ultraviolet radiation to produce fluorescence, this is not the only radiation that can be used for this purpose. Also, because it is possible to completely photograph an object by ultraviolet radiation with no fluorescence produced, the reason for the division is further justified. If an object is photographed by ultraviolet radiation reflected from it or transmitted through it (as in microscopy), the technique should be called ultraviolet. In the latter case, involving a microscope, the technique is sometimes referred to as ultraviolet micrography. If certain radiations (including ultraviolet) are used to excite fluorescence in an object, the recording of the resultant fluorescence is called fluorescence photography.

Ultraviolet Photography

The main purpose of ultraviolet photography is to obtain information about an object or material that cannot be obtained by other photographic methods. Obviously, if differentiation between two substances is produced in photography with visible light or infrared radiation, there is little need to resort to ultraviolet photography. If the first two methods fail, however, there is always the possibility that the third might succeed. In many cases, it is worth a try.

Ultraviolet photography is usually performed by using reflected radiation, and it depends upon the premise that two (or more) elements of an object will reflect or absorb ultraviolet radiation differently. Techniques in visible and infrared photography operate on essentially the same principle, except, of course, that in most visible-light photography, the elements of an object may show color contrast.

Some materials absorb ultraviolet radiation, while others reflect radiation. Some have partial absorption and partial reflection. These effects can be recorded photographically by using ultraviolet radiation.

Ultraviolet Radiation

Ultraviolet radiation cannot be seen by the naked eye and is often termed "invisible," as are other electromagnetic radiations except those in the short visible range. Photography emulsions, however, are sensitive to most wavelengths of ultraviolet radiation. By using a filter that absorbs all visible light but passes ultraviolet light, it is possible to make a photographic exposure with only ultraviolet light. This technique is called "ultraviolet photography."

For practical photographic purposes, the ultraviolet spectrum is arbitrarily divided into three very narrow bands: long-, medium-, and short-wave ultraviolet. Another band, called "vacuum ultraviolet," also exists, but is not usable in photography.

Radiation Sources

Sunlight. Sunlight is probably the most common source of long-wave ultraviolet radiation. Although the long waves and some middle-waves of ultraviolet radiation pass rather freely through the atmosphere, the short waves are attenuated by scattering and by absorption due to moisture and gases in the atmos-

phere. A sufficient amount of long-wave ultraviolet radiation is usually present, and bright sunlight could be used to illuminate large areas with ultraviolet radiation, particularly on a dry day. For ultraviolet photography using sunlight, a filter is placed over the camera lens. This filter should transmit long-wave ultraviolet radiation freely and should absorb all visible light. The filter should be closely fitted to the camera lens so that no visible light enters the lens.

Fluorescent tubes. Fluorescent tubes are often used in the photographic lab to provide visual illumination over a large area. Special tubes of this type can be used to provide ultraviolet radiation for photography. Ultraviolet radiation is produced in these tubes by a discharge of electricity through a carrier gas, such as argon. The gas ionizes enough to cause a glow, and develops enough heat to cause mercury in the tube to vaporize. As the mercury vaporizes, it is ionized by the electrical discharge and gives off visible light (mostly green and blue), but also emits ultraviolet light, both long wave and short wave. Because longwave ultraviolet light is wanted for ultraviolet photography, this tube is coated on the inside with a phosphor that absorbs short-wave, and emits longwave, ultraviolet radiation. The glass of the tube usually contains a chemical salt that acts as a filter. It is opaque to most visible light but freely transmits the long-wave ultraviolet radiation. Tubes of this type are often called "black light" tubes, because they appear black visually (see Figure 17.1). These tubes can be obtained in several lengths, up to 48 inches long, so they can be used to illuminate large areas with ultraviolet light. These tubes can be operated in standard fluorescent light fixtures, with the standard starter coil and ballast. Tubes of this type are called "low pressure" mercury vapor lamps.

Mercury vapor lamps. Mercury vapor lamps of "high pressure" consist of small, tubular, quartz envelopes, in which mercury vapor is produced under a pressure of several atmospheres. These lamps require high electrical current for operation, with a considerable output of long-wave ultraviolet radiation. They also, however, emit some middle-wave and short-wave ultraviolet radiation. They are of particular advantage in illuminating small areas with high ultraviolet brightness. Special mercury vapor lamps of this type, and of high wattage, are of particular interest in both ultraviolet photomicrography and ultraviolet spectrography. Mercury vapor lamps produce extremely bright spectral lines in both the ultraviolet and the visible

range. Special transformers are usually required for operation, and a warm-up period of several minutes is necessary for greatest brightness.

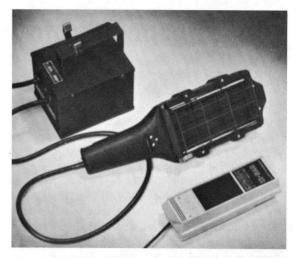

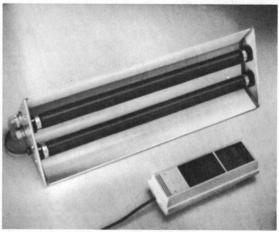

Figure 17.1 Typical ultraviolet lamps.

Arc lamps. Arc lamps are also used to produce very intense ultraviolet radiation, either medium-wave or long-wave. The cored carbon arc is probably the best-known lamp of this type. An arc is produced by impressing electricity across two electrodes of carbon in close proximity, and in air. Because the carbon is consumed in the process, a mechanical means is used to maintain a constant separation between the electrodes. In a similar manner, electrodes of cadmium can be used to produce an extremely bright line at 275 millimicrons. The xenon arc is enclosed in a small

glass tube that contains metal electrons in a highpressure atmosphere of xenon gas. Although this arc lamp emits some long-wave ultraviolet radiation, its primary use is in visual-light photography and photomicrography. A continuous spectrum is produced in the ultraviolet, visible, and infrared spectral ranges.

Electronic flash lamps. Electronic flash lamps vary considerably in ultraviolet output, depending to some extent on the type of gas contained in the tubes. A tube containing a high percentage of krypton or argon emits more blue and long-wave ultraviolet radiation than one in which xenon predominates. All electronic flash lamps, however, emit some long-wave ultraviolet radiation and can be used in reflected ultraviolet photography. The lamps in which the tube and envelope are composed of quartz also emit some shorter wavelengths of ultraviolet radiation.

Wire-filled flash lamps. Wire-filled flash lamps are also suitable for reflected ultraviolet photography, because these light sources, either blue-coated or clear, emit enough long-wave ultraviolet radiation for instantaneous exposures near the subject.

Illumination for Ultraviolet Photography

There are many sources that emit ultraviolet radiation. The selection of a source for ultraviolet photography depends primarily upon factors such as availability, cost, convenience, object size, and source emission. Sunlight, of course, is the most readily available, costs nothing, and provides a broad source of illumination. On the other hand, the intensity of ultraviolet radiation available from sunlight is quite variable due to changes in light conditions and by attenuation of ultraviolet radiation by scatter and absorption in the atmosphere. A bright, cloudless, dry day is best.

To control illumination conditions more satisfactorily, ultraviolet photography is usually performed indoors. The most readily available source of ultraviolet radiation is the "black light" fluorescent tube (see Figure 17.1). Tubes of this type can be obtained from all major electrical supply firms (General Electric, Sylvania, Westinghouse, etc.). These tubes can be fitted to, and used in, regular fluorescent light fixtures. They can be obtained in a variety of lengths to suit the size of the object to be illuminated and are reasonably priced. Because the glass for each tube contains a vis-

ibly opaque filter element, it is usually necessary to illuminate the subject temporarily with an auxiliary light source (such as a tungsten flood lamp). Long tubes of this type are excellent for ultraviolet illumination of large areas, such as the photography of large documents.

Mercury vapor lamps of the "high pressure" type are usually small and are most suitable for illuminating small objects in close-up photography, photomicrography, and spectrography.

Carbon arc lamps are not generally suitable for ultraviolet photography; they can be erratic and inconvenient. Also, they provide no advantage over previously mentioned light sources. They can be used for specific purposes, however, in photomicrography by transmitted or reflected light, and in spectrography. The xenon arc can be used for long-wave ultraviolet photography by filtering the visible emission.

Electronic flash lamps provide a broad source of visual illumination, with some ultraviolet emission. The efficiency of ultraviolet illumination is limited, however, by the type of gas contained in the tubes, and by the percentage of reflection of ultraviolet radiation from the reflector. An aluminum reflector provides a high percentage of ultraviolet reflection. Enough ultraviolet radiation is emitted from any electronic flash to permit instantaneous exposures with a hand-held camera, provided that the subject distance is not too great.

Wire-filled flash lamps are probably the least expensive and most convenient long-wave sources of ultraviolet radiation. They are available in a wide variety of sizes, representing various light intensities; can be easily procured; and can be used with most cameras. Even the smallest lamp (AG-1, AG-1B, or Flashcube) provides a high enough ultraviolet brightness for instantaneous exposure with a handheld camera at a subject distance of six feet or closer. Lamps of this type, however, cannot be used for mediumwave or short-wave ultraviolet photography, because these radiations are not transmitted through the glass envelope.

Filters

Regardless of the source of illumination used, a filter must be placed over the camera lens. This filter should have a high transmittance of ultraviolet radiation, and should not transmit any visible light. The goal of ultraviolet photography is exposure by ultraviolet radiation. Ultraviolet transmitting filters are usually made of glass in which coloring agents are contained to control transmittance. Most types of glass will transmit long-wave ultraviolet radiation, but will absorb all medium-wave and short-wave ultraviolet radiation. This is not a disadvantage in general ultraviolet photography, because lenses used in cameras are made of optical glass, whose transmittance is also limited to long-wave ultraviolet radiation. Gelatin filters are unsuitable for this type of photography.

Kodak Wratten Filter No. 18A is a glass filter with a high percentage transmittance of long-wave ultraviolet radiation, particularly the 365-millimicron line of the mercury spectrum. It is currently available in both two- and three-inch squares, and as a four-inch square on special order. It can be obtained through photographic supply dealers. This filter or its equivalent is highly recommended for long-wave ultraviolet photography.

A No. 18A filter can be attached to a camera lens by means of a Kodak Gelatin Filter Frame Holder and a suitable adapter ring. A Series 6 holder will accommodate a two-inch square filter; a Series 8 holder, a three-inch square filter; and a Series 9 holder, a four-inch square filter. The two-inch square filter is adequate for most 35mm cameras. The larger sizes are appropriate for view-type cameras. When a glass filter is mounted in front of a camera lens, it is imperative that all visible light be excluded, possibly with some kind of light seal around the filter.

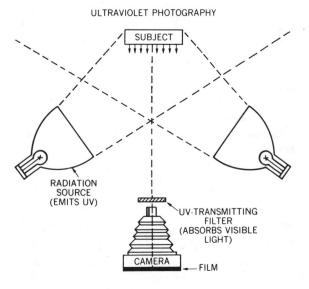

Figure. 17.2Typical setup for reflected ultraviolet photography. The number 18A UV transmitting filter may also be placed over the light source rather than the camera lens.

Ultraviolet-transmitting filters can also be obtained from other filter manufacturers. It is suggested, however, that filter transmittance curves be obtained and examined for efficiency of both ultraviolet transmittance and visible light absorption. Filters used for this purpose should have no visible light transmittance.

Film

All photographic emulsions contain silver halide, which is inherently sensitive to blue and ultraviolet radiation. Sensitivity to ultraviolet radiation actually extends far into this region, but the response of a film is somewhat limited, due to absorption of ultraviolet radiation by gelatin, the medium in which silver halide crystals are suspended. For long-wave ultraviolet photography, almost any type of film can be used to record an image. Only black-and-white films need be considered, because color film has no advantage in ultraviolet photography. In 35mm ultraviolet photography with long-wave radiation, Kodak Technical Pan film, Tri-X and T-Max, and Ilford HP5 films are all suitable, and are easily obtained through photographic supply dealers. Technical Pan film is strongly recommended because of its extremely fine grain, which permits great enlargement. All of the films mentioned above are currently available in 24or 36-exposure rolls in camera magazines, and in 50and 100-foot bulk rolls.

If a view camera is to be used, sheet film will be required. Again, a wide variety of sheet films are suitable because all films have ultraviolet sensitivity. A film of medium to high contrast, with very fine grain, should be the first choice. Although film-speed ratings are given only for visible light, a fast film is preferred to minimize exposure time. Films such as Kodak Plus-X Pan Professional (Estar Thick Base) and Kodak Tri-X Pan Professional (Estar Thick Base) are suitable. They have extremely fine to very fine grain, although their contrast is moderate. For medium to high contrast, one could use either Kodalith Ortho film (Estar Thick Base) or Kodak Technical Pan sheet film developed in HC-110 for high contrast.

Images formed with ultraviolet radiation usually present low contrast. Therefore, if a high-contrast film is not used, medium- to high-contrast development should be practiced for best effect. This can be achieved either by extending the development time in recommended developers or by using developers that produce elevated contrast.

Film Speed

The rated speed for any film is determined for visible light, and does not apply to ultraviolet radiation. An arbitrary ultraviolet film speed can be determined by making test exposures. This speed rating can then be applied when setting the meter to indicate exposure to ultraviolet radiation. The ultraviolet speed will be considerably lower than the visible-light speed. For example, one film has a speed of ISO/ASA 400 for visible light; exposure to ultraviolet radiation, however, indicated that the effective speed was only about ISO/ASA 10.

A specially designed meter for making a reading of ultraviolet intensity can be obtained from Ultra-Violet Products, Inc. It is called the Blak-Ray ultraviolet intensity meter, and is a handheld device for measuring the intensity of emission from ultraviolet sources and the radiation incident on a surface from a source. Visible light has no effect on the meter. Two sensors are available—one for long-wave ultraviolet radiation and another for short-wave ultraviolet radiation. Meter readings are in microwatts-per-square centimeter, which can be correlated to exposure time in ultraviolet photography. The meter requires no batteries, electrical supply, or any other source of power.

If an exposure meter is unavailable, or inadequate, exposure must be determined by making a series of test exposures. In general, exposure time will be considerably longer than if visible light were used (for one aperture setting). A test series could therefore be made at a small f/number, with variations in exposure time over a wide range, starting with a short exposure time and increasing by a factor of two. An approximate series could be 1/10, 1/5, 1/2, one, two, four, and eight seconds, etc. If all exposures are too long, then overexposure will result, and shorter periods are indicated. Conversely, if all exposures are too short, underexposure results and longer periods are necessary. Once a reasonable exposure period is determined for a given set of conditions, exposures for different conditions can probably be estimated. A shorter test series can be applied. Of course, if a film of higher or lower speed is used, another test exposure series must be made.

Focus

Although a camera lens is specified as having a definite focal length, this characteristic pertains to visible light only. When infrared radiation is used to form an image, the focal length of the lens is longer than specified; when ultraviolet radiation is used, it is shorter. An image in sharp focus visually may be quite blurry in a photo taken by ultraviolet radiation. For ultraviolet photography, a good technique is to achieve focus visually and then to stop down the lens aperture to obtain greater depth of field. The amount of aperture decrease is a function of normal focal length. Lenses of short focal length inherently have more depth of field, and will require less aperture decrease than those of long focal length. In 35mm photography, lenses usually have short focal lengths (38mm, 45mm, 50mm, etc.). A lens-aperture decrease of at least two stops below wide-open will usually suffice. Test exposures at various apertures, however, will definitely establish the largest f/stop number aperture for sharp focus in reflected-ultraviolet photography.

Exposure

The methods by which exposure can be determined in reflected-ultraviolet photography include using an exposure meter, making test exposures, or establishing a guide number when flash lamps are used. Most conventional exposure meters have some sensitivity to ultraviolet radiation. The incident-light type of meter is the most convenient. If the cell can be covered with a Kodak Wratten Filter No. 18A (or equivalent) so as to exclude all visible light, the meter will give an indication of ultraviolet intensity. The intensity will vary, of course, as the distance from radiation source to subject is varied. The source should be positioned so that the entire area to be photographed is well illuminated. If a mercury vapor lamp is used, no filter is necessary in front of the lamp, and the visible light emitted will ascertain efficiency of illumination. If the lamp contains an ultraviolet transmitting filter that cannot be removed, the coverage and evenness of illumination must be determined by ultraviolet intensity alone.

Flash

The determination of exposure with flash lamps is simplified, because a guide number can be determined from one test exposure series. The duration of a flash is fairly constant, so a fixed shutter speed ($\frac{1}{100}$ or $\frac{1}{125}$ of a second) can be used for the series. All exposures in the series should be made at the same lampto-subject distance. The test series should include exposures at all available lens-aperture settings.

Here is an example of a test series: A 35mm camera with an f/2.8 lens is used to make a test series on Kodak Tri-X Pan Film. With the shutter set at 1/60 of a second, exposures are made at f/2.8, f/4.0, f/5.6, f/8, f/11, f/16, and f/22. A Kodak Wratten Filter No. 18A is placed in front of the lens. The subject in front of the camera is six feet away. After the film has been processed, the frame showing good exposure is determined by examining the strip. In this case, the exposure at f/4 appears best. Because a flash guide number is equal to the subject distance multiplied by the lens-aperture number, six (distance) is multiplied by four (f/number), and a guide number of 24 results. This figure can be used for future exposure determination when the same camera, film, and flash are used. For instance, if the distance were changed to four feet, the new f/number would be six; if the distance were two feet, the new f/number would be 12, and so forth. With this technique, a flash guide number can be determined for any combination of film and flash. The same technique applies whether electronic flash or wire-filled flash lamps are used.

Blak-Ray Criminalistics and Detection Kits

Under ultraviolet light, many items will reveal a good deal of important information about the criminal that is not apparent when observed under ordinary light. Lipstick traces, for example, too minute to be seen under white light, will fluoresce under ultraviolet light. Oil and grease spots have a distinctive fluorescent glow, as do saliva and semen. Crimes can be detected by placing an invisible fluorescent powder or paste on such objects as money, fire alarms, and coin boxes.

Ultra-Violet Products, Inc. produces a criminalistics kit and a detection kit (see Figure 17.3) that can be used for a variety of detection methods. Some of

them are as follows: inspection of clues, detection of persons sounding false alarms, detection of tampered documents, inspection of documents, autopsy assistance, coin box tampering, trailing, illegal money transactions, use of firearms and weapons, repeated burglaries, petty theft and shoplifting, sex crimes, narcotics, espionage, kidnappings, forgeries and altered checks, fraud, and bunco.

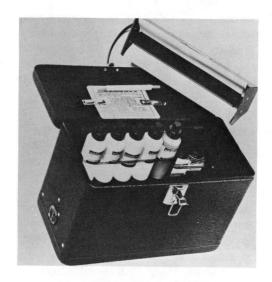

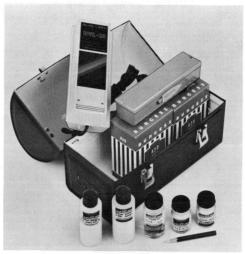

Figure 17.3
Blak-Ray criminalistics kit (top) and detection kit (bottom).

Fluorescence Photography

Luminescence

When certain materials (solids, liquids, or gases) are subjected to short-wave electromagnetic radiation, they will emit another type of radiation of longer wavelength, known as excitation, and very often are within the visible spectrum. The radiation source creating excitation may be X rays, gamma rays, electrons, ultraviolet radiation, or even some visible wavelengths. This phenomenon of induced light emission is called luminescence, of which there are two distinct types—fluorescence and phosphorescence.

Fluorescence

If the luminescence ceases within a very short time (eight to 10 seconds) after the exciting radiation is removed, the phenomenon is called fluorescence. Although fluorescence is commonly produced by excitation with ultraviolet light, other radiations can be used in some applications. It is also possible to stimulate fluorescence with some visible wavelengths. Blue light, for example, stimulates green fluorescence in some compounds.

There are many thousands of materials that exhibit the phenomenon of fluorescence, and fluorescence photography has numerous applications because it provides information that cannot be obtained by other photographic methods. Just the fact that a substance will fluoresce is an important characteristic. The particular radiation that excites fluorescence and the specific position of that fluorescence in the visible spectrum can be clues to the identity of a substance. Also, contrast between the elements of a material can often be produced by fluorescence, even when they otherwise appear similar.

Phosphorescence

Although fluorescence ceases almost immediately after the exciting radiation is removed, there are some substances that continue to luminesce for a long time, even hours, after removal of the exciting stimulus. This phenomenon is called phosphorescence and is produced in compounds called phosphores. Phosphorescence, like fluorescence, is stimulated by many radiations, but in fewer substances. The image on a television screen, for example, is produced by phosphorescence.

Infrared Luminescence

Although most luminescence appears in the visible spectrum and is excited by either ultraviolet or short, visible wavelengths of blue, it is also possible to excite luminescence in the infrared range by irradiation of certain materials with blue-green light. The phenomenon is referred to as luminescence, instead of fluorescence or phosphorescence, because it is not known whether the effect ceases immediately after the exciting stimulus is removed.

Excitation Sources

The most common radiations used to excite fluorescence are the long ultraviolet wavelengths, and many of the radiation sources used for ultraviolet photography in micrography can also be used for fluorescence photography. Some shorter visible wavelengths are occasionally used to produce fluorescence, either at longer visible wavelengths or in the infrared.

Although it is possible to use sunlight as a source of ultraviolet or visual light to produce fluorescence, it is not a practical procedure. Artificial radiation sources are preferable because they are constant, easily procurable, and convenient to use.

Mercury vapor lamps. All of the mercury vapor lamps, both high-pressure and low-pressure, have application in fluorescence photography. The selection of a lamp depends to a great extent on the application. If the subject is large, then a source is needed that can illuminate a large area with the desired radiation. If a small object is to be irradiated, then a small, intensely bright source will be advantageous. All mercury vapor lamps, however, emit long-wave ultraviolet radiation, and if the tube is made of quartz, then the shorter waves of ultraviolet may also be emitted.

Electronic flash. Electronic flash lamps are suitable for ultraviolet photography because they emit long-wave ultraviolet radiation. They can also be used for recording fluorescence, excited by ultraviolet radiation, in close-up applications such as photographing fingerprints dusted with fluorescent powder. A flash-tube with high intensity output should be obtained for this purpose. One of the difficulties encountered in using electronic flash is that the resulting fluorescence is not visible during the short flash interval. A continuous ultraviolet source is often necessary for

preliminary inspection to ascertain the presence of fluorescence.

Visual light sources. Fluorescence can be excited in certain materials by irradiation with blue or blue-violet light, and occurs at a longer wavelength in the visible spectrum, often green or yellow-green. A light source that has a high intensity with continuous emission in the blue region of the spectrum is needed for this application. The xenon arc is probably the most suitable light source, although electronic flash might also be used. Carbon arc lamps also emit light of high intensity, but they can be quite erratic unless a mechanical (or electrical) means of maintaining electrodes in a constant position is available.

There are several light sources that can be used for producing infrared luminescence. This phenomenon is exhibited in some materials by stimulation with blue-green light. Although it is possible that infrared luminescence may also be stimulated by irradiation with specific wavelengths of blue or green, it is suggested that a source that has continuous emission in the blue and green spectral regions be obtained. High-wattage tungsten lamps, the xenon arc, or even ordinary fluorescent lamps can be used for this purpose.

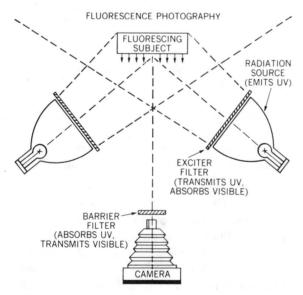

Figure 17.4Typical setup for fluorescence photography using ultraviolet light. The exciter filter is a number 18A UV transmitting filter and the barrier filter is a number 12 filter.

Photographic Technique

When fluorescence is stimulated with either ultraviolet or visible wavelengths, there are several factors that must be considered for efficient photography. The subject must be illuminated with the exciting stimulus, and this is accomplished by selecting a suitable source that emits the necessary radiation. A filter is used with the source to screen out other radiations and to transmit the exciting radiation. Another filter, usually placed between the subject and the camera, absorbs any residual exciting radiation and transmits the fluorescence. The fluorescence is then recorded on a suitable photographic material.

Illumination

One of the main factors influencing the brightness of fluorescence is the intensity of the exciting radiation. Fluorescence brightness is generally of very low order compared with image brightness in other types of photography. It is important, therefore, that the radiation source be as close to the subject as possible, while furnishing even illumination over the area to be photographed.

The size of the subject must be considered when selecting an appropriate source of illumination. When a large subject is to be photographed, the source should cover a large area with as bright an illumination as possible. Long fluorescent tubes (low-pressure mercury vapor lamps) are suitable. High-pressure mercury arcs are also useful, but they are small sources. If they are used to illuminate a large area, there may be a sacrifice in fluorescence brightness, resulting in extremely long exposure times. If the long tubes are selected, two or more (in suitable reflectors) can be placed on each side of the subject to provide a considerable quantity of exciting radiation. If the subject is large and flat, such as a large document, the tubes should be placed so that the incident illumination angle is less than 45 degrees. Make sure, however, that no direct light from the source is "seen" by the camera. The lamp reflectors can be placed so that this does not occur.

High-pressure mercury vapor lamps are excellent for illuminating small objects or small areas. One lamp, however, is usually inadequate, because illumination is then provided for only one side. At least two lamps should be used, one on each side of the subject, especially when the subject is three-dimensional.

Electronic flash lamps are especially useful when living subjects that exhibit fluorescence are to be photographed, because instantaneous exposures are possible. Although one lamp may be sufficient, two lamps (one on each side of the subject) will provide twice as much light and will allow smaller lens apertures (for increased depth of field) to be used.

The illumination of the subject should consist only of the radiations needed to excite fluorescence. All ambient illumination (room lights) and all other illumination from the source must be excluded from the subject. Fluorescence photography is often accomplished in either a darkened room or in a light-tight enclosure.

Exciter and Barrier Filters

At least two distinct types of filters are used in a fluorescence photography system. The first, called an exciter filter (No. 18A), is placed between the subject and the radiation source. It transmits the radiation to excite fluorescence. The second, a barrier filter (No. 12), is placed in front of the camera lens (or somewhere behind the objective lens in a microscope), to remove any residual exciting radiation and to transmit the fluorescence.

The exciting filter is used with the radiation source and its purpose is to transmit the exciting radiation efficiently and absorb all, or almost all, of the other radiations emitted from the source. When ultraviolet radiation is used to excite fluorescence, the exciter filter should pass a high percentage of the ultraviolet light radiated from the source. If visible blue or blue-green light is used to excite fluorescence, then the exciter filter for this purpose should transmit either of these radiations freely and absorb all others.

Fluorescence brightness, as previously stated, is usually of low intensity, and if anything other than exciting radiations are incident on the subject, they will be higher in brightness and may mask the fluorescence.

The exciter filter in front of the light source transmits the radiation necessary to excite fluorescence. Not all of this radiation is used, however, and some residual radiation still exists, reflected from or transmitted through the subject. If this residual radiation is not removed, it will record on film. Because it is usually of higher brightness than the fluorescence, it will cause more exposure than the fluorescence. Another filter must be used, usually in front of the camera lens, to prevent the residual exciting radiation from causing exposure. This filter acts as a barrier to the exciting radiation, and is called a barrier filter. An

efficient barrier filter absorbs all radiation transmitted by the exciter filter, and transmits only the wavelengths of light evident as fluorescence. If ultraviolet radiation is used to excite fluorescence, then the barrier filter must absorb ultraviolet radiation. If the exciter filter passes both ultraviolet and some short visual blue radiation, then the barrier must absorb both ultraviolet and blue radiation. For ultraviolet fluorescence photography, a No. 18A filter is used as the exciter filter and a No. 12 (deep yellow) filter is used as the barrier filter. For further information on the selection of exciter and barrier filters, refer to the Eastman Kodak Company publication *Ultra Violet Fluorescence Photography*, Kodak Publication No. M-27.

Films

All photographic emulsions are inherently sensitive to blue and ultraviolet radiation. This is why all blue and ultraviolet radiation transmitted by the exciter filter must be absorbed by the barrier filter. Otherwise, the film will be exposed to these radiations, which may cause a greater photographic effect than the fluorescence. If a color film is used, any ultraviolet radiation reaching the film will record as blue, seriously degrading the record of fluorescence colors. Similarly, any unwanted blue light passing through the barrier filter will degrade the fluorescence record.

Color film, of course, presents the greatest advantage in recording fluorescent colors. Daylight-type color film is especially recommended because of its balanced sensitivity to the blue, green, and red regions of the visible spectrum. Color film balanced for tungsten illumination is seldom recommended, because it has higher blue sensitivity than the daylight-type color film.

Roll color films, especially in 35mm size, are usually recommended for recording fluorescence because they have the highest speeds, are more readily available, are less expensive, and are more conveniently handled and processed than sheet color films. Because fluorescent images are faint, using a high-speed color film such as Ektachrome 1600 Professional is recommended.

Although there is no question about the advantage of using color film in recording fluorescent colors, there are applications for which black-and-white film may be perfectly satisfactory. Usually the black-and-white film should have panchromatic sensitivity and high speed.

Infrared luminescence is best recorded on an infrared-sensitive film such as Kodak Infrared Film or High Speed Infrared Film.

Exposure Determination

Because of the very low brightness of fluorescence, the most practical method of determining exposure is by test. The beginner should "bracket" by making several exposures, increasing time at a fixed lens aperture by a factor of two, in successive steps, over a wide range. Lens apertures could also be varied by using a fixed time, but this technique would cause a variation in depth of field that might not be desirable. Once the exposure time has been determined, however, the lens aperture can be changed to achieve the appropriate depth of field. As in all other photographs, if lens aperture is changed, exposure time must be changed in inverse proportion. When a constant source, such as a mercury arc lamp, is used, exposure time will be several seconds, or even minutes, if the fluorescence is extremely low in brightness. Extremely long exposures result when large subjects are to be photographed and illumination is spread over a large area. Extremely long exposures can also result when an image size is greater than object size, as in photomacrography.

Although it is seldom possible to use an ordinary exposure meter to read fluorescence brightness, an extremely sensitive meter can be used. If one is available, its cell should be protected with a barrier filter that absorbs ultraviolet radiation. Otherwise, the meter will indicate ultraviolet rather than fluorescent brightness. Ultraviolet radiation reflected from or transmitted through the subject will be much greater in brightness than fluorescence, so an erroneous indication of exposure time will be obtained.

When electronic flash is to be used (as in closeup fluorescence photography), an experimental guide number can be determined for a specific subject, flash unit, and film. If the subject is changed, however, the guide number may or may not apply, because fluorescent brightness may change. In this case, exposures should be bracketed. Exposure time will be constant, so changing the lens aperture is the only practical means of varying exposure.

No matter how exposure is determined, it is a good idea to make a record of all exposure conditions for future reference. These conditions include the subject, the radiation source, the exciter filter, the barrier filter, the position of the source, the film, the exposure time and lens aperture, and other details pertinent to fluorescence photography.

Focus

When fluorescence occurs in the visible spectrum, there is no problem involved in obtaining correct focus. It can be achieved by a distance setting on the camera, by means of a range finder, or by adjustment on a ground glass (as in a view camera).

Recording infrared luminescence, however, involves an invisible image, and lens focal length is longer for infrared than for visible light. The use of a small lens aperture is a practical means of obtaining correct focus. Usually the image is focused with visible light; the lens aperture is decreased to at least two stops below the wide-open position; the infrared-transmitting filter is placed in front of the lens; and the exposure is made. The exact lens aperture would be determined by the depth of field necessary to record a satisfactory image.

Applications of Ultraviolet and Fluorescence Photography

Because there are many thousands of substances that exhibit fluorescence when excited by specific radiations, it is reasonable to expect that there are many photographic applications in which this phenomenon is of particular interest. As with any type of photography, the photography of fluorescence is practiced to supply information that cannot be obtained by other means. The fact that a substance does fluoresce differentiates it from one that does not. When two substances both fluoresce, they may differ in fluorescence color, or their fluorescence may occur in distinctly different portions of the spectrum, visible or invisible. Most fluorescence occurs in the visible spectrum with long-wave ultraviolet excitation. Fluorescence can also occur, however, in long-wave ultraviolet (or in the visible spectrum) with shortwave ultraviolet excitation. It can also occur in the long-wave visible region with blue light excitation. Finally, some materials, as stated, produce infrared luminescence when excited by blue-green light.

Questioned Documents

An outstanding application of fluorescence photography is in the field of questioned documents. When other photographic methods fail to reveal suspected alterations of, or additions to, a document (check, letter, will, etc.), it is always possible that a fluorescence technique will provide fruitful results. Different inks may show a difference in visible fluorescence. The effects of bleaching or erasing can also often be detected by this means. Most papers on which documents are written or printed contain cellulose fibers. These fibers often fluoresce brightly when the paper is illuminated with ultraviolet radiation in a darkened room. Erasures will alter this fluorescence; the effect can be recorded and enhanced on a high-contrast black-and-white film. If inks have been bleached (e.g., with an "ink eradicator") the bleaching material still on the paper may show a fluorescent color. If it does, the effect can be recorded on either black-and-white or color film (see Figures 17.5, 17.6, 17.7).

Figure 17.5 This check (top) appears to be dated "1964" in the original photograph, but when ultraviolet photography is used (bottom), it shows that the check was actually dated "1960."

Because visible fluorescence may be produced by excitation with either long- or short-wave ultraviolet radiation, photographs should be made using each method. To produce fluorescence by short-wave ultraviolet radiation, a radiation source that emits this wavelength is needed. A high-pressure mercury arc in a quartz envelope emits several spectral lines of ultraviolet radiation, including the short-wave ultraviolet at 254 millimicrons. A filter that passes only short radiations must be placed in front of the source to provide only the necessary excitation. Narrow-band "interference filters" can be used for this purpose and are available from several firms.

Different inks may show different "infrared luminescence" when irradiated with visible bluegreen light. This can prove invaluable in detecting alterations in documents. The following is a method of illuminating a document in a light-tight box with blue-green light (provided by fluorescent tubes) and photographing the resultant infrared luminescence (see Figure 17.8). A box of this type can be constructed of wood (or other material) to accommodate average-sized documents, such as checks and letters. Because the camera is reasonably close, special close-up lenses are usually necessary if a camera with extendable bellows (or extension tubes) is not available. The box should be light-tight, so that no ambient light containing infrared radiation is incident on the surface of the document. A Kodak Wratten Filter No. 87 (or No. 88A), which transmits infrared radiation but absorbs visible light, is suggested for the front of the camera lens. Focus is accomplished first, however, with the blue-green light. The lens opening is decreased to a small aperture to assure good focus in the infrared. The blue-green filter in front of the lamps can be Corning Glass No. 9780, available from the Corning Glass Works. A long, narrow size is suggested for use in front of the fluorescent tubes. Information about available sizes and prices can be obtained from Corning. Because this type of luminescence is very low in brightness, Kodak High Speed Infrared film (35mm) is suggested for photography. Even with this high-speed film, however, exposure times may be of several seconds, or even minutes, duration.

The exposure box just described can also be adapted for regular close-up photography of visible fluorescence in documents or other objects. "Black light" fluorescent tubes, which emit ultraviolet radiation, can be used in place of the white light tubes, and the infrared-transmitting filter on the camera lens can be replaced by a barrier-type filter to absorb the ultraviolet radiation reflected from the subject. Fluorescence photographs can be made either on color reversal film or on black-and-white film.

Figure 17.6Typewritten receipt (top, A) looks bona fide, but ultraviolet fluorescence shows it to be a fraud (bottom, B).

The same equipment could also be used to photograph documents by reflected ultraviolet radiation. In that case, the "black light" tubes remain in place. A Kodak Wratten Filter No. 18A could then be used in front of the camera lens to transmit only ultraviolet radiation to a suitable black-and-white film.

The size of the box is governed by the length of tubes to be used and the sizes of documents to be photographed.

Fingerprints

Photographing fingerprints with visible light is a well-known, long-established procedure. Latent fingerprints on a dark surface are dusted with a light or white powder; those on a light surface, with a dark or black powder. In this way, a high-contrast effect is produced that can be photographed on a black-and-white film. As long as the surface is smooth and uniform in color or density, the fingerprint should photograph well. If a surface is multicolored or of alternate light and dark areas, however, neither a light

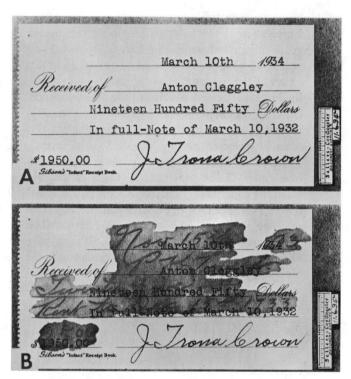

Figure 17.7
Faded signatures in document (top, A) are made visible with black light (bottom, B).

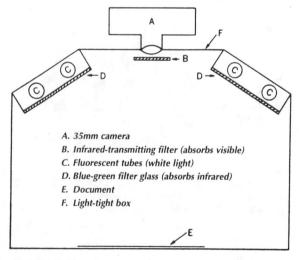

Figure 17.8
Suggested technique for photographing infrared luminescence in questioned documents.

nor a dark powder will give satisfactory contrast. Visualization of an entire fingerprint may be difficult. In this case, the area containing a latent print can be dusted with a powder that will fluoresce brightly when irradiated with long-wave ultraviolet radiation in a darkened room. The background will usually appear very dark, with little or no fluorescence, so that the fingerprint stands out and excellent contrast is achieved (see Figure 17.9).

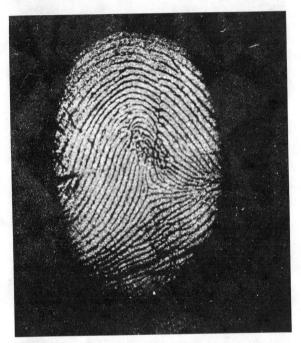

Figure 17.9 Fluorescent fingerprint.

A suggested technique for photographing such fingerprints is to use a single-lens-reflex camera (35mm) focused on the area suspected of containing a fingerprint (see Figure 17.10). An electronic flash unit attached to the camera with a long synchronizing cord will provide enough ultraviolet intensity to produce very bright fluorescence. The flash unit is placed at one side and is directed at the area to be photographed. A Kodak Wratten Filter No. 18A (or equivalent) can be taped in place on the front of the flash to provide only ultraviolet radiation, the exciting stimulus, and prevent all visible light from reaching the subject. A dusting powder, such as "Magna-Glo," a commercial powder (available from MacDonald Associates) made for the purpose, which fluoresces a bright yellow-green, may be used. Anthracene, a chemical compound that fluoresces a bright bluewhite, may also be used.

A barrier filter must be placed in front of the camera lens to prevent reflected ultraviolet radiation from exposing the film. A Kodak Wratten Filter No. 2A is suggested for this purpose. Focus and composition can be accomplished in room light, which is extinguished for the fluorescence exposure. The camera should be placed on a small tripod or bench clamp, because exposures are made in a darkened room. Kodak Tri-X Pan film or T-Max can be used for recording the image of the fingerprint. If higher contrast is desirable, Kodalith Ortho film, or Kodak Technical Pan developed in HC-110 for high contrast are suggested. Color film is neither necessary nor desirable, because the goal is to record the fingerprint with good contrast against the background. Exposure time is fixed at the flash duration, so it is usually necessary to vary test exposures by changing lens apertures. The actual lens aperture used will depend upon the brightness of the source and its proximity to the subject. An exciting source of relatively low intensity would necessarily have to be very close to the subject, but would produce a fluorescent brightness high enough for the instantaneous flash to cause adequate exposure on the film.

If an electronic flash lamp is not available, the dusted area can be illuminated with long-wave ultraviolet radiation from any source that emits this radiation. In any case, the exciting source should be placed very close to the area to be photographed in order to produce the highest fluorescent brightness.

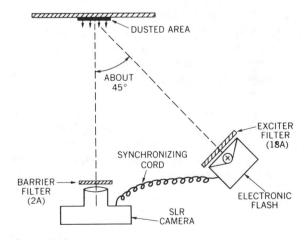

Figure 17.10 Flash technique for fingerprints.

Injuries

Dermatologists have long used a photographic technique, known as reflective ultraviolet photography (RUP), during examinations of patients to detect skin cancers and fungi growth. It is also useful in documenting pattern injuries that may have faded or disappeared visually. Pattern injuries are injuries that have a recognizable pattern or shape that can be identified such as bite marks, bruising, abrasions, scratches, cigarette burns, and whip or belt marks.

Victims of sexual assault may delay reporting the crime to police. During the delay, evidence of physical injury may heal or visually disappear creating problems documenting the injuries sustained. Child abuse victims may be too young to be credible witnesses, but documenting the injuries they may have sustained is a valuable source of evidence. Often, injuries that need to be documented are faded or healed to the point that normal photography will fail to capture the necessary details of the injuries. RUP can be used to document pattern injuries up to nine months after than have visibly healed (Aaron, 1991).

The basic principle of RUP is that only ultraviolet light rays that have been reflected from the surface of the skin are recorded on film. A Kodak 18A ultraviolet transmission filter is used over the light source (such as an electronic flash) or over the camera lens with normal light conditions. The 18A filter is visually opaque and transmits only long-wave ultraviolet rays between 300 and 400nm.

Exposure and focusing using RUP must be performed manually. Automatic focusing lenses must be switched to manual mode and focusing must be performed prior to placing the filter over the lens if normal light sources are used. Exposure should be bracketed since the metering system of the camera will not differentiate ultraviolet illumination. Exposures should be made by as many as five stops to ensure a good exposure. While color film may be used, it is recommended that a high-speed black-and-white film (such as T-Max or Tri-X 400 speed) be used. Generally, the higher the contrast the better the resulting image. Higher contrast prints may be produced through dark-room manipulation of the film developing process or by the printing process (see Figure 17.11).

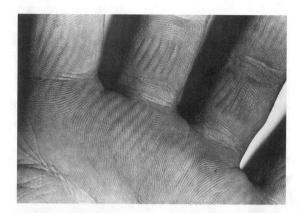

Figure 17.11
Photograph of an assault perpetrator's hand using the reflective ultraviolet photography technique. The perpetrator's hand was first sprayed with trace metal detection (TMD) solution then photographed using an electronic flash fitted with a UV filter. The thread marks correspond to the threaded three-quarter inch, three-foot-long bar the perpetrator used in the assault.

Alternate Light Sources

Alternate light sources are single portable units that are capable of providing light, from ultraviolet to infrared. There are several manufacturers of alternate light source units such as Omnichrome, Polilight (see Figure 17.12), BlueMaxx, and Luma-Lite. Most have a fine-tuning device that allow them to be tuned to any peak wavelength in the visible region (400-700nm). In addition, the ultraviolet (300-400nm) range may be selected, and an infrared range (700-

1100nm) is optional. This makes alternate light sources extremely valuable for document examinations. The output image may be videotaped or photographed. Goggles must be worn to visualize fluorescence and to drop out the excitation source. Goggles also protect the eyes from the intense light source. Camera filters must be used when photographing fluorescent evidence, ranging from yellow (Tiffen #15), orange (Nikon #056), red (Tiffen #29), and infrared (Kodak 87C). For more information, the reader should contact Rofin Australia Pty. Ltd. or Omnichrome.

Baldwin (1997) has suggested four rules for photographing fluorescent images using alternate light sources, including laser light:

- 1. Know the limitations of the camera and film being used.
- 2. Maintain a constant distance of the light source to the object for consecutive exposures.
- 3. Locate a starting point by a camera meter reading or a separate handheld light meter.
- 4. Bracket exposures by at least two stops.

References

Aaron, J.M. (1991). "Reflective Ultraviolet Photography Sheds New Light on Pattern Injury." Law and Order, 38:213-218.

Baldwin, H.B. (1997). "Photographic Techniques for the Laser or Alternate Light Source." http://police2 .ucr.edu/laser.htm

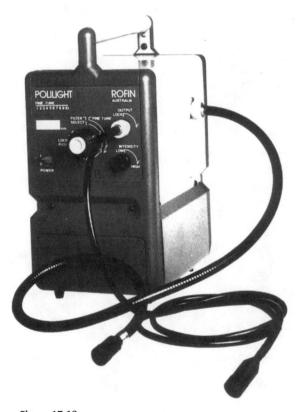

Figure 17.12 The Rofin Polilight.

rangan dan menganggan dan sebagai dan menganggan dan sebagai penganggan dan sebagai pengan beranggan beranggan Penganggan dan sebagai penganggan dan sebagai penganggan penganggan penganggan beranggan beranggan beranggan b

Commission of the Commission o

Infrared Photography

18

Infrared photography has found many applications in the field of criminalistics. These applications include the detection and deciphering of erasures and forgeries; deciphering of charred documents or those that have become illegible as the result of age or abuse; differentiation between inks and pigments that are visually identical but represent different compounds; detection of gunshot powder burns (Figure 18.1); stains and irregularities in cloth; examination of cloth, fibers, and hair that are dyed too dark to be easily studied by visible radiation; study of fingerprints; examination of the contents of sealed envelopes; detection of certain kinds of secret writing: determination of carbon monoxide impregnation of victims of gas poisoning; and photography in the dark, especially in the surveillance or apprehension of a burglar.

Cameras

Any type of camera regularly used for ordinary photography can be used for infrared photography. Because much of the work, especially indoors, deals with small specimens, the camera should be adaptable for close-up photography.

The most useful 35mm equipment for infrared photography is a single-lens-reflex camera with an automatic diaphragm. It is well-suited to handheld operation with infrared color film. Also, when opaque infrared-transmitting filters are placed over the lights instead of over the lens, the camera can be handheld for black-and-white infrared photography. However, when such filters have to be placed over the lens, a camera with a viewfinder may be useful.

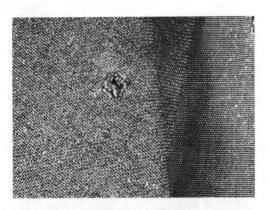

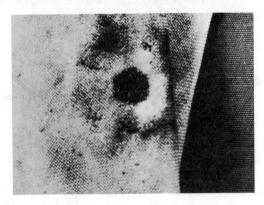

Figure 18.1
From the visual appearance of this garment (top), it was not possible to determine the cause of the hole in it. The infrared photograph (bottom) reveals the powder and burn marks of a firearm.

If the camera has a through-the-lens exposure meter, the meter should be turned off when an opaque filter is employed. Some work, especially outdoor work, can be done with a red filter and with the meter in operation. The camera should be set for the film speed rating without a filter. However, a red filter will affect the spectral response of the meter and may indicate an incorrect exposure for automatic operation. Tests may indicate the need to set a dummy film speed.

Checking the Camera

The photographer should be alert to possible radiation leaks through the bellows, camera body, or through a plastic lens board. Should obscure streaks show up on negatives, such a defect is probably the cause. A camera can be checked by placing unexposed film in it and then moving a tungsten light around in front of it for about a minute. Any density that occurs on the film is due to an unsafe bellows, lens board, or camera body, provided that the shutter and film holder are safe.

To rule out the possibility of a defect in the shutter, the lens should be covered with a metal cap when the test is performed. Then the shutter blades do not become a factor. For sheet-film cameras, load the film into the holder and insert the holder into the camera in the dark. The dark slide of the holder is thus not defective.

There is little chance that the blades of most current shutters will cause trouble. However, some older ones are made of hard rubber while some more recent ones are made of black plastic. Using them for infrared photography would be the same as employing blades of almost clear plastic for ordinary photography. A check can be made by focusing the camera on a light bulb. Then, in essence, a film is exposed with the shutter closed. About one minute at f/8 should be sufficient. If no image of the bulb appears on the negative, the photographer can proceed with confidence.

To check a dark slide for leaks, leave it in position over loaded film. Then place a large coin upon the outside of the slide and hold the light over the holder for about one minute. If neither streaks nor a shadow image of the coin appear after development of the film, the slide is safe. Streaks coming in at the edges of the negative would indicate, in the absence of a coin shadow, that the holder may not be safe for panchromatic photography either. Wooden slides and some hard rubber slides readily transmit infrared rays and should not be used. Eastman Kodak Company and Graflex Incorporated have placed five raised

indicator dots (instead of a lower number) on dark slides that are safe. Special-composition slides and metal slides are in this class.

Lenses

Unless a lens has been especially achromatized for infrared photography, there will be a difference between the infrared focus position and the visual-focus position. Usually this difference causes no serious problems for the photographer, but it should be investigated. Good lenses have a red dot on the focusing scale or a letter R to indicate an average correction for infrared photography (see Figure 18.2).

In the field of document copying, a high-quality lens should be used because fine detail is often needed.

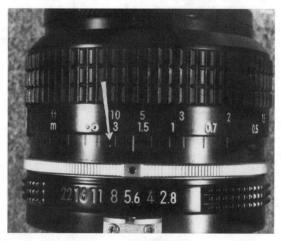

Figure 18.2 A Nikkor lens showing a red dot (indicated by arrow) indicating the focus adjustment for infrared illumination photographs.

Focusing

Focusing for an infrared image is often difficult. An infrared image, even when focused correctly, will not be as sharp as a panchromatic image because aberrations in the camera lens have been corrected for panchromatic photography. Many infrared images (particularly those of biological specimens) are formed from details that are not on the visible surface of the subject. Also, many images will have a translucent, scattering medium interposed between their outlines and the lens. Thus, a misty appearance may result from even the most carefully focused image.

When focusing for a panchromatic image, it is customary to shift back and forth across the sharp-focus position. For a correct infrared focus, this action should be stopped just when the image of the subject goes slightly out of focus and the lens-to-image distance is being increased. For simpler focusing, sharp detail in the subject should be sought. Absent this, a comb, ruler, or some other marker can be placed in the scene to facilitate focusing, and then removed from the photograph.

For most subjects, the lens must be stopped down to at least f/11 so that sufficient depth of field will be provided. This procedure also helps to offset the difference between visual and infrared focus. Specimens should be positioned and trimmed, if possible, to present a minimum of depth in the image.

Infrared Close-Up Photography

Cameras with non-extendable lenses can be used conveniently for photographing small specimens if the various close-up attachments and supplementary lenses are used. When supplementary lenses are used, it is not necessary to compensate in the exposure for close-up work, because the effective f/value remains unchanged. However, for best definition, the lens should be stopped down to f/11 or f/16.

Aperture Compensation

When small specimens are photographed, and a considerable camera bellows extension is used, the effective aperture becomes considerably less than that marked on the lens. The effective f/value for all close-up work can be computed from this formula:

Effective f/value = $\frac{\text{Indicated f/value x lens-to-film distance}}{\text{Focal length}}$

The lens-to-film distance is the focal length plus the lens extension from its position at infinity focus. This aperture compensation can be readily computed with the Effective Aperture Computer in the Kodak Master Photoguide, or with the tables in the Kodak Master Darkroom Dataguide and Kodak Color Dataguide. The plane of the diaphragm is usually a close enough reference point for distance measurements.

For 35mm cameras with lenses that must be extended for close-ups, the figures in Table 18.1 may be used for bellows corrections by measuring the length of the included subject area that will fill the length of the frame. Table 18.1 applies to full-frame 35mm film only.

Lighting

Photographic lights of all kinds have high emission in the infrared region of the spectrum. Infrared emission is closely related to heat radiation; thus, heat from a lamp indicates that infrared emissions are present. Any photographer who has come in contact with a hot lamp or who has taken a flashbulb out of a reflector too soon after it has been fired will attest to the presence of heat, and therefore the emission of infrared radiation, from ordinary photographic lights. It is even possible to feel a surge of heat from an electronic flash unit. Therefore, only rarely must the photographer employ special lighting for infrared photography.

Visible light intensity need not be greater for infrared photography than for panchromatic photography. Photographic exposure-meter readings for various setups with photoflood and similar lamps can be directly related. However, the fundamental exposure must be based on exposure tests in order to obtain negatives of a desired quality.

It is wise to check the evenness of the spot of illumination from any lamp, because variations will be exaggerated by the somewhat contrasty infrared technique. This can be done by photographing the spot of light itself on a sheet of cardboard or on a wall. Also, shadows from indistinct images of filaments or dirty condensers in spotlights should be guarded against.

Length of subject area (inches)	12	6	31/2	21/2	2	11/2	11/4	1
Open the lens by (stops)	1/3	2/3	1	11/3	12/3	2	21/2	22/3
Or multiply the time by	1.3	1.6	2	2.5	3	4	5	6

Table 18.1 Aperture compensation for close-ups.

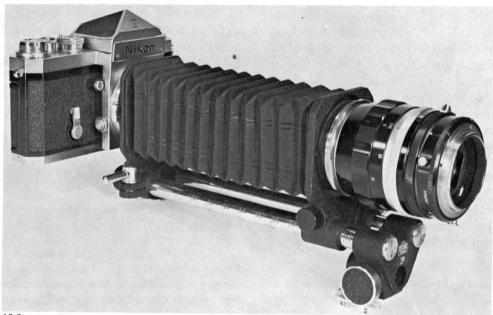

Figure 18.3
Micro-Nikon used with bellows for maximum extension. Lens is reversed to increase image size. E2 is added at the end for semi-automatic diaphragm control.

Photoflash Lamps

It is practical to coat a dark red, infrared-transmitting envelope over photoflash lamps in manufacture, because they are used only once. Other sources of light are usually too hot for such treatment. Flashbulbs of this kind are designated "R." They are valuable when bright visible light has to be withheld from living subjects, as well as from the emulsion. For instance, they may be used for photographing the actions of a suspect in the dark. The use of the "R" flashbulbs eliminates the need for special lamphouses with windows covered by large sheets of filter material. The practicality of changing bulbs for each exposure must be considered, however. Guide numbers published for these bulbs apply to indoor photography. For outdoor work it is necessary to open up the lens one additional f/stop.

The only type of infrared photoflash lamp now manufactured is the General Electric No. 5R. Many photographic dealers do not stock them, but they can be ordered from the manufacturer. The photographer may be required to accept a case lot because of the relatively low demand for these lamps.

Clear photoflash lamps should be used for routine laboratory work. The optimum filtering is then done at the lens or over the lamp reflector.

Electronic Flash Lamps

Electronic flash units have many advantages in the photography of living subjects. Their benefits of coolness and short exposure time are extendable to infrared photography. The amount of infrared radiation emitted in electronic flashtube setups is comparable, exposure-wise, to the intensities in photoflash setups that would be employed for photographing the same subjects. Another advantage of these units is that they are more readily obtainable with compact reflectors than with tungsten flood equipment. Preferably, they should be equipped with modeling bulbs. Low-voltage lamps have a higher proportion of infrared radiation than high voltage units.

Lamps for Infrared Color Photography

Electronic flash illumination is best for indoor infrared color photography. Photoflash bulbs are not suitable. Photoflood and quartz halogen lamps should only be used when circumstances require them, and then only with special filtering, as discussed in the section on filters. It is necessary to use heat-absorbing glass or a gelatin cyan filter.

It is worthwhile to make every effort to utilize electronic flash illumination in this technique. Not only can simpler filtering be achieved, but the advantages of coolness and quick exposure times can also be gained.

Filters

Because infrared emulsions are sensitive to the blue region of the spectrum as well as to part of the red and to the near-infrared region, filters are needed for infrared records. Filter factors are given in the data sheets packaged with infrared film.

In an emergency, black-and-white photographs can be made with infrared-sensitive materials without a filter, but the rendering will be more like that of a blue-sensitive film. The quality will usually be less satisfactory than that produced by either an orthochromatic or a panchromatic film. Reds, greens, and yellows will be reproduced darker than normal. Infrared color photography calls for particular filtering methods. In some black-and-white and color techniques, absorption filters are needed for the illumination.

Eastman Kodak Company supplies infrared-interference filters for highly specialized techniques, manufactured to customer specifications on special order only. These filters come in three main types: short-wavelength pass (cut-off), long-wavelength pass (cut-on), and band pass (1.5 to 11.0 microns). These filters are described in Kodak Publication No. U73.

Filters for Black-and-White Photography

Several considerations govern the choice of filters. The following Kodak Wratten filters will absorb violet and blue for black-and-white photography: No. 15 (G, orange); No. 25 (A, red); No. 29 (F); No. 70 (deep red); and No. 87, 88A, and 87C (infrared opaque visually). Wratten Filters 87 and 87C are often difficult to find. The red filters can be used when the camera must be handheld or when circumstances, like activity on the part of a live subject, make the addition of an opaque filter after focusing impractical. It should be noted again that critical focusing through the red filter is somewhat difficult.

Kodak Wratten Filter No. 89B has been designed for aerial photography. It produces records quite similar to the No. 25 filter. However, it affords additional penetration of haze with only a slight increase in exposure time. For aerial photography, filters should be mounted in "B" glass; unmounted gelatin filters are likely to result in poor definition.

All Kodak Wratten filters are available in unmounted two-, three-, four-, and five-inch gelatin squares, and the commonly used ones are mounted between optical glass in the first three sizes. Large unmounted sheets, up to 13 x 18 inches, can be obtained on special order for windows in light boxes or for placing over lamp reflectors. Gelatin filters are particularly useful when photographic techniques are being determined. Once a procedure has been established, it is convenient to order glass-mounted filters to fit the lens attachments that are available for the particular camera in use. This type of filter may be obtained in some circular sizes from your dealer's stock, while other sizes will have to be ordered.

For black-and-white infrared photography in some specialized applications, sharply selective filtration may be necessary. Experimentation should be carried out when there is reason to expect that using the red or longer-wavelength portion of the infrared spectrum might lead to significant differentiation.

Filters for Photography in the Dark

Most individuals can detect a slight red glow through a No. 87 filter with scotopic vision when they happen to be looking directly at the source during an exposure. Bouncing the radiation off a low ceiling, a reflector, or a wall is often helpful when a subject might see a tell-tale glow as photographs are made in the dark. Alternatively, a No. 87C filter should be considered. The filter coating on the "R" infrared flashbulb cuts just beyond the visible region. Because the cut is not sharp, a glow can be detected. Still, such bulbs do away with the need for an infrared filter over the lens when the scene is in darkness or when ambient or observation illumination is so low as to not affect a synchronized exposure.

Those who wish to construct a light-tight ventilated illumination box, with an enclosed tungsten lamp and an infrared-transmitting window for cinematography, should note that the No. 87 filter can withstand two weeks of exposure to a 1000-watt lamp at two feet. The gelatin sheet can be clamped loosely to glass on the lamp side but left free to radiate in front; a cooling fan can be directed onto it. In a laboratory, this filter can withstand five hours of exposure to a 500-watt reflector photoflood at one foot. No closer location should be considered and a hot, focused beam must be

avoided. The Corning Glass Color Filter, C.S. No. 7-69 (2600) molded, provides a similar filter, but it is a little more sensitive to cracking from heat than the gelatin filter.

Filters for Infrared Color Photography

While Kodak Ektachrome infrared film does not call for the use of an opaque filter for the infrared color photographic technique, a Kodak Wratten Filter No. 12 (deep yellow, minus blue) should be used over the camera lens. This filter absorbs the violet and blue to which the emulsion is sensitive. The color balance of the film is such that no other filter is normally needed under illumination of daylight quality.

For outdoor use, a Kodak Wratten Filter No. 12 should be used, although a No. 8 or No. 15 filter can be utilized for special effects. However, for scientific photography, the No. 12 filter must be used outdoors and indoors as well. Here, every effort should be made to employ electronic flash. Flashbulbs are not suitable. Special filters must be used for illumination of photoflood (3400K) quality.

A Kodak Color Compensating Filter CC20C and a Corning Glass Filter C.S. No. 159 (3966) (specify diameter) provide a good balance for photofloods. A filter factor of two should be tried. In some applications, a CC50-2 filter alone may suffice.

The unfiltered quartz halogen lamp is useful in the photographic laboratory. It can be utilized for infrared color photography. Because the iodine vapor in these lamps absorbs some infrared radiation, this type of incandescent source does not radiate quite as much excess as that emitted by the photoflood lamp. Accordingly, a heat-absorbing glass filter may not be needed over the lens. A Kodak Color Compensating Filter CC50C may suffice in the light beam of a photomicrographic setup in conjunction with the usual Kodak Wratten Filter No. 12. For general infrared photography, the CC50C-2 filter should be employed with 3200K and 3400K lamps, and a filter factor of two should be used.

Films

The characteristics and availability of Kodak and Konica films for infrared photography are presented in detail in the data sheets packaged with the film. General suggestions for using the films are given in the following sections. Because black-and-white neg-

atives can be made from color transparencies, anyone embarking on a color program can produce color or black-and-white prints.

Black-and-White

Specific data on film speeds, exposure, and reciprocity effects for Kodak and Konica black-and-white infrared films are given in the data sheets packaged with the film.

The indoor speeds of these films are low; however, a tripod is almost always used in routine laboratory photography, so film speed presents no great problem. Photoflood lighting can be used without causing undue discomfort to living subjects, but electronic flash illumination is more convenient, cooler for living subjects, and allows greater depth of field. It should be used whenever possible.

As a general rule, a black-and-white infrared negative should look fairly dense. Grass and trees, particularly, appear much darker than they do in a panchromatic negative. The main features of the subject and areas that photograph dark (light on the negative) should be recorded on the straight-line portion of the sensitometric curve. Small black shadows, of course, will have to be blank, because serious overexposure should be avoided. A shadow density of about 0.3 above fog for sheet film, and 0.5 for roll film, yields good separation.

Kodak High Speed infrared film is available in 35mm, 36-exposure and 100-foot rolls. Its major use is in the luminescence technique, in which it permits time exposures that are reasonably short for the faint emissions encountered. Nevertheless, the high-speed film is also valuable for photographing living subjects with handheld single-lens-reflex cameras, or for making records of action in the dark when it is not practical to provide a high level of radiation for the exposures. In addition, Konica 750 infrared film is available in 35mm and 120 formats. Konica's infrared film has an effective daylight ISO of 16.

Color

Kodak Ektachrome infrared film is very fast. It is available for scientific photography in 35mm, 20-exposure cassettes. This makes it well-suited for photography with a handheld, miniature, single-lens-reflex camera in numerous applications. It is infrared sensitive in the 700-900nm range. This film requires

Process E-4, which is no longer produced by Kodak. However, Kodak does publish the chemical formulas for Process E-4 and a list of photo finishing labs accepting E-4 process.

Kodak recently introduced Ektachrome EIR film in the near infrared range (about 700nm). The main advantage of Ektachrome EIR is its ease of processing. It is developed with the same readily available chemicals as other Ektachrome films (E-6). If the film is to be processed in a commercial processing lab, it may be necessary to advise the lab not to use infrared sensors or goggles during processing. Many labs use automatic focusing with infrared sensors and infrared goggles when processing film. These sensors and goggles could fog the film during processing. There is no DX coding for Ektachrome EIR so the camera must be manually adjusted for ISO and exposure as well as focusing.

Checking the Darkroom for Infrared Safety

All infrared films that are not placed in cassettes by the manufacturer should be loaded in the dark. Naturally, the darkroom must be light-tight. Also, an electric space heater with exposed heating elements or a cowling that becomes hot should not be turned on. Even though the heater may not produce enough visible glow to affect panchromatic films, it could fog infrared emulsions. The temperature associated with steam pipes and radiators, though, is not high enough to worry about during the handling times of loading and processing film.

Some wooden doors for interiors may leak infrared radiation through their panels. This can happen when the panels are thin and unpainted. Also, there is a type of door constructed of thin sheets of plywood bonded over a framework through which infrared is very likely to be transmitted. If a door is suspected as a source of fog, a photographic test should be made (see Figure 18.4). An attempt to photograph the door is made on infrared film from inside the darkroom and in the dark, but with full illumination outside. No filter is placed over the lens and an exposure of 30 minutes at f/5.6 is used. If no image of panels or air cells appears on the film, the door is safe.

Figure 18.4

Darkroom door photographed with infrared film shows image of panels, indicating unsafe door.

Processing Infrared Film

Development of black-and-white infrared film is best carried out in the dark, although a safelight can be employed to provide personal orientation or enough light to read a clock (see individual data sheets). Infrared films are carried through the development procedure like any other films. However, it is not advisable to develop a batch of sheet films in a tray by the leaf-over-and-over system. This can cause abrasion. Two sheets of infrared film can be developed in a smooth tray by handling them back-to-back. However, they should first be thoroughly wetted in a tray of clean water so that their backings do not stick together in the developer.

Developers and average processing times are shown in the data sheets. Development contrast can be varied within certain limits to provide negatives of more, or less, contrast. For records of faint patterns, film can be developed for a 30 percent increase over the average time, if moderate developers are used. The additional fog is negligible and the resultant pattern is strengthened. Consistent development contrast is imperative when making comparable serial records.

Some applications call for negatives of the highest practical contrast; they can be obtained with very active developers. The use of such developers is attended with some increase in graininess and requires a concomitant reduction in exposures. For some flat-surfaced subjects such as embedded fossils or faint texts, where surface contours do not introduce lighting contrast, an increased development contrast can be beneficial in strengthening faint patterns.

Rinsing, fixing, washing, and drying of blackand-white infrared films are carried out in the same fashion as for regular black-and-white photographic materials.

Directions for processing Kodak Ektachrome infrared film for scientific applications are given in the instruction sheet packaged with the film. No safelights or infrared inspection equipment are tolerable during processing. The photographer will usually have to do the work. Any custom-processing laboratory accepting rolls of infrared film must be advised of the above restrictions. As previously stated, Kodak no longer processes Ektachrome Infrared Process E-4. Photographers must use a custom laboratory setup for Process E-4 or mix the chemical formulas themselves. The alternative is to use Kodak's Ektachrome EIR infrared film, which can be developed using the readily available E-6 process.

Copying with Infrared

The infrared copying technique has been widely used in numerous applications, often in conjunction with other non-destructive methods of examination, such as ultraviolet photography and radiography. One of the categories that has a broad application in forensic science is in the investigation of questioned, illegible, censored, deteriorated, or forged documents (see Chapter 16). The infrared color method is valuable when inks and pigments that appear to have the same color can be differentiated photographically. The following sections broadly review the representative copying work done in various fields and do not purport to be all-inclusive. Particular aspects of technique are given in context. Where technical factors are not included, it can be assumed that only the general procedures are needed.

Kodak Wratten Filter No. 87 is usually employed in copying applications. When the photographer feels the need for a stronger infrared effect or greater differential penetration, he or she can try the No. 87C filter.

Illegible Documents

The most important application of infrared photography in copying is the deciphering of indistinct writing. The text may have been made illegible by charring, deterioration as a result of age or the accumulation of dirt, obliteration by application of ink by a censor, invisible inks, deliberate chemical bleaching, or mechanical erasure and subsequent overwriting.

Inks and Pigments

Inks, pigments, and other materials that appear identical to the eye are frequently rendered quite different by an infrared photograph. If an ink transparent to infrared radiation is applied over one opaque to it. the underlying ink will show up in an infrared photograph (see Figures 18.5 and 18.6). The original inks used in writing documents that have become blackened may be revealed by infrared photography, although success will depend on the condition of the paper. Writing that has been mechanically erased may be revealed in an infrared photograph by virtue of the traces of carbon or other pigment left embedded in paper fibers. Chemically bleached writing is often deciphered by infrared photography. The reaction of the bleach with the ink absorbs more infrared radiation than the surrounding paper. Particularly useful results have been obtained in deciphering certain falsified documents by photographing infrared luminescence induced by exposure to blue-green light or, in some instances, to ultraviolet radiation. The infrared luminescence technique involves the use of "glow powder" coupled with the infrared film. There are several light sources that could be used to produce infrared luminescence. This phenomenon is exhibited in some materials by stimulation with blue-green light. Although it is possible that infrared luminescence may also be stimulated by irradiation with specific wavelengths of blue or green, it is suggested that a source having continuous emission of the blue and green spectral regions be obtained. High-wattage tungsten lamps, the xenon arc, or even ordinary fluorescent lamps can be used. This technique should be tried when the reflection method (use of flood lamps, flashbulbs, or electronic flash) does not supply all the information desired.

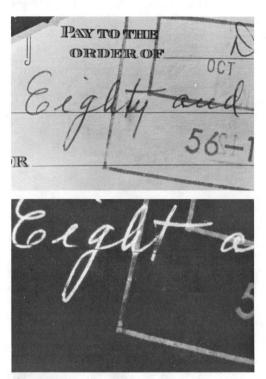

Figure 18.5 Check for \$80 (top) when photographed with infrared method (bottom) shows that the "y" in "eighty" was added later.

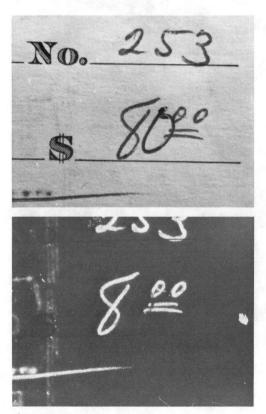

Figure 18.6The same check (top) photographed with infrared (bottom).

Charred, Aged, and Worn Writings

Documents that have become charred by fire, and those blackened by age, dirt, or stains can sometimes be deciphered in an infrared print. The investigation of papers surviving willful attempts to burn them and of forged documents is very important. Sometimes wear will obliterate writing so that it can no longer be seen with the naked eye or photographed with panchromatic film. Yet traces may remain that can be picked up by infrared photography.

Photographing in Darkness with Infrared

The capability of making infrared photographs "in the dark" is extremely pertinent to the area of surveillance in law enforcement, because evidence can be gathered without the knowledge of those committing the offense. It is relatively simple to rig infrared photoflash setups, or to utilize them in flashguns, to make still photographs in the dark. Human subjects can be photographed without being aware of it. This is of special value in apprehending burglars at safes, cash drawers, and so on.

For photographic traps and for many laboratory setups, cameras usually must be preset and flash-fired by circuits triggered with infrared detectors. It is necessary for the photographer to know where the subject is going to be. No lens filter is needed.

A piece of Kodak Wratten Filter No. 87 or 87C can be purchased in a size large enough to cover the front of the flash reflector and can be taped to a single piece of clear glass, or sandwiched between two pieces of glass, for protection. Because optical quality is not required for this light-source filter, the gelatin filter taped to ordinary glass suffices. A housing or even a rubber band can be devised to hold this filter on the flash gun. Guide numbers are easily determined by the user with a simple trial exposure series. Most of the portable low-voltage units (around 500 volts) yield guide numbers in the 200 to 300 range with Kodak high-speed infrared film, and 70 to 120 with Kodak infrared film.

Kodak Publication No. M-8, *Criminal Detection Devices Employing Photography*, gives details on rigging infrared photographic traps and other specific information for those employing photography in law enforcement.

Night-Vision Devices

Surveillance is often performed under adverse lighting conditions or in complete darkness. When there is insufficient ambient light for observed suspects to be identified, a light amplification device may be employed. Even with high-speed 35mm film, the ability to focus properly and see what is happening becomes problematic.

When ambient light conditions are so low that even light amplification devices cannot provide sufficient light to perform surveillance operations, other methods must be employed, such as the use of infrared film. Using infrared film in surveillance has the same disadvantage as using high-speed film—the photographer may not be able to distinguish those under surveillance and focusing becomes a problem. Infrared image converters may be used to convert infrared radiation to a visible image. An infrared image converter is a device similar to an image intensifier, but it extends the response to the infrared wavelength. The converter then converts infrared images into visible green images. The green image may be photographed with a 35mm SLR camera or may be recorded on video. As with any other infrared recording, the scene requires sufficient amounts of infrared illumination. If the use of infrared illuminators (filtered flashes or lamps) is not feasible, a passive thermal infrared TV camera may be used. These cameras detect wavelengths of infrared light that are emitted from warm objects, such as human beings, vehicles, etc. Thermal images appear white while cold objects appear black. Thermal imaging does not visually have the image quality to identify individuals under surveillance; therefore, a thermal imaging device is used primarily to locate the presence of individuals in dark areas as well as identifying recently used automobiles.

The Astrolight Viewer (available from Electrophysics Corporation) is a handheld night-vision device that, when operated in almost complete darkness, yields bright, sharp images under observation. A micro-channel plate image intensifier within the unit converts and intensifies visible and near-infrared light in the 500-900nm wavelength range. The visible green image output may be photographed with a 35mm SLR camera or video camera recorded with the appropriate "C" mount attachment. The unit can be used for surveillance operations and laboratory functions (e.g., questioned documents).

Other night-vision systems include Star-Tron MK series systems (available from Star-Tron Technology

Corporation), which replaced the original Starlight Scope, and the Find-R-Scope and Nite-Sight infrared viewers (available from FJW Industries).

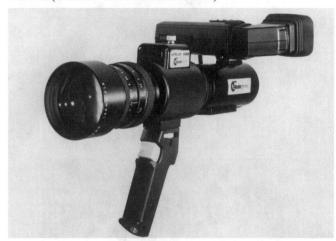

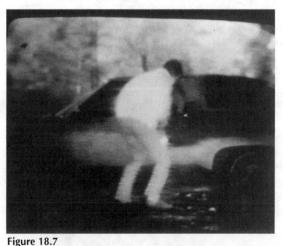

The Astrolight Viewer (top) and Star-Tron infrared viewer (middle) with photograph of TV monitor depicting infrared image (bottom).

Appendix

Additional Readings and Resources

Eastman Kodak Company publishes a number of books and pamphlets that are of interest to police photographers. Kodak's Index to Photographic Information (L-1) lists more than 300 books, guides, and pamphlets that provide information about selecting and using Kodak products. Kodak's Professional Photographic Catalog (L-9) lists all of Kodak's products, cameras, accessories and finishing equipment, and supplies. To obtain copies of any of Kodak's publications or information regarding any of their products, write or call: Eastman Kodak Company—Rochester, NY 14650-0608 (Phone: 800/242-2424).

Additional companies and their products have been mentioned throughout the text. Below is a list of how these companies may be contacted.

Brewer Ultra-Violet Products—3410 F. Lasierra #223, Riverside, CA 92503 (Phone: 909/340-4323)

Corning Glass Works—1025 Martin Street, Greenville, OH 45331 (Phone: 937/547-8700)

Edmund Scientific—101 E. Gloucester Pike, Barrington, NJ 08007-1380 (Phone: 609/573-6259)

Electrophysics Corporation—373 W. Route 46, Building E, Fairfield, NJ 07004 (Phone: 973/882-0211)

FJW Optical Systems—629 S. Vermont Street, Palantine, IL 60067 (Phone: 847/358-2500)

Iomega Corporation—1821 W. 4000 Street, Roy, UT 84067 (Phone: 801/778-1000)

MacDonald Associates—722 E. Industrial Park Drive, Manchester, NH 03109 (Phone: 603/669-1916)

Northwestern University Traffic Institute—405 Church Street, Evanston, IL 60204

(Phone: 847/491-5476)

Omnichrome—13580 Fifth Street, Chino, CA 91710 (Phone: 909/627-1594)

Porter's Camera Store, Inc.—Box 628, Cedar Falls, IA 50613 (Phone: 319/268-0104)

Rofin—1260 N. Main Street, Ft. Bragg, CA 95437 (Phone: 707/961-1559)

Star-Tron Technology Corporation—526 Alpha Drive, R.I.D.C. Industrial Park, Pittsburgh, PA 15238

(Phone: 724/295-2880)

West American Rubber Company—750 N. Main Street, Orange, CA 92868 (Phone: 714/532-3355)

There are a number of Web sites on the Internet that may be accessed for additional information; students should use one of the many search engines to seek for related Web sites. All of the major camera manufacturers have Web sites with technical information regarding their products. Listed below are several sites that provide helpful information, as well as links to other sources.

Crime Scene and Evidence Photography—http://police2.ucr.edu/photo.htm Provides information about police and forensic photography.

Digital Imaging Solutions for Law Enforcement—http://www.free-radical.com
Provides information about digital imaging software and enhancement for law enforcement.

Forensic Enterprises, Inc.—http://www.feinc.net Provides information about crime scene and digital photography.

International Fire Photographers Association—http://www.ionet.net/~pjames/ Provides information about the association, as well as links to related sites.

Media Cybernetics Image Analysis Software—http://www.mediacy.com Provides information about digital imaging and fingerprint comparison software.

PEI Magazine—http://www.peimag.com
Provides information about digital imaging and police photography, as well as links to related sites.

Glossary

Aberrations: Optical defects in a lens that cause imperfect images.

Abrasions: Marks on emulsion surfaces that appear as pencil marks or scratches. Usually caused by pressure or rubbing.

Accelerator: The alkali added to a developing solution to increase the activity of a developing agent and swell the gelatin, thus shortening developing time.

Acetate Base: The term used to designate a photographic film base composed of cellulose acetate. Also referred to as safety base because of its non-flammability.

Acetic Acid (HCHO): The acid widely used in short stop-baths to stop the action of the developer before negatives or prints are placed in the fixing bath. Often used in fixing baths.

Acetone (Dimethyl Ketone): A highly volatile, inflammable, liquid solvent for nitrocellulose, etc.; used as ingredient of film cements.

Achromatic Lens: A lens that is at least partially corrected for chromatic aberration.

Acid Fixing Bath: A solution of hypo to which an acid (usually acetic acid) has been added for the purpose of maintaining the hypo at the proper acidity.

Acrol: Eastman Kodak Company trademark for Amidol.

Actinic Light: Light that is capable of causing photochemical changes in a sensitive emulsion. Blue and violet are the most actinic of the visible light rays.

Adapter Back: A supplementary back for view cameras that permit the use of smaller film or plate holders than the size for which the camera was designed.

Adapter Ring: A device designed to permit the use of filters, supplementary lenses, etc. of a single diameter in connection with several lens mounts whose diameters differ.

- **Additive Process:** Pertains to color photography; it is the production of color by the superimposition of the separate primary colored lights on the same screen. Yellow, for example, is a mixture of red and green light rays in the proper proportion.
- Adurol: A form of hydroquinone that is used as a developing agent. Chemical name is monobromo-hydroquinone.
- **Advantix:** A 35mm film and camera system introduced by Kodak, but used by most major camera and film manufacturers. The system is geared toward amateur users rather than professional or technical users.
- **Aerial Perspective:** An impression of depth or distance in a photograph by means of progressively diminishing detail due to aerial haze.
- Aero: Applied to a lens, camera, or film intended for use in photography from aircraft.
- **Affinity:** The chemical attraction of one substance for another. Sodium sulfite has an affinity for oxygen, thereby reducing oxidation of the developing agent in a developer.
- **Afocal:** Applied to a lens system that has both foci at infinity; afocal systems include certain wide-angle and telephoto attachments for lenses that do not change the lens extension.
- **Agitation:** The procedure used in processing to bring fresh solution into contact with the emulsion. This may be done by moving the material in the solution, as in tank development, or by moving the solution itself, as in tray development. Agitation may be either constant or intermittent. Agitation is necessary to assure uniform development results.
- Air Bells: Small bubbles of air that attach to the surface of an emulsion and leave a small area unaffected by the solution. These can be removed by vigorous agitation.
- **Albumin Paper:** Sensitive paper, usually printing-out paper in which the silver salts are suspended in albumin instead of gelatin; sometimes spelled "albumen."
- Alkali: A substance, with basic properties, that can neutralize acid. An example of an alkali that is commonly used in developing solutions is sodium carbonate. Alkalies are often referred to as "accelerators" or "activators."
- **Alternative Light Source:** A light emitting device capable of producing light waves ranging from the ultraviolet through infrared wavelengths.
- **Ambient Light:** Light already existing in an indoor or outdoor scene, independent of any light supplied by the photographer.
- **Anamorphic:** A lens or optical system in which the magnification is different in two planes at right angles; used in wide-screen movie processes to "squeeze" a wide image into standard format and to "unsqueeze" it in projection onto a wide screen.
- **Anastigmat:** A lens that has been corrected for astigmatism, and therefore focuses vertical and horizontal lines with equal brightness and definition. Anastigmat lenses are also free of common aberrations.
- **Angle Finder:** A viewfinder containing a mirror or prism so that pictures may be taken while aiming the camera sideways.
- **Angle of View:** The angle subtended at the center of the lens by the ends of the diagonal of the film or plate.

- Angstrom Unit (AU): A unit of length equal to 1/10,000 of a micron. Commonly used as a method of expressing length of light rays.
- Anhydrous: Refers to chemical salts that contain no water of crystallization; desiccated.
- Aniline (Anilin): A coal tar derivative used as a base for many dyes. It can also be produced by the reduction of nitrobenzene.
- Ansco Color: An integral tripack natural-color film that can be activity processed.
- Antihalation Backing: A coating, usually gelatin, on the back of a film, containing a dye or pigment for the purpose of absorbing light rays, thus preventing the reflection from the back surface of the film base.
- **Aperture:** A small opening, usually circular. In cameras, the aperture is usually variable, in the form of an iris diaphragm, and regulates the intensity of light that passes through a lens.
- **Aperture Priority Automatic Camera:** An automatic exposure camera that automatically adjusts the shutter speed to correctly expose the picture, once the photographer has set the lens opening.
- **Aplanat:** A lens of the rapid-rectilinear type, sometimes better corrected for spherical aberration, but not for astigmatism.
- **Apochromatic:** Refers to lenses that are most completely corrected for chromatic aberration. These lenses focus rays of all colors to very nearly the same plane.
- **ASA:** American Standards Association rating of film emulsion. For example, Kodak Tri-X Film has an ASA rating of 400. The higher the ASA number, the more sensitive the film is to light. Also referred to as "speed" of the film. See also DIN, Exposure Index, and ISO.
- **Astigmatism:** A lens aberration in which both the horizontal and vertical lines in the edge of the field cannot be accurately focused at the same time.
- **Asymmetrical (Non-symmetrical):** Applied to a lens having differently shaped elements on either side of the diaphragm.
- **Autofocal:** Self-focusing; applied to enlargers that keep the image in focus when changing the degree of enlargement by raising or lowering the head.
- **Automatic Diaphragm:** A lens aperture that stays at its widest opening until the moment of exposure, when it closes down to the aperture at which it is set. After the exposure, it returns to the widest opening.
- **Automatic Exposure Camera:** A camera with a built-in metering system that automatically adjusts the lens opening, shutter speed, or both, for proper exposure.
- **Automatic Flash:** An electronic flash with a photocell that measures the amount of flash illumination reflected back by the subject. When enough light for a properly exposed picture is reflected by the photocell, it prevents the flash from emitting any more light.
- Automatic Focus: A camera or lens that automatically adjusts the focus by electronic means.

- **Autopositive:** Applied to a film or paper that renders a positive image when exposed to a positive, or a negative image when exposed to a negative, when processed in a single development stage. Distinguished from direct positive, which produces such images by reversal processing procedures.
- **Autoradiograph:** An image produced on a film or plate by radiations from a radioactive subject in close contact with the emulsion.
- **Autowinder:** A motorized mechanism for advancing the film in a camera and recocking the shutter. Most autowinders have a maximum speed of about two frames per second.
- Auxiliary Lens: A lens element that is added to the regular camera lens to shorten or increase its focal length.
- **Avoirdupois (avdp):** The systems of weights and measures used in the United States and Great Britain for dry chemicals (note that U.S. Customary and British Imperial liquid measures differ).
- Axis of Lens: An imaginary line that passes through the center of a lens and contains the centers of curvature of the lens surfaces.
- **Back Focus:** A trade term often used to designate the distance between the back surface of the lens and the surface of the focusing glass when the camera is focused at infinity. This dimension is used to determine the length of the camera bellows suitable for a given lens.
- **Back**, revolving: A camera back that can be revolved so that either a vertical or horizontal picture may be obtained. Usually found in the heavier types of cameras, such as press or view cameras.
- **Back**, **swinging**: A camera back that can be swung through a small area so that the divergence or convergence of parallel lines in the subject can be minimized or eliminated.
- Background: Generally, that part of a scene beyond the main subject of the picture.
- Backing Cloth: An adhesive fabric used to strengthen a photographic print to enable it to withstand handling.
- Bag, Changing: A lightproof bag equipped with openings for the hands, in which films can be loaded or unloaded in daylight.
- **Barndoor:** Folding wings used in front of studio spotlights to aid in directing light, and to shade portions of the subject from direct illumination.
- **Barrel Distortion:** A term applied to the barrel-shaped image of a square object; this occurs when the diaphragm is placed in front of a simple convex lens.
- **Baryta:** A treated emulsion of barium sulfate. It is commonly used in the manufacture of photographic paper to coat the paper stock before the light-sensitive emulsion is coated. It provides a white surface and keeps the light-sensitive emulsion from being partially absorbed by the paper base.
- **Bayonet Lock:** A means of quickly attaching or removing a lens from a camera by turning through only part of a revolution.
- Bed: The base of a camera, usually carrying the focusing guide rails.
- **Beer's Law:** The optical density of a colored solution is proportional to the concentration of the light-absorbing substance.

Bellows: A folding tube of the accordion type that permits movement for focusing between the back of the camera and the lens, and that collapses when the camera is packed. The camera bellows is usually made of leather or black cloth. Modern miniature cameras have a helical-threaded metal tube in place of a bellows.

Bellows Draw: The maximum extension of a camera bellows.

Between-the-lens: A shutter located between the front and back elements of a double lens.

Big Bertha: A custom-made camera, usually consisting of a 4 x 5-inch or 5 x 7-inch Graflex body combined with a powerful telephoto lens. Its most important feature is its lens. It is a very bulky camera.

Black Body: A theoretically perfect radiator, having no power of reflection.

Blackout (adj.): Applied to photoflash lamps, a lamp having a visually opaque coating transmitting only infrared radiation, and used for photography in total visual darkness.

Bleacher: A chemical compound, usually containing potassium ferricyanide, employed for bleaching or dissolving silver images. Bleachers are used in both reversal and toning processes.

Bleaching: The first step in the intensification of a negative is to bleach the negative until it appears white when viewed from the back of the film or plate. After bleaching, the negative is redeveloped. It is also necessary to bleach bromide prints before toning or developing them into sepia and white prints.

Blisters: Small bubbles forming under an emulsion due to the detachment of the emulsion from its base. Blisters are caused by an error in processing.

Blocked Up: Applied to highlights in a negative that are so overexposed or overdeveloped that no detail is visible.

Blocking Out: Painting out undesired background areas on a negative.

Blow-up: Photographic slang for enlargement.

Boom: A stand, usually on wheels, that has an extension arm on which a microphone or lamp may be attached.

Bounce Light: Flash or tungsten light bounced off ceilings or walls to give the effect of natural or available light.

Box Camera: An inexpensive camera, boxlight in form, with either few or no adjustable controls; also referred to as a "simple camera."

Bracketing: Taking additional photos of a subject over a range of varying exposures, when unsure of the correct exposure.

Breathing: Movement of a projected picture upon the screen due to buckling of the film in the projector.

Brightness Range: Variation of light intensities from maximum to minimum. Generally refers to a subject to be photographed. For example, a particular subject may have a range of one to four; that is, four times the amount of light is reflected from the brightest highlight as from the least bright portion of the subject.

Brilliance: A term denoting the degree of intensity of a color or colors.

Brilliant: A term used in reference to the tone quality of a negative or print.

Bromide Paper: A photographic printing paper in which the emulsion is made sensitive largely through silver bromide. Bromide papers are relatively fast and are usually printed by projection.

Bromoil: A process for the making of prints in permanent oil pigments on the base of a bromide print.

Bulb: Shutter setting in which the leaves remain open as long as the button is depressed, and close as soon as the button is released; marked "B" on cameras.

Bulk Film: Long rolls of 35mm film packaged in lightproof cans instead of in individual, ready-to-use cassettes. Must be cut into 36-exposure or shorter lengths and loaded into cassettes for use.

Burned Out: Applied to an overexposed negative or print lacking in highlight detail.

Burning-in: A method of darkening parts of a print in which certain parts of the image are given extra exposure while the rest of the image is protected from the light.

Butterfly: Silk gauze or scrim on a frame, used to soften or diffuse a highlight, or to cast a soft shadow on some part of a picture.

Cabinet Camera: An automatic camera, usually operated by a coin-slot device; occasionally combined with an automatic developing machine.

Cable Release: A flexible shaft for operating the camera shutter.

Camera Angle: The point of view from which a subject is photographed.

Camera Obscura: A darkened room in which an image is formed on one wall by light entering a small hole in the opposite wall.

Camera, Pinhole: A camera that has a pinhole aperture in place of a lens.

Candid Photography: A term applied to pictures taken without posing the subject. The object is to catch natural expression.

Candle: A unit of luminous intensity; approximately equal to the intensity of a 7/s-inch sperm candle burning at 120 grains per hour.

Candle-meter-second: A unit of exposure consisting of the light from a standard candle burning for one second at a distance of one meter from the plate.

Candlepower: Luminous intensity expressed in terms of the standard candle.

Capacitor: An electrical circuit element consisting of one or more pairs of plates separated by some insulating material; sometimes called a condenser, but the term capacitor is preferred because it is more specific.

Carbon Process: Referring to a process using a printing paper, the final image of which depends on the thickness of the gelatin layer in which finely ground carbon or other pigment is suspended.

Carbonates: A term applied to certain alkaline salts, such as potassium carbonate and sodium carbonate, used as an accelerator in a developer.

Carbro Process: A combination of the carbon and bromide methods for making a print.

Cardinal Points: In a thick lens or lens system, the two principal points, the two nodal points, and the two focal points.

Cartridge: A light-tight container that may be loaded with film in the dark and placed in the camera in daylight.

Cassette: A film cartridge or magazine.

Catch Lights: The small reflections of a light source, found in the eyes of a portrait subject.

CD: Compact disc; a storage medium for computers; used to store digital photographs.

Celluloid: A transparent film made from cellulose nitrate.

Celsius: The preferred name of the centigrade thermometer scale.

Centigrade Scale: A temperature scale in which 0 degrees represents the ice point and 100 degrees the steam point. Celsius is now the preferred term in technical use.

Centimeter (cm): A measure of length; 1/100 of a meter.

Cepa Paper: A Kodak trade name for a tough tissue paper for diffusion purposes or vignettes.

Changing Bag: A lightproof black fabric bag that permits film and other light-sensitive materials to be handled in normal room light. It has a double zipper on one end and two armholes with elastic sleeves on the other.

Characteristic Curve: A curve plotted to show the relation of density to exposure; sometimes referred to as the H and D curve.

Chloride Paper: A photographic printing paper in which the emulsion is made sensitive largely through silver chloride. Usually chloride papers are printed by contact and require comparatively longer exposure than bromide or chloro-bromide paper.

Chloro-bromide Paper: A photographic printing paper used primarily for enlarging. Its emulsion contains a mixture of silver chloride and silver bromide.

Chromatic Aberration: A defect in a lens that prevents it from focusing different colored light rays in the same plane.

Cinching: Tightening a roll of film by holding the spool and pulling the free end; this invariably results in parallel scratches or abrasion marks.

Cine: Word or prefix referring to motion pictures.

Circle of Confusion: An optical term describing the size of an image point formed by a lens.

Circle of Illumination: The total image area of a lens, only part of which is actually used in taking a picture.

Clinical Camera: A camera designed especially for use in hospitals and clinics.

Close-up Lens: A lens attachment that permits a lens to focus more closely than normal; usually sold in sets, with each close-up lens a different strength for focusing at varying distances.

Clumping: Relates to the effective increase in grain size in the emulsion due to the partial overlapping of grains of silver.

Coating Lens: A thin, transparent coating applied to a lens to reduce surface reflection and internal reflection; also cuts down transmission of ultraviolet rays, acting somewhat like a haze filter.

Cold Mount: Means of mounting photos on cardboard or mat board with adhesive that requires pressure instead of heat to make a permanent bond.

Collage: A composite photograph made by pasting up a number of individual prints.

Collimate: To produce parallel rays of light by means of a lens or a concave mirror.

Collimating Lens: A lens adjusted so as to produce a parallel beam of light.

Collinear: The line-to-line relation existing between the corresponding parts of the object and its image formed by a lens.

Collodion: A transparent liquid obtained by dissolving pyroxylin in a mixture of equal parts of alcohol and ether. It is used as the vehicle for carrying the sensitive salts in the wet-plate process.

Color: The sensation produced in the eye by a particular wavelength or group of wavelengths of visible light.

Color Analyzer: An electronic instrument for color printing that compares the color and density of a negative to that of a reference negative that has been programmed into the analyzer.

Color-blind: Applied to an emulsion that is sensitive only to blue, violet, and ultraviolet light.

Color Contrast: A property by which the form of an object can be recognized by its variation in color, whether or not the brightness of all parts of the object is equal.

Color Sensitivity: The response of a photographic emulsion to light of various wavelengths.

Color Temperature: A comparison of the color of a light source expressed in degrees Kelvin.

Coma: A lens aberration in which a coma or pear-shaped image is formed by oblique rays from an object point removed from the principal axis of the lens.

Combination Print: A composite print made from several negatives.

Complementary Colors: One color is complementary to another when a combination of the two produces white light.

Composition: The balancing of shapes and tones to produce a pleasing effect.

Compound Shutter: A trade name for an American (or German) shutter similar to the Compur, except that its slow speeds are controlled by means of a pneumatic piston retard instead of a gear escapement.

Compur Shutter: A trade name for a between-the-lens shutter containing independent mechanisms for time (and bulb) exposures and for instantaneous exposures varying from one second to as high as ½500 of a second.

Concave: Hollowed out; curved inward; applied to negative lenses that are thinnest in the center.

- Concave Lens: A lens that has one or two concave surfaces.
- Concave-convex Lens: A lens having one concave and one convex surface.
- **Condenser:** An optical system in projection printers used to collect the divergent rays of a light source and concentrate them upon the objective lens.
- Condenser Enlarger: An enlarger that uses one or more glass condenser lenses between the lamp and film plane to provide even coverage of light.
- **Contact Print:** A print made by placing a sensitized emulsion in direct contact with a negative and passing light through the negative.
- Contact Printer: A box or machine providing a light source and a means for holding the negative and the sensitive material in contact while they are exposed to this light source.
- Contrast: Subject contrast is the difference between the reflective abilities of various areas of a subject. Lighting contrast is the difference in intensities of light falling on various parts of a subject. Inherent emulsion contrast is the possible difference between the maximum and minimum densities of the silver deposits with a minimum variation of exposure; it is determined by the manufacturer. Development contrast is the gamma to which an emulsion is developed; it is controlled by the developer, time, temperature, and agitation.
- Contrast Filter: A color filter used to make a colored subject stand out very sharply from surrounding objects.
- **Contrast Paper:** Photographic paper having a contrasty emulsion in order to produce good prints from soft negatives; also called hard paper.
- **Contrasty:** Having a great difference between tones; sometimes applied to a print having mostly black-and-white tones, lacking in middle tones, correctly called chalky.
- **Convertible Lens:** A lens containing two or more elements that can be used individually or in combination to give a variety of focal lengths.
- Convex: The opposite of concave; curved outward; applied to a lens that is thicker in the center than at the edges.
- Copy Board: A board or easel to which photographs or other originals are fastened while being copied.
- Corex: A trademark of the Corning Glass Works for a type of glass that is highly transparent to ultraviolet light.
- **Coupled Range Finder:** A range finder connected to the focusing mechanism of the lens so that the lens is focused while measuring the distance to the subject.
- Covering Power: The capacity of a lens to give a sharply defined image to the edges of the sensitized material it is designed to cover, at the largest possible aperture.
- Crop: To trim or cut away the unnecessary portions of a print in order to improve composition.
- **Curtain Aperture:** The slit in a focal plane shutter that permits light to reach the film. The slit size may be fixed or variable.

Curvature of Field: The saucer-shaped image of a flat object formed by an uncorrected lens.

Cut Film: A flexible transparent base, coated with a sensitized emulsion and cut in sheets of various sizes. Often referred to as sheet film.

Cyan: A blue-green (minus red) color.

Daguerreotype: An early photographic process that employs a silver-coated plate sensitized with silver iodide and silver bromide. After long exposure, the plate is developed by subjecting it to mercury vapor.

Darkroom: A room for photographic operations, mainly processing, that can be made free from white light and is usually equipped with safelights that emit non-actinic light.

Darkslide: A British term for a plate holder or a sheet-film holder.

Daylight Film: Color film that is suitable for use in average daylight or with electronic flash without any filters needed.

Daylight Loading: Any arrangement on a camera, a film magazine, or a developing tank that permits insertion of film in daylight without the use of a darkroom or a changing bag.

Daylight Tank: A film processing tank that can be used in normal room light once the film has been loaded into it in total darkness.

Decimeter (dm): A measure of length; 1/10 of a meter.

Deckle Edge: A rough or irregularly trimmed edge on a sheet of paper.

Dedicated Flash: An electronic flash that is designed for specific camera makes and models. When the flash is attached to the camera and turned on, the camera's shutter speed will be automatically adjusted to the correct setting. Other settings may be made automatically as well.

Definition: The clarity, sharpness, resolution, and brilliance of an image formed by a lens.

Dense: Very dark; applied to a negative or positive transparency that is overexposed, overdeveloped, or both.

Densitometer: A device used for measuring the density of a silver deposit in a photographic image. It is usually limited to measuring even densities in small areas.

Density: A term used to express the light-stopping power of a blackened silver deposit in relation to the light incident upon it.

Depth of Field: The distance measured between the nearest and farthest planes in the subject area that gives satisfactory definition.

Depth of Focus: The distance that a camera back can be racked back and forth while preserving satisfactory image detail in focal plane for a given object point.

Desensitizer: An agent, usually a chemical solution, for decreasing the color sensitivity of a photographic emulsion to facilitate developing under a comparatively bright light. The emulsion is desensitized after exposure.

Desiccated: A term applied to chemicals in which all moisture has been eliminated.

Detective Camera: An early name for what is now called a candid camera.

Developer: A solution used to make visible the latent image in an exposed emulsion.

Developing Agent: A chemical compound that possesses the ability to change exposed silver halide to black metallic silver, while leaving the unexposed halide unaffected.

Developing-out Paper: A printing paper in which the image is made visible by developing in a chemical solution.

Development by Inspection: Development of negatives or prints by inspection, depending on the operator's judgment as to when development is complete.

Diaphragm: A device for controlling the amount of light that passes through a lens. It is usually an iris diaphragm, but may be in the form of slotted discs of fixed sizes.

Diapositive: A positive image or a transparent medium such as glass or film; a transparency.

Dichroic Enlarger: An enlarger equipped with dichroic filters for color printing. Dichroic filter values are adjusted by turning dials. Dichroic enlargers may have either diffusion or condenser lamp houses.

Dichroic Filters: Filters for color printing that are built into enlargers. The color balance of dichroic filters is set by adjusting dials, instead of moving individual filters in a filter tray.

Dichroic Fog: A two-color stain observed in film or plates. Appears green by reflected light and pink by transmitted light.

Diffraction: An optical term used to denote the spreading of a light ray after it passes the edge of an obstacle.

Diffusion: The scattering of light rays from a rough surface, or the transmission of light through a translucent medium.

Diffusion Enlarger: An enlarger that reflects the light beam from the bulb off white walls of a mixing box or chamber positioned above the film carrier.

Digital Camera: A camera without film, using a computer chip to record a visual image for computer downloading.

DIN: A European system of measuring film speed; little used in this country.

Diopter: A measure of lens power; the reciprocal of the focal length of the lens in meters.

Direct Finder: A viewfinder through which the subject is seen directly, such as the wire finder on various cameras.

Direct Positive: A positive image obtained directly, without the use of a negative.

Dispersion: The separation of light into its component colors, created by passing white light through a prism.

Distance Meter: An instrument used for estimating the distance to a particular object. Also known as a range finder.

Distortion: Defects caused by uncorrected lenses, resulting in images that are not the proper shape.

Dodge: To shade a portion of the negative during printing.

Dodging: The process of holding back light from certain areas of sensitized material to avoid overexposure of these areas.

Dots per Inch (DPI): A unit of measurement for resolution of computer printers.

Double Exposure: The intentional or unintentional recording of two separate images on a single piece of sensitized material.

Double Extension: A term used to describe the position of a camera bellows. A double extension bellows has an extended length of about twice the focal length of the lens being used.

Double Image: A blurred picture, caused by movement of the camera or of the subject during exposure.

Double Printing: Printing from two or more negatives to make one picture; for example, using a second negative to print clouds into a landscape.

Double Weight (DW): The heavier weight in which photographic papers are supplied.

Dragon's Blood: A resin used as an etching resist.

Drop Bed: A camera bed that may be lowered to avoid interference with the view of a wide-angle lens.

Drop Front: A type of rising front that permits the lowering of the lens below the center of the film.

Dry Mounting: A method of cementing a print to a mount by means of a thin tissue of thermoplastic material. The tissue is placed between the print and the mount and heat is applied to melt the tissue.

Duplicator: A split lens cap used to photograph a person twice on a single film without a dividing line between the two exposures.

Dyes, Sensitizing: Dyes used to extend the color sensitivity of an emulsion. Applied during the manufacture of emulsions to obtain selective sensitivity to colored light.

Easel: A device used to hold sensitized paper in a flat plane on an enlarger. Generally includes an adjustable mask to accommodate different sizes of paper.

Effective Aperture: The diameter of the lens diaphragm as measured through the front lens element; the unobstructed useful area of a lens; it may actually be larger than the opening in the lens diaphragm, due to the converging action of the front lens element.

Efficiency: As applied to shutters, the perceptual relationship between the total time a shutter remains open (counting from half-open to half-closed positions) and the time required for the shutter to reach the half-open and the fully closed positions.

Efficiency of a Lens: The ratio of the light actually transmitted by a lens to that incident to it.

Efflorescence: The process by which a chemical salt loses its water of crystallization upon exposure to air.

Ektalith: Eastman Kodak trademark for a diffusion-transfer system of producing lithographic plates.

Elon: Kodak trademark for a popular developing agent.

Embossing: The process by which the central portion of a print is depressed, leaving a raised margin.

Emulsion: The light-sensitive layer, consisting of silver salts suspended in gelatin, that is spread over a permanent support such as film, glass, or paper.

Emulsion Speed: The factor that determines the exposure necessary to produce a satisfactory image. This is commonly expressed in Weston, General Electric, or ASA emulsion numbers that have been assigned to the film.

Enlarged Negative: A negative made from a smaller negative.

Enlargement: A print made from a negative or a positive by projecting an enlarged image on sensitized material.

Enlarger: An optical projector that forms an image of a negative on a larger sheet of sensitized paper.

Equivalent Focus: The focal length of a group of lenses that is considered one lens.

Etch: To scrape away some of the density of a negative by means of a knife during retouching.

Evaporation: The changing of a liquid into vapor at a temperature below the boiling point.

Exposure: The product of time and intensity of illumination acting upon the photographic material. Intensity x Time = Exposure.

Exposure Index: A speed rating for film and paper; can be used interchangeably with ASA and ISO.

Exposure Indicator: A device attached to a camera to indicate the number of exposures; also attached to a plate holder to show whether the plate has been exposed.

Exposure Meter: An instrument for measuring light intensity and determining correct exposure.

Extension: The distance between the lens and the sensitive material in a camera.

Extension Tubes: Hollow metal tubes that go between camera and lens to permit closer-than-normal focusing. The longer the extension, the closer the lens will focus.

Extinction Meter: An exposure meter that measures the light by the minimum visibility of the image or target.

Eyepiece: The lens element of a microscope, viewfinder, or telescope, to which the eye is applied in order to view the image.

Factorial Development: A system of development in which a standard degree of contrast is obtained by developing for a certain period, which is estimated by multiplying the time interval (elapsing between the immersion of the negative and the first appearance of its image) by some recommended factor.

Fading: This refers to the gradual elimination, usually of the print image, due to the action of light or other oxidation.

Fahrenheit: A system of calibrating thermometers in which the freezing point of water is taken as 32 degrees and its boiling point as 212 degrees.

240

Far Point: The farthest object from the camera that is still acceptably sharp when the camera is focused at a given distance.

Farmer's Reducer: A formula, composed of potassium ferricyanide and hypo, used to reduce either negative or print densities.

Fast Lens: A lens that has a large relative aperture. Examples: f/1.2; f/1.5; f/1.9.

Faurot Foto-Focuser: An attachment placed in the lens of 4 x 5 camera to take photographs of fingerprints.

Ferrotype Plates (tins): Sheets of thin, enameled metal, chromium plated metal, or stainless steel, used to obtain high gloss on prints.

Fiber-based Paper: Photographic print paper consisting of light-sensitive emulsion on a durable paper base.

Field: The area covered by a lens or a viewfinder.

Filament: That part of an incandescent lamp, composed of resistance wire, that becomes luminous when heated by the passage of an electric current.

Fill-in: Secondary illumination directed so as to keep shadow areas from photographing too dark; also known as fill light.

Film: A sheet or strip of celluloid, coated with a light-sensitive emulsion, for exposure in a camera. The celluloid support has a nitrate or acetate base.

Film Base: The transparent material on which an emulsion is coated.

Film Cement: A solution of cellulose acetate or nitrate used to join strips of motion-picture film.

Film Cleaner: A liquid used to remove dust and grease from film without injuring the base or the emulsion.

Film Clip: A metal clamp used to hold film while processing or drying.

Film Hanger: A frame of non-corrodible metal in which film is suspended for processing.

Film Pack: A metal case containing a number of films arranged so that films may be changed by pulling out paper tabs.

Film Pack Adapter: A holder, by means of which the film packs may be used in a camera designed for plates or sheet films.

Film Sheath: A metal holder in which single sheets of film may be placed and inserted into plate holders.

Film Tank: A container holding solutions and films to be processed therein.

Film Trimming Guide: A metal form designed to allow one to cut the ends of film correctly for loading magazines.

Filter, Light or Color: A piece of colored glass or gelatin that is usually placed in front of the camera lens to compensate for the difference in color sensitivity between the film and the eye. Also used to modify or exaggerate contrast to provide primary color separation in color photography.

Filter Factor: The number by which the correct exposure without the filter must be multiplied in order to obtain the same effective exposure with the filter.

Filter Paper: A porous paper used to strain impurities from solutions.

Filter Ratio: The ratio between the factors of two or more filters used with the same film and illuminant; frequently used in color separation work in preference to the actual filter factors, because no exposure is normally made without filters in such work.

Filter Size: The diameter of the filter retaining threads on the front of a lens in millimeters. Common filter sizes include 49, 52, 55, 58, 62, and 67mm.

Finder: A viewer through which the picture to be taken may be seen and centered.

Fine-grain Developer: A developer of low potential that prevents the clumping of silver grains to form a mottled image.

Fine-grained: Applied to a negative with very little granularity; one that may be enlarged from 7 to 10 diameters or more with satisfactory quality.

Fingerprint Camera: A fixed-focus camera with built-in lights, used to photograph fingerprints, stamps, and other small objects.

Fisheye Lens: An extremely wide-angle lens. Most fisheye lenses cover more than 180 degrees angle of view and produce circle-shaped pictures on film.

Fixation: The process of making soluble the undeveloped silver salts in a sensitized material by immersion in a hypo solution.

Fixed Focus: A term applied to a camera in which the lens is set permanently in such a position as to give good average focus for both near and distant objects.

Flare Spot: A fogged area on the developed negative due to the multiple reflection of a strong light source by the several surfaces of the lens elements.

Flash Gun: The battery case, lamp socket, and reflector used with photoflash lamps.

Flash Meter: An instrument for measuring the amount of light produced by a flash unit.

Flash Synchronization: The adjustment and timing of camera and flash so that the flash fires when the camera shutter is open. Most 35mm SLR cameras synchronize with electronic flash at shutter speeds of 1/125 of a second or slower.

Flashtube: A glass or quartz tube, usually wound in helical shape, containing two electrodes and filled with xenon or other inert gases at a very low pressure; used as the light source in flash units and photographic stroboscopes.

Flat: The expression denoting lack of contrast in a print or negative.

Flatness of Field: The quality of a lens that produces sharpness of image both at the edges and at the center of the negative.

Floodlamp: In general, any lamp or lighting unit that produces a broad beam or flood of light; colloquially used as a contraction for photoflood lamp.

f/number: A system denoting lens apertures. Examples: f/5.6; f/11; f/16; f/32.

Focal Length: The distance between the center of the lens and the point at which the image of a distant object comes into critical view. The focal length of a thick lens is measured from the emergent nodal point to the focal plane.

Focal Plane: The plane at which the image is brought to a critical focus. In other words, the position in the camera occupied by the film emulsion.

Focal Plane Shutter: A shutter that operates immediately in front of the focal plane. A shutter of this type usually contains a fixed- or variable-sized slit in a curtain of cloth or metal that travels across the film to make the exposure.

Focus: The plane toward which the rays of light converge to form an image after passing through a lens. The most important function for the police or fire photographer to perform before snapping the shutter.

Focusing Cloth: A black cloth that is used to cover the camera while focusing so that the image on the ground-glass may be more easily seen.

Focusing Hood: A collapsible tube shading the groundglass of a camera so that a focusing cloth is not needed.

Focusing Magnifier: A lens through which the image on the groundglass is viewed for critical focusing.

Focusing Negative: A negative, containing geometrical patterns, that is temporarily substituted for the picture negative when focusing an enlarger.

Focusing Scale: A graduated scale on a lens or a camera, permitting focusing on a given subject by estimating its distance from the camera and setting a pointer to correspond.

Focusing Screen: A sheet of groundglass on which the image is focused.

Folding Camera: a camera that has a collapsible bellows so that it may be closed for carrying.

Foot-candle: The intensity of light falling on a surface placed one foot away from a point light source of one candlepower.

Forcing: Continuing development beyond the normal period, in an effort to secure more detail.

Foreground: Generally, the part of a scene that is closer to the camera than the main subject.

Formula: A list of ingredients and quantities necessary to compound a photographic solution.

Fresnel Lens: A lens consisting of a small central plano-convex lens surrounded by a series of prismatic rings; also known as an echelon lens.

Frilling: The detachment of the emulsion from its support around the edges; this happens most often in hot weather or because of too much alkali in the developer.

Full Aperture: The maximum opening of a lens or lens diaphragm.

Gallon (gal): A unit of liquid measure used in the United States and the British Empire; an American gallon contains 128 ounces; the British Imperial gallon contains 160 ounces.

Gamma: A numerical measure of the contrast to which an emulsion is developed.

Gamma Infinity: The maximum contrast to which an emulsion can be developed.

Gas Bells: Bubbles that force the emulsions from the support, caused by strong chemical action and resulting in minute holes in the negative.

Gelatin: A jelly-like by-product of bones, hoofs, horns, and other parts of animals.

Ghost: The reflection of an image on one or more lens surfaces caught by the negative.

Ghost Images: The reflection of the light from a bright subject, by the elements of the lens or its mounting, to form a spurious image.

Glossy: Applied to photographic papers that are heavily coated with gelatin so that they may be ferrotyped.

Glycerin Sandwich: A means of making prints from scratched or damaged negatives; they are placed between glass plates, coated with glycerin that temporarily fills in the scratches.

Gradation: The range of densities in an emulsion from highlights to shadows.

Graded Paper: Black-and-white print paper that is manufactured in specific contrast grades. Normal contrast grade is considered to be F-2. Low-contrast negatives may be printed on a high-contrast grade of paper, such as F-4, to compensate for the low-contrast negative.

Grain: Used in speaking of individual silver particles or groups of particles in the emulsion which, when enlarged, become noticeable and objectionable.

Grain: A unit of weight. In the avoirdupois system, 437.5 grams equal one ounce.

Gray Scale: A monochrome strip of tones ranging from pure white to black with intermediate tones of gray.

The scale is placed in a setup for a color photograph and serves as a means of balancing the separation negatives and positive dye images, and is cropped from the finished print.

Groundglass: A screen at the back or top of the camera upon which the image may be focused.

Groundglass Screen: A translucent screen mounted on the back or top of a camera, upon which the image formed by the lens can be observed.

Guide Number: A rating of a flash unit's power. It can be defined as the proper exposure setting for a photo taken with the flash 10 feet from the subject, multiplied by 10. For example, a flash with a guide number of 56 will produce enough light for an exposure of f/5.6 at 10 feet.

Gun: Any device for igniting flashlamps or flash powder; also, the gunstock for supporting small cameras and heavy lenses with greater firmness.

H & D (Hurter and Driffield) System: A system for measuring film speed; little used in the United States.

Halation: A blurred effect, resembling a halo, usually occurring around bright objects; caused by the reflections of rays of light from the back of the negative material.

Halftones: A term used when speaking of the middle tones laying between the shadows and highlights.

Halides (or Haloids): A chemical term applied to binary compounds that contain any of the following elements: chlorine, bromine, iodine, and fluorine.

Halogen: Iodine, fluorine, chlorine, and bromine are known as halogens.

Hard: A term used in photography to denote excessive contrast.

Hardener: A chemical, such as potassium or chrome alum, that is added to the fixing bath to harden the gelatin after development. Prehardening solutions may be used prior to development.

Hard-working: Applied to a developer that tends to give high contrast.

High-key: Applied to a print having the majority of its tones as light grays and white.

Highlights: The brightest parts of the subject, represented by the denser parts of the negative and the light gray and white tones of the print.

Hold Back: To shade portions of an image while printing, in order to avoid excessive density; similar to dodge.

Hot Shoe: A standardized method of mounting an electronic flash on a camera. The hot shoe fittings on both the camera and flash have an electrical contact in the center that fires the flash when the shutter is released.

Hue: The name by which we distinguish one color from another, e.g., blue or red.

Hydrometer: An instrument that is used to find the concentration of a single chemical in water. Its most common use is in mixing large quantities of hypo.

Hydroquinone: A reducing agent that is widely used in compounding developers for photographic materials.

Hyperfocal Distance: The distance from the camera, such that if an object at that point is in sharp focus, then all objects from one-half this distance to infinity give satisfactory definition on the groundglass screen.

Hypo: A contraction of sodium hyposulfite (sodium thiosulfate.) Hypo is used in compounding fixing solutions. These, in turn, make soluble the undeveloped silver salts in an emulsion.

Hypo Test: A method of checking the completeness of washing by running the drippings of wash water from the film or print into various testing solutions; also, commercial solution used to test the strength of hypo.

Illumination: The illumination at a point on the surface of a body is the intensity of light received, and is expressed as the number of lumens per square foot of the number of foot-candles.

Image: The representation of an object formed by optical or chemical means.

Imbibition: Literally, the act of absorbing. The process of dye transfer in the wash-off relief process of making color prints.

Incandescent: Glowing with heat, such as a tungsten filament in an incandescent lamp.

Incident Light: A meter reading designed to be held at the subject position, facing the camera, to measure light strength at the subject plane.

Index of Refraction: The mathematical expression of the deviation of a light ray entering a given medium at an angle to its surface.

Inertia: The exposure indicated by the intersection of the straight-line part of the characteristic curve with the log exposure axis (so named by Hurter and Driffield). It is an inverse measure of the speed of the plate.

Infinity: A distance so far removed from an observer that the rays of light reflected to a lens from a point at that distance may be regarded as parallel. Also, a distance setting on a camera focusing scale, beyond which all objects are in focus.

Infrared: Invisible rays of light beyond the red end of the visible spectrum.

Intensification: The process of building up the density of a photographic image by chemical means.

Internegative: A copy negative made from a slide.

Interval Timer: A laboratory clock that may be set to ring after a given period has elapsed.

Invasion Phase: Refers to the part of the development process during which the developer penetrates the emulsion.

Inverse Square Law: A physical law that states that illumination intensity varies inversely with the square of the distance from a point of light.

Invisible Rays: The rays, such as X rays, ultraviolet, and infrared, that are not visible to the eye.

Iris Diaphragm: A lens control composed of a series of overlapping leaves operated by a revolving ring to vary the aperture of the lens.

ISO: International Standards Organization rating of film speed. Used interchangeably with ASA.

Keeper: An acid chemical added to two-solution developers to prevent oxidation of the developing agent.

Kelvin: A thermometer scale starting at absolute zero (-273° C approximately) and having degrees of the same magnitude as those of the Celsius thermometer. Thus $0 = 273^\circ$ K and 100° C = 373 K; also called the absolute scale.

Key: The prevailing tone of a photograph, such as high-key, low-key, medium-key.

Kilo: 1,000. Examples: kilocycle (kc) = 1,000 cycles; kilogram (kg) = 1,000 grams; kilometer (km) = 1,000 meters; kilowatt (kw) = 1,000 watts.

Kodachrome: A commercial monopack produced by Eastman Kodak Company. It is processed by reversal to produce colored positive transparencies.

Kodalith: Trademark of the Eastman Kodak Company for its line of high-contrast photochemical films and developers. Fine for copying spot maps and documents.

Land Camera: Camera developed by the Polaroid Corporation in about 1950 that makes finished photographs in about 10 seconds by the diffusion-transfer process; also known as a "Polaroid" camera.

Lantern Slides: Small transparencies, either 2 x 2-inches, 3 x 3-inches, or 3 x 4-inches, intended for projection.

Latent Image: The invisible image formed in an emulsion by exposure to light. It can be rendered visible by the process of development.

Lateral Chromatic Magnification: Refers to the formation of colored images of different sizes in the same plane, of an object removed from the principal axis of the lens.

Latitude: Exposure latitude is the quality of a film, plate, or paper that allows variation in exposure without detriment to the image quality. Development latitude is the allowable variation in the recommended developing time without noticeable difference in contrast or density.

Leader: A strip of film or paper at the beginning of a roll of film that is used for loading the camera or projector.

Leica Thread Mount: A screw-thread lens mounting style with 39mm diameter threads; on most enlarger lenses.

Lens: An optical term applied to a piece of glass that is bounded by two spherical surfaces, or a plane and a spherical surface. The term is also applied to a combination of several glass elements, such as a photographic objective lens.

Lens Board: A detachable board carrying a lens and a shutter that is fastened to the front of the camera.

Lens Cap: A cover used to protect a lens from dust and damage when not in use.

Lens Hood: A shade used to keep extraneous light from the surface of a lens.

Lens Paper: A fine, soft tissue paper used for cleaning lenses.

Lens Shade: A detachable camera accessory used to shield the lens from extraneous light rays.

Lens Speed: The largest lens opening at which a lens can be set. A "fast" lens has a larger maximum opening than a "slow" lens. For example, an f/2.8 lens is faster than an f/4 lens.

Light Copy: Original material to be copied, containing only black and white areas or lines, without halftones.

Light Fog: The fog produced over an image by accidental exposure of film to extraneous light.

Light Meter: A device that measures the intensity of light; can be either built into a camera or a separate handheld device.

Light Trap: A system of passageways or double doors designed so that a darkroom may be entered or exited without light being admitted.

Line Pairs per Millimeter: lp/m, a traditional measure of resolution for video and digital images; 10 lp/m is equivalent to 20 pixels per millimeter.

Line Screen: A finely lined glass screen used in photomechanical reproduction to produce a halftone negative. Often referred to as a halftone screen.

Liter: A unit of capacity.

Litmus Paper: Paper impregnated with azolitmin, used for testing solutions; it turns red in acid solutions, blue in alkaline baths.

Litmus Reduction: The reduction of certain densities of a negative by the local application of a reducer or by rubbing with an abrasive paste.

Long Scale: A long-scale or contrast negative is one in which the least dense portion will transmit 50 to 100 times more light than the densest portion. A long-scale or soft-printing paper is one that requires 50 to 100 times the barely visible tint exposure in order to produce the deepest black.

Low Key: The balance of light or dark tones of a photograph. If light tones prevail with few or no dark tones, the photograph is said to be "high key"; if the opposite, "low key."

Lumen: A measurement of light equivalent to that falling on a foot-square surface which is one foot away from a point light source of one candlepower.

Lumenized: A trademark of the Eastman Kodak Company for an anti-reflection coating applied to lenses and other glass surfaces.

Luminosity: The intensity of light in a color as measured by a photometer.

Lunar Caustic: Silver nitrate.

Lux: Lumens per square meter.

Macro Lens: A primary lens that can be focused from a very short distance out to infinity; may be a fixed focal length lens or a zoom lens.

Macrophotography: Close-up photography, the taking of a picture larger than the size of the subject.

Magazine: The container that holds the film feed and take-up spools of a motion picture or still camera; also a device for holding and exposing from 12 to 18 sheet films or plates in succession.

Magenta: A reddish-blue (minus green) color.

Mask: A sheet of thin black paper, metal, or celluloid, used to secure white margins on a photograph.

Masking: A corrective measure used in three-color photography to compensate for the spectral absorptive deficiencies in pigments, dyes, and emulsions. This compensation improves the accuracy of color reproduction.

Matrix: A gelatin relief image used in the wash-off relief process of color photography.

Medium-key: Applied to a print having the majority of its tones as medium grays, with only a small proportion of solid black or pure white.

Megacycle (mc): 1,000,000 cycles.

Meniscus Lens: A positive or negative, crescent-shaped lens consisting of one concave and one convex spherical surface.

Meta-: A prefix to chemical names indicating substitution in the one and three positions in the benzene ring.

Meter (m): A unit of length; the U.S. equivalent is 39.37 inches.

Metol: A popular reducing agent that is sold under such trade names as Elon, Pictol, and Rhodal. The chemical name is monomethylparaminophenol sulfate.

Microdensitometer: A special form of densitometer for reading densities in very small areas; used for studying astronomical images, spectroscopic records, and for measuring graininess in films.

Micron (F): A unit of length; 1,000 of a millimeter.

Microphotography: Taking a photograph through a microscope; not necessarily using the lens of the microscope, but the lens of the camera.

Mil: 1/1,000.

Milky: Applied to the appearance of incompletely fixed films or plates; also of incorrectly prepared fixing baths.

Milligram (mg): A unit of weight; 1/1,000 of a gram.

Milliliter (ml): A unit of capacity; 1/1,000 of a liter; approximately (but not exactly) equal to one cubic centimeter.

Millimeter (mm): A unit of length; 1,000 of a meter.

Millimicron (m): A unit of length; 1,000,000 of a millimeter, or 1,000 of a micron.

Miniature Camera: A term more or less generally applied to a camera using film 2 x 3 inches or less in size.

Minim: A unit of capacity; 1/480 of one fluid ounce or approximately one drop.

Mirror Lens: A type of long telephoto lens that uses several mirror optic surfaces to "fold" the light path, reducing the size and weight of the lens.

Modeling: Applied to the representation of the third dimension in a photograph by the controlled placement of highlights and shadows.

Monochromatic: A single color.

Monopack: Another name for integral tripack.

Montage: A composite picture made by a number of exposures on the same film, by projecting a number of negatives to make a composite print, or by cutting and pasting-up a number of prints and subsequently copying to a new negative, or by any of a number of similar processes.

Mordant: An etching bath used on metal; also a chemical that causes a dye to become insoluble and prevents its washing out.

Motor Drive: A motorized mechanism for advancing the film in a camera and recocking the shutter. Motor driven cameras usually have a maximum speed of between two and six frames per second.

Mottling: Marks that appear on negatives or prints that have not been sufficiently agitated during processing.

Mount Board: The cardboard or paper support to which a print is fastened for display. Also called mat board.

Mounting Tissue: Thin sheets of paper impregnated with shellac and used for attaching prints to mounts by application of heat.

M-Q Developer: A developer containing Metol (Elon, Pictol, Rhodol, etc.) and Quinol (hydroquinone).

Mug Shot: A photograph showing head and shoulders, both side and front views, usually made of an arrested person during booking.

Multi-coating: The application of several coats of materials to the surface of lens elements to improve light transmission and reduce flares.

Multiple Camera: A camera that makes a number of small photographs on a single, large film or plate.

Multiple Printing: Repeated printing of the same image on successive coatings of sensitizer on one sheet of paper, usually in the gum-bochromate process, to secure greater contrast.

Multiplying Back: A sliding back for view cameras designed to make a large number of negatives in rows on a single plate or film.

Nanometer (nm): A unit of wavelength, used to measure the distance between the peak and valley of a wave;

Negative: A photographic image on film, plate, or paper in which the dark portions of the subject appear light and the light portions appear dark.

Negative Paper: A paper base coated with a negative emulsion, used mainly by photoengravers.

Neutral: Without color; gray; chemically, a solution that is neither acid nor alkaline.

New Coccine: A red, water-soluble dye used for dodging negatives.

Nicol Prism: A type of prism used to produce polarized light.

Nitrate Base: The term used to designate a photographic film base composed of cellulose nitrate; highly flammable.

Nodal Points: The points on the axis of a thick lens, such that a ray traversing the first medium, passing through one nodal point, emerges from the second medium in a parallel direction, and appears to originate at a second point.

Non-halation: A light sensitive material, the back of which is coated with a light-absorbing substance that tends to reduce halation.

Normal Lens: A lens with a focal length of approximately the diagonal measurement of the film image area. A 50mm lens is considered the normal lens for 35mm photography. Normal lenses view the subject as do unaided human eyes, neither reducing nor enlarging the subject size.

Objective Lens: A lens that is used to form a real image of an object.

Opacity: The resistance of a material to the transmission of light.

Opal Glass: A white, milky, translucent glass used as a diffusion medium in enlargers.

Opaque: Refers to an object that is incapable of transmitting visible light. A commercial preparation used to black out certain negative areas.

Optical Axis: An imaginary line passing through the centers of all the lens elements in a compound lens.

Original: In copying, that which is to be reproduced.

Ortho: An abbreviation for orthochromatic.

Orthochromatic Film: A film, the color sensitivity of which includes blue, green, and some yellow. It is not sensitive to red.

Orthochromatic Rendition: The reproduction of color brightnesses in their relative shades of gray.

Orthonon: Refers to a film whose color sensitivity includes ultraviolet and blue. Often referred to as "color-blind" film.

Overdevelopment: The result of permitting film or paper to remain in the developer too long, resulting in excessive contrast or density.

Overexposure: The result of too much light being permitted to act on a negative, with either too great a lens aperture or too slow a shutter speed or both.

Oxidation: The loss of activity of a developer due to contact with the air.

Pacifier (Flattener): A term for a mixture of water and glycerin used to avoid curling of prints.

Packard Shutter: A trade name of a type of shutter, operated by a rubber bulb and tube, much used on studio cameras.

Pan: An abbreviation for panchromatic.

Panchromatic Film: A film that is sensitive to all colors of the visible spectrum.

Panoramic Head: A revolving tripod head, graduated so that successive photographs may be taken that can be joined into one long panoramic print.

Parallax: The apparent displacement of an object seen from different points. Commonly encountered in photography in the difference between the image seen in the viewfinder and that actually taken by the lens.

PC Cord: Shutter cord.

Pentaprism: A five-sided prism used in single-lens-reflex viewing hoods to turn the image right-side-up and laterally correct.

Perspective: The illusion of three dimensions created on a flat surface.

pH: The acidity or alkalinity of a solution expressed in terms of the hydrogen ion concentration. A neutral solution has a pH of 7.0; an acid solution has a lower value; and an alkaline has a higher value.

Phenidone: A black-and-white film developing agent that converts exposed silver halides in the film to black metallic silver.

Phot: A unit of luminance; one lumen per square millimeter.

Photo CD: A compact disc used to store digitized photographs taken either with film cameras or with digital cameras.

Photochemical Action: A chemical action induced by exposure to light.

Photoengraving: A method of producing etched printing plates by photographic means.

Photoflash Lamp: A light bulb filled with aluminum wire or shreds in an atmosphere of oxygen; the heating of the filament ignites the primer, which in turn fires the aluminum, giving a short, brilliant flash of light.

Photoflood Lamp: An electric lamp designed to be worked at higher-than-normal voltage, giving brilliant illumination at the expense of lamp life; also called a floodlamp.

Photogrammetry: The science of mapping by the use of aerial photographs.

Photogravure: A method of making an intaglio engraving in copper from a photograph, using the gelatin image as an acid resist.

Photomacrography: Enlarged photography of small objects by the use of a long bellows camera and a lens of short focal length.

Photomicrography: Photography through a microscope.

Photomontage: A picture composed of several smaller pictures.

Photoregression: The gradual disappearance of the latent image that has not been subjected to development.

Photosensitive: Material that is chemically or physically changed by the action of light.

Photostat: The trade name of a camera that makes copies of documents, letters, drawings, etc. on sensitized paper; also the copies made by means of this camera.

Photo-topography: The mapping or surveying of terrain by means of photography.

Pincushion Distortion: A term applied to the pincushion-shaped image of a square object, obtained when the diaphragm is placed behind the lens.

Pinholes: Tiny clear spots on negative or positive images, caused by dust, air bells, or undissolved chemicals.

Pixel: A unit of measurement for resolution of digital images; one pixel contains at least three dots (dots per inch, DPI).

Pixelated: When an enlargement of a digitized photograph shows the individual pixels to the point that the image is not readily recognizable.

Plate Back: An attachment to certain roll film cameras such as the older Kodaks, the Rolleiflex, etc. permitting the use of plates or sheet film; incorrectly used as a description of a camera made primarily for use with plates—such cameras are plate cameras, not plate-back cameras.

Plate Holder: A lightproof holder in which sensitized plates are held for exposure in the camera.

Pola Screen: A screen that transmits polarized light when properly oriented with respect to the vibration plane of the incident light. When rotated to a 90-degree angle it will not transmit the polarized light.

Polarized Light: Light that vibrates in one manner only, in straight lines, circles, or ellipses. Light is commonly polarized by passing a light beam through a Nicol prism or a polarizing screen.

Polarizing Filter: A filter that removes reflections from water, glass, and other surfaces; it also increases color saturation.

Positive: The opposite of negative. Any print or transparency made from a negative is a positive.

Pre-exposure: Exposure of a sensitized material to light, either during manufacture or by the user before exposure in the camera, as a means of intensifying the latent image, particularly in shadowy areas.

Prefocused: Applied to a lamp having a special type of base and socket that automatically centers the filament with respect to an optical system.

Preservative: A chemical (such as sodium sulphite) that, when added to a developing solution, tends to prolong its life.

Press Camera: See View Camera.

Primary Colors: Any one of the three components of white light—blue, green, and red.

Printing Frame: A frame designed to hold a negative in contact with paper, under pressure, for the purpose of making prints.

Printing-out Paper (P.O.P.): A photographic paper that forms a visible image immediately upon exposure, without development. It must be fixed, however, for permanence of the image.

Process Lens: A highly corrected lens used for precise color separation work.

Processing: The chemical treatment of exposed film to form a permanent visible image.

Programmed Automatic Exposure Camera: An automatic exposure camera that automatically sets both the shutter speed and lens opening to properly expose the picture.

Projection Printing: A method of making prints by projecting the image of the negative on a suitable easel for holding the sensitive paper.

Proof Paper: Usually a printing-out paper (P.O.P.) that is exposed in contact with the negative to any bright light and does not require a developing solution to make a visible image. The image must be observed in subdued light or it will become dark and eventually disappear.

Proportional Reducer: A chemical reducing solution that reduces the silver in the shadows at the same rate as that in the highlights.

Props: Accessories used to add interest or provide variety in an illustration or a portrait.

Push-processing: The technique of overdeveloping film to compensate for intentional underexposure. Commonly used to gain faster shutter speeds or greater depth of field than normally exposed and processed film will permit.

Quart (qt): A unit of liquid measure, 32 ounces (American) or 40 ounces (British).

Quartz Lens: A special lens used for ultraviolet photography.

Racking: Moving either the lens board or the camera back to and fro while focusing.

Radiant Energy: A form of energy of electromagnetic character. All light that causes a photochemical reduction is radiant energy.

Rangefinder Camera: A camera equipped with a range finder focusing system, that provides a double image of the subject in a small central area of the viewfinder. When the camera is in focus, the double image appears as a single image.

Ratio: The degree of enlargement or reduction of a photographic copy with respect to the original.

Reagent: A chemical used to produce a desired reaction.

Reciprocity Law: A law that states that the blackening of photosensitive materials is determined by the product of light intensity and time of exposure. Thus, intensity is the reciprocal of time and, if one is halved, then the other must be doubled in order to obtain the same blackening.

Rectilinear Lens: A lens corrected so that it does not curve the straight lines of the image.

Redevelopment: A step in the intensifying or toning processes, when a bleached photographic image is redeveloped to give the desired results.

Reducer: A chemical solution used to decrease the overall density of a negative or print.

Reducing Agent: The ingredient in a developer that changes the sub-halide to metallic silver; usually requires acceleration.

Reflection: The diversion of light from any surface.

Reflective Ultraviolet Photography (RUP): A photographic technique in which an ultraviolet filter (such as an 18A filter) is attached either to the camera lens or to an electronic flash. The film captures only reflected UV illumination from the subject. Commonly used to record injuries on skin.

Reflector: Any device used to increase the efficiency of a light source. Examples are flashlight reflectors and tinfoil reflectors for outdoor pictures.

Reflex Camera: A camera in which the image can be seen right side up and full size on the groundglass focusing screen.

Refraction: The bending of a light ray when it passes obliquely from a medium of one density to a medium of a different density.

Replenisher: A modified developer solution that is added in small portions to a working developer to keep its properties constant.

Reproduction Ratio: The ratio of the actual size of an object to its reproduced size on film. A 1:1 ratio means life-size, a 2:1 ratio means two times the actual size, and 1:4 ratio means ½ life-size.

Resin-coated Paper: Photographic print paper that has a thin coating of plastic resin on the backside of the paper and in between the emulsion and paper support. RC paper absorbs less of the processing chemicals, requires a shorter wash, and dries faster than fiber-based paper.

Resolving Power: The ability of a lens to record fine detail, or of an emulsion to reproduce fine detail.

Restitution: Projection printing for the purpose of reducing the variation in the scale of prints.

Restrainer: Any chemical—such as potassium bromide—that, when added to a developing solution, has the power of slowing down the developing action and making it more selective.

Reticulation: The formation of a wrinkled or leather-like surface on a processed emulsion due to excessive expansion or contraction of the gelatin, caused by temperature changes or chemical action.

Retouching: A method for improving the quality of a negative or print by use of a pencil or brush.

Reversal: A process by which a negative image is converted to a positive. Briefly, a negative is developed, reexposed, bleached, and redeveloped to form a positive.

Reverse Adapter: An adapter ring that permits a normal lens to be mounted backwards onto a camera for improved results when taking extreme close-up photos.

Roll film: A strip of flexible film, wound on a spool between turns of a longer paper strip, for daylight loading into roll film cameras.

Roll film Holder: An accessory that permits the use of roll film in sheet-film cameras.

Safelight: A light that will not affect sensitive materials because of its intensity and color range.

Safety Film: Film with a cellulose acetate base.

Safety Shot: An unordered, duplicate exposure made in case of damage to one negative during processing.

Scale: Scale is the ratio of a linear dimension in the photograph to the corresponding dimension in the subject.

Schiener Scale (Sch): A European system of speed ratings for films. It is little used in the United States.

Scum: A surface layer that forms on pyro developers, and occasionally on chrome-alum fixing-hardening baths.

Secondary Colors: Colors formed by the combination of two primary colors. Yellow, magenta, and cyan are the secondary colors.

Selective Absorption: The capacity of a body to absorb certain colors while transmitting or reflecting the remainder.

Sensitizer: Dye used in the manufacture of photographic emulsions. Sensitizers can be of two types: (1) to increase the speed of an emulsion; and (2) to increase the color sensitivity of an emulsion.

Sensitometer: A device for producing on sensitized material a series of exposures increasing at a definite ratio. Such a series is needed when studying the characteristics of an emulsion.

Sensitometric Strip: A series of densities in definite steps.

Separation Negatives: Three negatives, each of which records one of the three colors—blue, green, and red.

Sepia Toning: A process that converts the black-silver image to a brownish image. The image can vary considerably in hue, depending on the process, the tone of the original, and other factors.

Set: An interior or exterior scene or part of a scene, together with furniture or natural objects, built in a studio for photography, or on a motion picture lot.

Shadow Area: The darker portions of a picture or the lighter portions of a negative.

Shadows: A term applied to the thinner portions of a negative and the darker parts of a positive slide or print.

Sheet Films: Individual films loaded into separate holders for exposure; usually on a heavier base than roll films and film packs.

Shoot: A term used in photography to mean to make an exposure.

Short-stop Bath: A solution containing an acid that neutralizes the developer remaining on the negative or print before it is transferred to the fixing bath.

Shutter: On a camera, a mechanical device that controls the length of time light is allowed to strike the sensitized material.

Shutter Priority Automatic Camera: An automatic exposure camera that automatically adjusts the lens opening to correctly expose the picture once the photographer has set the lens opening.

Silhouette: A photograph that shows only the mass of a subject in black, against a white or colored background.

Single Weight (SW): Applied to a photographic paper with a lightweight stock.

Siphon: A bent tube or similar device used to empty containers of fluid by using atmospheric pressure.

Skylight: A large window, usually inclined and facing north, used as a principal light source in certain photographic studios.

Skylight Filter: A very pale pink filter used with color film to reduce excess blue found in outdoor scenes. Commonly left on the lens at all times to serve as a lens protector.

Slave Sensor: A device with a photocell that fires a flash unit when it senses the light from another flash unit. The light from both flash units will be in synchronization with the camera.

Slide: A positive print on glass, or a film transparency bound between glasses for projection; also the removable cover of a sheet-film plate or film-pack holder.

Sliding Back: A camera arranged so that one-half of the film may be centered in front of the lens, in order for two pictures to be taken on a single sheet of film.

SLR: Single-lens-reflex camera, a type of camera design that permits the photographer to view through the image-taking lens instead of a separate viewfinder window.

Sludge: Chemical precipitate or impurities that settle to the bottom of the container.

Sodium Thiosulfate: Sodium hyposulphite, commonly known as hypo.

Soft: A term used in describing prints and negatives that have low contrast.

Soft-focus (adj.): Applied to a lens that has been deliberately undercorrected to produce a diffused image; also applied to pictures made with such a lens.

Soft-focus Lens: A special type of lens, used to produce a picture with soft outlines. Such lenses are well adapted to portrait work.

Solarization: The production of a reversed or positive image by exposure to a very intense light.

Spectrogram: A photograph of a spectrum, made by using a spectrograph.

Spectrophotometer: An instrument used for comparing the intensities at the corresponding wavelengths of two spectra.

Spectrum: A colored band that is formed when white light is passed through a prism or a diffraction grating; it contains all the colors of which white light is composed.

Speedgun: A device used to ignite flashlamps in synchronism with the opening of the camera shutter.

Spherical Aberration: A lens defect that causes rays parallel to the axis and passing near the edge of a positive lens to come to a focus nearer the lens than the rays passing through the center portion.

Split Feld Lens: A semi-circular close-up lens in a rotating mount. Attaches to the front of a lens and enables it to render near and distant objects in focus at the same time.

Spool: The reel on which film is wound for insertion into a camera.

Spot Lamp: A type of mushroom-shaped electric lamp that has an integral reflector and produces a narrow, concentrated beam of light.

Spotting: The removal of small blemishes in photographic negatives or prints.

Squeegee: A strip of flat rubber set in a handle; used to remove excess moisture from prints before drying; also the act of pressing surplus moisture from prints.

Step-down Ring: A filter-size adapter ring that permits a lens to use filters smaller than the lens filter size.

Step-up Ring: A filter size adapter ring that permits a lens to use filters larger than the lens filter size.

Stereo Camera: A camera that has two lenses or the equivalent through which the pair of pictures that make up a stereogram may be taken simultaneously.

Stereoscope: A device that contains lenses, prisms, or mirrors, through which a stereogram is seen as a single, three-dimensional picture.

Stills: Photographs, as distinguished from motion pictures.

Stirring Rod: A glass, Bakelite, or hard rubber rod used to stir photographic solutions.

Stock Solution: A concentrated solution that is diluted with water for use.

Stop: A lens aperture or a diaphragm opening such as f/4, f/5.6, etc.

Stop Bath: Preferred term for an acid rinse used following development of paper and films to neutralize them before placement in fixing bath; also incorrectly referred to as a short stop.

Stop Down: To use a smaller aperture.

Straight: Not retouched; applied to negatives or prints.

Strobe Unit: An electronic unit that can be used many times for flash photography.

Subtractive Process: A process in color photography that uses the colors magenta, cyan, and yellow. Contrast with additive color process.

Subtractive Reducer: A reducer that affects the shadows in a negative without noticeably affecting the highlights.

Sunshade: A hood placed over a lens to keep stray light from its surface; similar to lens hood.

Superproportional Reducer: A reducing solution that lowers the highlight density faster than it affects the shadow density.

Supplementary Lens: An attachable lens, by which the focal length of a camera objective is increased or decreased.

Surface Development: A characteristic of some fine-grain developers, which tend to develop the image mainly on the surface of the emulsion.

Swing Back: The back of a view camera that can be tilted in both vertical and horizontal planes.

Synchro-flash: A term applied to flash photography, in which a flash bulb is ignited at the same instant that the shutter is opened, the flash bulb being the primary source of illumination.

Synchro-sunlight: A term used in flash photography, in which flashlight and sunlight are used in combination.

Synchronizer: A device for synchronizing the shutter of a camera with a flashlamp, so that the shutter is fully opened at the instant the lamp reaches its peak intensity.

Tangent of an Angle: The ratio of the length of the opposite leg to the adjacent leg of a right triangle.

- **Tank:** A container or mechanical device in which films or plates may be processed, sometimes without the need of a darkroom.
- **Tele-converter:** A lens accessory that mounts between a camera body and normal, telephoto, or telephoto zoom lenses to double (or triple) the effective focal length. A 2X converter will make an 80-200mm zoom lens seem like a 160-400mm zoom lens.
- **Telephoto Lens:** A lens of long focal length that has a separate negative rear element; it is used to form larger images of distant objects; it is similar in result to a telescope.
- **Tessar:** A trade name for a type of anastigmat lens composed of two pairs of lens elements; one pair is cemented together, the other pair is separated by an air space.
- **Test Strip:** An exposed strip of bromide or chloride paper containing several different exposures, used to determine the correct exposure for printing.
- **Texture:** Applied to showing an object's surface roughness or smoothness in a photograph; often achieved by using light from a direction almost parallel to the surface of the object.
- Thin: Applied to a weak negative, lacking density in the highlights and detail in the shadows.
- Three-quarter: Applied to a portrait pose, standing or seated, including the figure approximately to the knees.
- **Thyristor:** A type of circuitry used in automatic electronic flash units that returns unused energy to the capacitor after each shot. This design substantially reduces recycling time and power consumption.
- Tilt-top: A device attached to a tripod head that permits the camera to be set at various angles in elevation.
- **Time Exposure:** An exposure in which the shutter is opened and closed manually with a relatively long interval between.
- **Time-gamma-temperature Curve:** A curve of developing time plotted against developed contrast, or gamma. The contrast for any given time may be read directly from the curve, or vice versa. The curve applies only for one particular developer and emulsion.
- Timer: A special darkroom clock that gives audible or visible indication of various time intervals.
- **T-Mount:** An interchangeable lens mounting system for slide duplicators, microscope and telescope attachments, lenses without automatic diaphragms, and other optical accessories. A T-mount is a metal ring with female 42mm threads on one side to screw onto the lens attachment and a male camera mount on the other side.
- T/number, T/stop: A system of marking lens apertures in accordance with their actual light transmission, rather than by their geometrical dimensions, as in the f/stop system.
- **Tone:** In photography this usually applies to the color of a photographic image or, incorrectly, to any distinguishable shade of gray. To change the color of a photographic image from its natural black to various colors, either by means of metallic salts, or by mordanting certain dyes to the image; such dyes do not stain the gelatin; note the difference from tinting.
- **Toning:** A method for changing the color or tone of an image by chemical action.

Translucent: A medium that allows light to pass but diffuses it so that objects cannot be clearly distinguished.

Transmission: The rate of the light passed through an object to the light falling upon it.

Transparency: An image on a transparent base that must be viewed by transmitted light. Also refers to the light transmitting power of the silver deposit in a negative and is the opposite of opacity.

Tray Siphon: A device for washing prints that projects a stream of water into a tray, and simultaneously siphons off an equal amount of hypo-laden water from the bottom of the tray.

Trimming Board: A device that consists of a board, a hinged blade, and a rule placed at right angles to the blade; used for trimming prints.

Triple Extension: Applied to a camera in which the bellows extension approaches three times the focal length of its lens.

Tripod: A three-legged stand used to support a camera.

Tripod Socket: A threaded opening in the base of a camera, used to fasten the camera to the tripod head.

Tungsten: A metallic element of an extremely high melting point, used in the manufacture of incandescent electric lamps. In photography, tungsten is used to refer to artificial illumination as contrasted with daylight. For example, film emulsion speeds are given both in tungsten and daylight.

Ultraviolet Filter: A filter that transmits ultraviolet light, as used for photography, by the reflected ultraviolet light method. Known as a Kodak Wratten No. 18A filter.

Ultraviolet Rays: Rays that comprise the invisible portion of the electromagnetic spectrum just beyond the visible violet. Ultraviolet wavelengths are comparatively short and therefore disperse more easily than visible wavelengths. This is a factor to be taken into account in high altitude photography because these rays are photographically actinic.

Underdevelopment: Insufficient development, due to developing either for too short a period in a weakened developer or at too low a temperature.

Underexposure: The result of insufficient light being allowed to pass through the lens to produce all the tones of an image; or of sufficient light being allowed to pass for too short a period.

Uniform System: A system of marking diaphragm aperture used until recently, in which an f/4 lens was marked U.S. 1; f/5.6 was equal to U.S. 2; f/8 equal to U.S. 4; f/11 equal to U.S. 8, etc.

Unipod: Similar to tripod but with only one telescoping leg; it is compact and easily portable.

Universal Developer: A developer that will give satisfactory results on films, plates, and photographic papers.

Variable Contrast Paper: Black-and-white photographic print paper in which contrast is controlled by using filters. Kodak Polycontrast and Ilford Multigrade are two variable contrast papers.

Variable Focal Length Lens: A type of zoom lens that requires refocusing as it is zoomed.

Vernier Scale: A device used on a camera to indicate distance.

View Camera: A style of camera that consists of a bellows connecting a lens support and film holder, mounted on a rail or pair of rails. View cameras offer the lens and film planes a great deal of unrestricted physical movement for controlling depth of field and perspective. Also known as press cameras.

Viewfinder: A viewing instrument attached to a camera, used to obtain proper composition.

Vignetting: Underexposure of the extreme edges of a photographic image; occasionally caused by improper design of lenses or too small a sunshade; sometimes intentionally done in portraiture.

Visible Light: The small portion of electromagnetic radiation that is visible to the human eye. Approximately, the wavelengths from 400 to 700 millimicrons.

Weak: In photography, applied to a negative that is thin due to underexposure or underdevelopment.

Wide-angle Lens: A lens of short focal length and great covering power that is used to cover a larger angle of view than a normal lens will include from a given viewpoint.

Working Solution: A photographic solution that is ready to use.

Zip Drive: A high capacity disk drive capable of storing 100 megabytes of data. Manufactured by the Iomega Corporation.

Zone Focusing: A type of focusing system that has two or more focus settings for varying subject distance ranges, rather than a continuous adjustable focusing ring.

Zoom Lens: A lens that can be varied in apparent focal length while maintaining focus on a given object; it gives the effect of moving to or from the subject when used on a motion-picture camera.

Bibliography

- Aaron, J.M. (1991). "Reflective Ultraviolet Photography Sheds New Light on Pattern Injury." Law and Order, 38:213-218.
- Baldwin, H.B. (1997). "Photographic Techniques for the Laser or Alternate Light Source." http://police2 .ucr.edu/laster.htm
- Eastman Kodak Co. (1995). Photography Through the Microscope. Rochester, NY: Eastman Kodak.
- Eastman Kodak Co. (1990). Ultra Violet and Fluorescence Photography. Rochester, NY: Eastman Kodak.
- Eastman Kodak Co. (1989). Color Darkroom Dataguide. Rochester, NY: Eastman Kodak.
- Eastman Kodak Co. (1988). Black & White Darkroom Dataguide. Rochester, NY: Eastman Kodak.
- Eastman Kodak Co. (1986). Photographing Television and Computer Screen Images. Rochester, NY: Eastman Kodak
- Federal Bureau of Investigation (1997). Crime in the United States, 1996. Washington, DC: Government Printing Office.
- Fisher, B.A.J. (1992). Techniques of Crime Scene Investigation, 5th ed. New York, NY: Elsevier.
- Gibson, H.L. (1980). Photography by Infrared—Its Principles and Applications, 3rd ed. New York, NY: John Wiley & Sons.
- Horenstein, H. (1993). Beyond Basic Photography: A Technical Manual. Boston, MA: Bulfinch Press.
- International Center of Photography (1984). Encyclopedia of Photography. New York, NY: Crown.
- Kaisai, A. (1997). Essentials of Digital Photography. Indianapolis, IN: New Riders Publishers.
- Krejcarek, P. (1996). Digital Photography: A Hands-On Introduction. Albany, NY: Delmar Publishers.
- London, B., B. Upton & J. Upton (1994). Photography, 5th ed. London, UK: Harper Collins Publishers.

- Marks, M.K., J.L. Bennett & O.L. Wilson (1997). "Digital Video Image Capture in Establishing Positive Identification." *Journal of Forensic Sciences* 42(3):492-495.
- Morton, R.A. (1985). Photography for the Scientist, 2nd ed. New York, NY: Academic Press.
- Saferstein, R. (1997). Criminalistics: An Introduction to Forensic Science, 5th ed. Englewood Cliffs, NJ: Prentice-Hall.
- Scott, C.C. (1969). Photographic Evidence, 2d ed. St Paul, MN: West Publishing.
- Siliander, R. & D. Fredrickson (1997). *Applied Police and Fire Photography*, 2d ed. Springfield, IL: Charles C Thomas Publishers.
- Staggs, S. (1997). Crime Scene and Evidence Photographer's Guide. Temecula, CA: Staggs Publishers.
- Suess, B. (1995). Mastering Black and White Photography. New York, NY: Allworth Press.

Index

Aberration, 45	Arson investigation photography
Abrasions	burn patterns, 167, 168
on negative, 94	cautions, 169
on print, 113	color photography, 167
Accident photography	equipment, 165
bad weather, 141	film, 166
basic considerations, 140	flames, color of, 168
camera angles, 142	how to photograph a fire, 164
color photography, 140, 147	importance of, 5, 167
daylight flash, 142	lighting for, 166
at dusk, 141	photographing after the fire, 165
fill-in flash, 147	preparations for photographing, 163
filters for, 147	problems, 169
first recorded use of, 1	size of fire, 168
hit-and-run, 147	smoke, 167
how to photograph, 144	what to photograph, 164
need for, 4, 139	who should photograph, 165
obstructions to view, 140	ASA, 34. See also Exposure Index (E.I.); ISO
permission to photograph, 141	black-and-white film, 36
poor conditions, 141	color film, 40-41
possible murder, 147	defined, 34
possible suicide, 147	exposure, 34, 61
rules for, 142	exposure meters, 52
viewpoints, 139, 141	Automatic camera, 16, 63
what to photograph, 139	Axial lighting, 175. See also Illumination
Achromatic lens, 216, 227	
Adjustable camera. See Cameras	Barrier filters, 211
Aerial photography, 156	Bellows extension: exposure for, 64, 218
Agitation, 82, 90	Blak-Ray Kits, 204
Air bells on negatives, 94	Blisters on negatives, 94-95
Alternative light source, 212	Bloodstains
American Standards Association, 34. See also ASA	color photography, 179
Aperture	filters for photographing, 179
compensation for infrared, 217	Luminol, 178
defined, 59	Blurred negative, 95
depth of field, 61	Bounce flash, 66
Aperture priority cameras, 63	Breaking and entering, 161

Brown spots on negatives, 95	Color film, processing, 117, 120
Bruises, 212	Color photography, 6
Bulb exposure, 61	Color sensitivity, 32
Bulk loading film, 29	Color wheel, 50
Bullet holes, 179	Colors, 50, 117
Bullets, 179	Commonwealth v. Best, 2
Burglary	Comparison microscope, 179
color photography of, 162	Condenser enlarger, 105
how to photograph, 162	Contact printing, 103
points of entry, 162	Contact writing, 197
Burn patterns. See Arson investigation photography	Contrast
Burning-in, 110	in document work, 194
	film and, 93
C-41 Process, 118	negative, 93
Cable release, 58	paper and, 100
Cameras. See also Minolta cameras; Nikon cameras;	Contrasty prints, 114
Polaroid cameras	Copying of documents
adjustable, 16	with infrared, 222
automatic, 16, 63	photography and, 182
built-in meters, 51, 63	Courtroom exhibits, 4, 129, 184, 189
Deardorff camera, 192	Crime prevention: photography and, 5
defined, 13	Crime scene photography
digital cameras, 24, 132	perspective grid, 149
fingerprint cameras, 184	Crimes. See entries for specific crimes
4 x 5 camera, 21	Crystalline surface on negatives, 95
infrared, 215	,
large format, 21	Daguerreotype, 1
medium format, 17	Dark lines on negative, 95
mounts, 57	Darkfield illumination, 182. See also Illumination
110 cameras, 15	Darkroom
120 cameras, 17	electrical outlets, 73
126 cameras, 16	infrared safety, 73, 221
pinhole, 13	layout, 71
Polaroid cameras, 23	lighting, 73
press camera, 21	location of, 71
rangefinder, 16	plumbing, 72
simple, 13	printing room, 71
single-lens-reflex, 17	sinks, 71
35mm camera, 16	size of, 77
twin-lens-reflex, 19	storage, 72, 92
21/4 camera, 17	ventilation, 74
ultraminiature, 15	work areas, 72
video cameras, 129	Data sheet, 172
Carbon paper, photographing, 197	Daylight flash, 142
Carbon ribbon, photographing, 197	Deardorff camera, 192
Cartridges, 179	Deaths. See Homicides; Suicide, how to photograph
Checks, 193	Defense wounds, 159
Chemicals	Density: negative, 63, 92
replenishment, 91	Depth of field, 61, 174
safety precautions, 92	Developers
storing, 92	black-and-white, 82
useful life of, 91	color, 117, 120
utensils for mixing, 85	for document photography, 193
Close-up photography, 173-174, 217. See also	film, 82
Macrophotography	Kodak Dektol, 103
Color film, printing, 120	Kodak HC-110, 83, 93, 194

paper, 103	Enlargers
Technical Pan, 83, 93	black-and-white, 105
Technidol, 83, 93	color, 124
Development. See also Enlarging; Film; Paper	dichroic, 112
agitation, 82, 90	Enlarging. See also Paper; Proof sheets
cleanliness of, 90	burning-in, 110
color film, 118	color prints, 120
film, 81	defined, 106
of infrared film, 221	dodging, 110
negative quality, 92	enlargers, 105
of 120 film, 88	procedure, 108, 189
safelights, 91	test strip, 109
of 35mm film, 87	EP-2 process, 122
tray processing, 88	Equipment, 43
Diaphragm, 59	Erasures, 194
Diffuse light, 9	Evidence photography
Diffusion enlarger, 105	accident photography, 140
Digital cameras, 132	arson, 164
Digital photography, 129, 185	bloodstains, 178
Distortion, lens, 44	bruises, 212
Document examination	bullets, 179
	cartridges, 179
carbon paper, 197	close-up photography, 173
carbon ribbon, 197	clothing, 180
contact writing, 197	
contrast, 194	comparison microscope, 179 data sheet, 172
copying, 222	
developers, 193	fibers, 179
erasures, 194	foot impressions, 173
films, 193	glass fragments, 179
filters, 222	identification photography, 180, 190
fluorescence photography, 195	lighting for small objects, 174
handwriting, 194	macrophotography, 175
indentations, 196	microphotography, 175
infrared photography, 195, 222	metal, 177
inks, 194, 198, 222	paint flakes, 179
obliterated writing, 195	particles of evidence, 179
reproduction for case study, 193	photomacrography, 175
ultraviolet photography, 195	photomicrography, 175
Document photography. See Questioned document	procedures, 171
photography	purposes of, 5, 180
Dodging, 110	soil particles, 179
Double-weight (DW) paper, 102	tire impressions, 143, 147
Dryers, 77	wood, 177, 188
Drying, negative, 85	Exciter filters, 207
Dust impressions, 177	Exhibits. See Courtroom exhibits
	Exposure
Easel, 107	ASA, 34
E.I. See Exposure Index (E.I.)	basic, 59
Electromagnetic spectrum, 9	with bellows extension, 64
Electronic flash, 54	built-in meters, 51, 63
Emulsion	defined, 59
coarse-grained, 27	enlarging, 124
	Exposure Index (E.I.), 34
film, 27	exposure meters, 52
fine-grained, 27	film latitude, 64
speed of, 100	
Energy, 9	film speed, 34, 203

fingerprint photography, 187	manufacturers of, 39
for flash, 69	monochromatic, 33
for fluorescence photographs, 208	negative sharpness, 35
f/16 system, 63	110 film, 28
f/stops, 60	120 film, 17, 31
guide number for flash, 69	126 film, 29
intensity of light, 12	orthochromatic, 33
inverse square law, 69	packages, 28
ISO, 34	
negative density and, 63	panchromatic, 33, 186
	Polaroid, 23-24
for ultraviolet photography, 203, 208	recommended developers for, 93
Exposure Index (E.I.), 34	roll, 29
Exposure meters	sharpness, 35
ambient light, 56	sheet, 32
built-in, 51	size, 28
and exposure, 52	speed, 34, 203
flash meters, 56	35mm film, 29
how to choose, 52	for ultraviolet photography, 202, 207
incident light reading, 53	unexposed, 27
Luna PRO, 51	washers, 84
photoelectric, 52	Film speeds, 34
reflected light reading, 53	Film washers, 84
spot meters, 53	Filters
Extension rings, 175, 217. See also Copying of docu-	for accident photography, 147
ments; Macrophotography	blue, 50
	care of, 51
F-16 system, 63	construction of, 47
F/stops, 60	for document work, 195
Fading, negative, 95-96	exposure with, 70
Faurot Foto Focuser, 21, 185	for fingerprint photography, 186
Ferrotyping, 111	for fluorescence photography, 187, 201
Fill-in flash, 67	green, 50
Film	for infrared photography, 187, 219, 220
acutance, 35	neutral density, 49
base, 27	polarizing, 49, 50
and cameras, 16	red, 50
cartridge, 29	for special problems, 47
cassette, 29	ultraviolet, 187, 201, 207
coarse-grained, 27	use of, 47, 186
color, 35, 37, 117	
color sensitivity, 32	uses for, 48, 49, 186
	yellow, 50
contrast, 35, 93	Fingermarks on negatives, 96
development, 81, 117	Fingerprint cameras, 185
for document work, 193	Fingerprint photography, 1, 184
DX, 29	equipment, 184
emulsion, 27	exposure, 187
exposed, 27	film, 184, 185
fine-grained, 27	"filmless" technique, 187
for fingerprint photography, 186	filters, 185
for fire photography, 166	with fluorescence, 210
for fluorescence, 202, 207	lifted prints, 185, 189
4 x 5 film, 31	with ultraviolet, 187
graininess, 34, 93	Fingerprints
for identification photography, 38	in burglaries, 161
infrared, 220	enlarging photographs for trial, 185, 189
handling of, 38	on glass, 188
latitude, 64	lifted, 189
	111000, 107

100	Frilling of negative, 96-97
on mirrors, 188	Future of photography, 6, 138
on paper, 189	Tuture of photography, e, 150
on wood, 188	Gas bells on negatives, 97
Fire photography. See Arson investigation photography	Graflok back for 4 x 5 cameras, 22
Fire prevention: photography and, 5	Graininess, 27
Fixing bath, 84	Gray cards, 53, 69
Flash. See also Illumination	Green v. City and County of Denver, 3
for accident photography, 142	Guide numbers for flash, 69
automatic, 69	Gunshot wounds, 154
bounce, 66, 70	Guilshot woulds, 154
daylight, 142	Halation, 97
electronic, 54, 218	Halftone, 93
exposure for, 69	Handwriting comparisons, 194
fill-in, 67	Hangings, 158
for fire photography, 169	
guide numbers, 69	Hesitation marks in suicide, 158
for homicides, 158	Highlight, 92
for identification photography, 180, 191	Hit-and-run accidents, 147
for infrared photography, 206, 217	Homicides
inverse square law, 69	before photographing, 154
multiple, 66	bullet holes, 154
oblique lighting, 195	chalk outline of body, 155
off-camera, 66	color photography, 157
painting with light, 67	handling of body, 154 how to photograph, 154
photoflash, 54	
power source, 54	lighting for, 158
principle of, 54	perspective grid, 149
ringlight, 175	sketch of scene, 155
single, 65	weapons, 154
slave units, 66	Hypo-clearing agent, 84
strobe, 54	190 100
synchronization, 54	Identification bureau, 180, 190
for ultraviolet photography, 204	Identification photography
Flash meters, 56	color, 191
Flat prints, 114	digital cameras for, 192
Fluorescence photography, 199, 205	film for, 191
Focal length, 43	history of, 2
Focus	lighting, 180, 191
defined, 62	Polaroid, 192
depth of field, 62	purposes of, 180, 184, 190
for fluorescence photography, 203, 208	views, 180, 191
general, 62	Illumination. See also Flash; Lighting
for infrared photography, 216	axial lighting, 175
for ultraviolet photography, 203	backlight, 182
Fog on negative, 96	darkfield, 182
Foot impressions, 173, 177	flash, 54
Footprints in burglaries, 161, 173	for copying, 182
Forgery. See Questioned document examination	exposure for, 217
Formulas, developing	types of, 191, 201
black-and-white film, 93	vertical, 175
C-41, 118	Image
color film, 117, 120	negative, 27
E-6, 120	positive, 27
Kodak HC-110, 93	replica, 17
Kodak Technidol, 93	Impressions, 143, 147, 173, 177
Frequency, defined, 9	Incident light reading, 53

Indentations, 196 Infinity, 62	Metal photography, 177
	Meters
Infrared photography, 195, 205, 215	ambient light, 56
Inks, 194, 198, 222	built-in, 51, 63
International Standards Organization, 34. See also ISO	color analyzing, 124
Inverse square law, 69	flash, 56
ISO, 34. See also ASA; Exposure Index (E.I.)	incident light, 53
	light, 51
Latent image, 184	reflective light, 53
Lens, 43	spot, 53
care of, 47	through-the-lens (TTL), 51
component, 43	Microphotography, 175
defined, 43	Microscope, 176. See also Microphotography
diaphragm, 43	comparison, 179
element, 43	compound, 176
enlarger, 106	photography through, 176
focal length, 43	Minolta cameras, 19
focus of, 62	Monochromatic film, 33
focusable, 46	Monopod, 57
f/stops, 60	Mounts
how to clean, 47	
for infrared photography, 216	camera lens, 43
microscope, 175	microscope camera, 176
mounts, camera, 47	tripod, 57
mounts, video, 131	video camera lens, 131
Lens brush, 58	Moving objects, photography for, 62
	Muddy prints, 114
Lenses	Mug shots. See Identification photography, 191
long-focal, 44	Multicolored surfaces and fingerprints, 195, 199
macro, 47, 56	Multiple flash, 66
normal, 43	Murder. See Homicides
tele-lens, 44	
telephoto, 44	Negative carrier, 106
wide-angle, 44	Negatives. See also Development; Film
zoom, 46	brightness range, 32
Licenses, 193	contrast, 93
Light	corrections, 94-98
ambient, 56	defects, 94-98
artificial, 55, 65	density, 63, 92
bending of, 10	halftone, 93
defined, 9	highlights, 92
incident, 53	and photographic paper, 102
intensity of, 12	processing control, 89
reflected, 10	shadows, 93
sources of, 9	sharpness, 35
speed of, 10	tonal gradation, 93
Light meters, 51	Neutral density filter, 49
Lighting. See Flash; Illumination	Nikon cameras, 19
Lightweight paper, 101	Nikor tanks and reels, 87
Long-focus lenses, 44	
Luco v. United States, 1	Non-luminous objects, 205
Luminol. See Bloodstains	011' 1' 1.1'
	Oblique lighting, 195
Luminous objects, 178, 205	Obliterated writing, 195
Luna PRO meter, 51	Offender detection, 169
Magra lana 47 56	Opaque objects, 10
Macro lens, 47, 56	Orthochromatic film, 33
Macrophotography, 175, 217. See also Close-up photography	

Painting with light, 67 Panchromatic film, 33, 186	Proof sheets, 103 Public relations and police photography, 5
	Push-pull processing of film, 120
Paper	rush-pun processing or rimi, 120
bases, 99, 100	Questioned document examination, 193
color, 120 contrast, 100	Questioned document photography, 193, 209
emulsions, 99, 100	Questioned document photography, 195, 209
	RA-4 process, 126
glossy surfaces, 99 matte surfaces, 99	Rangefinder camera, 16
negative contrast and, 99	Rape, 159
	RC papers, 99
packaging, 102 processing for contact print, 103	Red eye effect, 66
processing for contact print, 103 processing for enlargement, 108	Redden v. Gates, 2
selecting a, 99	Reduction of image, 107
	Reflectance, subject, 63
sizes, 102	Reflected light reading, 53
speeds, 99	Reflection, 10
storage, 99, 102	Refraction, 10
surfaces, 99, 102	Reproduction ratio, 47
weights, 101	Resin-coated papers, 99
Parallax, 173	Reticulation on negatives, 97
People v. Jennings, 2	Reversal photography, 125
Personnel training, photography and, 5	Reversal rings for lens, 174. See also Close-up photography
Perspective grid	Ring light flash, 175
accidents, 149	Rules for composition, 11
crime scenes, 149	Rules for composition, 11
Photo CD, 137	Safelights, 74, 91
Photoelectric exposure meters, 52	Secondary image, fingerprints on mirrors, 188
Photoflash. See Flash Photogram patry: See Perspective grid	Semen, 160
Photogrammetry. See Perspective grid	Sex offenses, 159
Photographic paper. See Paper	Sharpness, 35
Photomacrography. See Close-up photography;	Shells, 179
Macrophotography	Shoe impressions, 173
Photomicrography. See Microphotography	Shoe prints, 173, 177
Photon, 9	Shutter
Pinhole camera, 13	adjustable, 16
Pinholes on negative, 97	defined and, 14
Pit marks on negative, 97	flash, 54
Point of origin, in fires, 165	focal plane, 14
Polacolor film, 38	speeds, 61
Polarizing filter, 49, 50	Shutter priority cameras, 63
Polaroid cameras	Shutter speeds, 61
CU-5 close-up camera, 185	Silver halides, 27
identification cameras, 192	Simple camera, 13
Land 4 x 5 camera system, 22	
microscope cameras, 176	Single flash, 65 Single-lens-reflex camera, 17
MP-4 copy camera, 135	
use of in police work, 38	Single-weight paper, 101
Police photography	Skidmarks, 143, 147
and arson, 163	Slave units, 66. See also Flash
history of, 1	SLR camera, 17
uses of, 1	Spectrum, electromagnetic, 9
Positive image, 27	Spectrum, visible, 9
Press camera, 21. See also Cameras	Specular light, 9
Print dryers, 77	Spherical aberration, 45
Printing. See Contact printing; Enlarging	Spot meter, 53
Prism, 10	Spots on prints, 114

Spy cameras. See Ultraminiature cameras Stabilization processing, 113
Stained prints, 115
Starlight scope, 224
State v. Thorp, 3
Stop bath, 84
Streaks
on negatives, 98
on prints, 113
Strobe, 54
Suicide, how to photograph, 158
Surveillance photography, 169, 223
Synchronization for flash, 54
Systems for photography, 15
Tanks, processing, 75

Technical Pan film, 93 developed in HC-110, 93 developed in Technidol, 93 as high-contrast, 93 Tele-lenses, 44 Telephoto lens, 44 Television. See Video Test strip, 109 Time exposure, 61 Timers, 76 Tire impressions, 143, 147, 177, 178 TLR cameras, 19 Toolmarks, 177 Tools of photography, 12 Traffic accidents. See Accident photography Translucent objects, 10 Transmitted illumination, infrared, 195 Transparent objects, 10 Trays, 75, 88 Tripod substitutes, 57

Tripods, 57 TTL flash systems, 51 Twin-lens-reflex camera, 19

Ultraminiature cameras, 15
Ultraviolet photography, 195, 199. See also Fluorescence photography
Ultraviolet filters, 187, 201, 207
Ultraviolet light, 195

Vertical illumination, 175. See also Illumination Video cameras, 129 formats, 129

monitors, 136 screens, photography of, 132 surveillance and, 129, 169, 223 tapes, 129

Viewfinder, 131 Visible spectrum, 9

Warrant, when needed, 141
Washers, film, 84
Washing negatives, 84
Washing prints, 111
Water resistant paper, 99
Water rinse, 83, 90
Wavelength, 9
Weapons, 154
West, William and Will, 2
Wide-angle lenses, 44
Wood photography, 177, 188
Wounds, photography of, 212

Zip drive, 136 Zoom lenses, 46